GRAND ILLUSIONS

Also by David M. Lubin

Flags and Faces: The Visual Culture of America's First World War
Shooting Kennedy: JFK and the Culture of Images
BFI Modern Classics: "Titanic"
Picturing a Nation: Art and Social Change in Nineteenth-Century America
Act of Portrayal: Eakins, Sargent, James

GRAND ILLUSIONS

American Art and the First World War

DAVID M. LUBIN

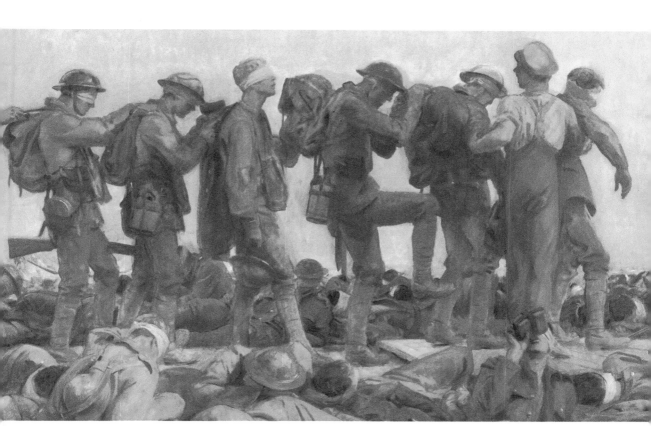

OXFORD
UNIVERSITY PRESS

OXFORD
UNIVERSITY PRESS

Oxford University Press is a department of the University of Oxford.
It furthers the University's objective of excellence in research, scholarship,
and education by publishing worldwide. Oxford is a registered trade mark of
Oxford University Press in the UK and in certain other countries.

Published in the United States of America by Oxford University Press
198 Madison Avenue, New York, NY 10016, United States of America

First issued as an Oxford University Press paperback, 2019

Library of Congress Cataloging-in-Publication Data
Lubin, David M., author.
Grand illusions : American art and the First World War / David M. Lubin.
pages cm
ISBN 978-0-19-021861-4 (hardback)— ISBN 978-0-19-090664-1 (paperback)
ISBN 978-0-19-021862-1 (updf)—ISBN 978-0-19-021863-8 (epub)
1. World War, 1914–1918—Art and the war.
2. Arts, American—20th century—Themes, motives.
3. Arts and society—United States—History—20th century. I. Title.
NX650.W67L83 2016
709.73'0904—dc23 2015024857

This publication has been made possible through support from the
Terra Foundation for American Art International Publication Program of
the College Art Association.

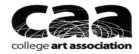

9 8 7 6 5 4 3 2 1
Printed in Canada on acid-free paper.

CONTENTS

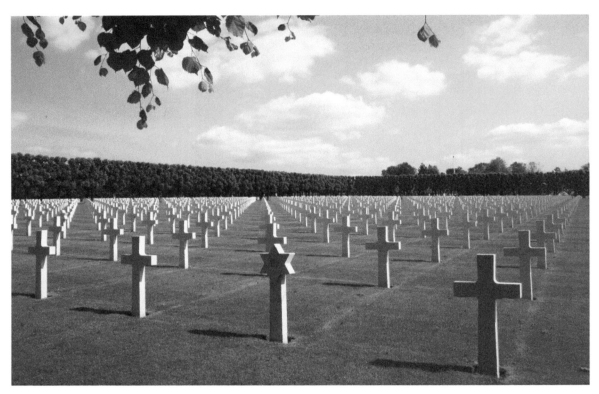

1. | Meuse-Argonne American Cemetery, established 1918, dedicated 1937.

PREFACE

THE WEATHER WAS PERFECT DURING a week in June when I drove through western Belgium and northeastern France on a tour of First World War battlefields, cemeteries, and memorials. My trip began in the Flemish town of Ypres, which had been the site of intense fighting throughout the four-year conflict. While strolling on the ramparts, I came across a tiny British cemetery nestled above a bend in the Yser River. Nearby, and far grander, looms the Menin Gate, a neoclassical monument dedicated to 55,000 British soldiers who died at Ypres. In a nightly ceremony conducted at the stroke of 8 p.m. year-round, a British soldier trumpets a poignantly beautiful "Last Post" in honor of those who fell in defense of the Empire.

Over the next six days, I sought out war cemeteries large and small. All were beautiful, well-manicured, and humbling. I especially remember one little French military cemetery perched on a hillside overlooking a twelfth-century Cistercian abbey. Other graveyards were majestic, none more so than the Meuse-Argonne American Cemetery and Memorial, spread out over 130 acres and containing the largest number of American war dead (14,246) of any American cemetery in Europe. Here, in hypnotic row upon row of white marble crosses, interspersed with the occasional Star of David, were the remains of thousands of American soldiers who never returned to their homeland (Fig. 1).

The scene called to mind a slide lecture I heard while in graduate school by the renowned art historian Vincent Scully. Describing the truncated tower that visually anchored another of America's World War I cemeteries in France, he became suddenly emotional, comparing the tower to the truncated lives of the young men buried there. His voice broke as he said the words, and he had to gather himself before moving on to the next slide. This triggered in me, and I'm guessing everyone else in the darkened auditorium that day, a similar response.

A third of a century later, I found myself questioning the emotions I had experienced in that lecture hall. *Dulce et decorum est pro patria mori*, said the ancient Romans. But is it sweet and fitting to die for your country?

A few kilometers beyond Ypres, I visited the Tyne Cot cemetery, permanent home to the bodies of twelve thousand soldiers of the British

2. | Käthe Kollwitz, *Grieving Parents*, 1931–1932, in the German war cemetery, Vladslo, Belgium.

Commonwealth, eight thousand of them unnamed. Their graves, set neatly within herbaceous borders and marked by simple white headstones in undulating patterns on a gentle slope, are surrounded by pastoral farmland that might have reminded family members of countryside back home, thus making good on the plea of the British war poet Rupert Brooke: "If I should die, think only this of me: / That there's some corner of a foreign field / That is for ever England."[1]

Some fifty or sixty kilometers from Tyne Cot, outside the village of Vladslo in Western Flanders, lies a German cemetery. Getting there is difficult; the roads are small and the signage minimal. When I found the place at last, a German religious group was just leaving, singing a Lutheran hymn at the entrance gate before boarding their coach for another destination. With them gone, I had the graveyard to myself. What a contrast to the British cemeteries. This resting place was dark and enclosed, shaded by large, leafy trees, as if even the sky was to be blotted out. The markers indicated that the bodies were buried twenty to a grave; obviously the dead on the losing side did not merit the real estate accorded to their counterparts on the winning side.

In the back of the cemetery was the monument, or anti-monument, that I had come to see. This was the *Grieving Parents* double-statue by the German sculptor and printmaker Käthe Kollwitz, whose son Peter had died fighting in Flanders (Fig. 2). Kollwitz depicts herself and her husband, each stricken with grief for their lost child. They occupy separate plinths. The distance separating them is small but immeasurable, for grief is the most private of emotions. There is nothing noble about it. Nor is there in death for the homeland. That, it seems to me, is what *Grieving Parents* has to say. It haunted me throughout my journey.

IN 1937, CAPPING AN ALMOST decade-long international trend in favor of pacifism, the left-wing humanist French filmmaker Jean Renoir made a movie about a small group of French soldiers from different social classes who serve time together in a series of German prisoner-of-war camps. He entitled it *La grande illusion* (and, in doing so, probably had in mind the title of the British author Norman Angell's 1909 antiwar tract, *The Great Illusion*, which was reprinted in 1933 when Angell won the Nobel Peace Prize). Renoir was a messy, spontaneous, big-hearted artist, and here, in his gently ironic, never assertive way, he calls into question all kinds of "illusions" that, in his view, sustain modern warfare: that one side is morally superior to the other, that humanity can be meaningfully and legitimately divided by national borders, that class divisions are natural, that men must be conventionally manly, that Jews are inferior to Gentiles, and so forth. That warfare can ever lead to a lasting peace is perhaps the greatest illusion of all. After winning a prize at the Venice Film Festival, the movie was banned in Germany by propaganda minister Joseph Goebbels. When the Germans marched into Paris three years later, they seized and destroyed every print of the film they could find.

In the spirit of Renoir, this book takes stock of an array of "illusions" that visually defined the First World War experience for Americans. It examines how the war affected American painters, sculptors, graphic designers, photographers, and filmmakers during a period that stretches roughly from the sinking of the *Lusitania* in 1915 to the rise of the Third Reich in 1933—and how, in turn, that period was affected by their art and imagery. Among artists to be considered were traditionalists and modernists, innovators and reactionaries, patriots and anarchists, expatriates and nativists. Together, they reveal diverse creative responses to a notably turbulent era in American history. Sometimes their art specifically addressed war and violence, but just as often it approached the war indirectly, through a collateral concern for, say, the changing role of women in society, the place of minority Americans in a self-consciously white Anglo-Protestant hegemony, and the virtues and vices of isolation, urbanization, and modernization.

Never previously in the history of warfare had visual images been employed so effectively and abundantly. The First World War was the first fully industrialized war, and an important aspect of that industrialization was the mass production and dissemination of war-related images. They informed and misinformed opposing populations about the need to go to war, the nature of war itself, and the consequences of war. In the modern era, notes Paul Virilio, a theorist of war and media, "Images have turned into ammunition."[2]

Let us reconsider, then, the conventional art-historical wisdom that the First World War had little effect on American art.[3] I want to claim instead that it had a vast impact, but one that cannot be quantified or otherwise measured. A core assumption of this book is that visual images, especially the most persuasive ones, do their work beneath the surface, for who can say, finally, how images are processed in the remoter regions of the psyche? Nonetheless, it is possible to contemplate such images a century later and ask ourselves how they generated meanings, what those meanings might have been, and how these have, or have not, remained relevant. It will become clear in the pages ahead that the war had a tremendous effect on well-known and lesser-known artists across the spectrum of political viewpoints and artistic media and genres. The diversity of their responses prevents us from making any sort of one-size-fits-all encapsulation. That's the beauty of it, I hope you will agree. American art, we shall see, was no more homogenous or unified than was the nation itself in those fractious and perilous times.[4]

After the war ended and the troops came home, American involvement was quickly disavowed and forgotten or repressed by many American artists and intellectuals, as well as by much of the public at large. The Great Depression and the Second World War further obscured the significance of the First, and with the coming of the nuclear age, those earlier days of destruction seemed practically quaint. But now, after a century has elapsed, the deep geopolitical fissures that surfaced during the 1914–1918 war have proven to be inescapable.[5]

In a sense, this book addresses you from the still-contested ideological terrain of the military cemeteries I visited in Belgium and France. "Who controls the past controls the future," noted George Orwell, adding, "Who controls the present controls the past." Each of the following chapters seeks to understand how visual artists and their patrons and audiences strove to control their present—and thus, in effect, their collective past and future—through powerful, provocative, and persuasive imagery. The vastness and beauty of the graveyards are but one example of controlling the past through imagery in the present.[6]

In picturing heroic manhood, vulnerable femininity, blighted landscapes, and monstrous enemies with vivid, sometimes unforgettable, images, image-makers absorbed and recirculated the religious, political, and philosophical doctrines of the day. Doing so they rendered them more accessible to mass audiences, many of whom were recent immigrants or untutored rural folk

with little command of written English but a ready understanding of clearly etched visual archetypes. Other creative artists, as we will see, sought to dissent from or undermine these dominant cultural representations.

The purpose of this book is to show how American artists of a century ago portrayed themselves, their countrymen, and their enemies during the world's first global cataclysm. In examining these works, many of which have long since been forgotten, we can understand with greater clarity how Americans of today—and their counterparts and adversaries across the world—rely on or reject those archetypal images for their own self-definition in equally perilous times. Probing grand illusions of the past can help us understand, if not necessarily break free of, their continuing hold on the present.

WHEN I WAS A GRADUATE student casting about for a dissertation topic, my American Studies program chair, Charles Feidelson, knowing I was intrigued by visual images and their relationship to history and literature, suggested I write on WWI art, posters, and movies. I chose a different subject. Only now, some thirty-five years later, do I realize that I took his advice after all. Just not in a timely manner.

I began working on this book in earnest during a year-long residential fellowship at Harvard University's Warren Center for Studies in American History and completed it (well, not quite) during my next sabbatical, while a residential fellow at the Center for Advanced Study in the Visual Arts (CASVA) at the National Gallery of Art. I thank both organizations for the financial support and lively intellectual atmosphere they provided.

For their full-throttle critical engagement with bits and pieces or entire chapters of this book at various stages, I thank Elena Baraban, Joel Bernard, David Cateforis, Holly Clayson, Nancy Cott, Jay Curley, Charlie Eldredge, Stephanie Fay, Pearl James, Scott Klein, Julia Kleinheider, Jason LaFountain, Gus Lubin, Molly Lubin, Barry Maine, Angela Miller, Alex Nemerov, David Peters Corbett, Jules Prown, Jenny Raab, Jennifer Roberts, Dick Schneider, Joshua Shannon, Cécile Whiting, and the late Peter Brunette, as well as members of classes, reading groups, and lecture audiences at a variety of institutions. Special thanks to Magua, the Wily Fox. Other scholars and colleagues who contributed ingredients to the stew that is this book include Martin Berger, Bob Cozzolino, Randy Griffin, Frank Kelly, Anne Knutson, Michael Leja, Mark Levitch, Bibi Obler, Miles Orvell, Kirstin Ringelberg, Bruce Robertson, Bill Truettner, Alan Wallach, and Jay Winter.

At my home institution, Wake Forest University, the Z. Smith Reynolds library is my clean, well-lighted place, and staff members there, especially James Harper, Kaeley McMahan, and my all-purpose trouble shooter Peter Romanov, have been creative and enterprising in finding me every obscure or

out-of-print book, article, or movie that I thought I needed (and sometimes, it turns out, did not). Wake Forest has also provided me with a string of excellent undergraduate research assistants, of whom I'd like to single out Jordan Anthony-Brown, Mary Beth Ballard, Sarah Pirovitz, Amanda Smith, Emily Snow, and Lauren Woodard for their assiduous information-gathering and synthesizing. Erin Corrales-Diaz, then a Master's student in art history at Williams, volunteered her services to me as a "remote" research assistant and did an outstanding job, as did my former student Laura Minton after she had moved on to graduate school in Kansas. Sarah Pirovitz has been with me on this project longer than anyone; after graduation she went into publishing and has continued to read drafts and make valuable suggestions for improvement.

In the art department, staff members Kendra Battle, Millie Herrin, Paul Marley, and Martine Sherrill have been helpful in countless ways. I also wish to thank my chair, John Pickel, my dean, Michele Gillespie, and my provost, Rogan Kersh, whose father, Earle, it turns out, was the art editor for a Time-Life volume on WWI that was one of the first books I ever owned—and still have with me.

Oxford University Press has been a pleasure to work with, especially production manager Joellyn Ausanka and production editor Claudia Dukeshire, assistant editor Steve Bradley, editorial intern Grace McLaughlin, who was resourceful in tracking down difficult-to-locate images, and my editor, Brendan O'Neill, who showed me his Maxwell Perkins side more than once, for which I'm most grateful.

Finally, my thanks to Libby Lubin, for more than she'll ever know.

GRAND ILLUSIONS

1

WAR, MODERNISM, AND THE ACADEMIC SPIRIT

IN THE EARLY DAYS OF the conflict, most observers believed the fighting would be over by Christmas. This was one of the first illusions to be dispelled. Another was that the war would be a limited affair, restricted to aggrieved parties, and not suck neutral nations into its orbit. Quickly shattered, too, was a third illusion, that the war would be fought by regulation armies and not spill over into civilian populations. Europe had not seen a full-fledged war since Napoleon surrendered at Waterloo a century earlier and even that pan-European melee was restrained compared to what befell Europe now: total war.

If Europeans found it difficult to imagine what lay ahead, this was even truer for Americans, who were buffered by three thousand miles of ocean and whose own great internal war was half a century earlier. Those who had fought in that upheaval were now white-bearded old men. Full-scale war was too far away, both in space and time, for Americans to imagine that they too would be swept into the maelstrom.

In July, as rumor of war increased, a commercial illustrator named Emmanuel Radnitzsky, who two years earlier had changed his name to Man Ray (using both parts together, à la "Mark Twain"), was studying the work of the early Renaissance master Paolo Uccello. Uccello's theories of perspective were far less influential than those of his fellow Florentine Leon Battista Alberti, but that made them all the more intriguing to Man Ray, who was attempting to rethink the ground rules of representational painting. He focused his attention on Uccello's *Battle of San Romano* (c. 1438–55), a large three-part fresco painting whose sections are owned, respectively, by the National Gallery in London, the Louvre in Paris, and the Uffizi in Florence. In its entirety the fresco depicted an eight-hour skirmish between Florentine and Sienese armies outside the gates of Florence in 1432. Man Ray was not

interested in the subject of Uccello's masterwork—chivalric warfare—but rather in its unorthodox techniques of perspective and foreshortening.

He started work on a large, three- by six-foot oil painting using a specially prepared canvas that would simulate the texture of a fresco. It filled the space of his living room in Ridgefield, New Jersey. This as-yet untitled piece was to be his modernist version of the *Battle of San Romano*.

Early in August, as he was finishing the large painting, war broke out in Europe. His wife, Aldon ("Donna") Lacroix, whose Belgian family was uprooted by the German invasion, remarked on the appropriateness of the subject matter, which until then had been inconsequential to him. As he later recounted, "Donna said it was prophetic, that I should call it War. I simply added the Roman numerals in a corner: MCMXIV."[1] The painting, now known as *A.D. MCMXIV (War)*, or, for short, *A.D. 1914*, shows impersonal, faceless, machine-like automatons surging against one another in hand-to-hand combat (Fig. 3). These generic foot soldiers, clad in featureless, rust-colored uniforms attack a smaller unit of blue infantrymen in front of a drab, planar, shard-like forest of the sort favored by the proto-cubist landscape painter Paul Cézanne. Knights on horseback, as stylized as chess pieces, look on impassively. The painting's date is inscribed in Roman numerals on a large rock in the foreground. Beneath it sprawls the body of a dead child.

With the date added in Roman numerals, the painting makes the banal observation that war is timeless: that the conflict of 1914 was, in essence, no different from those that have occurred over millennia. In this view, modern-

3. | Man Ray, *A.D. MCMXIV (War)* ("*A.D. 1914*"), 1914. Philadelphia Museum of Art.

day Belgium simply stood in for Renaissance Florence and ancient Rome and countless other times and places. In the summer of 1914, Man Ray had no idea that the war to come would be unlike anything the world had ever seen.

In his autobiography Man Ray describes the impact that the announcement of war had on him and his contemporaries: "It was a field day for the newspapers with accounts of battles and atrocities; Wall Street was booming; speculators were reaping fortunes in a day. During my lunch hour when in town I walked around the streets near the stock market, filled with gesticulating employees shouting to me in the open windows of the offices, transmitting orders to buy and sell. It was like a great holiday, all the profits of war with none of its miseries." Still incensed about the experience some half a century later, he writes, "Walking home in the evening through the silent wood, I felt depressed and at the same time glad that [Donna and I] had not yet been able to get to Europe. There must be a way, I thought, of avoiding the calamities that human beings brought upon themselves."[2]

While working on the large painting, Man Ray produced an antiwar drawing for the September 1914 cover of Emma Goldman's anarchist magazine, *Mother Earth* (Fig. 4). It depicts an abstracted American flag. The stripes of this flag are constituted by the prison apparel of conscientious objectors. In the field of stars, foot soldiers bayonet one another under starbursts of artillery fire. A crucified Christ hangs from the crossbars of the flag pole.[3]

Even here, Man Ray's understanding of the war is simplistic. He sees it abstractly, in archetypal terms. It was only after the war had ended that he found objective correlatives for its unprecedented strangeness, as in *Elévage de Poussière*, or *Dust Breeding* (1920), a carefully constructed photograph taken in collaboration with Marcel Duchamp (Fig. 5). Working with a close-up lens and strong side lighting, Man Ray photographed dust balls that had accumulated on a lower panel of Duchamp's mixed-media work-in-progress, *The Bride Stripped Bare by Her Bachelors, Even* (1915–23), which he referred to informally as "the Large Glass" and had been creating over the years in fits and starts (hence the accumulation of dust).[4]

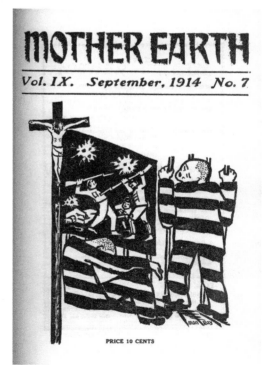

MOTHER EARTH

Vol. IX. September, 1914 No. 7

PRICE 10 CENTS

4. | Man Ray, *Mother Earth* cover, September 1914.

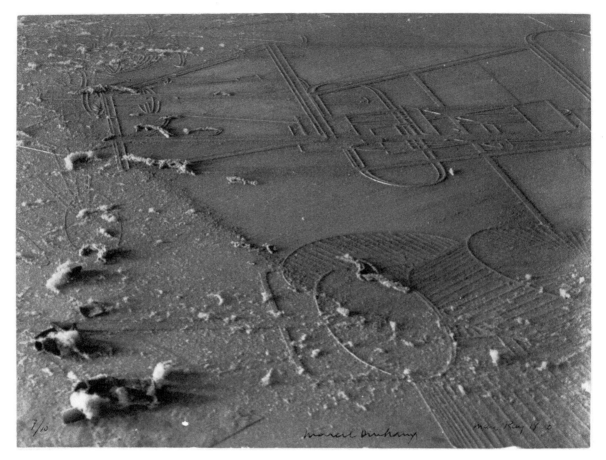

5. | Man Ray, *Dust Breeding (Duchamp's Large Glass with Dust Notes)*, 1920. Metropolitan Museum of Art.

The photo has an eerie look about it, like the surface of the moon—or, more to the point, no man's land. Indeed, it resembles nothing so much as an aerial reconnaissance photograph from the Western front, showing roads, fields, farmhouses, gun emplacements, and troop movements, all from a great height, as seen in Edward Steichen's beautiful photographic views of destruction in the Château-Thierry sector in 1918 or his "straight" (unfiltered and unretouched) but almost apocalyptic *Mine Craters, Combres Hill* (Fig. 6). Steichen's aerial reconnaissance photography, made on assignment for the army, was not shown publicly at the time Man Ray and Duchamp photographed *Dust Breeding*, but they were both acquainted with Steichen personally and ran in the same social circles, as evidenced by their mutual friend Florine Stettheimer's 1917 painting *Sunday Afternoon in the Country* (Cleveland Museum of Art), which depicts, among other friendly exchanges

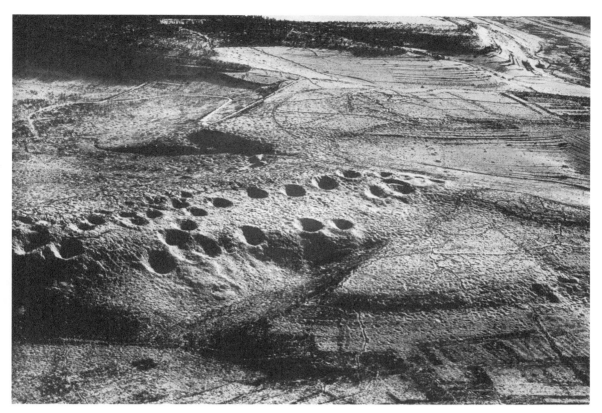

6. | Edward Steichen, *Mine Craters, Combres Hill*, 1918. Art Institute of Chicago.

in a modern-day *fête galante*, Steichen photographing Duchamp, who sits casually on the edge of table.

The year that Man Ray painted *A.D. 1914*, the new war was equally remote and unimaginable for an artist who was half a generation older, Marsden Hartley, one of America's leading non-representational painters. Hartley was living in Berlin in 1914, having moved there after a brief stint in Paris, where he had become acquainted with Pablo Picasso and other cubists who gathered at the salon of Gertrude Stein. He had also spent time in Munich, where he was befriended by the Blue Rider artists Wassily Kandinsky and Franz Marc.

Hartley had settled in Berlin in 1913, through the largesse of his art dealer and patron Alfred Stieglitz, in order to pursue his art, but also because, as a gay man, he felt relaxed in the Wilhelmine capital, with its relative sexual tolerance. More specifically, he had fallen in love with a young cavalry officer, Karl von Freyburg, who, at age twenty-four, was thirteen years his junior. Whether or not von Freyburg reciprocated Hartley's affections is not known, but the sojourn proved to be the most fertile period in the artist's long and restless career.

In September 1914, Hartley wrote Stieglitz that it broke his heart "to see Germany's marvelous youth going off to a horrible death...seeing those thousands simply walk out of homes leaving wives and children." Early in October, Hartley received the shattering news that von Freyburg had died in battle. The painter tried to explain to Stieglitz what this meant to him: "If you knew Freyburg you would understand what true pathos is—there never was anywhere a man more beloved and more necessary to the social well-being of the world—in every way a perfect being—physically—spiritually and mentally beautifully balanced."[5]

The death of this one youth whom he cherished in a personal and physical way stood in Hartley's mind for a much greater loss for humanity, that of an entire generation. "This is for me the most heartrending phase of the war—I seem to have lost all sense of victories and defeats of the great changes in history....I don't know how races expect to continue [to] thrive and prosper—I do not yet become used to the atrociousness of the very idea of war."[6]

The loss of von Freyburg caused Hartley "unendurable agony" and "eternal grief." Though he himself was not a warrior, his response calls to mind that of Achilles to the death of his companion Patroclus. The *Iliad* recounts that "Achilles went on grieving for his friend, whom he could not banish from his mind, and all-conquering sleep refused to visit him. He tossed to one side and the other, thinking always of his loss, of Patroclus's manliness and spirit....As memories crowded in on him, the warm tears poured down his cheeks."[7]

In despair, Hartley picked up his brush and began painting a dozen or so semi-abstract emblematic portraits. Collectively, they are called the War Motif series. Several of them, including the first and largest, *Portrait of a German Officer* (Fig. 7), refer directly to von Freyburg through an accretion of numbers, symbols, flags, and insignia: the Iron Cross, which he won for bravery in the field; the number 4, which identifies his regiment; the number 24, which was his age at death; black-and-white squares, signifying the chess matches he and Hartley played together; his initials, KvF; a rider's spur; a Bavarian banner: and so forth. The black, white, and red flag of the Second Reich figures prominently in the lower portion of the painting, but it does so upside down, a comment on the up-ending, over-turning effect of the war on Germany in general and this one German officer in particular. The black background activates the vividly colored objects and insignias seemingly strewn across it, but it also represents a funereal void, a gaping existential darkness, from which they briefly emerge and into which they will ultimately disappear.

Given the long-standing association of riding paraphernalia, such as boots, stirrups, spurs, and leather crops, with sexual fetishism, the painting vibrates with an additional wave of encoded meaning, as do Hartley's other

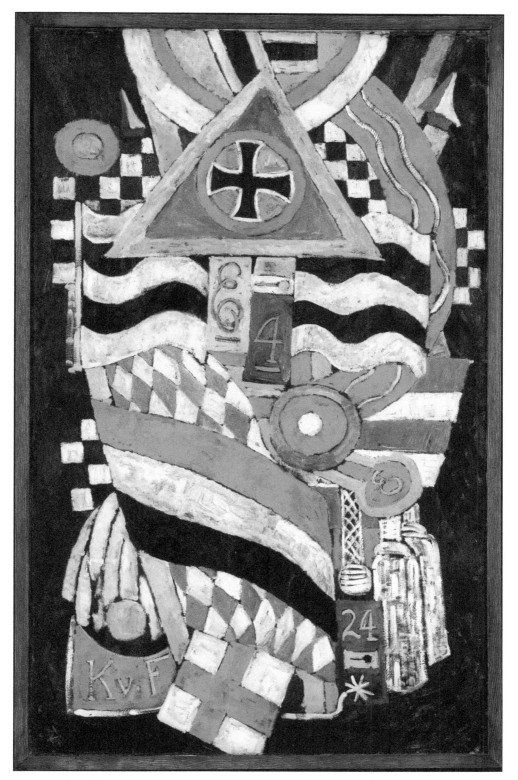

7. | Marsden Hartley, *Portrait of a German Officer*, 1914. Metropolitan Museum of Art.

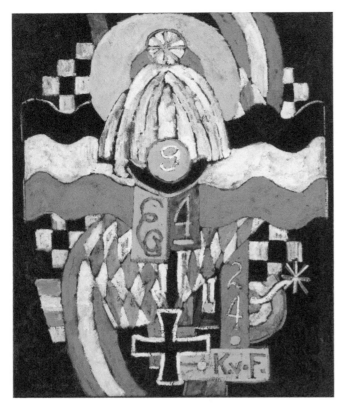

8. | Marsden Hartley, *Painting No. 47, Berlin*, 1914–15. Hirshhorn Museum and Sculpture Garden.

symbolic portraits of von Freyburg (Fig. 8). To be sure, the fetishism here is not solely sexual, for the objects depicted are fetishes of another sort: votive items that magically stand in for the deceased. Thus national, regimental, sentimental, and quasi-religious signifiers interact with symbols of physical desire on a two-dimensional surface to form a three-dimensional portrait.

Other paintings in the War Motif series do not allude specifically to von Freyburg. Yet they too both invoke the German officer corps that Hartley persistently idealized and disavow the ugliness and abjection of the warfare that Hartley witnessed from his vantage point in Berlin, a city increasingly tormented by the scourges of death, pestilence, and starvation.

Formally, the War Motif paintings are variations of the synthetic cubism then being practiced in Paris by Picasso and Braque, who similarly arranged flat, colorful, variegated semi-abstract forms on the picture plane. They also call to mind the heraldic devices of medieval chivalry, in which knights rode to battle bearing brightly colored flags and pennants laden with symbolic geometries. Like Man Ray at virtually the same moment in 1914, before anyone realized how radically different the new war would be from all previous modes of waging hostilities, Hartley drew on art and craft of the late Gothic period to enhance his modernist exploration of visual form. As did Man Ray, he could only understand the present by means of antiquated feudal templates.

By the end of 1915, the hardships of living in wartime Berlin proved too much for Hartley. Reluctantly, he came home. He brought the *Portrait of a German Officer* with him and had the rest of his paintings shipped later, when the means to pay their freight became available. Stieglitz celebrated the

artist's return by giving him a solo exhibition at Gallery 291 in April, 1916. Not surprisingly, the response proved cool. Reviewers wrote respectfully of Hartley, recognizing the integrity and verve of the War Motif paintings, but these were, after all, tributes to the German officer corps at a time when America was veering toward war with Germany.

Apart from Stieglitz, who acquired the *Portrait of a German Officer* for himself, collectors were reluctant to buy. Hartley tried to counteract their hesitancy by denying that the paintings contained any sort of extra-artistic meaning. "The forms [in the paintings] are only those which I have observed casually from day to day," he claimed. "There is no hidden symbolism what-soever in them; there is no slight intention of that anywhere.... I have ex-pressed only what I have seen. They are merely consultations of the eye ... my notion of the purely pictorial."[8]

Let us not take Hartley's words at face value. The forms in his Berlin paintings are more than "merely consultations of the eye." They are not "purely" pictorial. They reference, within Hartley's personal symbol system, the German officer whom he loved. But more than that, they reference a cultural system of Belle Époque military codes, displays, and behavior pat-terns that, in 1914–1915, were about to be obliterated by total war. In the age of machine guns, tanks, and barbed wire, bridles, spurs, and colorful pen-nants no longer made sense. Some fifty years later, the point was tartly made in the title sequence of Richard Attenborough's satiric antiwar film *Oh! What a Lovely War* (1969). Underlying the opening credits are a succession of close-ups of plumed helmets, epaulettes, and shiny breastplates. These give way slowly but inexorably to close-ups of machine guns, gas masks, and hand grenades, arriving at last on a single strip of barbed wire that stretches across the letterbox screen.

Another expatriate American artist who failed to grasp the world-upend-ing magnitude of the new war was Romaine Brooks. A wealthy heiress, she lived in a cloistered environment on the Avenue Trocadéro in the sixteenth arrondissement of Paris. She disdained commerce, practicality, and jockey-ing for prestige. Aloof from the art world, despite the favorable reviews her work received, she kept to a small circle of similarly rich and refined lesbians and devoted herself to her art. In the later summer of 1914, she painted a war picture to benefit the efforts of the Red Cross, but like Marsden Hartley several hundred miles away in Berlin, she was motivated by romantic or erotic desire and did not have anything especially insightful to say about the war.[9]

Her lover at the time was Ida Rubinstein, a Russian actress and dancer who was described as "a creature of genius with perfect legs." Those legs were, indeed, remarkably long, a characteristic that made Rubinstein a striking, Amazonian figure on the ballet stage—so much so, in fact, that it hampered her career more than it helped, for she was significantly taller than the rest of

her troupe. As a member of the Ballet Russe, she captivated the attention of Parisians when that company first appeared in France in 1909. She danced with Nijinsky in Sergei Diaghilev's 1910 production of *Schéhérazade*, her costumes designed by Léon Bakst. Wealthy admirers flung flowers at her, jewels, and even themselves, but, on meeting Romaine Brooks at a backstage party, Rubinstein fell in love with the reticent American artist.[10]

At the time, Brooks had entered into an intimate relationship with the Italian novelist, journalist, and poet Gabriele D'Annunzio, who lived in Paris. Braggart, narcissist, and self-proclaimed Superman, D'Annunzio—characterized by an acquaintance as "a frightful gnome with red-rimmed eyes and no eyelashes, no hair, greenish teeth, bad breath, the manners of a mountebank . . . and a reputation, nevertheless, for being a ladies' man"—would seem to be the last person on earth to win the heart of an introspective, publicity-abhorring lesbian. Natalie Barney, an avant-garde writer, who later became Brooks's lifelong lover and companion, quipped that whereas she only liked men from the ear to the forehead, D'Annunzio only liked women from the waist down. Brooks herself teased her boastful male friend for his sexual obsessions: "In heaven, dear poet, there will be reserved for you an enormous octopus with a thousand women's legs (and no head) which will renew themselves to infinity."[11]

Despite or because of D'Annunzio's indiscriminate sexuality, Brooks became compulsively attracted to him. On the eve of the First World War, a romantic triangle developed, in which D'Annunzio was in love with Rubinstein, Rubinstein with Brooks, and Brooks with D'Annunzio. It was at this point that the events of 1914 intruded. Brooks and Rubinstein were on holiday in Switzerland when Germany declared war on France. They hurried back to Paris on an overnight train. Rubinstein went down on her knees to beg God to intercede. Brooks was dismissive of war-making and annoyed by the fuss. Yet once she got home, she turned her basement into a bomb shelter, sent her paintings to Bordeaux for safe-keeping, and established a charitable fund for wounded French artists.

She also painted a fantasy portrait of Rubinstein dressed as a Red Cross nurse (Fig. 9). A tall and angular female with chiseled features stands at three-quarters length against a gray, windswept background. In the distance, across a large, empty expanse, the Belgian city of Ypres, with its famed Gothic spire, is engulfed in smoke and flame. The young woman, beautiful and resolute, wears a sweeping black cape that bears at the shoulder a large red cruciform insignia that directs the viewer's eye to the flaming city on the horizon. Her nurse's headpiece gleams with white highlights, standing out against the grayness of the roiling sky. A tendril of her hair, flying off in a lateral direction, echoes the black smoke billowing out of the distant city. With her dark cloak, her white nurse's gown unbuttoned at the throat, revealing an expanse of bare flesh, her long, elegant neck, and her bleak, almost desolate, facial

expression, she is a stunning avatar of Byronic solitude.

This is a work of high Romanticism, with its towering figure—here, atypically female rather than male—smoldering at the edge of no man's land. Yet it is rendered in the cool, monochromatic, underplayed visual style of Brooks's artistic hero, James Abbott McNeill Whistler. The Red Cross nurse burns with feeling, analogizing her to the city in the background, but the emotion is interiorized, suppressed by a palette of icy blues, grays, and blacks.

The painting was called *The Cross of France*. D'Annunzio wrote an accompanying poem, connecting Christ's suffering to that of France. The painting and poem were reproduced in a brochure that was sold to raise money for the Red

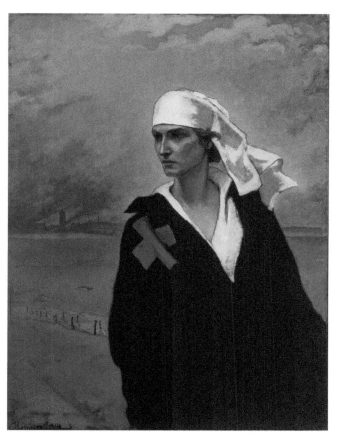

9. | Romaine Brooks, *Cross of France*, 1914. Smithsonian American Art Museum.

Cross. In 1920 the French government awarded Brooks the *Légion d'honneur* for her service to the nation. In retrospect, the painting has an aura of propaganda about it. Oddly, the private and professional trajectories of Brooks's endeavor merged. Her lesbian gaze at a desired love object, coupled with her predilection for Byronic melancholy, the crepuscular monochrome of Whistler, and modernist flatness of composition happen to accord with the newly developing style of propaganda art, in which (as Chapters 2 and 3 will detail) idealized, larger-than-life figures were dramatically set off against spare, visually uncluttered backgrounds.

In the spring of 1915, D'Annunzio, a brilliant orator who stirred the masses with his inflammatory rhetoric, urged his countrymen to go to war with Austria and reclaim lands that had long been in Austrian possession. Curtailing his self-imposed exile in France, he crossed into Genoa and delivered an impassioned nationalistic speech that is credited with persuading Italians, who were still undecided as to which side to take in the conflict, to join the

Allied powers. With Italy at last declaring war on Germany and Austria, he assumed command of an air squadron based in Venice. There he concocted a foolhardy but successful operation to fly across the Alps to Vienna and drop thousands of propaganda leaflets on the sleeping city. Crash-landing his plane on another mission in 1916, he temporarily lost sight in one eye.

Brooks hurried from Paris to be by his side. She took a studio on the Zattere, beside the Giudecca Canal, and painted a heroic portrait of her friend, entitled *Il Commandante* (Fig. 10). Again, her flat, monochromatic

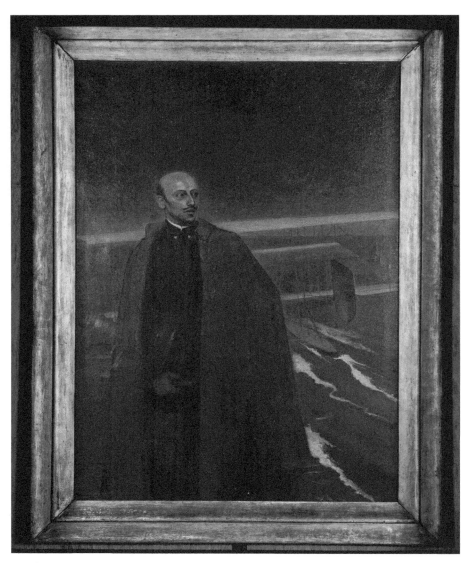

10. | Romaine Brooks, *Il Commandante* (Gabriele D'Annunzio), 1916. Museo Il Vittoriale, Gardano.

style corresponded, certainly without any such intention on her part, to the newly developing techniques of celebrity advertising and propaganda art. Lean and fine-boned, wearing jodhpurs and a gray cape over a black tunic, a pistol holstered at his side, D'Annunzio stands at the water's edge. The phallic spyglass positioned at his groin calls attention to his prodigious sexuality. To the side, a seaplane awaits his command, like the trusty steed of a modern knight errant.

D'Annunzio recovered use of the injured eye and went on to further glory. After the war he became one of the nationalist ideologues most admired by his countryman Mussolini. He epitomized romantic fascism. Long after Brooks had ceased to be romantically entangled with the self-proclaimed man of destiny, she continued to be enthralled by him and remained his confidante to the end of his life.

ALL THREE ARTISTS CONSIDERED HERE were naive about what modern warfare entailed and how total war would radically alter the world they knew. So was virtually everyone else, including journalists, politicians, and seasoned generals. Indeed, the more seasoned they were, the less able they were to see what was coming. One American art-world expatriate who, writing some twenty years later, claimed to have understood the paradigm-wrenching nature of the Great War from early on, is Gertrude Stein. The Pennsylvania-born, Harvard-educated experimental writer and modern art collector established her famous art salon in Paris in 1903 and cultivated friendships with the likes of Georges Braque, Henri Matisse, and, as mentioned above, Pablo Picasso.

In her 1938 book on the Spanish artist, she recalled that one evening in 1914, as she was strolling with him along the Boulevard Raspail, they saw their first camouflaged truck. "It was at night, we had heard of camouflage but we had not yet seen it and Picasso amazed looked at it and then cried out, yes it is we who made it, that is cubism." She uses this anecdote to explore her theory that artists, at least the best of them, are more attuned to the present than regular people are, and that's why modern art seems strange and peculiar to the latter, when all it is doing is capturing the essence of the moment in which they live. The artist, says Stein, is merely "the first of his contemporaries to be conscious of what is happening to his generation."[12]

Conventional, or what she calls "academic," art is too mired in the past to be able to see and understand the present. She compares academic artists to the generals who blundered through the Great War thinking they were fighting a war of the nineteenth century when they were engaged instead in a war of the twentieth. "That is what the academic spirit is, it is

not contemporary, of course not, and so it can not be creative because the only thing that is creative in a creator is the contemporary thing."

Unlike the generals, whose perceptions of reality were blunted by habit and routine, Picasso reacted to the present in a direct and innovative manner, able to see things for what they were rather than for what they had been. His contemporaries caught up with him only when the war forced them to "understand that things had changed to other things and that they had not stayed the same things, they were forced then to accept Picasso." The idea here is similar to her pronouncement in another context about the instability and impermanence of modern identity: "The minute you or anybody else knows what you are you are not it."[13]

It is a cliché that the public is always fighting the last war instead of the one in which it is currently embroiled. But Stein offers an audacious variation on this theme: "It is an extraordinary thing but it is true, wars are only a means of publicizing the things already accomplished." War, that is, comes after, and not before, society's transformation. It simply makes apparent to the masses what has already transpired. Thus, for example, "The French revolution was over when war forced everybody to recognise it; the American revolution was accomplished before the war; the war is only a publicity agent which makes every one know what has happened; yes, it is that."[14]

According to Stein, the Great War made ordinary citizens recognize the sweeping changes that modern art had already begun to register: the breakdown of hierarchy and the advent of democratic mass culture. She analogizes the war to a cubist composition, in which there is no central viewpoint or outstanding personage: "Really, the composition of this war, 1914–1918, was not the composition of all previous wars, the composition was not a composition in which there was one man in the centre surrounded by a lot of other men but a composition that had neither a beginning nor an end, a composition of which one corner was as important as another corner, in fact the composition of cubism."[15]

On the eve of Great Britain's declaration of war on Germany, the foreign minister Lord Grey elegiacally remarked: "The lamps are going out all over Europe; we shall not see them lit again in our life-time."[16] He was right, for the war changed everything. Art fashioned after 1914 might resemble art of the past by appropriating its forms, as in Man Ray's neo-Renaissance cubist war painting, Marsden Hartley's neo-Gothic *portrait d'apparat* of a German officer, and Romaine Brooks's neo-Romantic and late-Decadent fantasy portraits of a Red Cross nurse and a dashing air squadron commander. But that past was irrevocably gone and its lamps could not be re-lit, certainly not by such feeble attempts to invigorate new art with old.

The most "modern"—in the sense of being radically transformative—cultural act to come out of Europe in 1914 had nothing to do with

art, music, or poetry. It was the war itself. Across the sea in America, the most modern cultural act of 1914 occurred not in New York City, the home of advanced thinking in the arts, but rather in Dearborn, Michigan. There, the industrialist Henry Ford adopted the conveyor belt system used by meat packers. In 1913–1914, before switching over to the assembly line, Ford Motor Company produced a total of 248,367 cars. Less than two years later, with the new system in place, it was manufacturing two thousand cars *per day*. Not unlike the war in Europe, the assembly line in Dearborn changed the world forever.

Gertrude Stein brought modernity, the Great War, and the Ford Motor Company together in her own life in 1916 when she requested that a large Ford van be shipped to her in Paris so that she and her companion, Alice B. Toklas, could take part in the American Fund for French Wounded. This relief organization, which distributed food and medical supplies to military hospitals in outlying regions of France, was sometimes referred to as the "heiress corps" because it required volunteers to supply their own delivery vehicles.

While waiting for the Ford to arrive, Stein asked a friend who owned a taxi to give her motoring lessons. Driving a car in those years, before the introduction of automatic transmissions, synchromesh gears, and power steering, was not an easy affair. It required strength and coordination. "One had to keep both hands and both feet in action all the time," notes an historian of modern technology. "Gear shifting and steering both demanded significant upper body strength. Furthermore, a full generation of drivers had to use a hand crank to start their cars.... Consequently, it was a rather remarkable woman who undertook to drive any of the early motor vehicles." Such a woman was Gertrude Stein, who "had both the mechanical talent and the muscle. She could field-strip the primitive ambulance, and (although her driving was notoriously hair-raising), she loved doing it."[17] Stein was an obstinate driver. Insistent on looking ahead and always moving forward, she refused to put her car in reverse, regardless of circumstances, which was a source of consternation for her navigator, Toklas, especially when they missed a turn.[18]

The women adopted quasi-military uniforms for themselves. Their friend Georges Braque, who was recovering in Avignon from a bad head wound, was amazed by their appearance. "They looked extremely strange in their boy scout uniforms with their green veils and colonial helmets," he later recalled. "Their funny get-up so excited the curiosity of the passers-by that a large crowd gathered around us and the comments were quite humorous." Toklas wore something like a British officer's tunic, with patch pockets and a pith helmet. Stein wore a Cossack-type hat and Russian greatcoat that emphasized her already massive bulk. They may have hoped by their paramilitary costumes to provide themselves with a degree of legitimacy that as volunteer

service workers they otherwise lacked. Additionally, though, in terms of lesbian-feminist performativity, they were exerting agency rather than seeking acceptance. Through their fanciful costumes, they deflated military and medical self-seriousness with modernist panache.[19]

After the war, Stein replaced the Ford van, which she called Auntie, with a smaller, sleeker car she named Godiva. Several years later, while she and Toklas were touring the countryside in Godiva, the car had engine problems and needed to be taken to a garage. The mechanic on duty complained that his young assistant, a youth in his twenties, did not have good instincts for car repair, because he had been in the trenches during the crucial years when young men are expected to learn their trade. Throwing up his hands in a gesture of exasperation, the older man said of his assistant and others of his age cohort that they were *une generation perdue*, a lost generation. Stein evocatively borrowed this term to describe her young friend Ernest Hemingway and his fellow expatriates as they roamed restlessly through postwar Europe.[20]

The term "lost generation" caught on. In the aftermath of the Great War, many young people, not simply artists, writers, and expatriates, identified with it. They rejected what Stein called the academic spirit. But that was after the war. At the beginning, as we have seen, the academic spirit remained very much in place. One of the first big blows against it came in May 1915, when a German submarine torpedoed the British ocean liner *Lusitania* off the coast of Ireland and killed nearly everyone on board. That was a radically modernizing event. It was the beginning of total warfare. Yet even in the midst of these new, untested waters, the academic spirit would not, could not, die.

2
WOMEN IN PERIL

A BEAUTIFUL, WRAITH-LIKE YOUNG WOMAN, eyes pressed shut and hair sweeping upward, sinks to the bottom of the sea (Fig. 11). A wet nightgown, bared at the shoulder, reveals her firm, athletic body. Her naked foot touches moss-covered rocks. With a sleeping infant enclosed in her arms, she embodies maternal bliss. Bubbles rise from her lips. The water is dark but translucent. A fish floats by in the depths, an impassive observer.

What a strange, almost surreal scene this is. It seems at once terrifying and tranquil, summoning the viewer's primordial fear of drowning only to merge it with an equally primordial desire to return to the liquid warmth of the womb. It pulls together two of the most powerful pairings in art and literature: Mother and Child and Death and the Maiden. To modern eyes, this image might seem hokey and kitsch. But to thousands, if not millions of Americans who saw it plastered on walls across the land in the late spring and early summer of 1915, it must have been disturbing, even shocking. The historical record does not reveal how many copies of the poster were produced, where it was displayed, and what those who encountered it thought or said about it. Most of the several thousand war-related posters produced in the United States during this period share a similar fate: We simply do not know how many copies were printed, where those copies hung, and what passers-by noticed about them, if they noticed them at all.[1]

Still, we can be certain that in June 1915 few viewers would have missed the poster's reference to the recent sinking of R.M.S. *Lusitania* by a German submarine. At two in the afternoon of May 7th, the Germans fired a single gyroscopic torpedo at the unguarded ocean liner on its return voyage from New York to Liverpool. The vessel went down in eighteen minutes, before life boats could be deployed. Twelve hundred victims drowned, among them 128 Americans. Most of the bodies were never recovered; only two hundred corpses

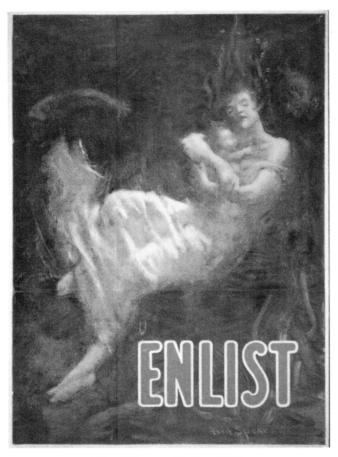

11. | Fred Spear, *Enlist*, 1915.

washed up on shore. Two of these, according to a widely circulated news report, belonged to a mother and child: "On the Cunard wharf lies a mother with a three-month-old child clasped tightly in her arms. Her face wears a half smile. Her baby's head rests against her breast. No one has tried to separate them."[2]

The poster is eloquent in its brevity. A single word, floating in space beneath the descending forms of the mother and child, conveys its message in pastel pink letters: ENLIST. Outlined with soft white contours, these letters epitomize lingering Victorian notions of feminine frailty. By minimizing the text of the poster to one well-chosen, well-rendered word, the artist shows an economy of form that must have been a model for legions of future commercial and political advertisers, whose goal was to scrub ads clean of verbiage and visual clutter in order to speed up communication and heighten impact. Here, a single, stand-alone word has been "enlisted" to drive home the poster's message.[3]

And that message was simple: Enlist in the armed forces to help prevent further crimes of this order. In 1915, the United States was not yet at war with Germany, but the poster insists that it *should* be at war with the aggressor nation that committed this atrocity. Designed by an unknown artist named Fred Spear (which, given the appropriately bellicose last name, could have been a pseudonym), *Enlist* was printed and distributed by the Boston Public Safety Committee, an organization named after the Revolutionary-era civic association on whose behalf Paul Revere made his midnight ride.[4]

The poster addresses male and female viewers alike. Men, join the army or navy. Women, make sure your men join the army or navy. Maurice Rickards, a pioneer in the academic study of ephemera, called *Enlist* "perhaps

the most powerful of all war posters," and with good reason. Both *Enlist* and an equally inflammatory poster, *Destroy This Mad Brute*, conjured up the historically relevant trope of imperiled femininity to stir visceral emotions. At a time in United States history when more Americans were likely to be troubled by rapidly changing sex roles in society than they were by military skirmishes on a distant continent, posters such as these managed to collapse the two areas of concern into one.[5]

INSTEAD OF LOOKING AT *ENLIST* solely in terms of its direct relationship to the *Lusitania* crisis and the so-called Preparedness Movement (a campaign to expand the United States armed forces and ready them for war), let us first consider it as an aquatic image deriving from earlier depictions of women in the water. There were many of these. Underwater imagery fascinated turn-of-the-century Americans. As the art historian Charles Eldredge points out, "the world beneath the sea was explored and exploited by many imaginative artists toward the end of the nineteenth century and provided writers, composers, scene designers and the like with an attractive alternative to terra firma and its phenomena." In part, Eldredge surmises, this was because of the scientific and technological innovations that had led to advances in deep-sea diving and submarine exploration. Cultural commodities imported from abroad also stimulated interest in the oceanic unseen. These included Jules Verne's fantasy novel *Twenty Thousand Leagues under the Sea*, Hans Christian Andersen's popular tale *The Little Mermaid*, Tennyson's poems "The Mermaid" and "Sea Fairies," and even Wagner's opera *Das Rheingold*. At its New York premiere in 1889, the latter was praised for its opening scene, showing, in the words of one journalist, "the gambols of the nixties [mermaids] below the surface of the Rhine." Before long, the American sisters of the Rhinemaidens were cavorting regularly on stage at the New York Hippodrome in a spectacle entitled *Neptune's Daughters*.[6]

In 1915, captivation with the watery depths remained strong in American art and popular culture. *Enlist* taps into this imagery but injects it with a tragic tone. In its lugubrious mood (no gambols or cavorting here), the poster invokes august Victorian-era literary paintings such as Sir John Everett Millais's *Ophelia* (1852), a celebrated Pre-Raphaelite tableau that pictures Shakespeare's deranged heroine floating fully dressed on the surface of a brook before her weighty, water-soaked attire drags her to the bottom, or James William Waterhouse's 1894 depiction, which shows the love-stricken maiden seated among water lilies before her demise.

Hamlet was Shakespeare's most acclaimed tragedy and in America the most frequently staged. Nineteenth-century performances by a succession of

illustrious touring actors such as Edmund Kean and Edwin Booth (the brother of Lincoln's assassin, John Wilkes Booth) were legendary. According to one theater historian, Booth's "100 consecutive nights of *Hamlet* at the Winter Garden Theatre in New York during the 1864/65 season inaugurated the era of the Shakespeare long-run in America, and he played the role, in cities large and small, for more than thirty years." The approaching tercentenary of Shakespeare's death in 1916 further heightened public awareness of the Bard and his slavishly worshipped drama. No fewer than five motion picture versions of the tale had appeared in American nickelodeons by 1913.[7] Despite the obvious differences between Spear and Shakespeare, vague similarities between poster and play may well have reverberated in the minds of viewers.

Ophelia, for example, embodies the unprovoked violation of innocence. She is one of literature's most renowned victims, subjected to an unwarranted attack by the man she loves. Psychologically unmoored by his verbal abuse, she falls into a "weeping brook," at which point, "Her clothes spread wide, / And mermaid-like awhile they bore her up; / ... But long it could not be / Till that her garments, heavy with their drink, / Pulled the poor wretch from her melodious lay / To muddy death."[8] In *Enlist*, the garments of an innocent victim "spread wide" and "mermaid-like" as she sinks to her "muddy death."

Hamlet is relevant in another way. It is the story of a young man who has difficulty fulfilling his father(land)'s entreaty to avenge a crime. The ghost of Hamlet's father calls out to the prince from the battlement of Elsinore castle: "If thou didst ever thy dear father love ... Revenge his foul and most unnatural murder." The ghost, that is, seeks to *enlist* young Hamlet in justifiable violence, as Spear's poster sought to enlist young Americans in authorized revenge against the "foul" Germans. What is Hamlet's "To be or not to be" soliloquy if not a call to arms? The prince must decide whether to take action or remain in his shell; whether to "suffer the Slings and Arrows of outrageous Fortune" or retreat into solipsistic denial, a suicidal "sleep" that would spare him "the thousand Natural shocks / That flesh is heir to." The Ophelia-like drowning in the recruitment poster poses a Hamlet-like question to American viewers, circa 1915: Will you do the right thing and go to war with feudal tyrants, whatever shocks and suffering this may entail, or instead swaddle yourself in a suicidal isolationist torpor?[9]

Shakespeare's play was not the only cultural reference that viewers of *Enlist* might have brought to it. Its dire death-by-drowning imagery harked back to a series of novels, stories, and paintings by proponents of naturalism such as Stephen Crane, whose 1898 allegorical tale "The Open Boat" tells of death at sea, and Winslow Homer, an artist who often portrayed existential loneliness in terms of watery hazard. In *Life Line* (1884, Philadelphia Museum

of Art), for example, Homer pictures a swooning young woman saved from drowning in a sexually charged encounter with an anonymous male rescuer who clasps her in his arms. In *Undertow* (1886, Clark Art Institute), the artist shows two shapely young female swimmers pulled from the deadly surf by muscular male life guards. In preparing these paintings, Homer repeatedly doused his models with water to capture the look of wet drapery, giving his depictions of aquatic endangerment an erotic tremor that complements, indeed, enhances, their life-and-death seriousness. For all its sensationalist melodrama, *Enlist* possesses gravitas deriving from its resemblance to the literary and artistic naturalism of Homer, Crane, and their peers.[10]

Or is that putting it too favorably? *Enlist* is lightweight compared to Homer's work, less engrossed in existential complexity. Indeed, it eschews complexity, for the reasons given above. And yet, if the key to late-nineteenth-century American naturalism is a burning outrage against cruel Darwinian processes of natural selection and the stony indifference of the cosmos (Crane's theme in particular), then *Enlist* shares that mood, only here the outrage is not directed against indifferent gods but rather immoral Germans. In the end, however, the visual roots of *Enlist* can be found less in turn-of-the-century naturalism than in the sort of academic formality (similar to Gertrude Stein's "academic spirit") favored by prominent New England painters such as Thomas Dewing and Abbott Handerson Thayer, both of whom specialized in the depiction of ethereal females hovering in pristine isolation from the manly world of action.

The art historian Ann Uhry Abrams observes of Dewing and Thayer, "Both were responding to uncertainties of a changing industrial society by removing their women from worldly environments and by revising an older image of feminine subservence." As traditional social patterns shattered in turn-of-the-century America, contends Abrams, the "nostalgic idealization of pure, unworldly, and submissive womanhood increased."[11]

Dewing was acclaimed for his monochromatic images of beautiful young women lost in reverie, as in *The Lady in Gold* (1888, Brooklyn Museum), which won a prize at an international competition in Paris. Dewing's typical subject was an attractive, well-bred woman standing or seated alone, her features finely chiseled, her gown long and flowing, her eyes half-closed in a trancelike state, the space surrounding her diffuse and empty. His women are rarefied objects, gorgeous creatures from another planet; they epitomize late Victorian notions of fragile femininity.[12]

Likewise, Thayer depicted young women and girls (his daughter was a frequent model) as latter-day Madonna figures or winged angels, idealizations of pure, unthreatened and unthreatening femininity (Fig. 12). Significantly, Thayer devoted considerable attention to the study of camouflage in nature. In later years, his self-directed studies in that area led to him wielding a strong

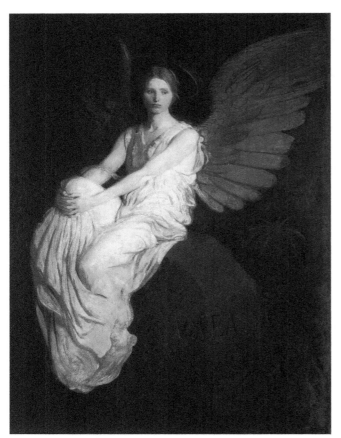

12. | Abbott H. Thayer, *Stevenson Memorial*, 1903. Smithsonian American Art Museum.

influence on the way that American battleships and transport vessels were painted with camouflage patterns during the First World War, making them difficult for enemy submarines to distinguish from the ocean at large. His rigorous investigation into the principles of camouflage in the natural realm might seem unrelated to his vibrant renderings of women as transcendent mothers and angels, unless one wants to consider that girls and women who willingly adapted such roles were, in a sense, providing themselves with social camouflage.[13]

More than artistic influence is at work in *Enlist*'s depiction of a young, ethereal, heavily gowned mother in airless isolation. In keeping with the presumed mission of the Boston Public Safety Committee, it drives home an essential point: that German barbarism poses a direct threat to modern civilization, as represented by the Dewing- or Thayer-like incarnation of femininity that sinks into the abyss. Women in war posters allegorize the nation as a whole, and when they come under attack, the nation itself is claimed to be in danger. When the women in such depictions are young, beautiful, and vulnerable, the intensity of concern ratchets up, and the manliness of the man to whom the poster is directed is pressed into service with a simple, unambiguous demand: ENLIST.

In the Cult of True Womanhood, as it has come to be known, middle and upper-class women demonstrated their virtue by remaining at home, apart from the work force and out of the public eye, so as to nurture future citizens, instilling them with poetry, spirituality, and patriotic ardor. In so doing, women, it was widely believed, had enormous power to influence society, albeit indirectly. In the refrain of a popular Victorian

poem that formed the philosophical core of D. W. Griffith's 1916 epic film *Intolerance,* "the hand that rocks the cradle rules the world." Most admired of all within this cultural value system were elite and refined white women, those who radiated elegance and grace—and thus whose loss, as depicted in the poster, would have cost society more dearly than the loss of a working woman or one who was boisterous and crude.[14]

That the woman in *Enlist* clutches an infant in her arms would have made the assault by the Germans on the unprotected passenger ship seem all the more heinous, for what could be worse than killing babies? Babies are icons of innocence, the epitome of helplessness. They are also symbols of the future: the future of individuals, of families, and, perhaps most importantly, of society as a whole. Their murder forecloses on the future of that society.

When the poster appeared in June 1915, the very notion of national birth and rebirth was a topic of discussion, and nowhere more so than in the venerable town of Boston, proud of its role in the nation's founding. Two months earlier, the city had been embroiled in controversy over the release of D. W. Griffith's incendiary Civil War saga *The Birth of a Nation.* Thousands of Bostonians, white alongside black, had marched down Tremont Street, across from the Boston Common, to protest the opening of Griffith's motion picture at the Tremont Theatre. The Boston chapter of the National Association for the Advancement of Colored People (NAACP), which had been founded six years earlier, objected to the movie's depiction of black Union soldiers as vile rapists of white Southern women and black politicians as figurative rapists of the Reconstruction-era South. The organization especially condemned Griffith's veneration of the Ku Klux Klan, an insurgency group that he credited with giving new life—or "birth"—to a faltering nation in the aftermath of the Civil War. Street fighting broke out in Boston between detractors and defenders of the film's race-based account of recent American history.[15]

Viewers of *Enlist* in the early summer of 1915 might not have consciously associated it with Griffith's cinematic milestone, which, after all, concerned itself with the American South, not Europe, and with the Civil War, not the Great War. Still, it seems important to recognize that Griffith's controversial masterpiece, as well as other, far less innovative motion pictures, instructed viewers in a melodramatic manner of seeing that would have heightened their indignation in imagining the murder of an innocent mother and child by armed barbarians. Thomas Dixon, Jr., the southern-born author of the two best-selling novels on which *The Birth of a Nation* was based, had already achieved notoriety as a fiery evangelical preacher in Boston before turning his hand to fiction.

As a favor to his fellow southerner and old friend Dixon, Woodrow Wilson screened Griffith's film in the White House. Marveling at its technique,

the president of the United States described it as "history written with light-ning." Spear's poster, despite its contemporary North Atlantic subject matter, bore traces of the sexual and sectional conflicts germane to Griffith's block-buster. *The Birth of a Nation* did $10 million worth of business in the first year and remained the highest-grossing American film of the following decade.[16] *Enlist* piggybacked on its popular success, transposing to a new time and setting its melodramatic language of violated innocence and barba-rous oppression.

It is instructive to compare *Enlist* to a British poster issued in the same year, *Irishmen—Avenge the Lusitania* (Fig. 13). In this depiction, survivors clutch broken spars and paddle about on the surface of the sea while the great ocean liner heaves upward before plunging to the depths. The British poster adheres to the conventions of earlier shipwreck engravings such as *The Sinking of the Titanic* (ca. 1912) by German artist Willy Stöwer: listing ship, passengers flailing in the water, the vastness of the sea with no rescuers in sight. The ur-text for shipwreck art is Théodore Géricault's *Raft of the Medusa* (1818–1819), but the genre goes even further back in the history of European art, as in the late eighteenth-century shipwreck paintings of

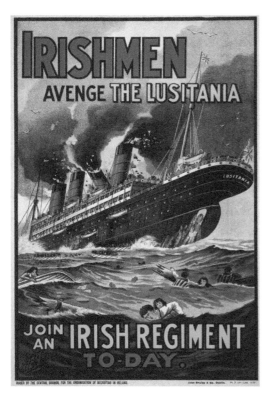

13. | *Irishmen – Avenge The Lusitania*, 1915.

Claude Vernet. *Enlist*, to the contrary, es-chews large-scale spectacle and opts in-stead for intimacy. In the manner of Griffith's newly invented psychological cinema, it draws the viewer into an emo-tionally precise relationship with the female protagonist who plummets to her death.[17]

The brilliance of Griffith lies not so much in his innovative editing techniques or pioneering camera work, but rather in his use of these techniques, along with new forms of dramatic writing, to *enlist* the viewer in an intimate psychological connection with the onscreen character. *Enlist* enjoins the viewer to identify emo-tionally either with the drowning mother or with the unseen loved ones who will re-ceive news of her death. Although "only" 128 Americans were among the 1,198 passengers and crew members who per-ished during the sinking—about 10 per-cent of the total—Americans who read accounts of the *Lusitania* sinking or saw

this poster were invited to envision in this one woman's death that of their own mother, sister, or daughter. To identify with victims of a crime is to cease feeling detached from their suffering; it is instead to feel *attached*. In an aphorism commonly attributed to Joseph Stalin, "one death is a tragedy; a million deaths is a statistic." The poster brings the sinking home, literally, by focusing the viewer's attention on two deaths, not 1,198.

Enlist wrung emotion out of viewers not only by arousing their sympathy for the victims but also by activating universal fears of death by drowning. In an era unlike our own, when ocean travel, even in peacetime, was risky, as demonstrated by the *Titanic* sinking three years earlier, viewers of the poster would have been all the more susceptible to primordial dread. In the decade following the First World War, fear-based advertising became standard in the industry, although the fears engendered were normally not of life-or-death significance: a pretty young woman is shunned by potential suitors because of bad breath or a bright young salesman by potential customers because of his smelly underarms.[18] A precursor of such ads, *Enlist* sold its product—military recruitment and, beyond that, national preparedness—by playing on anxieties about social isolation that may in their own way be nearly as primordial as terror of drowning.

In her analysis of totalitarian propaganda, the political philosopher Hannah Arendt comments that American soap ads impressed Hitler for their ability to strike fear in the hearts of their intended audience. "The strong emphasis of totalitarian propaganda on the 'scientific' nature of its assertions has been compared to certain advertising techniques which also address themselves to the masses," she writes. The comparison is justified, she continues, for it is "true that there is a certain element of violence in the imaginative exaggerations of publicity men, that behind the assertion that girls who do not use this particular brand of soap may go through life with pimples and without a husband, lies the wild dream of monopoly, the dream that one day the manufacturer of 'the only soap that prevents pimples' may have the power to deprive of husbands all girls who do not use his soap."[19]

Enlist visualized for viewers something otherwise invisible: the bottom of the ocean. In this regard, it was original and unique. While Géricault's *Raft of the Medusa* and Stöwer's *Sinking of the Titanic* and countless other visual representations of shipwreck presented a view that in theory anyone could have, that is, from the surface of the sea, *Enlist* offered a sort of privileged visibility. Only a deep-sea diver, or a submarine operator, or a fish similar to the one pictured in the poster, could obtain the view that the poster provides. The view is ludicrous, of course, but in 1915, when there was no such thing as underwater photography, and undersea exploration was still in its infancy, this tableau was far more convincing, more *breathtaking*, than it could possibly be in any later period.

The American cartoonist and animation pioneer Winsor McCay borrowed from Spear for the concluding sequence of his short animated film *The Sinking of the Lusitania* (1918). McCay's influential comic strips for daily and Sunday newspapers, *Dreams of a Rarebit Fiend* (1904–1905) and *Little Nemo in Slumberland* (1905–1914), reveled in fantastic, cockeyed views of the world. *Dreams of a Rarebit Fiend* humorously imagined the hallucinations of adults who have overindulged in food and drink. *Little Nemo* recreated the grandiose dreams and daydreams of a super-imaginative child. Outraged by the sinking of the *Lusitania* and eager to push America out of neutrality and into war, McCay set about making an animated film of the disaster. Because the production process was so painstaking in those days, requiring 25,000 animation cells drawn by hand, the film did not appear until late 1918, during the last days of the war. In the final sequence, the "camera eye" descends in counterpoint to bubbles rising to the surface of the ocean as a mother and infant, based on Spear's holy pair in *Enlist*, sink to the depths. Again, the emotional impact for the viewer comes at least in part from seeming to see something impossible to see.[20]

McCay's film ends with a sarcastic title card: "The man who fired the shots was decorated by the Kaiser. And they tell us not to hate the Hun."[21] Spear's poster is not so direct in assigning blame, but that might have made it all the more effective in doing its job, which was not only to stir sympathy for the victims of the crime but also to arouse fear and indignation concerning the perpetrators. In other words, it wasn't enough to horrify viewers by what happened to the unfortunates on the *Lusitania*. The supporters of military intervention who sponsored the poster would have wanted their countrymen to feel both horrified *and* terrified by what had happened.

Horror is a reaction to something that has already happened, terror to something that has yet to occur. Horror concerns what we see and terror what we can't see. Onlookers to a "terrorist" atrocity are horrified by what they witness, but only as a prelude to the more powerful emotion of being terrified by imagining what is yet to come. Alfred Hitchcock offered a similar distinction between surprise and suspense. According to the filmmaker, if he were to show men seated at a table when a bomb explodes at their feet, without any previous indication of its presence, this would surprise viewers but not involve them emotionally. If, however, he were to reveal to the audience something that the men do not know—that a bomb at their feet is about to explode—that would awaken a far more intense and insidious emotion, which Hitchcock called suspense.[22]

Allowing for a crucial distinction between motion pictures, in which multiple images are woven together over a stretch of time, and posters, in which a single, motionless image must do all the narrative and emotional work in an instant, *Enlist* may have operated on viewers in an analogous manner. By not showing the Germans, or even naming them in the accompanying text, the

poster probably heightened the viewer's concerns. For in 1915, with the *Lusitania* disaster such a recent event, the poster's viewer could not help but imagine the underwater attackers to be close at hand, just beyond the field of view. This would have made those attackers that much more frightening, like a villain who lurks in the shadows, unseen and thus all the more difficult to resist.

A RAMPAGING GORILLA STOMPS HIS clawed feet on a patch of shoreline marked "America." Fangs bared, spittle flying, eyes flashing with fury, he clutches a limp, half-naked woman in his blood-soaked arms (Fig. 14). A nightmarish materialization of nature in its most savage state, he is nonethe-

less decked with trappings of civilization. He wears a Prussian spiked helmet on his head, sports a Kaiser Wilhelm II upturned mustache, and wields a bloody cudgel marked *Kultur*. This personification of Germany as a crazed beast is the most outrageous poster to come from America during the Great War. "Destroy This Mad Brute," the ornate, block-letter text cries in alarm, adding (in some but not all extant versions of the poster): "If this War is not fought to a finish in Europe, it will be on the soil of the United States." All variations of the poster end the same way, with an un-ambiguous command to the viewer: ENLIST

Whereas in *Enlist* the perpetrators of violence against women and children remain unseen, hiding devi-ously out of sight, this time they are front and center, as

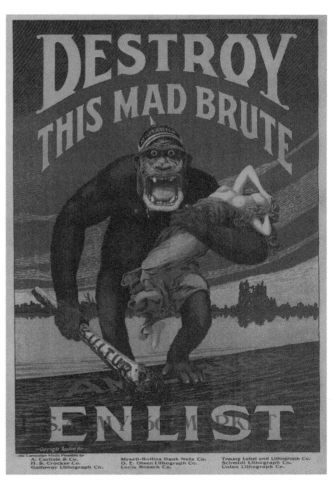

14. | H. R. Hopps, *Destroy This Mad Brute*, ca. 1917.

anthropomorphized by the apish beast. That is to say, this poster proves to be less interested in creating a sense of terror in viewers than one of outright horror. A new phase in political representation has arrived. No other American poster from the war years is as blatantly hostile, as viciously derogatory, as this. It foams at the mouth with the hatred it attributes to the enemy. So explosive is its rhetoric that two decades later, at the start of the Second World War, the Nazi propaganda minister Joseph Goebbels resurrected the image for an anti-American poster that indignantly asserts: "When they assaulted us 25 years ago, they wrote on their rotten slanderous poster: 'Destroy this mad beast'—they meant the German people!!!" (Fig. 15).[23]

Even Americans may have found the poster distasteful, for no other posters from the period are as vehement as this. One of them, *That Liberty Shall Not Perish from the Earth*, Joseph Pennell's 1918 apocalyptic Liberty Loan poster of German biplanes bombing New York City (see page 103), compares to *Destroy This Mad Brute* in magnitude of imagined violence, but it does not personify the enemy as a drooling monster. Looking at scores of

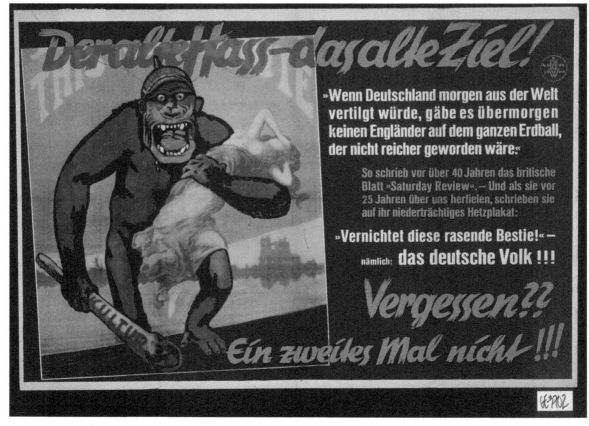

15. | *The Old Hatred—The Old Goal!*, 1939.

WWI propaganda posters prepared by American artists for American audiences, one notices that they are rarely violent in nature. There are exceptions, to be sure, but for the most part American military and home-front posters from 1917–1918 were anodyne in their depiction of war, emphasizing the camaraderie of soldiers, the winsomeness of the girls they left behind, the maternal radiance of older females, and the virile but unassuming strength of the farm workers and factory laborers who supplied the nation with food and matériel. Only a handful of posters depict American forces in battle, and few of those show direct engagement with the enemy.[24] Punishing, mutilating, disabling, destroying, and killing—the byproducts of war—were largely unrepresented by visual pleas to the American public.

Destroy This Mad Brute is signed "H. R. Hopps." Harry Ryle Hopps was a San Francisco stained glass artist who moved to Los Angeles in 1917 or 1918 to work in the film industry. The exact date of the poster is unknown, but it comes from this transitional time in his life and seems to combine the luminosity of stained glass (orange eyes, red tongue, pink lips, and putrescent green sky) with the spectacle of cinema. Hopps worked as an associate art director on films produced by Mary Pickford and her husband Douglas Fairbanks. The most acclaimed of these was Fairbanks's 1924 hand-tinted fantasy classic Thief of Bagdad, with its magnificent production design by William Cameron Menzies, in whose department Hopps was employed.[25]

Whether created while Hopps was still in the stained-glass business in San Francisco or after he joined the movie colony in Los Angeles, Destroy This Mad Brute is likely to remind the modern-day viewer of a subsequent fantasy tale about interspecies sexuality, King Kong (1933). That movie was produced in the depths of the Depression by WWI veterans who surely recalled the bestial eroticism of Hopps's poster of fifteen years earlier when they set out to establish their own version of same. They probably were prompted as well by the now-forgotten 1930 exploitation film Ingagi, in which a gorilla makes sex slaves of half-naked African tribal women. The lobby card for the film, like that of its famous successor, King Kong, though with considerably less finesse, mimics Hopps's WWI recruitment poster. It shows an ape dragging off a bare-breasted captive. One of his hairy mitts squeezes her bosom, while, overhead, the advertising copy shouts out like a carnival barker, "Wild Women—Gorillas—Unbelievable!"[26]

Not that Hopps's poster was itself original in concept. Its iconography derives from earlier ape-rape fantasies in art and literature dating from the eighteenth century. In Notes on the State of Virginia, for example, written in 1785, Thomas Jefferson contended that black men sexually prefer white women in a manner that parallels the "preference of the Oranootan [orangutan] for the black women over those of his own species." In 1859 the French wildlife sculptor and illustrator Emmanuel Frémiet shocked the Salon jury

with a life-sized plaster cast entitled *Gorilla Carrying off a Dead Negress*. To an audience already disturbed by Charles Darwin's controversial *Origin of Species*, which appeared that same year, the suggestion of cross-breed rape proved too disturbing for middle-class Parisians, and the piece was rejected. Three decades later, however, Frémiet won a medal of honor at the 1887 Salon and achieved great public success at the 1889 World's Fair in Paris with his reworking of the theme as *Gorilla Carrying off a Woman* (Fig. 16). This time the victim was white, naked, and alive, and the artist showed her actively, if futilely, resisting the overpowering strength of her captor. Coincidentally, this was the World's Fair for which the Eiffel tower was built; to picture the *Gorilla Carrying off a Woman* beside or on this high-rising symbol of architectural modernity is to imagine the ultimate primitive-versus-modern source for *King Kong*.[27]

Perhaps the statue enthralled Parisians because, in addition to offering lurid sexual melodrama, it crystallized their anxieties about African colonization and exploration. It tapped into Malthusian fears about "civilized" white society being overrun by dark-skinned masses and Darwinian worries about the origins of the human species. Even though the monster portrayed in *Destroy This Mad Brute* is semiotically marked as German, with the appropriate military accouterments and imperial mustache, the poster, like Frémiet's statue, alludes to longstanding white fears of black insurrection. As such, it echoes the infamous admonition of the European ivory trader Kurtz concerning African natives in Joseph Conrad's 1899 novella *Heart of Darkness*: "Exterminate all the brutes!"[28]

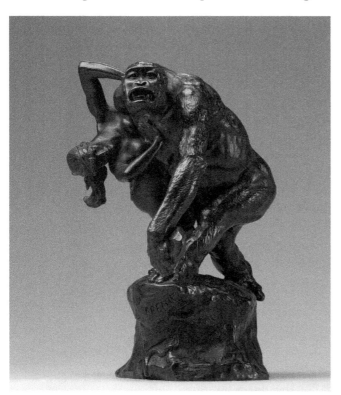

16. | Emmanuel Frémiet, *Gorilla Carrying off a Woman*, 1887. National Gallery of Victoria, Australia.

Even before Darwin, pseudo-scientific racism argued that black-skinned people were directly linked to apes. In 1854 the South Carolina slave owner and surgeon Josiah C. Nott teamed up with the cranial "expert" and Nile explorer George Glidden in their book *Types*

of Mankind to advocate for polygenism, the theory that races descend from different original sources. In placing drawings of apes and black people side-by-side to certify its claims, the volume established a visual motif that permeated racist popular culture. For example, in 1900 a Midwestern Bible publisher issued a best-selling tract entitled *The Negro a Beast*, which depicted apelike black men ravishing virginal white women.[29]

It was not until the First World War, in films such as *The Birth of a Nation* and posters such as *Destroy This Mad Brute*, that the abducting-ape motif forged a link between negritude (a nineteenth-century term for racial blackness), bestiality, and the barbarity of the enemy. The cultural-sexual-racial anxieties embodied in the WWI-era film and poster began to boil over in Germany in 1933 with the ascension of Hitler, leading onlookers everywhere to fear the start of another world war. *King Kong* may be seen, in this regard, as a resurrection of and talisman against the earlier ape-rape fascination and dread touched off, respectively, by Frémiet, Griffith, and Hopps. Adolf Hitler kept a copy of *King Kong* in his private film library and enjoyed watching it after a hard day's work. We can only speculate as to whether he identified with the snarling ape who imperiously threatened American civilization or derived satisfaction instead from seeing the subhuman Negro- or Jewish-surrogate monster brought crashing down from his perch.[30]

The woman-and-gorilla motif, a subset of the larger category "beauty and the beast," continues to have staying power in popular culture, as seen in the 1976 and 2006 remakes of *King Kong* and various other movie spectacles of their ilk. In the words of a film-industry reporter, "Gorillas plus sexy women in peril equals enormous profits."[31] Sometimes Hollywood has successfully substituted other types of muscular, quasi-human creatures in the role of the gorilla, as for example in *Forbidden Planet*, a classic science fiction movie from 1956. In the film's advertising poster, a beefy robot carries a recumbent, scantily clad blond in its arms. The species has changed, but the contrast of sexualities remains the same.

As recently as 2008, *Vogue* magazine spoofed *Destroy This Mad Brute*, although few *Vogue* readers would have caught the reference that the photographer Annie Leibovitz had in mind when she posed black NBA superstar LeBron James in the part of the gorilla and white supermodel Gisele Bündchen in the role of the victim. But even if they did not grasp the reference to Hopps's poster, its cinematic offspring, *King Kong*, would have occurred to them. Most readers of *Vogue* would have understood the cover to be a joke, not to be taken seriously. The photo seems designed to flatter the magazine's readers for their knowing sophistication, their ability to read the cover as tongue-in-cheek, a postmodern send-up of old-fashioned racism and misogyny, rather than simply a politically incorrect reinstatement of those

17. | Gino Boccasile, $2-*Venus*, 1943.

benighted belief patterns. Not every reader appreciated the send-up, however, and *Vogue* received heated complaints (which may explain why Condé Nast, the magazine's publisher, denied permission to reproduce the image here).

Whatever the intentions of Leibovitz's restaging of *Destroy This Mad Brute*, the poster on which it was based was indeed racist and misogynist. Even though it vilified a white European ethnic group, the Germans, the wellsprings of its animus were fear and hatred of black men. A variant of the poster produced in fascist Italy during the Second World War by the one-eyed illustrator Gino Boccasile suggests as much (Fig. 17). It depicts a leering black G.I. with oversized arms and simian features wrapping his hairy mitt around a snow-white Venus de Milo whom he carries off as plunder. The absurdly low resale price of $2 that he has scrawled across her belly shows the black soldier to be as stupid as he is brutal. If *Destroy This Mad Brute* charges WWI Germany with cultural barbarism, the latter-day Italian variation accuses WWII America, particularly black America, of cultural rape.[32]

In creating his poster, Harry R. Hopps was doubtlessly inspired by *The Birth of a Nation* and its extraordinary popular success. Griffith's 1915 melodrama hinges on the threatened abduction of a Southern white virgin by a black Yankee soldier (Fig. 18). That aspect of the film may, in turn, have been partially inspired by the Mary Phagan case that had occurred two years earlier, in 1913. Phagan was a thirteen-year-old factory worker in Atlanta, Georgia, who was raped and murdered. One of the factory managers, a Jewish engineer named Leo Frank who had moved to Atlanta from New York some years earlier, was arrested for the crime. When a jury failed to convict him, the public was incensed. A local politician insisted that the rape of Mary Phagan symbolized a larger political and economic attack on the South: "Our grand old Empire State HAS BEEN RAPED!" he wrote. "Jew money has debased us, bought us, and sold us—and laughs at us." In June 1915 a lynch mob calling itself the Knights of Mary Phagan stormed the prison and hanged Leo Frank from a tree.[33]

18. | Abduction scene, *Birth of a Nation*, 1915.

In doing so, they were acting out in real life the vigilante violence cele-brated in *The Birth of a Nation*, then playing to mammoth acclaim in movie theaters throughout the South (and the North, too, though with much more mixed response, as evidenced by the Boston protest mentioned above). They were also, in a sense, acting on the mandate of the newly issued *Enlist*, with its implied call for organized vengeance against "foreign" murderers of white women and children.

Keeping *The Birth of a Nation* and the lynching of Leo Frank in mind when viewing *Destroy This Mad Brute*, we see that America's most notori-ously anti-German war poster was not entirely anti-German in disposition. It may also have been anti-Semitic as well as anti–African American (and anti-Irish too, as suggested in Thomas Nast's nineteenth century cartoons showing working-class Irishmen of decidedly simian mien). The mad brute of the poster projected festering domestic fears about blacks and/or Jews onto a relatively new and still safely external enemy, Prussian militarism.[34]

In the overheated rhetoric of the American South, the rape of a white woman by a black man warranted the justice of the rope. "The lynching of such a monster," opined one Southerner, "is nothing—compared with what he has done. . . . there is no torture that could suffice." Another white suprem-acist spoke of the fear aroused in white women at the thought that "The

black brute is lurking in the dark ... a monstrous beast, crazed with lust." In an infamous speech in 1897, the Georgia reformer and suffragist Rebecca Latimer Felton, later to become the first woman to serve in the United States Senate, proclaimed, "If it needs lynching to protect woman's dearest possession from the ravenous human beasts, then I say lynch a thousand times a week if necessary." To justify her call for the swift and terrible vengeance of lynching, Felton explains, "The poor girl [who has been raped by a black man] would choose any death in preference to such ignominy and outrage and a quick death is mercy to the rapist compared to the suffering of [the victim's] innocence and modesty." Blacks who sought equality with whites were, in Felton's considered opinion, nothing more than "half-civilized gorillas."[35]

Destroy This Mad Brute may also have allowed sexually repressed citizens of the Progressive era to imagine what it would be like to let themselves go and, regardless of whether they furtively identified with the storming ape or the swooning maiden, vicariously enjoy the raw energy connected to libidinal self-gratification. Sigmund Freud's theories of sexual instinct were popularized (and largely misrepresented) in America during this period, encouraging members of the Protestant white middle class to "de-sublimate" and assent to the urges they had for too long, and to their own detriment, ruinously suppressed. Freud's Vienna-born nephew Edward Bernays, the advertising and public-relations expert, campaigned tirelessly on this note, ballyhooing the psychological benefits for the public at large in dropping age-old inhibitions and other forms of financial or consumer self-restraint.[36]

The aggressive sexuality evident in *Destroy This Mad Brute* bids the viewer to loathe the ape but also, somewhere deep down, *be* the ape. In its darkest manifestation, the poster invites rape fantasy. This is not to claim that American men, circa 1917, harbored a secret identification with the hyper-masculine rape figure of the poster or that American women yearned to be carried off into the jungle by a brutish male. Nevertheless, the image's unrestrained carnality dovetailed with two popular cultural phenomena of the time: Edgar Rice Burroughs's *Tarzan* ("the ape man") novels and, slightly later, Rudolph Valentino's *Sheik* movies. The mass appeal of both indicates that a somewhat milder version of the fantasy resonated with a broad swath of the public. The fictional character Tarzan, raised in Africa by a tribe of wild apes after the deaths of his shipwrecked and marooned British parents, was introduced to readers in magazine format in 1912. The first of twenty-five *Tarzan* novels appeared in 1914 and the first of numerous *Tarzan* movies in 1918. He was Jean-Jacques Rousseau's "noble savage" in a loincloth, preternaturally sexy despite his childlike goodness of heart.[37]

Valentino's handsome Sheik Ahmed Ben Hassan, on the other hand, is anything but innocent in "taking" (that is, raping) the English aristocrat he holds captive in his desert tent. After repeated assaults, she escapes, only to

return of her own accord when she realizes that she has fallen in love with her captor and his primitive honesty (Fig. 19). Adapted from the bestselling romance novels by Edith Maud Hull, the 1921 movie (*The Sheik*) and its 1926 sequel, *The Son of the Sheik*, were box-office hits, especially with female viewers. Valentino's most important films were written by women, including two of the most powerful in the business, June Mathis, who discovered the young Italian immigrant and shaped his career, and Frances Marion, a WWI combat correspondent who went on to become the most influential female screenwriter in Hollywood history and at one point the industry's highest paid screenwriter, regardless of sex. The movie that made their protégé legendary in his lifetime, *The Four Horsemen of the Apocalypse* (1921), written by Mathis, was the first major motion picture about World War I made in its aftermath. Valentino plays a young Argentinian who volunteers to fight for his ancestral France, but the most notable sequence in the film takes place early on in a sleazy Buenos Ares saloon, when, dressed in full gaucho regalia, he dances a torrid tango with a sultry woman he has seized from the arms of another man.[38]

Valentino died suddenly at age thirty-one of complications arising from appendicitis. A hundred thousand mourners (or curiosity-seekers) filed past his casket in New York. At his funeral in Los Angeles several days later,

19. | Rudolph Valentino in *The Sheik*, 1921.

streets had to be closed off to accommodate the crowds. Fans swooned and attempted suicides were reported. One of his biographers avers that "Women were to find in *The Sheik* a symbol of the omnipotent male who could dominate them as the men in their own lives could not," but the extraordinary allure of Valentino seems not to have been so one-sided. At the heart of his screen persona was a gentle, almost feminine sensitivity hidden beneath his rough, sexually dominating physicality.[39]

According to the gender historian Gail Bederman, by 1921 "the moviegoing public was eager to see perfect primal manhood on the verge of rape, if not yet an actual rapist. Women in the audience swooned with passion. Libraries reported a sudden rush of interest in books about Arabs and Arabia; the press reported that hundreds of girls were running away to the Sahara; and the word "sheik" meaning "a masterful man to whom women are irresistibly attracted" became a staple of the 1920s' romantic vocabulary. This visceral response made Valentino a star and suggests that ideologies of passionate primitive masculinity had become pervasive in American culture."[40]

Female viewers may have fantasized about ravishment (the polite term for rape; one that implies pleasure on the part of the victim) by the likes of the swarthy, foreign, and non–middle class Valentino, in part out of a desire to escape the strict moral codes and family obligations that bore down heavily on them. Yet, as the film scholar Miriam Hansen contends, they also wished to *ravish him*, which is to say, ogle and dominate him for their spectatorial and psychological pleasure. In that regard, they turned the tables on the "mad brute" and made Valentino, not themselves, into a vulnerable beauty object, one whom they could mentally abduct for sexual, but also maternal, fantasies. Known as "the male orchid," "Theda Bara in trousers," and "the male Helen of Troy," Valentino, one female journalist wrote, made women want to "bandage his wounds, comfort him, stroke that well-brushed hair, spank him, [and] proudly show him off." *Screenland* magazine also noted the erotic charge conveyed by his vulnerability: "Sometimes he looks exactly like a small boy who is being abused, so that every woman instinctively wants to pat his shiny black head and comfort him. Yet she knows perfectly well that he is not a small boy and that it would be rather like patting dynamite. Which, of course, makes him very *interesting*." A third journalist wrote, "Rodolph has been naughty, Rodolph must be spanked."[41]

Destroy This Mad Brute partook of the same titillating eroticism that made *Tarzan* and Valentino popular in those years. Emerging from an era of sexual repression into one of unprecedented sexual expression, women and men alike probably thrilled more than they would care to admit to the primal (and primate) desire represented by the poster. In this regard, even if the roaring gorilla was originally intended as a symbol of German infamy, it prefigures the libidinous and licentious era dubbed the Roaring Twenties.

Curiously—or perhaps, when we stop to think of it, not so curiously—fantasies of being ravished and those of being rescued have something in common. In both, an individual mentally (but not otherwise, not in actuality) surrenders autonomy to his or her physical, intellectual, or moral superior. While careful to insist that no one wants to be "raped in reality," the feminist psychoanalytic critic Elizabeth Cowie acknowledges the existence of rape fantasy, explaining it as "a profoundly passive fantasy, and apparently found as commonly in men as in women; in its benign form it absolves the subject from the guilt and responsibility of his or her desire, which appears to come from outside, apparently imposed, but in which the subject will be pleasured."[42]

Ravishment and rescue have long been intertwined in visual culture. Take, for instance, a French illustration from the 1840s discussed by the art historian Linda Nochlin in her analysis of Manet's seaside paintings of the 1870s. The illustration, which appeared in a medical volume advocating the health benefits of sea-bathing, shows a bearded and fully dressed male lifeguard hoisting in his arms a drenched female bather, an invalid, whom he has immersed in the waves for therapeutic reasons. The drawing is captioned *Baigneur faisant la lame*, which Nochlin translates as "[Master] Bather Making Woman 'Take the Wave.'"(Fig. 20) Though the context of this image is entirely different from that of *Destroy This Mad Brute*, they are in some ways comparable: planting

20. | (Master) Bather Making a Woman "Take the Wave," 1846.

his feet at the edge of the sea, a big furry male cradles a helpless young female in his muscular arms. For all their obvious dissimilarities in form, function, and context, the hairy ape and the hirsute lifeguard emerge from nonetheless compatible corners of the sexual-cultural unconscious.[43]

The theories of Sigmund Freud on sexuality, violence, and repressed desire became increasingly popular in the United States after his landmark visit to America in 1908, when he was welcomed by leading intellectual figures of the day. One of the first attempts to explicate and praise Freud's insights regarding war and the release of suppressed instincts appeared in the journal *Current Opinion* in 1918. "Reversion to Primitive Emotions as a Result of the War," by an unidentified author, contends that psychoanalysis "proves that the deepest character of man consists of impulses of an elemental kind which are similar in all human beings, the aim of which is the gratification of certain primitive needs." The article begins with the statement, "War strips off the later deposits of civilization and allows the primitive man in us to reappear," and repeats it at the conclusion, this time properly attributing it to Freud.[44] Thus Americans, at least those of the intellectual class, would not have had difficulty identifying the mad brute of the poster not only with Germany, as was clearly intended, but also with themselves, or any other civilized individuals, whose cultured idealism was being relentlessly peeled away by the demands of a long and brutal war.

The flip side to civilized men becoming raging monsters in the course of battle was that they also had the potential to become sniveling babies. This prospect was even less publicly countenanced than the other, that warfare would release their basest animal instincts. No one, it seems, was willing to admit that men could be *emasculated* by warfare, that the terrors of continual threat of death or maiming could *unman* them. The term shell shock was coined during the First World War, but it was a radical concept at the time, mostly dismissed as a euphemistic excuse for malingering or cowardly soldiers who deliberately staged abject helplessness as a way of eluding combat and being sent to nursing facilities far from the front lines. Such hapless individuals were often hurried away to the hospital precisely so as not to infect more robust soldiers with their cowardliness. Or they were imprisoned. Some were executed and buried in remote sections of military graveyards, in order to protect the virtuous dead from having to associate, presumably in the afterlife, with those who had seriously failed to be men.[45]

Yet even "normal" soldiers, those who did not succumb to psychological breakdown, felt powerless under artillery attack, as helpless as babies. Lieutenant Hervey Allen, the future novelist, wrote in a letter, "To be shelled is the worst thing in the world. It is impossible to adequately imagine it. In absolute darkness we simply lay and trembled from sheer nerve tension. There is a faraway moan that grows to a scream and then a roar like a train,

followed by a groundshaking smash and a diabolical red light." A corporal named Pierce told his family what it was like to endure a prolonged barrage: "I am soon a nervous wreck. I lose control as the bombardment wears on into hours. . . . I want to scream and run and throw myself. . . ."[46] These responses, while not considered cowardly, were nonetheless kept out of print during wartime, because of the demoralizing effect they would have on the public at large. They were strictly private. But countless men, it would appear, experienced such sensations of total helplessness and passivity. In terms of the mad brute poster, war was the unbridled monster that swept them into its arms, and they the frail, half-naked blond victims that swooned in its grip. Walter Benjamin, the German essayist, summed up the pervasive feeling: "A generation that had gone to school in horse-drawn streetcars now stood in the open air amid a landscape in which nothing was the same except the clouds, and, at its center, exposed to a force of destructive torrents and explosions, the tiny, fragile human body."[47]

Men rendered "fragile" in this way would have abhorred the gorilla in the poster and yet, at a different level of response, might have admired his unconstrained physicality, emotionality, and freedom from middle class strictures of behavior, sexual or otherwise. The mad brute is the avatar of anti-gentility. In 1911, the Harvard philosopher George Santayana coined the term "genteel tradition" to refer to an overly refined and convention-bound nineteenth-century New England sensibility, against which American artists, writers, and intellectuals of his generation, and youth in general, were rebelling. The wild beast was a positive figure for those who rejected the Puritan way of life.[48]

Not all were so naive as to assume that a "return" to authenticity through primitivism, if even possible, could end happily. That pretty illusion, like so many others, was shattered by the war. The young dramatist Eugene O'Neill took delusionary primitivism to task in his 1922 expressionist play *The Hairy Ape*. It presents the tale of a white coal stoker named Yank (how symbolic is that?) who is spurned as a "filthy beast" by an upper-class woman whom he desires. Humiliated by her disdain, he falls into a tragic spiral that leaves him helpless and impoverished. Drunkenly, he seeks solace in the arms of a gorilla in the zoo. Instead of consoling Yank, the beast unthinkingly crushes him to death.[49]

All this is to say that *Destroy This Mad Brute*, while nominally an attack on German barbarism and also an echo of the racist and sexist stereotypes fostered by *The Birth of a Nation*, must have compelled attention from an anxious public at still further depths of unarticulated reception. Despite the ridiculous, over-the-top heavy-handedness of its approach, it invited the viewer to inhabit at the same time mutually opposed subjective states (active and erect; prone and passive) within the realm of fantasy and imagination,

where all is possible and permitted. Its two archetypal figures defined hyper-masculinity and hyper-femininity. Although it might at first seem obvious that men would identify with the dominant figure and women with the subordinate one, why might not the reverse have taken place within the recesses of consciousness? Could not vulnerable young men who dreaded being swept up by the tide of war and hurled violently toward an unwanted destiny have secretly identified less with the monster than with the weak and helpless female in his grasp?

Alonzo Foringer's *The Greatest Mother in the World* suggests as much (Fig. 21). It depicts a beautiful, only somewhat matronly American Red Cross nurse cradling a wounded and supine soldier in her arms. (Then in her early twenties, the New York artist Agnes Tait, who later became known for her Santa Fe landscape paintings, posed as the nurse.) Although the wounded man is clearly an adult, he is scaled more diminutively than the nurse/mother, causing him to resemble an infant. Ten million copies of the poster were printed during World War I, and it was one of the most popular posters of World War II as well.

21. | Alonzo Foringer, *The Greatest Mother in the World*, 1918.

Most viewers would have missed its references to art of the Italian Renaissance: a Raphael *Madonna and Child*, the *Piéta* of Michelangelo, and Piero della Francesca's *Misericordia*, in which a super-sized Madonna blesses diminutive worshippers. Still, they responded enthusiastically to its clear-cut message: Maternal love, particularly as denoted here by Red Cross nursing, was a powerful, all-encompassing force that protected the physical and spiritual well-being of American soldiers. Though they are opposites, *The Greatest Mother* forms a perfect counterpart to *Destroy This Mad Brute*, for in both of them a powerful and commanding figure takes control of a delicate and diminutive one.

Role-reversal could have worked in the other direction as well. Might not feisty young feminists who were outraged by atrocity abroad and inequality at home, especially that from which they as women suffered, have secretly identified (perhaps even in secret from themselves) with the

snarling mad brute of the poster and through him vicariously enjoyed his earth-stomping power and radical rage?

WITH THE QUESTION OF WWI-ERA feminism before us, let us return to *Enlist*. Notice this about the young woman who sinks to the bottom of the sea. She is not dressed for a swim.

The significance of this point would not have been lost on her contemporaries, for in those years swimsuit attire was a matter of recurring controversy. Guardians of public morality sought to ensure that women at the seashore remained thoroughly covered by clothes, while advocates of healthy living, including feminists but not limited to them, argued that women needed to be able to shed clothing at the beach in order to derive the salubrious benefits of swimming, an activity increasingly seen as beneficial to health and well-being. As early as 1888, a magazine devoted to outdoor activity contended, "one of the chief reasons why males learn to swim easier than females is that they wear fewer and closer-fitting garments in the water—when they wear any. A woman's clothing interferes much with the free play of muscles, and when wet, constitutes a drag as the body is forced through the water. Too much importance, therefore, cannot be put on the choice of a bathing suit."[50]

The controversy took wing in 1907 when a policeman arrested Australian diver, long-distance swimmer, and vaudeville entertainer Annette Kellerman for indecency when she appeared on Boston's Revere Beach wearing the one-piece bathing suit she had designed for efficiency of movement in the water. (For years afterward, a woman's one-piece swimsuit was known as "an Annette Kellerman.") Six years later, in 1913, a woman who dared to wear a short bathing suit at Atlantic City was confronted by an outraged crowd. The controversy deepened during the war years. According to beach-leisure historians Lena Lenček and Gideon Bosker, "Chaos was clearly threatening to erupt on the home front. While Europe was going up in flames and mustard gas, America seemed to be rushing toward rack and ruin on the backs of scantily clad bathers."[51]

In 1915, the year the *Lusitania* went down and the celluloid Klan rode to the rescue of the cinematic South, Hollywood studio head Mack Sennett introduced the movie-going public to "bathing beauties." These were pretty young women at the seaside who wore precious little and did even less, apart from provocatively twirling parasols in a peek-a-boo manner. Sennett's famed bathing beauties (one of whom later became the international film star Gloria Swanson) enhanced audience enjoyment of the comedy performed by his resident troupe of slapstick buffoons, the Keystone Kops.

Not all women in those years were as inept in the water as Sennett's bathing beauties. Indeed, aquatic proficiency was a sign of the modern woman.

Previously, it was considered unfeminine to swim, regardless of how the swimmer was attired. But by 1912 attitudes had changed to the extent that swimming competitions for women (specifically, the 100-meter freestyle, 100 × 4 relay, and diving) were introduced to the Olympic Games in Stockholm. In 1926, Gertrude Ederle, an American who had won three swimming medals in the 1924 Paris Olympics, became the first woman to swim the English Channel. In doing so, she shattered the men's record by two hours and became the first woman in the history of a major sport to break a record established by men.

Enlist should be seen in terms of these controversies, spectacles, and accomplishments, not viewed in isolation from them. Though the immediate and unmistakable context for the poster was the *Lusitania* atrocity, the question of women and water, of swimming and attire, of health and morality, provided an inevitable social background to the disturbing image of a fully dressed woman sinking to the bottom of the sea. No, she had not elected to go in the water, and she certainly was not out for a swim. Still, that she wears an elegant gown in the watery depths would have marked her, in regard to the women and swimming debates of the day, as a figure of old-fashioned decorum. As such, she implicitly represented the traditional moral order that provocatively attired bathing beauties, female sports stars, and suffragists, not unlike malicious Germans, appeared to threaten.

Detached from its specific wartime context and placed in this other, more general crucible of conflicting social attitudes surrounding the public presentation of female bodies, *Enlist* can be seen as a cry of conservative outrage at the threatened "sinking" of the traditional American family by so-called New Women and their clamor for social and political rights. Two years after the poster's initial appearance (it was subsequently reproduced in greater quantities), with Woodrow Wilson calling for war in defense of democracy abroad, radical feminists such as Alice Paul picketed the White House with signs protesting America's denial of voting equality to women at home. One banner, directed at emissaries from post-Czarist Russia who arrived for a conference with Wilson, proclaimed, "We, the women of America, tell you that America is not a democracy. Twenty million American women are denied the right to vote. President Wilson is the chief opponent of their national enfranchisement." Jailed on multiple occasions for disturbing the peace, Paul and her fellow protestors resorted to hunger strikes and were force-fed by prison officials, thus shaming the president and eventually leading to his reluctant support for female suffrage. In that regard, the cultural work performed by Spear's poster was not only to enlist soldiers in the army but also "enlist" recruits in the rear-guard struggle against women's suffrage and female sexual empowerment.[52]

In general, suffragists linked their cause to the war, taking a position similar to that of African American leaders who were convinced that political concessions would be secured for their constituent group further down the line because of their undisputed commitment to the war effort. Not all suffragists embraced the pro-war position. The most notable exception was Congresswoman Jeannette Rankin, the first woman elected to a national legislature anywhere in the world and the only woman seated in the U.S. House of Representatives. An independently minded Republican from Montana, Rankin was both an avid suffragist and pacifist, and when she cast one of the fifty dissenting votes against the Declaration of War, many suffragists regarded her as a traitor. "I am sorry to have to say that the attitude of most of the leaders of the woman suffrage movement was far from sympathetic to my stand," she diplomatically recalled. "They thought that the 'cause' would have been much better off if I had taken what they considered a patriotic stand. They brought a great deal of pressure to bear on me." Consistent with her principles, she also voted against America's entry in the Second World War.[53]

In 1921, eight years after a woman in an abbreviated bathing suit was harangued in Atlantic City for public indecency, the New Jersey seaside resort hosted the newly invented Miss America pageant, which, controversially, included a parade of contestants in bathing suits. The judge who presided over the competition was the renowned magazine illustrator Howard Chandler Christy, who had become famous before the war for his glossy depictions of the all-American girl. During the war, Christy was actively engaged with the Office of Pictorial Publicity, a government agency responsible for producing propaganda posters to aid the war effort and boost the morale of soldiers and civilians alike. He designed posters showing beautiful young women flaunting their physical charms on behalf of their country. In one such poster, a coquettish brunette in a sailor suit winks her eye and exclaims, "Gee!! I wish I were a man, I'd join the Navy" (Fig. 22). Now, at Atlantic City, it seemed that parading about in a skimpy swimsuit before the astonished eyes of the public, who had never seen such a thing, was a good and proper, even patriotic (*Miss America!*) thing to do. What had previously been concealed from sight, a woman's body, was now meant to be revealed. As the historian Lois Banner notes about the pageant, "although the contest rhetoric, the composition of the parade, and the festival setting were all attempts to make a display of women's bodies respectable, they did not overshadow the fact that the contestants were being judged on how they looked in bathing suits."[54]

Not everyone was convinced that this was a good thing. Perhaps the single greatest "war" fought in American society in the postwar decade was between traditional and modern approaches to morality. These played out in a variety of

22. | Howard Chandler Christy, *Gee!! I Wish I Were a Man, I'd Join the Navy,* 1918.

social and cultural arenas, not only the obvious ones of art, religion, and education, but also drinking, gambling, dancing—and beach-bathing. Even in the early twenties, despite the popularity of the pageant in Atlantic City, women in short swimsuits were still being arrested elsewhere for public indecency. A series of three news photos taken in Chicago in 1922 gives an account of one such arrest.

In the first photo, two middle-aged women, one of them a "beach censor" attired in male garb, confront several younger women decked out in the new, short swimming apparel. In the second photo, the beach censor forcibly leads two of the young bathers from the beach. In the third of the series, the bathers resist arrest (Fig. 23). A crowd of onlookers, most of them men wearing straw hats, has gathered to watch the melee. Off to the side, one of the offending bathers tries to pull free of a fully dressed woman, who grips her arm and drags her toward a waiting police wagon.

A decidedly more physical moment of resistance takes place in the center of the photo. A middle-aged man in a white shirt and straw hat struggles against the other bather, who has thrown her arms around his throat. The man seems befuddled by her ferocity, and he recoils. It's not clear who is in control here. We know what the outcome will be, for a uniformed police officer (not a Keystone Kop) stands by, ready to assist in the arrest if necessary. Yet in the moment captured on film, she seems to have flung herself at her would-be captor rather than passively accommodate him, thus reversing the logic of *Destroy This Mad Brute*. He wraps his arms around her waist but in

23. | Bather resisting arrest, Chicago, 1922.

self-defense, as if to break free of *her* grasp. She is airborne, her long, naked legs scissoring the air. This woman is neither an objectified Sennett bathing beauty nor a "Christy girl" in a sailor suit, wishing she were a man. Nor is she a demure mother in an old-time gown sinking to the bottom of the sea. She may be going down, but not without a fight.

Earlier in the century, prominent advocates for manly fitness such as Theodore Roosevelt praised war for its ability to turn boys into men. The former president does not appear to have had the female half of the population in mind when he made his pronouncements. But we can only wonder if the war had a similar effect on a sizable segment of America's female demographic, leading girls and women to have new attitudes toward their own bodies and a new sense of entitlement in the public realm, thanks to the access to previously restricted manufacturing and bureaucratic jobs that the wartime economy afforded them. Paramilitary civic organizations such as the Red Cross, the YMCA, and the Salvation Army also provided them with opportunities to improve their social status. War, as always, has unintended consequences. In this case, one such consequence may have been that women,

at least temporarily, became more self-assured while men, in certain regards, became less so.[55]

By all accounts, American women were emboldened by the war, and the active roles they played in it. In most cases, this was a matter of temporarily filling in for absent men in factory, clerical, and agricultural jobs or knitting socks, sweaters, mittens, and surgical dressings for soldiers and refugees. Some sixteen thousand American women accompanied the AEF overseas as physicians, nurses, drivers, telephone operators, and YMCA "canteen girls." The job of the latter was to provide healthy and wholesome (and entirely non-sexual) relaxation for soldiers on leave from the front: playing cards with them, helping them write letters to their sweethearts back home, or simply engaging them in pleasant conversation that would enable the men to take their minds off their injuries and the troubles they had seen. Similar were the Salvation Army's "doughnut lassies," who dispensed doughnuts to doughboys to keep them happy and warm. A popular photograph from the period shows a pair of "lassies" in operation, their tin helmets hovering over their heads like secular haloes. Another period photo shows a young woman identified as "Miss Winifred Bryce, 294 Henry Street, Brooklyn, N.Y., of the American Red Cross" conversing with a burn victim whose head is entirely swathed in bandages (Fig. 24). The blurred motion of her hand indicates that

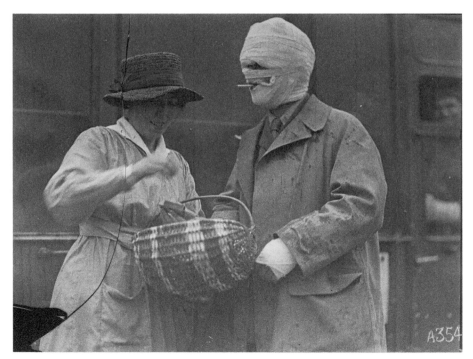

24. | "Miss Winifred Bryce and Henry L. Wales," 1918.

she may be striking a match to light his cigarette, thus appropriating a gesture that in those days was more typically associated with men.[56]

In the realm of illustration, the war helped propel the career of an artist from rural Illinois, Marjorie McMein, who dispensed with the old-fashioned "Marjorie" and rechristened herself "Neysa" after a race horse she admired. Moving to New York in 1913, where she studied at the Art Students League, McMein worked briefly on the stage before selling a cover illustration to the *Saturday Evening Post*. She became a specialist in the depiction of beautiful, athletic, ruddy-cheeked young American women and, as was frequently noted, she was as pretty as any of her models. In a 1916 welcome to their new cover artist, *American Magazine*, which had previously featured the hard-hitting investigative journalism of Lincoln Steffens, Ida Tarbell, and others, but recently reoriented itself toward a middle-class female readership, praised McMein's bold sense of adventure (Fig. 25): "With a girl companion she travelled by motor boat along the Algerian coast, joined a tribe of Arabs, and rode a hundred miles through the desert on camel-back. She has been entertained by Count Zeppelin and has made a flight in his finest dirigible. She has written an opera, and has traveled extensively on three continents. She has walked and ridden hundreds of miles in suffrage parades."[57]

A *New York Times* photograph from 1917 shows her wielding a large American flag in a suffrage parade on Fifth Avenue (Fig. 26). The marchers' goal was to demonstrate that American women who loyally supported the nation's effort on behalf of democracy abroad deserved to enjoy democracy at home.[58]

Soon after appearing in the parade, McMein put aside her paintbrushes and went to France as a YMCA canteen girl whose job was to entertain hospitalized doughboys. To that end, she gave illustrated lectures and screened comic movies. She also designed popular war-themed posters, such as *One of the Thousand Y.M.C.A. Girls in*

25. | "An Artist Who Paints Some of Our Covers, Neysa McMein." *American Magazine*, July 1916.

26. | Neysa McMein carrying the flag at a suffrage parade, 1917.

France, which shows an earnest young woman in uniform (probably McMein herself) balancing a stack of books in one arm while extending a cup of coffee with the other (Fig. 27). She was one of only three women given an honorary commission in the United States Marine Corps because of her service to the cause. On her return from the Western front, she told an interviewer, "Since I have lived through air bombing I never will be frightened by anything on earth. The terror of air raids cannot be imagined."[59]

In the 1920s and well into the 1930s, McMein was celebrated for her depictions of female self-confidence. The most important women's magazines of the era featured McMein women on their covers, and she herself was the celebrity endorser of beauty products. She was also known in literary circles as a member of the Algonquin Round Table; three of her close friends, whom she had met overseas during the war, were the journalists Harold Ross and Jane Grant, founding editors of *The New Yorker*, and Alexander Woollcott, the theater critic, playwright, and celebrated wit. Along with

27. | Neysa McMein, *One of the Thousand Y.M.C.A. Girls in France*, 1918.

Howard Chandler Christy and Harrison Fisher, who, like her, were distinguished connoisseurs of female pulchritude, she judged *Motion Picture* magazine's "Fame and Fortune" contest, bestowing the top prize on a then-unknown, sixteen-year-old actress from Brooklyn named Clara Bow. In doing so, McMein and her colleagues launched a film career that soon was to become one of the most incandescent of the flapper era. The citation praised young Bow for her "confidence, determination and ambition. She is endowed with a mentality far beyond her years.... Her personal appearance is almost enough to carry her to success without the aid of the brains she indubitably possess."[60]

McMein's glittering accomplishments in the postwar mass media boom made her a role model for younger women. A chapter was devoted to her in a young-adult book called *Girls Who Did: Stories of Real Girls and Their Careers*. Though she herself was acclaimed as a great beauty, she made it clear she was more interested in pursuing art than men: "I'm in love with work. I expect to die when I'm about 80 or so with no hair, and no teeth with a piece of pastel chalk in my mouth," she told a reporter in 1921. That said, she was a fan of unmarried heterosexual sex. According to her biographer Brian Gallagher, "She despised virginity and celibacy, seeing them

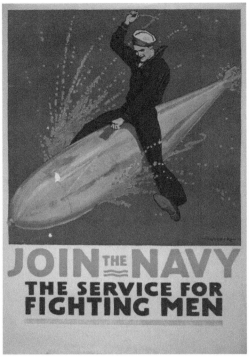

37. | R. F. Babcock, *Join the Navy*, ca. 1917.

Though Brey's poster describes morbid isolation of the sort James painfully recalled, it does offer a direct and easy way out: Join the army! As a theme, isolation may have had greater persuasive resonance in the United States than in Britain. Compared to Europeans, Americans lacked firm roots in class and community and were therefore, it could be surmised, more susceptible to the fear of being alone. Moreover, in the early years of the war, Americans were deeply divided over isolationism, a longstanding diplomatic policy regarding foreign entanglements that in the opinion of many citizens was no longer valid. In that regard, the poster addresses not only the individual whom it cajoles into enlisting. It also poses a question to the nation as a whole, implicitly reprimanding backsliders who would prefer that the United States "hide" in its room while the greatest event of the modern era was transpiring outside its window.

IN THIS CHAPTER WE HAVE scrutinized posters that put young men in a double bind, encouraging them to identify themselves with idealized manhood but also threatening them that they would never have the wherewithal to measure up to that ideal. Nowhere more so was this agonizing dichotomy brought to the surface than in the infamous British recruitment poster, *Daddy, What Did You Do in the Great War?* (Fig. 38). Designed by an advertising artist named Savile Lumley and issued by the Parliamentary Recruiting Committee in March of 1915, it envisions a young adult in the postwar future looking back at the now-ended conflict. He sits pensively in an upholstered armchair, his wrist cocked pensively beneath his chin. Thick drapes close off the outer world. His boy in short pants parades toy soldiers at his feet. His little girl, wearing a ribbon in her hair, perches on his lap. She points to an illustrated history book and innocently poses the excruciating question that clouds his brow with shame.

Similarly to *On Which Side of the Window Are You?*, the Daddy poster implicitly invokes Shakespeare's rousing Saint Crispin's Day speech from

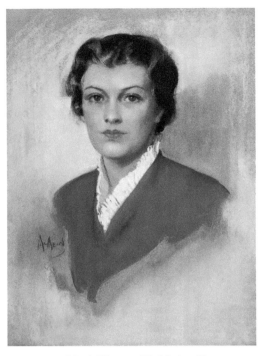

28. | Neysa McMein, *Betty Crocker*, 1936.

as strictly negative virtues and as ways of keeping women all too easily in their place."[61]

She painted thousands of magazine covers and interior illustrations, but by far the most famous one she ever created was at the height of the Great Depression, when she designed the appearance of "Betty Crocker," a fictitious housewife who reassured real housewives throughout the country with her plain, sensible, and inventive approach to feeding the family (Fig. 28). When McMein died in 1949, her obituary in the *New York Times* noted that "She ended the vogue of the 'baby doll' type with her portraits of attractive, high-bred, smart-looking American girls."[62]

Neysa McMein, then, was in every way the counter-type to the frail female victims of the recruitment posters. She epitomized the self-made and sexually confident modern woman. She and the hundreds if not thousands of women she portrayed exuded self-assurance. Formulaic though they may be in their appearance—McMein, after all, was a commercial illustrator who stuck to the formulae she devised—they radiate a vibrancy and power that must have held great allure for American women who were tired of the female vulnerability and abject victimhood proffered by the likes of *Enlist, Destroy This Mad Brute, The Birth of a Nation*, and the postwar offshoots of the pathetically weak females featured in representations such as these.

At first blush, one might chalk up the enduring notoriety of *Destroy This Mad Brute* and *Enlist* to their bold impact and unambiguous meaning. There would seem to be no mistaking what each of them has to say: The Germans are barbarians, they are monsters, they murder innocent women and children, and justice requires them to be restrained. Still, as we have seen, each of them is more complicated than that. Under scrutiny, visual images that might at first strike us as simple and unproblematic can convey unexpected or unsuspected meanings. Affecting viewers subliminally, beneath the surface of conscious awareness, they can be unruly brutes, impossible to restrain. Sometimes they submerge us in dark fantasies against our will or carry us in their arms to places we had not intended to go.

3

MIRRORING MASCULINITY

IS THERE A MORE WIDELY recognized image from America's First World War than the portrait of a gruff Uncle Sam pointing his finger at the viewer and declaring "I Want YOU"? It is by far the best-known visual artifact made by an American during the war. Nothing else, really, can compare, not a painting, photograph, or film, and certainly not another poster. Indeed, I would be hard pressed to think of a visual image from *any* nation during the 1914–1918 conflict that is as universally familiar as this one, made in 1917 by James Montgomery Flagg (Fig. 29).

Today, a century after it first appeared, the visage on the poster is beloved and despised around the globe, the source of countless parodies, from political satires to commercial advertisements to keg-party invitations, and yet its origins in the First World War are little-known. Nothing about it specifically invokes that war. No gas masks, biplanes, or early model tanks, no muddy trenches or prickly barbed wire—symbols all of the Great War—lay their heavy presence on the image, which is jaunty in tone and comedic in feel. Uncle Sam doesn't even seem to hail from the twentieth century; most viewers would assume that he stepped out of an earlier time frame, perhaps even earlier than the Civil War. In a way, they would be right, for Flagg was intentionally referencing archaic nineteenth-century representations of America by his gaudy and light-hearted portrayal of the national icon.

Flagg's Uncle Sam brazenly steals from the most famous British recruitment poster of the Great War, Alfred Leete's *Britons: Join Your Country's Army!*, or, as it is otherwise called, *Lord Kitchener Wants You* (Fig. 30). Although this book focuses mostly on American art, cultural correlations between the United States and Great Britain were especially strong during the period in question, and it will thus be useful to examine British antecedents to American posters. What we will find is that the some of the era's

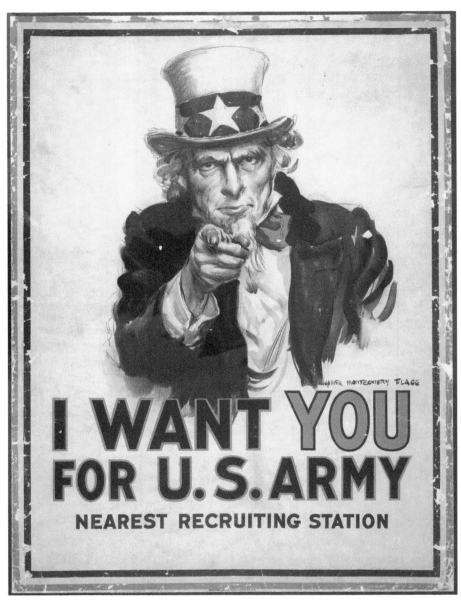

29. | James Montgomery Flagg, *I Want You [Uncle Sam Wants You] for U.S. Army*, 1917.

most eye-catching recruitment placards, whether issued by the British or the Americans, specifically targeted young men's gnawing anxieties about their own sexual and social status. These posters taunted and goaded young men, questioning their abilities to fulfill culturally mandated norms of healthy masculinity.

It has sometimes been said that the First World War didn't actually end in 1918, when the armistice was signed, but continued in other forms until

1945, when the Second World War concluded, or maybe not even until 1989, with the collapse of the Berlin Wall. With that decades' long, multi-phased conflict in mind, let us begin our discussion of Leete's 1914 poster by referring to another, more overtly ominous poster, which actually never appeared anywhere except in the pages of a certain much-read futuristic novel first published in 1949.

GEORGE ORWELL'S *NINETEEN EIGHTY-FOUR* ENVISIONS an ever-watching, all-seeing, psychologically invasive civil state of the near future. Its physical embodiment, "a man of about forty-five, with a heavy black mustache and ruggedly handsome features," peers intrusively at the public from large color posters plastered everywhere:

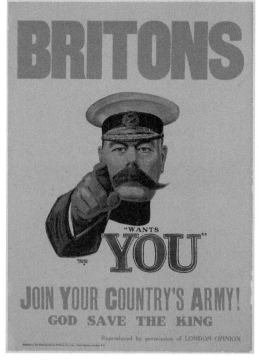

30. | Alfred Leete, *Britons: [Lord Kitchener] Wants You, Join Your Country's Army!*, 1914.

> *On each landing, opposite the lift-shaft, the poster with the enormous face gazed from the wall. It was one of those pictures which are so contrived that the eyes follow you about when you move. BIG BROTHER IS WATCHING YOU, the caption beneath it ran.*[1]

When the book first appeared, readers may have imagined the Soviet leader Joseph Stalin as the prototype for the face in the poster—Stalin's mustache was as notoriously large as Hitler's was tiny. But more likely the particular mustache Orwell had in mind belonged to the erstwhile hero of British Victorian imperialism, Field Marshal Herbert Horatio Kitchener, his childhood idol, who was renowned for his chiseled features, penetrating gaze, and luxuriant mustache. That mustache, according to one biographer, "was justly celebrated not only throughout the Army but throughout the Empire. Its length and bushiness were unique, and it would be easy, but wrong, to dismiss it with a smile. It was the ideal of all mustaches of drill sergeants throughout all the armies of Europe; and in that exaggerated form it became a symbol of national virility."[2]

The source for Orwell's Big Brother poster, Alfred Leete's recruitment poster, showed Kitchener, his mustache dark and heavy as ever, jabbing his

finger at the viewer and pinning him with a severe gaze, while beckoning him to fulfill his duty as a citizen and join the military. As an eleven-year-old, Orwell had dedicated an admiring poem to the field marshal whose visage the poster depicted. By the time he was an adult, the author no longer embraced the chauvinistic militarism that had stirred him in his youth. In effect, he turned the patriotic poster on its head, making it serve in his novel not as a symbol of heroic national resolve but rather of insidious government intrusion into the lives of its citizens.

Lord Kitchener was famous—or in some circles infamous—for his severity. As leader of the British army during the Second Boer War (1899–1902), he had instituted a "take no prisoners" scorched earth policy against his enemies, laying waste to the South African countryside and detaining large numbers of civilians in a newly invented form of outdoor/indoor imprisonment known as the concentration camp. While the Boer War proved disastrous for the British in many regards, most Britons lionized the hero of the Transvaal and in 1914 looked to him to lead them back to their former heights of imperial magnificence. So ubiquitous was Kitchener's visage in the early years of the war that Lady Asquith, wife of the prime minister, jokingly referred to her husband's cabinet minister as "The Poster."

As the propaganda historian Toby Clark has noted, "British people would have seen patriotic recruitment imagery before, but until 1914 joining the army had been an option only considered by a small minority. For the majority, the affairs of state would have been a remote and separate sphere about which they were neither informed nor consulted." Now the situation had changed. For the first time, the state needed to place enormous demands on private individuals. "In this context," writes Clark, "the idea that 'your country needs you' would have been a strikingly novel notion for most of its audience."[3]

Because most cabinet ministers believed, or hoped, that the war would be over by Christmas, they resisted the field marshal's hugely expensive goal of putting a million Britons in uniform. Lord Kitchener won out, however, and by January 1915, a million men had enlisted. "Kitchener's Army," they were called. The Kitchener broadside, originally drawn by Leete as a magazine cover, most likely played an integral role in forming this army. Clark credits the poster's unusual design for its efficacy: "The composition of the poster, with the remarkably direct address of the disembodied face, the inescapable eyes, and the pointing finger, highlights this sudden intensification of the bond between the individual and the state."[4]

In 1915, a second, anonymously designed Kitchener poster called for enlistment (Fig. 31). Some historians have argued that this was the more widely seen and noticed by the public.[5] A direct comparison of the two images would suggest otherwise. The earlier poster is far more arresting and

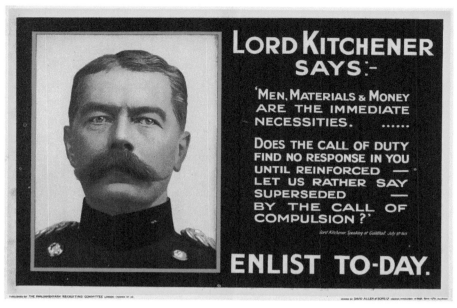

31. | *Lord Kitchener Says*, 1915.

is certainly more memorable and modern. Its uncluttered layout, bold textual graphics, direct address, and intensity of gaze give it an immediacy that the stolid and verbose second poster lacks. This later poster, relying on a photograph instead of a drawing, features a prim and proper Kitchener, head bare and hair matted down. His trimmed mustache fits neatly within the dimensions of his face. His shoulders are cropped at the sides, making them seem diminutive and weak. His eyes do not align (in real life, Kitchener suffered from strabismus, or "wandering eye," as it was known), and thus his attention seems to be focused elsewhere. Leete's Kitchener, by contrast, resounds with strength, authority, and focus, qualities that are conveyed by his scowling gaze, clenched fist, swooping mustache, head-enlarging cap, and, most persuasively of all, by his foreshortened index finger, which dominates the pictorial space like a snub-nosed revolver. This Kitchener, unlike the other, is an iron-bodied warrior; a hawk, a lion.

The wording of the Leete poster is stark compared to that of the official poster: "Britons—[Kitchener] Wants YOU" versus "Lord Kitchener says: ...Does the call of duty find no response in you until reinforced—let us rather say superseded—by the call of compulsion?" While the prose of the earlier poster has the blunt force of a military command, the language of the latter is rhetorical ("Does the call of duty find no response in you...?") and hesitant ("reinforced—let us rather say superseded—by..."). This Kitchener sounds more like a character in a late novel by Henry James than a charismatic leader rousing his countrymen to militant defense of their homeland.

Leete was no modernist, but his design is modern in its simplicity and economy of means. He restricts the composition to three core elements: the face, with its remarkable lateral extensions (mustache, eyebrows, braided brim); the gloved fist punching its way out of the darkness of the sleeve and culminating in that dramatically foreshortened index finger; and the bold, small-capital lettering climaxing graphically in the large, block-lettered terminal pronoun, YOU. Flaring outward, the mustache echoes the upper rim of his field marshal's cap as well as the horizontal finials atop the Y and the U of YOU. It engages in a sort of visual play with the bushy arched eyebrows and thrusting forefinger, and it underlines the eyes while also forming a wedge that points to them like a directional arrow. As the Great War began, the abundantly virile mustache that features so prominently in Leete's poster (but not in the bland version by the unknown designer) alluded to the bygone glory of Victorian imperial dominance. It may have aroused in British viewers, alarmed over the decline of their empire, fantasies of its restoration.

In an essay on militarism, gender, and the First World War, the feminist scholar Melissa Hall has analyzed the authoritarian and indoctrinating nature of the Leete poster. "The menacing finger that points directly out of the picture, and the bold letters spelling out 'YOU,' function to capture, or 'hail,' the viewer as a specified subject of address," she writes. These textual and pictorial devices "literally implicate the viewer into the poster's meaning structure: To read the poster is to occupy the subjective position constructed by it." Thus, "by becoming the subject of the linguistic address, the viewer is consequently subjected to its message, and the authority embodied in Kitchener's looming figure."[6]

The clarity of the Leete poster, its easily read nature, even hyper-legibility suggests honesty, straightforwardness, lack of artifice. It seems simple and direct, which is precisely the self-image that Great Britain needed to project. On August 31, 1914, less than a month after the nation entered the war, the prime minister reported to the king that His Majesty's cabinet "urged the importance of setting on foot an organization to inform and influence public opinion abroad and to confute German mis-statements and sophistries."[7] The resulting propaganda office, which insisted that its only function was to set the record straight, was found after the conclusion of the war to have been prodigiously deceptive in its manipulations of the record. During the war, though, it was naively admired by the British people for probity. The Kitchener poster lent support to the government's claim to transparency and legibility: It substituted the rhetoric of honesty for honesty itself, and in that regard was presciently Orwellian in its skillful manipulation of truth values.

Leete's poster can be viewed historically as one of the first mass-produced advertisements to invoke the countenance of a famous person in

order to sell a product (in this case, enlistment in the king's army). In the first years of the twentieth century, celebrity endorsements were associated with quack medicines and regarded with suspicion, but by the mid-1920s they were everywhere. One might surmise that the Kitchener poster had something to do with the changing status of the celebrity endorsement. The irreproachable honesty and commanding authority of the distinguished field marshal, who addressed the viewer in a "manly" and forthright manner, set the terms by which authority figures in other fields of endeavor incurred the trust of strangers by locking eyes with them in an intimate, imaginary exchange.[8]

Celebrity advertisements in general enjoin the spectator to identify emotionally or psychologically with the protagonist-celebrity. Leete's poster must have elicited from young male viewers a powerful fantasy of interpersonal connection, or, more than that, even, a fantasy of self-projection, wherein they could imagine themselves *being* Kitchener, the Lion of the Transvaal, with his leonine but also manly mane. True, the viewer finds himself subject to the field marshal's panoptic gaze, unable to escape its searchlight glare, but at the same time, the male viewer is encouraged to identify with the general, to assume, within the libidinal economy of fantasy, his super-masculinity: to supersede him. To the potential young volunteer understandably hesitant about endangering life and limb for noncompulsory military service, Kitchener as portrayed by Leete was nothing less than a paragon of omnipotence and omniscience, a national father figure, a supreme *pater familias*. While the poster prompts the male viewer to quiver and quake at the potential wrath of the stern, all-seeing father, it also entices him to fancy himself a stand-in for that figure. In doing that, the viewer who feels himself to be insufficiently masculine may enjoy, within the realm of projection and imagination, the untold bounty that comes from being he who can narrow his eyes to penetrate and dominate any friend or foe who dares to approach him.

The real Lord Kitchener was not nearly as omnipotent as his persona in Leete's poster. The real Lord Kitchener died in June 1916 when the naval vessel he was taking to Russia for high-level negotiations struck a German mine off the coast of Scotland. He was among the six hundred British soldiers and sailors who drowned. In that regard he was as helpless as the beautiful young mother in *Enlist*, unable to master his fate. But the ultimate powerlessness of the man who modeled for Leete's poster did not undermine the patriotic determination he embodied. If anything, his death at sea in the service of his country made that determination appear all the more majestic.

From a Freudian perspective, Leete's Kitchener embodies the superego, a socially constructed force that rouses emotions of anxiety, guilt, and fear of castration. Hall takes this perspective. "In the Oedipal scenario," she writes, "the authority of the Father is precisely a castrating authority. If becoming a soldier promises the rewards of masculinity, Kitchener's dominating figure

insinuates the dire consequences of resisting the Patriarchal mandate." That is, the poster assures young men they will achieve the manhood for which they yearn by joining the army, but, at the same time, it puts them in an adolescent position of cowering before a super-manly father figure whom they dare not disobey. To defend against such dark and unwelcome emotions, the trembling youth resorts to unconscious fantasy, in which he substitutes himself for the father—he returns Kitchener's threatening gaze, and in doing so he *becomes* Kitchener, the man who fearlessly looks other men in the eye and tells them what to do. In his essay "The Uncanny," published in 1919, Freud avers that "no physical injury is so much dreaded by [men] than an injury to the eye." This universal fear, he surmises, is related to a deeper fear: "A study of dreams, phantasies and myths has taught us that anxiety about one's eyes, the fear of going blind, is often enough a substitute for the dread of being castrated. The self-blinding of the mythical criminal, Oedipus, was simply a mitigated form of the punishment of castration."[9]

We might speculate, therefore, that the Kitchener poster, with its emphasis on direct looking and the manly exchange of the gaze, worked on its enlistment-age viewer in a dual manner. It castigated (and, in a symbolic sense, castrated) him, pinning him with its authoritarian stare and threatening him with its upraised fist and hard, rapier-like finger, while at the same time it soothed the anxieties it provoked by offering the subject a chance to identify with the stern father, to appropriate his gaze, his fist, his rigid digit.

The spare design of Leete's poster contributes to this latter effect. It creates an optical experience similar to that of gazing in a mirror and focusing only on selected body parts (face, foreshortened arm, pointed finger) while filtering out extraneous details. During that moment of mirror-gazing when we narrow our vision to a tight focus on our own eyes or some other nearby feature of the face, we, like Leete in his depiction of Kitchener, abstract the part from the whole. When we are dissatisfied with what we see in a mirror, the face that peers back may often, like Kitchener's face, be harsh and disapproving. To the extent that his stern stare mimics the one we sometimes give ourselves, his unforgiving countenance mirrors our own.

THE MIRROR-LIKE NATURE OF "KITCHENER Wants YOU" was literalized in 1917 in Flagg's *I Want YOU* (see Fig. 29). The previous year, before converting his droll depiction of Uncle Sam into a recruitment poster, Flagg had painted the mythical figure for an Independence Day edition of *Leslie's Weekly* (July 6, 1916) that urged Americans to prepare militarily for the likelihood of their joining the European war. "What are you doing for preparedness?" the caption had inquired.

Known for his dashing good looks, Flagg, who was then thirty-nine, comically made himself up as the venerable old Yankee figure of Uncle Sam, a staple of editorial cartoonists since the Gilded Age. Parodying Leete's already quite well-known depiction of Kitchener, Flagg furrowed his bushy eyebrows, raised a hectoring forefinger, and glowered at himself in the mirror. Whereas Leete had conjured Kitchener out of minimal elements—cap, face, mustache, arm, fist, and finger—Flagg copiously provided details of face, flesh, and costume. The British poster is monochromatic; the American one, a fantasia of red, white, and blue. When the United States declared war, Flagg donated his copyright to the government, which printed more than four million copies of the color lithograph, making the object, in the artist's words, "the most famous poster in the world." During the Second World War, it was dusted off and adapted for use all over again, and nearly a million and a half new copies went into circulation.[10]

Playfully alluding to his last name, Flagg made several flag-based patriotic paintings during the war. He was one of the founders of a group of artists and writers who dubbed themselves "the Vigilantes." Their stated purpose was "to drive the peace-at-any-price men to cover, to arouse the youth of the nation to their duties in peace and war, and to carry on a propaganda that will thrill the country."[11] By "peace-at-any-price men," they meant pacifists and other opponents of war, whom they regarded as traitors to the national interest.

The term *vigilante* derives from the Latin *vigilare* (to watch). A vigilante is one who watches—a "watchman" or "watcher"—especially when others have their eyes closed; a vigilante keeps a vigil or remains vigilant. Thus Flagg's Uncle Sam, drilling the viewer with his eyes, can be regarded as an embodiment of vigilance, if not necessarily of violent, extralegal vigilantism. As with Leete's Kitchener, the rigidity and inescapability of Uncle Sam's gaze are the poster's most salient features. Yet unlike Leete's field marshal, who intimidates the viewer with his stern, "we are not amused" High Victorianism, Flagg's extravagantly coiffed and clownishly attired mythic figure only glowers in mock seriousness, as if sharing a joke with the viewer: "Young man, don't even THINK of not heeding my call."

As a national icon, Uncle Sam had always retained an element of the comic. In addition to appearing regularly in editorial cartoons as a humorous or ironic symbol of America, he was also frequently pressed into service by advertisers to flog their wares.[12] Flagg decks him out in garish mid-nineteenth century garb, brashly invoking the colors of Old Glory. How was one to take seriously a human billy goat adorned in a white top hat beribboned in stars? Flagg's Uncle Sam combines the jerky angularity of Honest Abe Lincoln, the Illinois rail-splitter, with the dude-like flamboyance of a Kentucky colonel or a Mississippi riverboat gambler. The picture smacks of the music hall; one can almost see and hear dapper Sam breaking into a soft-shoe routine. In his

memoirs, the artist comments, "I didn't like the circusy Uncle Sam with stars all over him," so he cut back on the number of stars and eliminated the stripes altogether, but nevertheless there is something "circusy" about his Uncle Sam.[13] While Leete's Kitchener browbeats the viewer, Flagg's Uncle Sam admits him to an inside joke.

In playing off the British recruitment poster, Flagg thus made two important changes. First, by converting an actual historical personage, Lord Kitchener, into an allegorical abstraction, Uncle Sam, he subtly reinforced America's self-characterization as a nation based on principle rather than personage. Second, by treating Uncle Sam with mild irreverence, Flagg played up his countrymen's self-flattering view of themselves as a folksy people who always enjoy a chuckle and a grin. Unlike the stuffy Edwardian in Leete's poster, Flagg's avatar of America exaggerates seriousness only to show that Americans don't take themselves too seriously. Flagg commends his viewers for being able to see through the poster's appearance of admonishment to its inner core of playful self-reflexivity.

As techniques of humorous double-coding became prevalent in the twentieth century, careful observers of American advertising noted the effectiveness of making consumers think themselves "in the know" about the pitches aimed at them, and thus worthy of self-congratulation for their supposed superiority to the wiles of advertisers. The commentators Theodor Adorno and Max Horkheimer tartly remarked, "The triumph of advertising in the culture industry is that consumers feel compelled to buy and use its products even though they see through them."[14] The tongue-in-cheek, self-mocking humor of the Uncle Sam poster seems to confirm this observation. Flagg's Uncle Sam succeeded in "selling" men on enlistment not by hammering them into submission through blatant appeals to their patriotism and manhood but rather by establishing a consensual bond through a shared sense of humor.

Flagg's Uncle Sam poster, we may speculate, made the viewer feel *seen* by the State and thus subject to its surveillance, while also allowing him to identify with his impish but virile "uncle." The viewer could thus retain his imagined sense of male potency. In addition, the poster appealed to his vanity by enabling him, in Adorno and Horkheimer's apt phrase, to *see through* the call to arms. The poster's implicit acknowledgment that the viewer shared the joke—"got" its humorous self-reflexivity—constructed the viewer as a mentally nimble individual, competent to decipher complex codes of modern communication. In other words, the poster encouraged the man of the masses to consider himself superior to the masses; to feel recognized, accepted, *seen*, not in the negative sense of being subjected to a disciplinary gaze, but in the positive sense of being singled out, in his own mind at least, for his above-average capabilities.

THE DESIRE OF SOCIAL SUBJECTS to be seen—or to see themselves—in an admiring light, and to avoid being seen otherwise, was ruthlessly exploited by other well-known recruitment posters to lure or cajole men into enlistment. Two in particular, one British and the other American, approached the topic by way of windows. Art historians have noted the fascination that the window, as a visual device, held for the surrealists, who regarded it as a transitional or liminal plane between levels of reality.[15] But a decade or so before the surrealists used windows to signify the split nature of reality or the fragile duality of the individual, conventional illustrators such as the designers of these two posters employed the picture-within-a-picture device of a window to intensify issues of yearning, loneliness, separation, and isolation that played such an important role in the discourse of duty and enlistment.

Printed in London in 1914, *Women of Britain Say—"Go!"* (Fig. 32) shows two young women and a boy peering through an open casement window at the back of a column of marching soldiers. The women and child cling together, their gestures and expressions indicating a mixture of pride and concern. Protagonists of a domestic drama that is elevated by the caption to national significance (for this scene is implicitly repeated throughout Britain), they look across the threshold to the bucolic homeland that, ironically, their men must turn away from, the better to defend. The text is syntactically ambiguous—it can be read as both a description and a command: Either it states, in a factual manner, that women all over Britain have been encouraging their men to enlist (that is, have been saying to them that they should "go"), or it enjoins women from this moment forward to do precisely that (urge your men to "go").[16]

Within the fictive realm of the poster, the space indoors is soft, emotional, and feminine. The taller woman, blond and erect, her noble form etched against the sky, is presumably the mother of the tousle-haired boy who peers with evident fascination at the sturdy soldiers marching in the distance. He grasps the garment of the third figure, whom we might speculate to be an Irish maid, cook, or nanny because of her dark tresses and complexion, upturned nose, shawl-covered shoulders, and white servant's apron. Mother and maid,

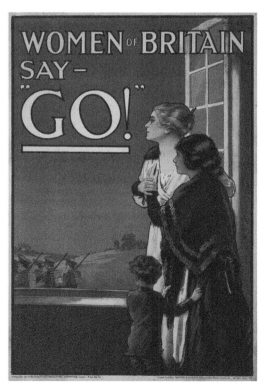

32. | E. V. Kealey, *Women of Britain Say— "Go!"* 1915.

upper class and working class, adults and child: all categories represented here are unified, the poster implies, in their commitment to the wartime cause. One cannot say for sure that the maid is meant to be Irish. If she were, however, that would be significant, given that Irish loyalty to the crown was in question as the war began.

By positioning the viewer within a domestic interior, looking out beyond the women and child to the soldiers trooping to war, the poster uses the window as a trope for the permeable membrane separating the masculine and feminine spheres of obligation during national crisis. They are ultimately intertwined, the poster indicates, and the one cannot survive or thrive without the other. Men must be willing to lay down their lives to protect the womenfolk, and the womenfolk must be willing to part with—indeed, send away—their husbands, brothers, fathers, and sons for the greater good. The window signifies social transparency. In this case, it allows the women to keep a proud, if anxious, eye on their men, ensuring they act in a properly masculine fashion.

At the same time, it allows the men to "see" the equally patriotic behavior of their loyal, self-sacrificing women. Although none of the marching men actually looks back toward the window, we can think of the women who are framed within it as occupying a "thought bubble" in the men's collective imagination. The compositional location of the women relative to the men has symbolic overtones: They literally "stand behind" and rise "above" them. With the didactic clarity of a tableau by Jacques-Louis David, the leading artist of revolutionary-era France, *Women of Britain* schematically lays out the ideal scenario of gender-appropriate thought, action, and emotion in a condition of mutual surveillance.

This poster and others like it participated in shaming rituals aimed at British men and later their American counterparts to make them enlist. Most notorious of these was the "penalty of the white feather." On seeing a military-age man not in uniform, a patriotically zealous young woman would approach him on the street, at a public event, or in a restaurant and silently hand him a white feather, thus accusing him of dereliction of duty, if not outright cowardice. These patriotic zealots were also known to hand so-called slackers a card that read, "Wanted: Petticoats for all able-bodied men who prefer staying home when their country needs them." Sometimes an act aimed at humiliating an able-bodied man not in uniform ended up embarrassing the feather-giver instead, as when the intended victim's wife angrily explained that her husband was home on leave and she was laundering his uniform, or when a man pulled up his shirt to reveal the unmistakable signs of recent surgery for an abdominal wound.[17]

Recruitment posters could be similarly taunting. One of these warned sweethearts that, "If you cannot persuade him to answer his Country's Call and protect you now *Discharge him* as unfit!" Another declared, "If your

young man neglects his duty to his King and Country, the time may come when he will *Neglect You*. Think it over—and then ask him to JOIN THE ARMY TO DAY!" While *Women of Britain* and other posters like it "were criticized in Parliament and in the feminist press for their blatant manipulation of gender," observes the historian Nicoletta Gullace, "the state had nevertheless assumed the guise of a woman for the purpose of recruiting."[18]

Recruitment posters such as *Women of Britain* may have been aimed primarily at domestic British audiences, but they would also have been intended to pull in soldiers from across the British Commonwealth. Likewise, they were meant to encourage neutral Americans to favor the Allied cause. As Peter Buitenhuis notes, "The Allies and their enemies, the Central Powers, both recognized that the United States, the richest and most powerful of the neutral nations, had the power to tip the balance of war, and both concentrated their propaganda efforts there." On orders from Wellington House (headquarters of Britain's propaganda bureau), Sir Gilbert Parker worked diligently to ensure maximum distribution of British propaganda in the United States. In a secret report to Parliament in June 1915, he described how he had assembled an immense mailing list of influential Americans in the professions, the church, the press, and the universities who could be induced to persuade their fellow citizens to support the Allied nations. Thus British propaganda was showered on Americans from the start, and British enlistment posters, such as *Lord Kitchener Wants You* and *Women of Britain* were known across America well before it entered the war.[19]

Women of Britain probably inspired the design of the 1917 American recruitment poster *On Which Side of the Window Are You?* (Fig. 33). In this prize-winning entry by an art student from Chicago named Laura Brey, a well-groomed, well-dressed, almost epicene young man stands beside a large window.[20] His upper body silhouettes against the outside light, his midsection and legs all but disappear in the obscurity of the empty interior space, and the black tint of his shoes and trousers merge into the obsidian darkness that surrounds him. Outside, beneath a giant billowing flag, doughboy soldiers parade in dazzling sunlight. The flag's radiance casts a reddish glow on the young man's pensive, shadow-sculpted face. Above him, bright yellow letters outlined in black urge him to ENLIST. At his feet, hovering in the dark, a nagging question besets him and, by implication, every other young man who had not yet enlisted: "On Which Side of the Window are YOU?"

We might easily mistake the troubled soul at the window for J. Alfred Prufrock, one of the defining fictitious figures of literary modernism. T. S. Eliot first published "The Love Song of J. Alfred Prufrock" in June 1915 in Harriet Monroe's *Poetry* magazine—a small but influential journal from Chicago, Laura Brey's hometown. Two years later, the year of her poster, it

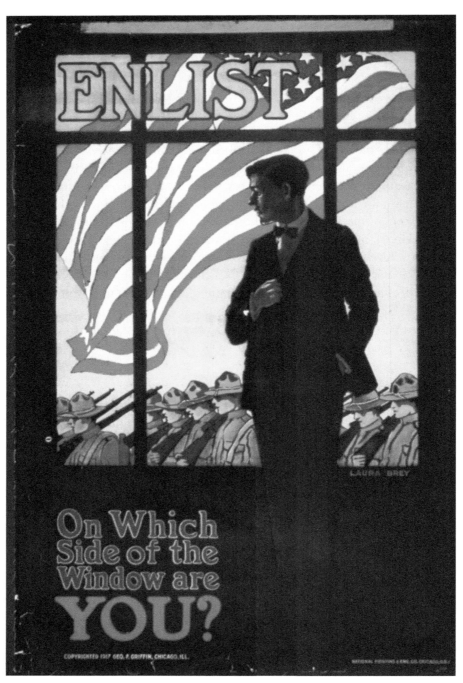

33. | Laura Brey, *On Which Side of the Window Are You?* 1917.

appeared in a chapbook from Eliot entitled *Prufrock and Other Observations*. Eliot's alter ego Prufrock, like Brey's man at the window, stands forever apart from life, immersed in paralyzing thought. "I have measured out my life with coffee spoons," says Prufrock in melancholy admission of his uselessness. Not unlike Prufrock, the unnamed figure in Brey's poster appears riddled with longing, in this instance to burst through the suffocating silence of his isolation and merge with the marching men and their transcendent purpose, as symbolized by the brilliance of the flag. The asymmetry of the composition, its frame-within-a-frame segmentation of the window into vertical planes, the vivid contrast of "happy" exterior and "melancholy" interior, and the flag's surging energy also add to the emotional urgency of the question put to the viewer. [21]

Another cultural touchstone for the man at the window is Thomas Eakins's 1900 full-length portrait of his brother-in-law Louis Kenton, a painting often called *The Thinker* (Fig. 34). Eakins, who specialized in drab, unflattering, and psychologically intense portrayals of his sitters, was relatively unknown beyond his native Philadelphia until the early years

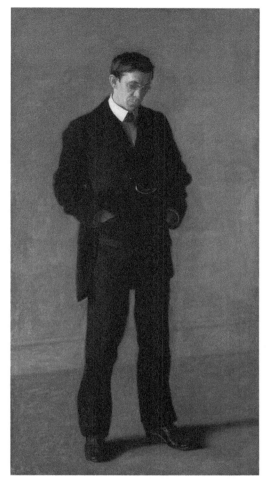

34. | Thomas Eakins, *The Thinker: Portrait of Louis N. Kenton*, 1900. Metropolitan Museum of Art.

of the twentieth century, when his fame began to spread. By the time of his death in 1916, he was widely regarded as an old master artist, the founding father of modern American realism. The following year the Metropolitan Museum mounted a memorial exhibition in his honor. *The Thinker* was one of the star attractions of the show, and the museum purchased the painting for its permanent collection. The "thinker" in the Brey poster bears superficial similarities to Eakins's Kenton, but he is younger and slicker in appearance, more of a dandy clad in black than a rumpled introspect weighted down by gravity, melancholy, and age—typical characteristics for an Eakins portrait subject.[22]

Several steps down the cultural ladder from Eliot's Prufrock and Eakins's Thinker as potential comparison points for Brey's *Man at the Window* is the Arrow Collar Man of famed commercial illustrator J. C. Leyendecker. If Leyendecker was not the best-known illustrator of the day—the honor might have belonged either to Flagg or Howard Chandler Christy—he was certainly among them. No one, including Norman Rockwell, his future rival, ever designed more covers for the most popular magazine of the era, the *Saturday Evening Post*. Leyendecker was also the force behind the legendary advertising campaign for shirts and detachable shirt collars manufactured by a men's apparel company out of Troy, New York. Leyendecker used a succession of handsome male models, the most frequent of whom was his long-time companion Charles Beach, to portray the idealized man in the Arrow collar (Fig. 35). So attractive was the Arrow Collar Man, as he came to be known, to female magazine readers that he received dozens of marriage proposals over the years, even though he was a purely made-up creation.[23]

35. | J. C. Leyendecker, the Arrow Collar Man, ca. 1915.

Laura Brey's sensitive, noble-jawed young Hamlet, poised on the precipice of a huge, life-changing decision, whether to remain hidden within the shadows of anxious, narcissistic selfhood or to join his generation and leap boldly into the fray of patriotic service, resembles the Arrow Collar Man, handsome in appearance and refined in apparel. Yet, given the sales pitch being made by the recruitment poster and its emphasis on anxiety, he conspicuously lacks the commercial icon's manly self-assurance. Even less does he have anything in common either physically or psychologically with the hyper-masculine figures portrayed in *These Men Have Come Across*, by J. C. Leyendecker's brother Francis Xavier Leyendecker

(Fig. 36). In this popular recruitment poster, two bare-chested sailors rippling with muscles load a narrow projectile into an outrageously phallic weapon that is being cocked by a third sailor in the direction of an unseen enemy. Another poster, R. F. Babcock's *Join the Navy*, when viewed from a post–*Dr. Strangelove* perspective, seems comically brash in its ride-'em-cowboy depiction of a Navy seaman sporting a stupendous torpedo between his legs (Fig. 37).

Both *These Men Have Come Across* and *Join the Navy* are a far cry from *On Which Side of the Window Are You?*, yet all three are alike in preying on male fears of sexual inadequacy. In addition, Brey's poster invokes dread of social isolation. Its inside/outside dichotomy etches into sharp relief the difference between joyful participation in a noble cause and painful alienation from it. Henry James (to return from shirt collars to modern literature) addresses this theme in an autobiographical memoir published in 1914. He recounts an emotionally scarring episode of half a century earlier when an "obscure hurt" that he does not identify prevented him from joining the Union army during the Civil War. James recalls the departure of a younger brother's regiment from Boston "to great reverberations of music, of fluttering banners, launched benedictions and every public sound" and then adds, with palpable shame, "from that scene, when it took place, I had to be helplessly absent." Elsewhere in the memoir he speaks of his "hour of a felt rage of repining at my doomed absence from the sight of that march ... out of Boston." Now in his seventies, James continued to suffer pangs over his nonparticipation in the greatest military event of his lifetime.[24]

36. | F. X. Leyendecker, *These Men Have Come Across*, ca. 1917.

Henry V. On the eve of the Battle of Agincourt in France the young English king exhorts his troops, whom he glorifies as a "band of brothers," by noting with scorn that "gentlemen in England now abed / Shall think themselves accursed they were not here, / And hold their manhoods cheap whiles any speaks / That fought with us upon Saint Crispin's day."[25]

Many viewers, especially those already in uniform, made fun of the poster. They directed their scorn not at the pitiful man in the armchair, brooding over his shameful nonparticipation in the preeminent event of his era, but rather at the government agencies that insulted their intelligence with such a transparent effort at moral arm-twisting. The poster gave rise to a catchphrase that was widely parodied, as in a trench poem from the Lancashire Fusiliers that began, "What did you do in the Great War, Dad? / Please Daddy, tell us, do; / For they censor all your letters, / So we know they

38. | Savile Lumley, *Daddy, What Did You Do in the Great War?* 1915.

can't be true." Soldiers enjoyed a laugh following up the child's wide-eyed query, "Daddy, what did *you* do in the Great War?" with sarcastic rejoinders such as, "Shut up, you little bastard! Get the Bluebell and go and clean my medals." Thus mocked from the start for its vulgar attempt at psychological manipulation, the poster gained further notoriety in the 1920s as the public recoiled from the platitudes and injunctions of wartime rhetoric.[26]

Crude and obvious as *Daddy* may be, and thus easily dismissed as propaganda, it nonetheless works, like the other masculinity posters we have been examining, to raise issues of sight, blindness, and insight that were particularly relevant to the war. It resonates with *Women of Britain Say—"Go!"* and *On Which Side of the Window Are You?* The window features prominently in this poster, as in the others, but more so by its absence than its presence. It has been heavily draped, allowing for no access to the outer world that is rendered verdant in the one poster and resplendent in the other.

Despite the proximity of his children, or perhaps all the more because of it, this pathetic individual is entrapped, almost in solipsistic isolation, in a room, a world, of his own. Whereas "real" soldiers march bravely off to war in the other two posters, in this one they have been replaced by tin soldiers

who assemble at the man's feet. There are three disconnected gazes here. The boy, lost in reverie, sees through the medium of his toy soldiers to the valorous deeds he will someday accomplish. His sister, pointing to an illustration in a history book, sees in her idealized father the war hero she assumes him to be. He, in turn, peers glumly into his own past, measuring the dimensions of his cowardice and shame.

Or so the poster would seem to suggest. When issued in the first year of the war, it was meant to be proleptic: a representation of a moment in time some five or ten years hence. It asked the viewer to see his future self looking back at his past. Once the war was over, the poster no longer served to help insecure young men picture their future but instead was brought out of mothballs as prima facie evidence of the way that wartime agencies of information (or misinformation) had subjected the population to emotional blackmail.

In this postwar context, however, the poster might have resonated in a new, unexpected way for veterans of the war. Earlier, the man in the armchair appeared to be distraught at not having fought in the conflict, but now, five or ten years afterward, his distress could be attributed to precisely the opposite cause: that he *had* fought in the war, and the memories revived by his daughter's innocent question were nothing less than unbearable. With the window to the outer world—the present; the companionship of other adults—symbolically sealed off by the drawn curtains, the traumatized veteran finds himself doomed to look again and again through his internal window at a past he finds intolerable yet impossible to purge from his mind.

Freud found this pattern of pathological behavior to be widespread among veterans of the Great War. He identified the problem as a "compulsion to repeat" their traumatic wartime experiences in order to gain some modicum of mastery over disturbing and uncontrollable events that left them shattered inside. The pioneering British military psychiatrist W. H. R. Rivers, who showed remarkable acumen while treating cases of "shell shock" and "war neurosis" during and after the war, was inspired by Freud. Yet he believed that the psychotherapist must steer the patient away from over-indulgence in rumination, for although "I advocate the facing of painful memories, and deprecate the ostrich-like policy of attempting to banish them from the mind, it must not be thought that I recommend the concentration of the thoughts on such memories." In his view, "it is just as harmful to dwell persistently upon painful memories or anticipations, and brood upon feelings of regret and shame, as to banish them wholly from the mind." By these lights, the *Daddy* poster, originally intended to induce feelings of shame in men who shirked the war, inadvertently yet presciently envisioned the persistence of shame in those who survived it.[27]

IN 1991, AN ART CONSERVATOR at the Phillips Collection, America's oldest repository of modern art, examined an oil painting by a now little-known artist named Gifford Beal, who, at the time the collection was established in Washington in the early 1920s, had been a favorite of the founder, Duncan Phillips. The painting, called *Parade of Elephants*, had long been kept in storage. The Phillips Collection boasts an array of masterworks by the likes of Renoir, Rothko, Van Gogh, Bonnard, Eakins, and O'Keeffe, and there has never been much demand for Gifford Beal's works, despite his patron's strong preference for them. In the mid-1920s, Beal was going through a circus phase, and *Parade of Elephants* belongs to this period. Brightly colored and carefully drawn, the painting shows two ivory-tusked elephants proceeding side-by-side under the Big Top before a crowd of spectators. Riding each of the splendid pachyderms is a turbaned driver seated on its head, while, mounted on its back, a female passenger attired in Oriental finery is ensconced in a throne-like box.

What the Phillips conservator discovered is that there was a second, fully finished painting lying beneath *Parade of Elephants*. It had been signed and dated by Beal and was in flawless condition, having been kept entirely out of sight for three quarters of a century (Fig. 39). The underlying canvas,

39. | Gifford Beal, *On the Hudson at Newburgh*, 1918. Phillips Collection.

when carefully extracted from *Parade of Elephants*, showed a bright, impressionist scene in which an attractive young mother, with an infant in her arms and at her side a little girl wearing hair ribbons and a sailor suit, watches a distant parade of soldiers (not elephants!) marching beneath a pageant of flags toward a waiting locomotive, its steam billowing pristinely into the early morning sky. The scene takes places on the heights above a large, broad river, across from a range of purplish peaks receding into the distance. The S-curve of the mother's body echoes the outline of the mountains, linking her to their timeless presence. Curatorial research revealed that the setting was Newburgh, New York, sixty miles above New York City, where the artist's parents owned a summer home. The curators gave the newly discovered canvas a neutral title, *On the Hudson at Newburgh*.[28]

It is as if Beal, painting in 1918, combined *Women of Britain Say— "Go!"* with *On Which Side of the Window Are You?* and moved the pair of them outside to a glorious exterior setting. Unlike the posters, the painting conveys no sense of anxiety or shame; instead, the scene is vernal and placid, even with the dramatic sweep of the mountains, the urgency of the engine steam, the sunlight glinting off the spiky bayonets, and the brilliant fluttering of flags. The viewer might sense melancholy concern on the part of the mother, or of her daughter, as an unseen husband and father marches off to war, perhaps never to return. But somehow, on this radiant morning, in this spectacular setting, amid all these American flags, the natural order of things seems right, and the moment blessed.

On the Hudson at Newburgh celebrates the departure of men for war as a timeless and worthy Homeric ritual. It's a sumptuously beautiful painting but old-fashioned in sentiment as well as style, and perhaps that is the reason that Gifford Beal stretched a fresh canvas over it in 1924, six years after completing it, and painted an à la mode parade of elephants instead—a work immediately snapped up by his collector. Clearly the artist had not managed to find a buyer for his leave-taking scene and probably had given up hope of doing so. By 1924, the moment had passed.

The following chapter looks at that moment when it had yet to pass, when Americans could feel good about going to war, when nothing untoward had yet occurred and fantasies of virtue and glory were very much in bloom. To many it seemed a new day in America, Edenic with promise. Shame, alienation, and envy had yet to take root.

4

OPPOSING VISIONS

WITHIN A MONTH OF DECLARING war on Germany in April 1917, the government set in motion a two-pronged effort to control the nation's production and consumption of war-related visual materials. On one side of the equation was George Creel, a liberal Kansas newspaper editor and former investigative journalist with dashing good looks and abundant Midwestern charm. President Wilson named him head of the new Committee on Public Information (CPI)—America's official propaganda agency. The CPI, also known as the Creel Committee, commissioned thousands of paintings, posters, sculptures, cartoons, and illustrated lectures to engage Americans in the war effort. Creel titled his account of the wartime enterprise *How We Advertised America* (1920) and, indeed, he and the many artists he enlisted viewed their endeavor as an exercise in collective salesmanship.[1]

Creel's counterpart on the darker side of information management was postmaster general Albert S. Burleson, a reactionary from Texas whose father had served as an officer in the Confederacy. In the name of public safety, Burleson diligently obstructed the flow of radical periodicals and pamphlets through the postal system. He used a variety of judicially approved law enforcement procedures, including secret surveillance, police raids, and prolonged pretrial incarceration, to intimidate and harass left-wing editors and artists so they would not circulate antiwar imagery.[2]

Many prominent Americans, including the millionaire automobile manufacturer Henry Ford, the statesman William Jennings Bryan, the author-lecturer Helen Keller, and the newspaper magnate William Randolph Hearst, had opposed military involvement in the Great War. Editorial cartoons in Hearst papers mocked the so-called warmongers and profiteers. In December 1915, Ford, one of the wealthiest men in America, went so far as to charter an ocean liner to take him and a group of fellow pacifists to Europe in a well-publicized effort to

promote peace and empty out the trenches by Christmas. The press mocked the expedition as "the ship of fools," in-fighting broke out among the participants, and Ford, suffering from influenza and admitting the naïveté of the mission, threw up his hands and booked passage home four days after landing in Oslo.[3]

Despite such efforts from rich, famous, and influential opponents to American intervention in the Great War, American visual culture, both popular and elite, was dominated by pro-intervention imagery. As early as September 25, 1914, New York artists formed the American Artists' Committee of One Hundred, which organized an exhibition and sale of paintings and sculpture to provide a relief fund for the families of French soldier-artists; by May, 1917, the organization had 170 members in thirty cities across the nation. In 1916, the best-known of these artists, an impressionist named Childe Hassam, embarked on a series of patriotic paintings that over the course of three years would result in some thirty canvases depicting New York City adorned with high-flying American flags.[4]

Until the spring of 1917, when unfolding events changed their minds, most Americans opposed entering the European conflict, but the visual record of the era contains surprisingly little evidence of this opposition. Most of it came from farmers, industrial workers, and ethnic-immigrant groups, especially German Americans and Irish Americans, who former president Theodore Roosevelt disparagingly called "hyphenated Americans."[5] For the most part, these sizable and significant subsets of the larger population did not avail themselves of visual means of communication to represent their antagonism to intervention. In those days, the main conduits for visual imagery in America—theater, publishing, advertising, the fine arts, and movies—were dominated by individuals or families who were proud of their Anglo-Saxon heritage (or, if lacking it, as was often the case in the film industry, made all the

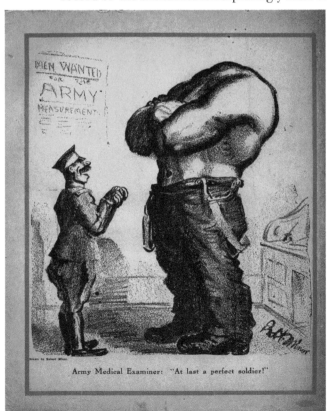

Army Medical Examiner: "At last a perfect soldier!"

40. | Robert Minor, *At Last a Perfect Soldier! The Masses,* July 1916.

more effort to mimic and flaunt it). This discrepancy in control of the media explains why interventionist art was far more plentifully produced and disseminated than the anti-interventionist variety.

The radical socialist magazine *The Masses*, edited by Max Eastman and Floyd Dell, was one of the only consistent sources of antiwar, antimilitary visual imagery. The urban-scene painter and illustrator John Sloan served as the periodical's art editor from 1913 to 1916, until he had a falling out with Eastman, who insisted that the editorial cartoons be more didactic and text-driven than Sloan preferred. Sloan wanted the images to tell their own story without heavy-handed captions, and when he resigned in protest, he was joined by several, though not all, of the magazine's best-known political illustrators. Still, both before and after Sloan's departure, the magazine frequently featured acerbic antiwar images. For example, Robert Minor's satirical cartoon *At Last a Perfect Soldier!*, published in 1916, shows a medical examiner rubbing his hands in gleeful admiration of a gigantic, headless, bare-chested recruit, literally all brawn and no brain (Fig. 40).[6]

When Congress declared war and made antiwar speech (and art) illegal under the Espionage Act of 1917, *The Masses* ran afoul of censors. Postmaster General Burleson sought to shut down the magazine. His office withheld second-class mailing privileges, which made the cost of circulation by subscription prohibitive. News dealers, concerned to stay on the right side of the law, refused to sell the magazine. In November 1917, the government indicted the editors and owners of the periodical on the grounds that it had obstructed enlistment. One of the offending images was by George Bellows, a frequent contributor of satirical drawings to *The Masses* and other left-wing periodicals (Fig. 41). The cartoon shows Jesus in prison. Manacled, clad in stripes, bound by ball and chain, the Prince of Peace has been incarcerated for preaching the seditious words "Thou shalt not kill" during wartime.[7]

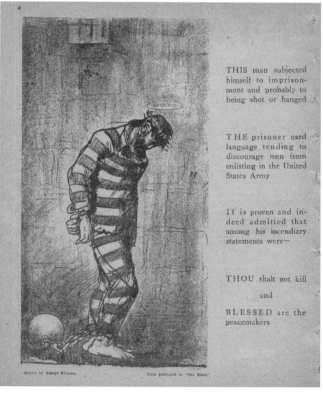

41. | George Bellows, *Blessed are the Peacemakers. The Masses*, July 1917.

Even more inflammatory was Henry Glintenkamp's drawing of a skeleton measuring a naked young recruit for his coffin. This was indeed a direct assault on enlistment, and Glintenkamp was named in the indictment. He fled to Mexico to avoid trial. The following year, a split jury acquitted Eastman and his codefendants, but by then *The Masses* had gone out of business, unable to withstand the combined costs of legal fees and first-class mailing rates.

IT IS AGAINST THIS BACKDROP of thwarted antiwar activism that we turn to the patriotic flag paintings of Childe Hassam. Rather than hasten through a swath of the thirty he produced, let us focus on one that is in many ways representative, *Early Morning on the Avenue in May 1917* (Fig. 42). This sunny

42. | Childe Hassam, *Early Morning on the Avenue in May 1917*, 1917. Addison Gallery of American Art.

tableau commemorates the dawn—or, if you will, the early morning—of American involvement in the First World War. It depicts Fifth Avenue pedestrians, mostly women, promenading beneath a canopy of flags representing the Allied nations England, France, Italy, Belgium, and, most prominently, the United States of America, which had entered the alliance only a month earlier, with its declaration of war.

Together, the flags direct the viewer's eye to the busy thoroughfare thronged with pedestrians and motor buses. Hassam didn't invent these flags and impose them on the composition for aesthetic reasons alone. They actually festooned Fifth Avenue in mid-May 1917, when he made the painting. They flew from the walls and rooftops of the Avenue, as well as many other parts of the city, in a civic greeting that New Yorkers orchestrated for Allied war commissioners, who were passing through the city to bolster enthusiasm for the Allied cause.[8]

Stillness pervades the picture. Aside from the flags, which flutter in the breeze, nothing moves. The back foot of the delivery man crossing the street rises from the pavement, but otherwise stasis prevails. Pedestrians seem frozen in place, as if by the chalky white ambience that glazes the image, but also by their attire, which emphasizes length and physical compactness. Heads extended upward by fashionable millinery, arms downward to their calf-length skirts, the women occupy space vertically but do not cross it horizontally.

Architecture dominates the setting, as seen from the intersection of Fifth Avenue and 54th Street: the chunky white blocks of St. Thomas's Episcopal Church at left, the cliff-like recession of lofty office towers or hotels at right. The image as a whole is geometric, an orderly array of rectangular slabs constituted by buildings, conveyances, and pedestrians alike, neatly spaced on a grid, with only the dancing flags, the patch of opalescent blue sky, and a few diagonal shadows interrupting the vertical regularity of the serenely static world portrayed. The flags bring the city to life, imparting sanguine warmth to its otherwise cool, early morning pallor.

For contrast, we might look at a street scene by Bellows, who was Hassam's opposite. A generation younger, trained in New York rather than Paris, and deeply committed to left-wing politics, Bellows disdained the genteel tradition that the older artist exemplified. His paintings of urban life, such as *New York* (1911, National Gallery of Art) are dense with crowds, thick with pigment, laden with atmosphere. The paint handling is rough, muscular, and abrasive, like the mean streets depicted. Bellows insists on the polyglot, heterogeneous, multiclass, multiethnic, multilayered nature of New York and, by extension, America itself, while Hassam's celebrates unity, homogeneity, metropolitan rationality, and civic order. Indeed, *Early Morning on the Avenue* could even be understood as a riposte to Bellows's 1913 painting *Cliff Dwellers*, where the laundry of immigrants from around the

43. | George Bellows, *Cliff Dwellers*, 1913. Los Angeles County Museum of Art.

world, not the ceremonial flags of preferred nations, flutters and flies over the heads of pedestrians (Fig. 43).

The red, white, and blue color scheme of Hassam's painting is no accident. Attesting to the fervor of the moment in history when the United States shrugged off its time-honored policy of political isolation and leapt onto the world stage, the painting conflates flags, femininity, commercial culture, and religious worship to remind viewers of the democratic values that they were supposedly going to war to defend. A passionate supporter of the Allies, Hassam was elated by his nation's abandonment of neutrality. Like many American painters who had trained in France (in his instance, several decades earlier), he nursed a sentimental attachment to the land of his artistic apprenticeship.

Hassam was also an Anglophile, proud of his English ancestry and New England upbringing, which he repeatedly referred to with an iconic series of paintings of a New England country church. Although his surname Hassam

(which he pronounced *HASS-em*) struck his contemporaries as vaguely Middle Eastern, he made a point of noting it was completely English in derivation. He liked to joke about his descent "from that pure Arabian stock that landed in Dorchester [Massachusetts] in 1631."[9] In *Early Morning on the Avenue* he expressed his American patriotism, his Francophilia, and his Anglophilia, while exploring the chromatic effects of light in modern urban settings, his longstanding impressionist agenda.

Hassam's flag paintings constitute his last significant body of work. They pay homage to the theme-and-variation method of Claude Monet, the French master he most revered, who serially painted haystacks, cathedral fronts, and water lilies. More specifically, Hassam's flag paintings allude to works by Monet such as *Garden at Saint-Adresse* (1867, Metropolitan Museum of Art), where two pennants, one nautical, the other national, snap in the seaside breeze, or, even more apt, *Rue Saint-Denis, fête du 30 juin 1878* (1878, Museum of Fine Arts, Rouen), in which myriad French tricolors spring from the windows and walls of Parisian buildings in a frenzy of brushwork that proclaims the democratic energy of the French Third Republic.

A handful of Hassam's flag paintings strive for the delirium of Monet's *Rue Saint-Denis*; among them are *Allies Day, May 1917* (Fig. 44) and *Red Cross Drive, May 1918 (Celebration Day)*. But most of his flag paintings are too circumspect to let loose with such a daring farrago of light, color, and nationalistic fervor. None is more orderly, tranquil, and still than *Early Morning on the Avenue*, with its almost Euclidean geometry, in which flat patches of crimson, representing the flags, rhythmically punctuate the bluish-white recession into space.

Hassam was no artistic innovator. There was nothing controversial about his complacent impressionism,

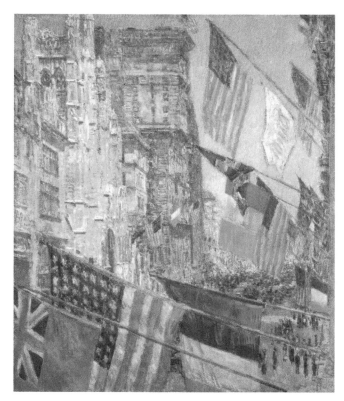

44. | Childe Hassam, *Allies Day, May 1917*, 1917. National Gallery of Art.

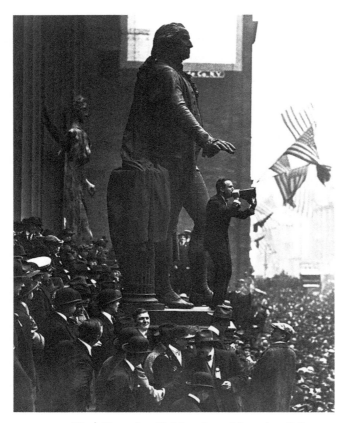

45. | Douglas Fairbanks addressing Liberty Loan rally on Wall Street, April 1918.

in which the armature of solid geometric form holds light's flickering transience securely in check. For years, if not decades, impressionist technique had been assimilated into American art, so if anything about Hassam's flag paintings struck his contemporaries as controversial, it was their ardent support of intervention, for, as we have seen, great numbers of Americans opposed it. Besides, unlike its lower-status cousin graphic illustration, which included editorial cartooning, fine art painting was not supposed to express a manifestly political point of view.[10]

Though outraged by the *Lusitania* atrocity in May 1915, most Americans seem to have regarded it as an unfortunate instance of what today we call collateral damage. Invoking George Washington's venerable advice to his countrymen not to become entangled in foreign embroilments, they rejected military engagement abroad and in November 1916 reelected the peace candidate Woodrow Wilson, who campaigned on the slogan, "He kept us out of war." Once the United States entered the war, however, even Washington, the Father of His Country, blessed the endeavor, as suggested in a photo of the actor Douglas Fairbanks addressing a crowd at a war rally on Wall Street. The general's statue appears to be bestowing a benediction, or even patting the patriotic movie star on the head (Fig. 45).

HASSAM PAINTED AS A CHAMPION of the preparedness movement. Preparedness advocates, citing the ancient Roman maxim, "Let him who desires peace, prepare for war," urged the government to build up American armed forces and ordnance to unprecedented levels so that the country could

respond instantly and forcefully when the call to war came, as surely it would. They sought every means to achieve their goal, and that included sponsoring elaborate Preparedness Day parades in cities across America.

Although the business leaders and Chamber of Commerce representatives who organized these large public events claimed their only goal was to foster national unity, the parades themselves aroused fierce class antagonisms. Labor leaders contended that preparedness did not help nations achieve peace but rather pushed them toward war, as was evident from the current conflagration in Europe. "A country which carries a large standing army and navy is like a school boy with a chip on his shoulder, always courting trouble," a spokesman for the machinists union warned, adding: "If the masters of the country want preparedness let them go to war, but let the working class prepare their unions so that they will not be led into slaughter as their brothers in Europe have been." A representative of the musicians' union observed that "preparing for war to insure peace is about as logical as to saturate wood in oil to protect against fire; preparing for war means war."[11] Labor leaders argued that under all the patriotic bluster, the real reason for going to war was to line the pockets of the bosses, cut wages, and deprive workers of their rights to collective bargaining.

Henry L. Stimson, formerly secretary of war under William Howard Taft, was a leading figure in the preparedness movement. In 1916 Stimson, along with others, including Roosevelt and J. Pierpont Morgan, Jr. (son and successor of the banking titan, who had died in 1913), organized the National Defense League, a coalition of financiers, industrialists, corporate heads, and politicians dedicated to heightening America's military prowess. When the nation finally did go to war, Stimson went along with it, as an artillery officer stationed in France, though he was dissatisfied to find himself posted far from the front.

Stimson's older sister Alice purchased Hassam's *Early Morning on the Avenue* in 1930, intending to bequeath it in his honor to Phillips Andover Academy, his alma mater. When Hassam's work finally entered the school's art collection in 1944, Stimson was again serving as secretary of war, this time under Franklin Roosevelt and his successor, Harry Truman. Perhaps Stimson, more than any other figure, can be regarded as the architect of the modern national security state or, as the political scientist Harold Lasswell called it in 1942, the garrison state, in which ongoing preparedness for war displaced the nation's broader concern for democratic openness and transparency.[12] Stimson's top project as war secretary was the development of nuclear weapons. In the summer of 1945, despite clear indications that Japan teetered on the verge of collapse, Stimson campaigned tenaciously, and at last successfully, to overcome the president's reluctance to drop the atomic bomb without warning on Hiroshima and Nagasaki.[13]

It is easy to imagine what Henry Stimson would have liked about *Early Morning on the Avenue*. Portraying his beloved New York City in pristine light, with a Protestant church and Allied flags lofting protectively over its womenfolk, Hassam's painting, or works similar to it, must have reinforced his desire to defend the homeland at any cost. The prominence of the women in the painting is noteworthy. Showing white, middle-class women implicitly or explicitly endangered by the barbarism of the enemy helped to sell the war to a public initially reluctant to take arms.

Stimson may have been paternalistic in his views about women, but it should be noted that he championed women's suffrage. In late February 1913, shortly before the March 3rd inauguration of incoming president Woodrow Wilson, Alice Paul planned a suffrage march in the nation's capital. When the District of Columbia police informed Paul and her fellow organizers that they could not protect the marchers from angry crowds, the suffragists asked Stimson, the outgoing secretary of war and the brother-in-law of one of the planners, to provide army troops for their protection. Though sympathetic to the cause, the secretary was constrained by law from using federal troops for this purpose, so he worked tirelessly behind the scenes to effect a solution, which in this case meant inducing the DC superintendent of police to safeguard the marchers. The police chief, however, remained adamantly opposed to the parade. Stimson went over to nearby Fort Myer in Virginia to drill a cavalry detachment in crowd control and bivouacked them on the western outskirts of the city, in case pandemonium broke out, which it did, but not in such a way that federal troops could be asked to intervene.[14]

Half a million onlookers, mostly men, many of whom were seen drinking to excess, jeered at the marchers, hurling obscene epithets at them, and stones, too. According to the historian Kimberly Jensen, "One woman was struck in the face, and others were 'pinched black and blue.' At several points along the way young men in the crowd linked arms to form a chain to prevent the women from passing. Some men took hold of women marchers or those sitting on floats and fondled their arms, legs, and breasts. . . . And some threw lighted cigarettes in an attempt to ignite the parade flags and banners as the marchers passed through this human gauntlet." The police stood by and watched, or, in some cases, flung anti-feminist jeers of their own. The physical and sexual violence enacted on the suffragists on Pennsylvania Avenue one day before the inauguration of the presidential candidate who had won election to the White House on a "peace" platform shows how deeply Americans in general feared women's rights and how desperately they resisted any change to traditional gender patterns.

Thus it comes as no surprise that the establishment art world represented by Childe Hassam and the cognate worlds of commercial and political illustration would predominantly favor conservative, old-fashioned views of women

as fragile vessels of virtue requiring rugged manliness to keep them from harm. The melodramatic motif of the violated virgin appeared in numerous recruitment posters after America entered the war.[15] *Destroy This Mad Brute* was the most extreme of these, but others come close. Ellsworth Young's *Remember Belgium* shows a middle-aged, spike-helmeted Hun, a phallic firearm conspicuously poised between his legs, dragging an unwilling female child by the hand, both of them silhouetted against a flaming sky (Fig. 46). Another poster, Louis Raemaekers's *Enlist in the Navy* (ca. 1917, Library of Congress) pictures Uncle Sam in military garb pointing a revolver at a whip-wielding Kaiser, who is about to ravish a maiden chained to an overturned cross. Still another poster, issued by the American Association of Motion Picture Advertisers (ca. 1917, Library of Congress), depicts Uncle Sam hovering in dismay over the violated body of his daughter, the

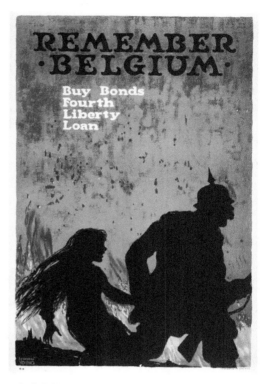

46. | Ellsworth Young, *Remember Belgium*, 1918.

red stripes of the American flag gushing from her lap like blood: "It's up to you" admonishes the text. "Protect the nation's honor—enlist now."

Patriotic posters used the flag as a means of associating threats to American virginity with the defilement of national purity. Particularly noteworthy in this regard were posters designed by the Anglo-Saxon old-guard triumvirate Howard Chandler Christy, Harrison Fisher, and the aptly named James Montgomery Flagg. The flag of the United States serves frequently in their work as a lavish adornment for the fine-boned, delicately featured WASP femininity that they liked to purvey as the allegorical symbol for America (Fig. 47). Even when leading American troops into imaginary battle, these allegorical figures were dainty, softly contoured, long-lashed female beauties, as in Christy's famous *Fight or Buy Bonds* poster (Fig. 48), modeled on Eugène Delacroix's rousing revolutionary tableau from 1830, *Liberty Leading the People*. These artists belonged to the same social set and cultural milieu as both Henry Stimson and Childe Hassam. Rather than feature pretty maidens wrapped in Old Glory, Hassam's flag paintings limit themselves to surveying from afar the white, upper-class enclaves of New York, populated by faceless stick figures. Still, they benignly associate beauty, purity, Puritan lineage, and patriotism. As one of

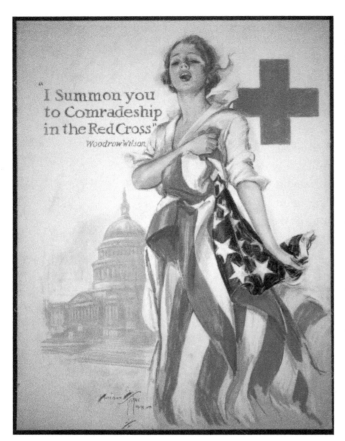

"I Summon you to Comradeship in the Red Cross."
Woodrow Wilson

47. | Harrison Fisher, *"I Summon You to Comradeship in the Red Cross,"* 1918.

Hassam's admirers wrote shortly after the war, "He made the Flags symbolic of his heritage. Only a Puritan could have painted flags as he did."[16]

RECRUITMENT AND LIBERTY LOAN POSTERS were not alone in flooding popular culture with gender-based appeals for enlistment and other forms of patriotic support. The sheet music and recording industries made similar appeals. For instance, following the initial popularity of the 1915 pacifist song "I Didn't Raise My Boy to be a Soldier" (which ex-President Roosevelt singled out for contempt), there were plenty of anti-pacifist parodies, among them, "I Didn't Raise My Boy to Be a Coward," "I Didn't Raise My Boy to Be a Slacker," and "I'm Going to Raise My Boy to Be a Soldier and a Credit to the U.S.A."[17] George M. Cohan's "Over There," the most popular war song of the era, explicitly appealed to conventional sex-role expectations. Before the fighting was "over, over there," hundreds of thousands of recordings sold, as well as more than two million copies of sheet music. "Johnnie, get your gun, get your gun, get your gun," the singer implores. "Hurry right away, no delay, go today. / Make your daddy glad / To have had such a lad. / Tell your sweetheart not to pine, / To be proud her boy's in line."

Undoubtedly, the great fame and lasting allure of the song have less to do with its masculinity-affirming lyrics—which, to be sure, are not unimportant—than its rousing chorus, which takes an agitated and insistent three-note bugle call ("Send the word, send the word, over there") and resolves it rapturously, "That the Yanks are coming, the Yanks are coming... / And we won't come back 'til it's over, over there."[18]

Four successive editions of the sheet music were published in the United States and England in 1917 and 1918. One of these used a cover illustration by the young, relatively unknown graphic artist Norman Rockwell, whose first of what amounted to several hundred *Saturday Evening Post* covers had appeared in 1916. His sheet music cover for "Over There" shows four fresh-faced, practically juvenile doughboys singing, strumming a banjo, and merrily snapping their fingers. They gather around a campfire like scouts on a weekend retreat. Cohan's other most famous tune, composed for his 1906 Broadway musical *George Washington, Jr.*, was "You're a Grand Old Flag." This was the first Broadway song in history to sell over a million copies of sheet music, and it was recorded many times. The song's catchy chorus is irrepressible: "You're a grand old flag, / You're a high flying flag / ... the emblem of / The land I love, / The home of the free and the brave."

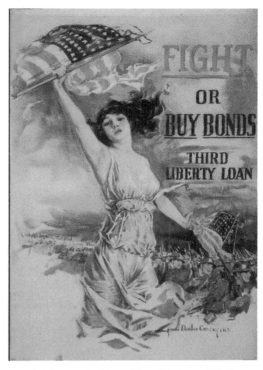

48. | Howard Chandler Christy, *Fight or Buy Bonds*, 1917.

The flag paintings of Childe Hassam could not compare in popular appeal with the "flagophilia" of Cohan's beloved song, but the paintings, like the song, participated in a concerted effort in the late nineteenth and early twentieth centuries to sanctify the flag. Originally "Old Glory," as the national banner was dubbed in the mid-nineteenth century, did not enjoy that status. It appears to have been designed for the Continental Congress in the late 1770s by a New Jersey lawyer, poet, and signer of the Declaration of Independence, Francis Hopkinson, who asked to be remunerated for his efforts by "a Quarter Cask of the public wine." Francis Scott Key wrote his famous ode, "The Star-Spangled Banner," during the War of 1812, and politicians began exploiting the flag for campaign purposes in the 1840s, but it wasn't until Secessionists pulled down the Stars and Stripes at Fort Sumter in 1861 that it gained widespread currency, in the North at least, as America's ultimate rallying symbol.[19]

During the last quarter of the nineteenth century and first of the twentieth, powerful veterans' lobbies such as the Grand Army of the Republic and exclusionary patriotic societies such as the Daughters of the American Revolution urged Congress to declare Flag Day a national holiday and make

"The Star-Spangled Banner" the national anthem (it only officially became so in 1931). The Pledge of Allegiance was written in 1892 with the intent of instilling patriotic ardor in the hearts and minds of children and immigrants, two groups of individuals in whom patriotism was not presumed to be innate.[20]

In the late nineteenth century, bills were introduced in Congress to protect the flag. The proposed legislation sought to quell not political protesters (who at that time did not see an advantage to be gained or point to be made by desecrating the flag) but commercial retailers, who had discovered that flying the flag in advertisements and window displays was an effective way to peddle merchandise. The bill failed because members of Congress worried that it would prohibit them from using the flag themselves in their reelection campaigns. Flag protection acts were put forward again at the start of the twentieth century, but by now the target had shifted from advertisers to protesters. Indeed, anarchists, socialists, and labor activists sometimes literally ripped or burnt the flag as a form of dissent. It was at this time that flaunting one's respect or disrespect for the flag became a powerful means of expressing approval or disapproval of where America was headed.

In 1915, for example, a socialist clergyman contended that the flag "is a symbol that is used today chiefly to fool the voters and to whoop-it-up for patriotism. Men will lay down their lives to preserve that symbol without considering in the least what those who wave that flag really stand for." He adds "Capitalist politicians are trying to blindfold the eyes of workingmen with our flag, while the capitalists pick your pockets and exploit you."[21]

The anarchist Emma Goldman agreed, arguing that business, church, and government leaders were stirring up "flag mania" to divert workers and immigrants from their own continued exploitation. A cartoon in the April 1916 issue of the *Masses* showed a clergyman, a politician, and a businessman cloaked in the flag as they stride arm-in-arm over a pile of dead soldiers; the man of God seems sorrowful but no less ready to renounce his patriotic covering than the others wrapped with him in Old Glory. In the years leading up to Hassam's painting of *Early Morning on the Avenue*, the flag was disliked by a sizeable minority of the American population as intensely as it was revered by those in the majority.[22]

Occasionally the Stars and Stripes served as a symbolic prop in the public violence staged by vigilantes who sought to intimidate and humiliate foreign-born, radical, or working-class individuals whom they deemed insufficiently patriotic. The most egregious instance occurred in April 1918, when a mob in southern Illinois wrapped a German-born union activist, Robert Prager, in a large American flag and forced him to march up and down the street waving and kissing smaller flags before they hanged him from a tree.

When the leaders of the lynch party were subsequently acquitted of murder by a jury of their peers, a local band celebrated by striking up "The Star-Spangled Banner," "Over There," and other flag-waving tunes.[23]

Anti-German sentiment was not always so violent. More typical was the renaming of sauerkraut "liberty cabbage," frankfurters "liberty dogs," and hamburgers "liberty steaks." Still, the mood was ugly and grew uglier as the war progressed and the number of American casualties mounted.

The lofty realm of classical music, long thought by purists to be immune to worldly politics, suffered as well. Beethoven, Bach, and Brahms, along with other titans of Teutonic culture, were banished from American orchestra concerts. The Swiss conductor Karl Muck, who had served for more than a decade as the distinguished music director of the Boston Symphony Orchestra, was heavily criticized when he failed to begin a concert in Providence, Rhode Island, with a performance of "The Star-Spangled Banner." Since the advent of war, most of America's leading orchestras, such as the New York Philharmonic, had taken to opening their concerts with a full-scale rendition of the patriotic anthem. Outraged and insulted, or perhaps merely looking for controversy, the press created such a furor over the musical omission that Muck became a target of nationalist anger. Some months later, on the eve of an Easter performance of Bach's *St. Matthew Passion*, he was arrested on charges of espionage. Allegedly his markings on the score were a means of passing along secrets to fellow spies in the orchestra. Although found not guilty of the charges against him, he was remanded to an internment camp in Georgia, where he languished until August, when he and his wife were deported.[24]

Mounting anti-German sentiment bled into the intellectual realm as well. The most egregious case concerned the Harvard psychologist Hugo Münsterberg. In the prewar years he enjoyed his fame as the nation's most highly regarded German-American intellectual; indeed, he was perhaps America's most celebrated living academic. As a brilliant young psychology professor in his native Germany in the late 1880s, Münsterberg came to the attention of the great William James, the pragmatist philosopher and father of modern psychological studies. Accepting James's offer of an instructorship at Harvard, Münsterberg moved to Cambridge with his family, set up his laboratory, and became a favorite among students, one of them the young Gertrude Stein, who he in turn described as "the ideal student." Rewarding James's faith in him, he swiftly attained international prominence as an innovative experimentalist and prolific author.[25]

He helped found the field of industrial psychology. As the modern industrial revolution was getting under way in America—Ford's assembly line started rolling in 1914—Münsterberg studied the effects of industrial processes on the

lives and habits of workers. Like his fellow corporate consultant Frederick Winslow Taylor, the inventor of "scientific management" motion studies, he sought ways of increasing worker efficiency, but, unlike Taylor, he also recognized the mentally deadening and spiritually numbing effect on workers of endless mechanical repetition. Stein's own later experiments in verbal repetition ("A rose is a rose is a rose") were inspired in part by the experiments she had observed as an undergraduate in Münsterberg's laboratory.

He was also a public intellectual, who wrote books explaining America to Germans and Germany to Americans. He corresponded on political matters with the likes of Theodore Roosevelt and Woodrow Wilson. When the war began in 1914, during the period of American neutrality, Münsterberg crisscrossed the country, speaking vociferously to German-American civic groups in defense of their shared fatherland against the slanderous charges of British propaganda. In a much-criticized letter to the *Boston Herald*, he described the war in Europe as a clash between the forces of civilization, represented by Teutonic Germany, and the forces of barbarism, led by Slavic Russia. His brazenly partisan views became increasingly untenable for most Americans after the sinking of the *Lusitania*, and the professor himself became the object of backlash. Old friends in Cambridge crossed the street when they saw him approach, and he was denounced at Harvard faculty meetings.[26]

As a means of escape that summer, he went to the movies and had a conversion experience, particularly after seeing the Australian bathing beauty and swimming champion Annette Kellerman in *Neptune's Daughter* (now lost). Kellerman, as mentioned in Chapter 2, had once been arrested on Revere Beach, just north of Boston, for wearing her infamous one-piece bathing suit, but by 1915, she was a bona fide movie star. Münsterberg was intrigued by her ability, and that of other celluloid attractions (the term "star" was not yet in use), to fire the imagination. Kellerman is said to have performed the first nude scene in film history—"clad only in a fish tail," one observer reported—although it's more than likely that she wore a flesh-colored bodysuit. Previously a self-confessed snob about motion pictures, which he regarded as mindless, formulaic, lower-class entertainment, Münsterberg discovered their potential artistry, and by the end of the year he had written *The Photoplay: A Psychological Study*, the first theoretical book to take film, and film study, seriously.[27]

The movies proved not to be an adequate hiding place, however, and controversy continued to dog Münsterberg. Public opinion turned viciously against him. Both Roosevelt and Wilson broke off correspondence after requesting that he no longer attempt to contact them. He was humiliated and despondent. In December 1916, while delivering an undergraduate lecture at Radcliffe, he collapsed at the podium, struck down by a fatal heart attack. One of his friends commented that sudden death gave the troubled professor

"happy relief from persecution and malignant attacks, which have been a disgrace to American scholarship and civilization." Another friend said simply, "He falls, a victim of war."[28]

Intriguingly, Münsterberg's pioneering forays into industrial psychology, in particular the unwanted effects of mechanical repetition on assembly-line workers, might have helped military physicians understand how the new phenomenon of industrialized warfare afflicted the central nervous systems of its front-line workers, that is, soldiers. What were the differences, for example, between standing for hours on end in a drab factory, deafened by the roar of machines, and standing for days on end in the trenches beneath a gray, featureless sky, deafened by the roar of cannons and bombs?

After the war, Freud described a "repetition compulsion" that haunted the dreams of emotionally blocked veterans, who kept mentally reliving the violent trauma they had experienced in war in a failed effort to gain mastery over their inner chaos. Freud wrote: "A condition has long been known and described which occurs after severe mechanical concussions, railway disasters and other accidents involving a risk to life; it has been given the name of 'traumatic neurosis.' The terrible war which has just ended gave rise to a great number of illnesses of this kind."[29]

Though Münsterberg had no truck with Freudian theory and largely dismissed the idea of the unconscious, it is fascinating to think that his insights might have been synthesized with Freud's and those of other clinicians, such as the British researcher W. H. R. Rivers, who, as we saw in the previous chapter, pondered the strange and heretofore unexplained phenomenon that came to be known as shell shock. Likewise, his insights into cinema as a theater of the mind, which anticipated by more than half a century modern film theory and reception studies, were all but forgotten at his death, thanks in no small part to the ignominy of his later years as an abrasively outspoken champion of his homeland at a time when it was politically incorrect in Anglo-oriented academia to take such a stance.

Münsterberg grasped the enormous power that visual images can have in swaying the mind and stirring the emotions. His acumen on the subject could have proved timely in understanding the appeal of the flag in wartime. For flags, ubiquitous in American visual culture during the war years, became, as never before, potent signifiers, capable of arousing, on sight, intense emotions, among them patriotic fervor, jingoist pride, anarchist disgust, and vigilante hate. They served as visual weapons par excellence. To be sure, saturating the visual landscape with symbolically charged colored cloth to stir nationalist loyalties was not a phenomenon unique to the United States. Men everywhere were willing to kill for their country's flag and, if need be, die for it.

The British historian W. J. Gordon observed in 1915, "Symbols are sacred things: and one of the chief that every man holds dear is the national flag.

Deep down in our nature is the strong emotion that swells the heart and brings the tear and makes us follow the flag and die round it rather than let it fall into the hands of the enemy."[30] On the home front as well as on the battlefield, flags resonated powerfully with viewers and provoked consuming passions.

OCCASIONALLY PAUL STRAND, A BRASH young photographer with avid ties to the American left, ventured with his camera into Childe Hassam's uptown world. His 1915 photograph *Fifth Avenue* is one of his sprightliest images (Fig. 49). Composed on the vertical axis, it shows the spires of St. Patrick's cathedral piercing the gray tonality of the sky, while, at the bottom edge of the photo, opposite the cathedral and distinct from the crowd, three young women in stylishly decorated millinery stroll shoulder-to-shoulder beneath an angled flagpole, from which an American flag curves into the shape of a crescent. Two of these women look back at the photographer, as if from curiosity or bemusement; the other, with the most elaborate of the hats, continues

her forward march. Their plumed headgear rhymes roguishly with the flag and flagpole and the twin spires of the church, gently undermining the respectful attitude toward church, state, and femininity that, two years later, Hassam embodied with paintings such as *Early Morning on the Avenue.*

While surely not intended by Strand as a commentary on the war in Europe, nor likely to have been viewed by anyone in that regard, *Fifth Avenue* embodies the irreverent spirit of the Lyrical Left during the period that the preparedness advocates such as Hassam, Morgan, and Stimson were beginning to make their case. The Lyrical Left is a term that was later given to a loose coalition of artists, intellectuals, professors, social workers, and political activists centered in Greenwich Village. In the decade or so before America entered the war, they believed—naively, it seemed in retrospect—that radical artistic and sexual experimentation, together with

49. | Paul Strand, *Fifth Avenue, New York*, 1915.

radical politics, could help de-
molish archaic social patterns
and lead the way to a freer and
more equitable society.[31]

Another of Strand's pho-
tographs from this time, *Blind*,
provides a head and shoulders
study of a sightless mendicant
who stands with her back
against a wall (Fig. 50). The
medallion license on her neck
authorizes her to beg—but it
also resembles a slave shackle
or dog collar. A large, hand-
painted sign hung across her
chest labels her "BLIND." Her
sightless eyes angled obliquely
from the gaze of the camera,
her face weathered but hand-
some, her silver hair covered
by a shawl, the woman seems to
be some sort of urban oracle or
sibyl: blind, yet a seer.

50. | Paul Strand, *Blind*, 1915.

As a teenager, Strand had
attended New York's progres-
sive Ethical Culture School, where one of his teachers was Lewis Hine, a
documentary photographer who chronicled the lives of the urban and rural
poor. Hine inspired his students to believe that photography could and
should be used as an instrument of social reform, and even when Strand, in
the wake of the Armory Show and under the influence of his new mentor,
Alfred Stieglitz, embraced modernist aesthetics, he remained committed to
the social-reform principles he had imbibed from Hine. With *Blind*, the
young photographer combined the divergent lessons he had learned from
both his masters.

That is, the photograph is modernist in form, filled with angular sym-
metries and asymmetries that engage the eye in abstract relationships, but its
formal complexity cannot dispel—if anything, it enhances—its social con-
cerns. The picture indicts a capitalist economy that regards the sub-proletarian
poor as unsightly marginal figures, who are best ignored or overlooked. In
that sense, the word "blind" emblazoned on the woman's chest constitutes
not her scarlet letter but ours; it levels a charge of moral blindness *at the*

51. | Edward Steichen, *J. Pierpont Morgan*, 1903. Metropolitan Museum of Art.

viewer, an indictment of those who can look at poverty without empathy or, more importantly, a sense of outrage. The beggar does not reproach the rich, who remain on our side of the camera lens, but the photograph most certainly does.[32]

Blind holds its own against another iconic photographic portrait of the early twentieth century, Edward Steichen's 1903 depiction of J. Pierpont Morgan, Sr., who sat impatiently for the photographer and tore the resulting print to shreds when it was delivered to him (Fig. 51). With good reason, too, for the analogy the photograph makes between capitalism and piracy could hardly be more explicit: The scowling plutocrat, bathed in darkness, appears to clutch a deadly knife in his hand, although, on closer inspection, the blade turns out to be the glossy arm of his chair flashing in the light.[33]

Similarly, Strand's 1915 photograph *Wall Street*, his most universally admired image, attacks the Morgan banking empire, though most viewers, particularly today, when we are so far from the animosities in question, have little inkling of how that might be so (Fig. 52). The photo also, indirectly, attacks the efforts of interventionists such as Hassam, Stimson, and J. P. Morgan, Jr., to pull the United States into the war. Exhibited by Alfred Stieglitz in Gallery 291 in 1916 and published in the final issue of *Camera Work* in 1917, *Wall Street* portrays Gotham in a manner that seems strikingly unpatriotic compared with Childe Hassam's views of the city. The photo historian Glyn Davis aptly describes the image: "Workers scuttle across the bottom of the frame, low sunlight stretching their shadows into dramatic diagonal smears; above the human figures towers an imposing bank, an edifice to the status and power of capitalism. . . . Wall Street, a global symbol of monetary might, dwarfs the nameless and faceless individuals exiled to the lower limits of the image."[34]

52. | Paul Strand, *Wall Street*, 1915.

One is reminded of the German aphorism, "When the sun of culture is low, even dwarves will cast long shadows." Strand's white-collar workers, isolated from one another by those ponderous shadows, file into the jaws of the impersonal corporate machine, represented by the vast coffin-like casements looming over their heads. In terms such as these Strand and his fellow cultural radicals in the Lyrical Left would have understood the image, which eloquently distilled their rancor toward capitalist America.[35]

WHAT A CONTRAST TO *EARLY MORNING ON THE AVENUE*. In both images, pedestrians pass beneath an immense edifice in the bright light of early morning, but in the painting it is a Fifth Avenue church and in the photo, a Wall Street bank. The painting exudes old-fashioned gentility, the photograph modernist alienation. The flags of the allied nations wafting above Hassam's Fifth Avenue shoppers symbolically safeguard them. Strand's Wall Street workers lack any such protection. Passive, unresisting, they march to work like infantry heading to the front.

Years later, Strand recalled the impression the bank building made on him. "I had a friend who worked in that building, with whom I went to school:

for me it seemed too bad, I thought he could have done something much more useful. Well, I also was fascinated by all these little people walking by these great big sinister, almost threatening shapes...these black, repetitive, rectangular shapes—sort of blind shapes, because you can't see in, with people going by. I tried to pull that together."[36]

On another occasion, Strand recalled that "at that time I knew nothing about cartels etc. I was trying to photograph the 'rushing to work' and no doubt the black shapes of the windows have perhaps the quality of a great maw into which the people rush." As photo historian Maria Morris Hambourg concludes, "Whether the shapes represent the consolidated power of Wall Street, the mad dash after money, the weekday routine, the inhuman quality of metropolitan life, the inexorable march of time, or some combination of these ideas, their oppressive regularity and crushing size, in contrast to the small individual human silhouettes below, constitute an abstract expression of [Strand's] emotional response."[37]

The Wall Street building beneath which they tread is not any old building. It is the headquarters of the Morgan bank. The House of Morgan was instrumental in bringing the United States into the war. It floated loans worth billions of dollars to the British and French governments. During the two-and-a-half years the United States remained neutral, the bank served as the purchasing agent for the British in North America, buying food and supplies to be shipped to England. In violation of neutrality laws, it also procured munitions.[38]

The *Lusitania* was carrying a contraband cargo of Morgan-purchased munitions, although this information was not made public until after the armistice. Even at the time of the catastrophe, many Germans and German-American sympathizers doubted that the sole torpedo launched by the U-boat could have caused an ocean liner to plunge into the sea so quickly, before lifeboats could be deployed. They speculated that the underwater missile had inadvertently detonated a stockpile of illegal explosives in the ship's hold.[39]

Whether or not Strand and his fellow Greenwich Village radicals believed the rumors about the *Lusitania* carrying Morgan-funded munitions, they knew without question that the House of Morgan solidly favored US military intervention on behalf of Great Britain. The subsequent confirmation of the bank's involvement materially changes the way we read Strand's representation of its headquarters. More than a generalized attack on Wall Street capitalism, it specifically manifests the Lyrical Left's animus against the war and its rich and powerful advocates.

Once war was declared, political criticism of Morgan or Wall Street could land a dissident in jail. A district court judge in New Hampshire sentenced a man named Gustave H. Taubert to three years in prison for obstructing liberty bond sales by claiming in print that "this was a Morgan war

and not a war of the people." The judge explained that he was being lenient in his sentencing: "These are not times for fooling. The times are serious. . . . Out West they are hanging men for saying such things as this man is accused of saying." The United States Attorney General, on another occasion, chastised a federal judge for acquitting a defendant who had publicly referred to the president of the United States as "a Wall Street tool."[40]

After the war, Morgan headquarters, erected in 1913, the year the elder Morgan died, became the symbol par excellence of corporate capitalism (equivalent, more than half a century later, to the World Trade Center). In September 1920 a horse-drawn wagon carrying five hundred pounds of iron sash weights pulled alongside the building at lunchtime. Moments later, the wagon exploded in a ferocious blast that killed thirty-eight people and injured three hundred others (Fig. 53). The young banker Joseph P. Kennedy, father of a future president of the United States, happened to be walking

53. | Crowd gathered following the explosion on Wall Street, 1920 (note Washington statue in background).

down Wall Street at the time. The force of the explosion hurled him to the ground. Morgan's massive building survived the assault, though the huge recessed windows that loom over the pedestrians in Strand's photograph were punched from their casements. Investigators never identified the cause of the explosion, and an army of private detectives hired by the Morgan firm found no culprits to arrest, but it was widely believed that anarchists had plotted and executed the attack.[41]

Strand, though not an anarchist himself, abhorred the world presided over by the likes of Morgan, Stimson, and Hassam. On the eve of his induction into the army in the summer of 1917, he wrote to the radical antiwar journalist Randolph Bourne to thank him for his recent essay "Below the Battle," which Strand believed expressed his own disheartened feelings about the current state of America.

In the essay, Bourne describes an unnamed friend of his, who, "because his parents happened to mate during a certain ten years of the world's history," was being shipped overseas "to kill Germans or be killed by them." Bourne's young friend loathed "reputable people," those conventionally minded, well-off Americans who exhibited "neurotic fury about self-defense." Like the thousands of young pacifists, including Strand, that he typified, Bourne's friend had no use for the patriotic importuning of the preparedness advocates. "All the shafts of panic, patriotism and national honor have been discharged at him," wrote Bourne, "without avail." The essay concludes, "If the country submissively pours month after month its wealth of life and resources into the work of annihilation...bitterness will spread out like a stain over the younger American generation. If the enterprise goes on endlessly, the work, so blithely undertaken for the defense of democracy, will have crushed out the only genuinely precious thing in a nation, the hope and ardent idealism of its youth."[42]

Surely few if any viewers would have compared *Early Morning on the Avenue* to Strand's *Wall Street*, if only because the audiences for the two images were so unalike. Hassam and his patrons and fellow artists lived in the same city as Strand and his friends and patrons but in a different world. They exhibited in very different venues and thought in very different ways about art and society and, in particular, the war in Europe. As indicated above, Hassam, Stimson, and Morgan strongly favored intervention; Strand, Bourne, and Stieglitz distinctly opposed it. Another reason that viewers of Hassam's painting were unlikely to have seen Strand's photograph is simply that, in those days, paintings and photographs would rarely be drawn into any kind of comparison; they, too, occupied distinct worlds (still the case today, though less so).

But that should not prevent us from taking the trouble to think of them comparatively. Hassam and Strand may have been politically and artistically

antithetical, but they were both highly proficient artists who used their well-honed skills of visual communication to envision, each from his own politically committed perspective, America's great metropolis on the eve of or onset of war.

To return, then, to Strand's foot soldiers of capitalism marching past the cathedral of commerce built by Morgan, we might juxtapose it with another haunting image of the period, this by Ernest Brooks, a British army photographer who recorded the damage done to the Belgian city of Ypres, the site of four terrible, long-lasting battles between 1915 and 1918 (Fig. 54). Appearing without attribution in *Collier's New Photographic History of the World's War*, the photo shows captured German soldiers and their guards shambling down a road in the town center, which is piled high with the rubble of its once-glorious Gothic architecture. They provide a bleak counterpart to Hassam's female pedestrians strolling placidly past a Gothic Revival church. Despite the obvious differences, Hassam's painting and the *Collier's* photograph are alike in that both invited Americans to think reverently or sentimentally about homeland, their own or that of the Belgians, whereas Strand's photo asks for a critical perspective on it.

54. | Ypres in ruins, 1917.

COLLIER'S NEW PHOTOGRAPHIC HISTORY OF THE WORLD'S WAR, published in several successive editions, attracted a wide readership. Like other photographic compilations, of which there were many, it provided Americans with the impression that they were getting a good, unbiased look at the war and its devastation. All such photography, however, was carefully censored to ensure that Americans did not see genuinely frightening or grotesque images, which, in turn, might have caused them to withdraw their support for the war. The torrent of approved photographs that they did see, along with the ever-replenished supply of recruitment and savings-bond posters, performed much of the visual labor of sustaining America's military enterprise. So did a sudden glut of Hollywood melodramas, with titles such as *Escaping the Hun* (1917), *Claws of the Hun* (1918), *The Hun Within* (1917), and *The Kaiser, the Beast of Berlin* (1918).

Between the declaration of hostilities in April 1917 and the end nineteen months later, government agencies, civic organizations, and manufacturers' associations distributed in massive quantities throughout the land as many as two thousand different war-related posters, their evocative colors, eye-catching designs, and unambiguous messages urging the public to stay the course. It is impossible to know how effective these were in achieving their goal. Not much has changed since O. W. Riegel, a pioneering expert on war posters, cautioned in 1979, "No measuring instrument has been devised for a precise evaluation of the effect of posters upon their targets. Evaluations are therefore largely a matter of hunch and of post hoc reasoning—after this, therefore because of it. The war loans were subscribed; ergo, the poster campaigns for them were successful.... The difficulty with this reasoning is that it obviously ignores other factors that contributed to the result."[43]

America's World War I posters, including those mentioned in previous chapters, range from the humorous to the harrowing, from sappy-sentimental to leering-lecherous, from blatantly obvious to cool and quizzical. Many are loud and brash, others quiet and insinuating. One can easily detect in these pictorial pitches the birth roots of modern commercial advertising. Indeed, many of the most successful advertising and public relations wizards of Madison Avenue during the 1920s, 1930s, and beyond learned their craft while working for the Creel Committee or apprenticing in the poster campaigns.[44]

One of the essential lessons that commercial advertisers drew from their involvement in selling the war was that well-designed pictures can be more immediately persuasive than verbose copy in grabbing the fickle attention of pedestrians traipsing down the street or readers flipping through the pages of a magazine. Not that the value of "eye-appeal" was unknown to advertisers and marketing experts long before America entered the war. "Pictures are first principles," insisted one such expert in the early 1900s. "You may forget what you read—if you read at all. But what you see, you know instantly!"

A billboard advertiser told clients, "It is hard to get mental activity with cold type [but] YOU FEEL A PICTURE."[45] Still, the war drove the point home to those in the persuasion business and made it a first principle.

After the war, the Austrian-born American public relations expert Edward Bernays, a nephew of Sigmund Freud, avidly sought to transfer the propaganda techniques he had learned while working on the Creel Committee to the realm of American business. He insisted that the propaganda model, so successful in swaying public opinion during wartime, could be used benignly to prosper the economy. His Viennese uncle's dark insights into the implacability of human desire could be tapped, he believed, in a way that would contribute to America's gospel of success.[46]

Walter Lippmann, a liberal journalist, editor, and intellectual who, after co-founding the *New Republic* magazine, also worked in the propaganda mills during the war, came away from the experience much less sanguine about the transfer of propaganda techniques from wartime mobilization to peacetime commercialism. Like Bernays, he believed that societies were dominated by "herd instinct," but, whereas Bernays saw this in a positive light (the herd could be led to a place that was good for them), Lippmann fretted over the public's susceptibility to mind-controlling methods, such the purveying of stereotypes. Borrowing the term from the printer's trade, Lippmann gave *stereotype* its meaning today as a categorical and pejorative notion about a racial, ethnic, religious, or sexual identity group other than one's own.[47]

The literary critic Edmund Wilson shared Lippmann's concern over the ease with which public opinion could be manipulated, especially during wartime. The "unanimity of men at war," he wrote years later, is like "a school of fish, which will swerve, simultaneously and apparently without leadership, when the shadow of an enemy appears."[48]

Creel and his lieutenants knew how to make those fish swerve. No less an authority on propaganda than Adolf Hitler, in his memoir *Mein Kampf* (1925), acknowledged that American propagandists and their British counterparts had bested the Germans in sophistication of technique and saturation of message.[49] Later, when the Nazis came to power, Hitler and his propaganda minister, Joseph Goebbels, determinedly studied Creel's methods of mobilizing public opinion. As seen in Chapter 2, they even appropriated the outrageous poster *Destroy This Mad Brute* for one of their own.

Some of the government's advertising campaigns focused on recruitment and enlistment, others on conservation of food and natural resources, and still others on citizenship in general. The most concerted effort of all was devoted to the four "liberty loan" campaigns that took place during the war and a fifth that followed shortly after, the Victory Liberty Loan. Liberty bonds were interest-bearing certificates sold by the United States government to

underwrite the war effort. The first campaign, occurring eighteen days after the declaration of war, was not successful. When the second campaign, launched in October, also failed to reach the hoped-for sales figures, the secretary of the treasury, William McAdoo, determined that the next loan campaign would be heavily promoted. To that end, his office enlisted eminent artists and illustrators to design posters and beloved film stars to travel across the country urging their fans to buy bonds.

During this campaign, which began in April 1918, the world's three most popular screen actors—Mary Pickford, Douglas Fairbanks, and Charlie Chaplin—addressed enthusiastic crowds everywhere they went. Pickford alone is said to have raised $5 million in a single day. Efforts such as these were supported by vast amounts of promotional materials distributed to crowds and plastered on walls: nine million posters, five million window stickers, and ten million buttons were distributed during this fund-raising drive.[50]

Never before had a democratic government launched such a massive campaign to mold the minds of its citizens by means of the visual arts—in this case, not only through mass-produced posters, stickers, and buttons, but also illustrated stories in newspapers and magazines and newsreel footage of loan rallies, and, above all, through the patriotic, pro-war endorsement of celebrities such as Pickford, Fairbanks, and Chaplin, who were themselves, in the era of silent cinema, carefully manufactured visual artifacts. Recall Figure 45, showing Fairbanks, with the implied blessing of George Washington, addressing a crowd on Wall Street for the third loan campaign.

At that same rally, Chaplin, a little man, endeared himself to the crowd by gamely allowing his friend Fairbanks to hoist him above his shoulders (Fig. 55). In truth, though, the beloved comedian was despondent over the very euphoria he helped create. Looking back years later, he recalled, "New York was depressing; the ogre of militarism was everywhere. There was no escape from it. America was cast into a matrix of obedience and every thought was secondary to the religion of war. The false buoyancy of military bands along the gloomy canyon of Madison Avenue was also depressing as I heard them from the twelfth-story window of my hotel, crawling along on their way to the Battery to embark overseas." The mania sweeping the nation was out of control, he writes. "Draft dodgers were being sentenced to five years and every man was made to carry his registration card. Civilian apparel was a dress of shame, for nearly every young man was in uniform, and if he was not, he was liable to be asked for his registration card, or a woman might present him with a white feather."[51]

In the late 1920s and early 1930s, before it became apparent that the United States would again become embroiled in a global cataclysm, many Americans looked back at their role in the previous war with regret. When asked in a national poll if they believed "it was a mistake for the United

55. | Fairbanks holding up Chaplin at Liberty Loan rally, April 1918.

States to enter the [last war]," a full 70% of the respondents answered yes.[52] That the country had blundered into the previous war and gotten very little out of it in return was bad enough, but that it had done so on account of manipulation, deception, and trickery at the highest levels was even worse.

A scene from a now-forgotten war film made in 1933, *Ace of Aces*, directed by Walter J. Ruben, offers a blistering portrayal of social and sexual pressures applied to American men in 1917 to make them enlist. Early in the film, soon after war has been declared, the protagonist, a young sculptor named "Rocky" Thorne, is visited in his New York studio by his fiancée, Nancy, who is nattily turned out in an American Red Cross uniform. Legions of doughboys parade on the street below, bands play Sousa and other rousing military marches, and Nancy, misty-eyed with patriotic ardor, salutes from the window (Fig. 56). Rocky is amused by this "mindless" behavior and asks if she knows what lemmings are. Catching his drift, Nancy becomes indignant. "It's war, Rocky. No more watching and waiting. That must mean something to you. Aren't you

56. | Patriotism encounters skepticism in *Ace of Aces*, 1933.

going to do anything about it? This is a war against all nations, Rocky. There will be no discrimination. The challenge is to all mankind."

Urbane and giddy with affection for his sweetheart, Rocky intones propaganda exhortations mockingly: "'Up thou sluggard, awake! The bugle calls! The day of battle dawns!'" Returning to his own voice, he adds, "It's a fine excuse for college kids to throw their textbooks out of the window, for clerks to quit their jobs, and for married men to run away from their wives. It's a grand chance for everyone to escape work, obligations, responsibilities." When Nancy counters his ridicule by saying it is "a chance for a woman to show pride in the courage of the man she loves," he responds, "Courage? At a time like this, it takes courage to stick to one's principles!... I don't like the idea of killing my fellow man for something I'm quite sure that he hasn't done. It's sort of a moral scruple."

His defiance makes Nancy indignant. "Moral scruple! This is no time for moral scruples. Everyone is making sacrifice now. What are you in the face of the suffering of the world? How can you think of yourself? How can you refuse to give whatever you have?" He answers: "Don't you see, just as you feel that all this is right, I feel that it's all wrong. I *know* it's wrong, and I refuse to be herded like cattle." The scene ends with Nancy calling him a coward and storming out of the studio. He closes the window, but the patriotic parade music from the street below blares incessantly, much as it did for Charlie Chaplin in his aerie twelve stories above the street.

Pensively, Rocky returns to the allegorical figure he was sculpting when the scene began, but something has changed. He puts down his chisel. The next scene reveals that this cynical pacifist has enlisted, and the remainder of the film chronicles his zigzagging emotions. Insistent on restoring his devastated manhood, he becomes fanatically devoted to aerial combat and proves himself so adept at bringing down enemy planes that he acquires the moniker "ace of aces." At moments, though, he is sickened by the bloodlust he discovers within himself. At the end, returned from war, he wonders if he can ever again find the strength to create, since for so long his only goal has been to destroy.[53]

Rocky's masculinity-withering confrontation with Nancy in *Ace of Aces* calls to mind *On Which Side of the Window Are You?*, the shaming poster

examined in the previous chapter. Sometimes, though not often, American war posters made horror, not shame, their goal. The most notable of these, aside perhaps from *Destroy This Mad Brute*, was one designed by Joseph Pennell, a Whistler protégé in his youth who had since become America's most distinguished graphic artist (Fig. 57). In the apocalyptic scene Pennell laid out for the Fourth Liberty Loan campaign, the Statue of Liberty has

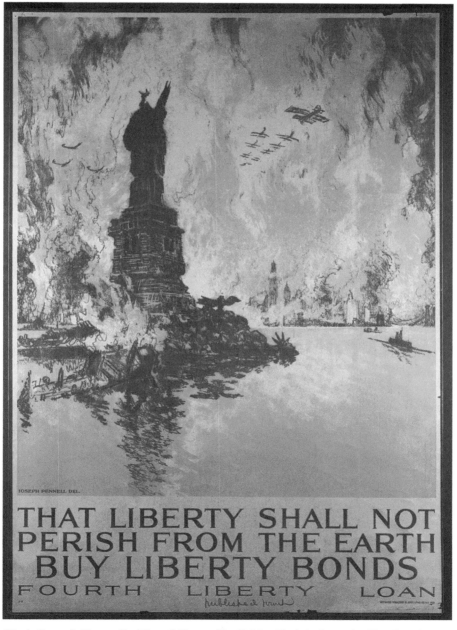

57. | Joseph Pennell, *That Liberty Shall Not Perish from the Earth*, 1918.

been decapitated. Her noble head lies half-submerged in New York harbor, while enemy bombs turn Manhattan into a cauldron of smoke and flame. Pennell's poster, *That Liberty Shall Not Perish from the Earth*, is one of the most unforgettable of the war because it so skillfully manipulates emotion-laden symbols of America, subjecting them to spectacular violence. A viewer can practically hear the buzz of the biplanes, the cascading thunder of the bombardment, the furnace-roar of the flames, and the shrieks of unseen citizens running in panic through the streets.

The nightmare envisioned, an uncanny precedent to the mayhem un-leashed on New York City more than three-quarters of a century later during the September 11 attack, provides a dystopian counterpart to Hassam's light-drenched, flag-fluttering American metropolis. This is Hassam's sunny morning on the avenue wrenched upside down, a horror show having less to do with impressionism and its early twentieth-century variants than with the Armageddon fantasies of Romantic-era British artists such as John Martin and J. M. W. Turner and their American contemporary Thomas Cole. Pennell surely had Cole's well-known 1836 history painting *Course of Empire: Destruction* in mind when he conceived his own version of Gotham's dev-astation. In Cole's allegorical depiction of an ancient Roman metropolis overrun by torch-wielding barbarians, a decapitated gladiator statue occupies roughly the same compositional location and is in the same condition as Pennell's Statue of Liberty.

Pennell described his original conception for the poster as "New York City bombed, shot down, burning, blown up by an enemy," while the caption was to read, "Buy Liberty Bonds or You Will See This." Government officials toned down the blunt language, but the rhetoric of the image itself was no less inflammatory than the incendiary bombs raining down from the sky, and more than two million copies of the poster circulated throughout the land. The very thought of an air strike on New York was outrageous and terrifying and would have firmed Americans in their resolve to take the war to the enemy over there before the enemy had any chance to bring it here.[54]

IN APRIL 1918, ALMOST A YEAR to the day that Congress declared war on Germany, Childe Hassam was arrested as a German spy. While sketching a camouflaged American transport vessel anchored in the Hudson River, he was stopped by a suspicious policeman who delivered him into the hands of federal authorities. Learning who he was, they promptly released the distin-guished artist. He congratulated the policeman for his vigilance, saying that if everyone were as alert, "there would not be so many dangerous enemy aliens traveling about the country."[55]

Later that year, probably in early autumn, Hassam painted the most uncharacteristic work in the flag series. *The Flag, Fifth Avenue* offers a partial view across the southeast corner of Central Park, as represented by a flurry of blue brush strokes in the middle ground, to an alignment of light-catching limestone structures on Fifth Avenue (Fig. 58). The artist impedes a full view, however, by placing the posterior of a high-rise building smack in the middle of the composition and running a ridge of cluttered rooftops across the painting's base.

It is almost as if he has set out to violate his long-standing aesthetic principles and predilections by indis-

58. | Childe Hassam, *The Flag, Fifth Avenue*, 1918. Private collection.

creetly portraying not the dignified front of a building but its rear end and not looking up admiringly at an urban structure but looking down on it, showing the messy disarray that would be invisible from the street. For Hassam, this must have been equivalent to picturing a gentleman in his underwear. Perhaps he wished to demonstrate that he too could be an Ashcan School artist, if he so desired. The vignette at the lower left of a washerwoman or housewife hanging laundry to dry is straight out of John Sloan's series of paintings of his neighbors doing the same on the Lower East Side, as, for example, in *Sun and Wind on the Roof* (1915, Maier Museum of Art, Randolph College).

But it is not only the uncouth subject matter and behind-the-scenes vantage point that make *The Flag, Fifth Avenue* so unusual for Hassam. What is really strange about it is the flag itself, great in size but "flagging," so to speak, in energy. It appears heavy, worn, fatigued. Other adjectives come to mind: deflated, dispirited, limp. We might wonder if the artist himself was unintentionally confessing, by way of this symbol, to a sort of phallic deflation of his professional potency, even as he attempted to vie with his younger rivals, the urban realists, in conveying a side of city life he normally kept out of sight.

Whatever personal and professional meanings the lifeless flag in the painting held for Hassam, it points to a larger political meaning, especially when considered in contrast to the exuberant flags that danced in the breeze and rippled in the sun or braved the rain in almost all the other works in the series. One senses here an admission of national exhaustion, a weariness of war and all the high-flying rhetoric that accompanied it. Old Glory looks not so glorious anymore. In this regard, the painting seems prescient of the mood that prevailed throughout much of the United States as the war drew to a close. For Hassam, it is an unusually quiet and introspective painting, one that looks inward, perhaps in a manner that anticipates the isolationist mood of postwar America, in which the public turned away from grandiose ideals (making the world safe for democracy) and schemes (the League of Nations, which it roundly rejected) and sought instead to tend to its own dirty laundry.

A curious architectural detail within the painting complicates our reading of it in terms of the war. At the base of the flagpole there is a strange, greenish-blue shape, not immediately recognizable. Research into the precise location of the buildings in the foreground reveals this to be Hassam's rendering of the backside of the imperial German eagle that had formerly adorned the *Deutscher Verein*, New York's elegant German Club. Erected in 1890 at 112 West 59th Street (Central Park South), the five-story Renaissance-revival building was presided over by a bronze eagle. The structure was abandoned during the war and the eagle removed from its perch, but Hassam, who would have been familiar with it from the vantage point of his studio on 58th Street, has restored the symbol of imperial Germany to the rooftop and juxtaposed it with the symbol of America.[56]

All the more, then, does the painting suggest the Pyrrhic nature of America's triumph over its enemy. Yes, Hassam's land of the free, the homeland made safe for wives, mothers, and daughters, the America of the pilgrim fathers, had stood its ground against the barbaric hordes in Imperial German uniform. But what would happen next, when the barbarians who attacked the citadels of culture were dressed instead in workingman's uniforms or the garb of illiterate peasants from southern Europe and poor blacks from the American south—or, for that matter, in the informal attire favored by Bohemian artists from Greenwich Village? Could the flag withstand these assaults, too?

I do not mean to say the painting answers, or even directly asks, such questions. Yet, indirectly, by its uncharacteristic iconography, it does raise them. Hassam gives us the back rather than front of a building, a cluttered, disorganized rooftop, window shades of various colors pulled down to varying heights (later to become a signature device in the melancholy urban art

of Edward Hopper), a washerwoman hanging out the laundry, and, above all, a huge, deflated, drooping flag. Compared to the typical exuberance of Hassam's flag paintings, this late entry in the series emblematically portrays a nation in transition. It conveys what was already, by 1918, becoming a faltering swagger and newfound unease about the shape of America's future.

59. | Marcel Duchamp, *Fountain*, 1917 (1964 replica). Tate Modern.

5

OPENING THE
FLOODGATES

IN 2004, THE TATE MODERN MUSEUM polled five hundred art experts and opinion-makers, requesting that they list the five most influential works in the history of modern art. When the results came in, Henri Matisse's *Red Studio* took fifth place. Pablo Picasso's *Guernica* ranked fourth. Andy Warhol's *Marilyn Diptych* achieved third position, and Picasso's *Les Demoiselles d'Avignon* scored second. The place of honor for the most highly esteemed and influential work of modern art went to Marcel Duchamp's *Fountain* (Fig. 59).

Fountain is the pristine porcelain urinal that Duchamp acquired from a plumbing supply house in 1917, signed with the facetious pseudonym "R. Mutt," and anonymously submitted to the all-inclusive exhibition of the newly formed American Society of Independent Artists, of which he was a board member. In a spirit of democratic zeal ("no juries, no prizes"), the organizers had announced that no properly submitted work of art would be refused; all that was required was a fee of $1 to join the Society and a payment of the $5 annual dues. *Fountain* was properly submitted. But it was refused, on the grounds that it was not art.

That opinion has been contested ever since. As a writer for the little magazine *The Blind Man* contended in defense of the "readymade" (found object) aesthetic that *Fountain* embodied: "Whether Mr. Mutt with his own hands made the fountain or not has no importance. He CHOSE it. He took an ordinary article of life, placed it so that its useful significance disappeared under the new title and point of view—created a new thought for that object" (Fig. 60 a and b).[1]

Fountain was never publically displayed, and the original artifact disappeared, possibly destroyed but more likely discarded. For the next several decades, the piece was little known outside Dada and Surrealist circles, and

60. a & b | *The Blind Man*, no. 2 (May 1917), two-page spread with photograph of *Fountain* by Alfred Stieglitz.

Duchamp himself was largely forgotten. Then, in the late 1950s, he was rediscovered by a new generation of artists and intellectuals, who made him into a cultural icon. "Duchampomania" swept the art world in the 1960s. As the art historian William Camfield notes in his meticulous history of *Fountain* and its reception, the decade was "marked by a deluge of publications" about the now-venerated artist and "an unparalleled example of timing in which the burgeoning interest in Duchamp coincided with exhilarating developments in avant-garde art, virtually all of which exhibited links of some sort to Duchamp." In short order, Dada as practiced by Duchamp in the early twentieth century was transformed from "a minor, aberrant phenomenon in the history of modern art to the most dynamic force in contemporary art."[2] A number of authorized replicas of his long-lost readymades, signed by the artist, entered public collections, where they were widely seen and, some fifty years after he first introduced them to the art world, scoffed at and praised anew.

Fountain's defiance of social and artistic decorum appealed to antiestablishment art viewers of the later 1960s, who admired it for "taking the

piss" (to use British slang for deflating pretension). It was arcane and populist at the same time; cerebral and guttural; elite and egalitarian. It was philosophically heavy, saturated with ontological and epistemological perplexity (what is an original? what is a copy? what is "art"?), and yet also light and witty. It was effervescent, impossible to pin down.

Surprisingly, despite the antiwar fervor of the late sixties and early seventies, admirers of *Fountain* seem not to have noticed that the work sprang from an earlier period of American involvement in a foreign war and quite possibly registered a protest against that involvement. On Monday, April 9, 1917, the French artist, who had abandoned his war-mired homeland in disgust at the excessive nationalistic rhetoric that flourished there, submitted the urinal to an American art organization that made a great fuss about its all-inclusive democratic spirit. Three days earlier, America had joined the European war in the name of that same spirit. *Fountain* registers Duchamp's contempt for all such posturing.

BORN IN NORMANDY IN 1887, Duchamp was twenty-seven when the Germans invaded France in the summer of 1914. Though handsome, athletic, and fit, he was exempted from military service because of a heart murmur. The defect was not outwardly visible. To the casual observer the tall, lean, well-dressed young artist seemed perfectly capable of wearing a uniform and was suspect for not doing so. Strangers verbally abused him for shirking his patriotic duties and even spit at him on the street for not serving his country at a time of grave national crisis. After ten months of such unpleasantness (less unpleasant, to be sure, than risking his life at the front), he decamped for the United States in June 1915. His arrival was reported in the newspapers, because he had achieved notoriety two years earlier, when his controversial cubo-futurist painting *Nude Descending a Staircase, No. 2* (1912) proved to be the sensation of the New York Armory Show.[3]

Although Duchamp, as an artist, gentleman, and dandy, perfected a persona of impeccable detachment, it's reasonable to suspect that being spat on as a shirker left its mark on him. It would be wrong, surely, to advance a simplistic psychobiographical account of *Fountain* as a sort of spitting back at those who assailed him for his apparent lack of devotion to the defense of his homeland. But it would be equally so to ignore ways in which *Fountain* may have been an outgrowth of the artist's deep-seated dislike of flag-waving nationalism and other vehement expressions of patriotic loyalty. He told an interviewer:

> *I came over here not because I couldn't paint at home, but because I hadn't any one to talk with. It was frightfully lonely.*

I am excused from service on account of my heart. So I roamed about all alone. Everywhere the talk turned upon war. Nothing but war was talked about from morning until night. In such an atmosphere, especially for one who holds war to be an abomination, it may readily be conceived existence was heavy and dull.[4]

Impishly he adds, "From a psychological standpoint, I find the spectacle of war very impressive. The instinct which sends men marching out to cut down other men is an instinct worth careful scrutiny. What an absurd thing such a conception of patriotism is!" His response to such nonsense? "Personally I must say I admire the attitude of combating invasion with folded arms."[5]

That was in 1915. Two years later, with America jumping into the melee, he unfolded his arms and shook a fist. *Fountain* is that fist. The independent artists who took angry exception to *Fountain* when it was delivered to the exhibition hall objected to the way it implicitly ridiculed their artistic idealism, which was built on a foundational belief in truth, beauty, and authorial originality. That much has long been understood. But the insult went further than that. It also traduced their *political* idealism, which only days earlier the president of the United States had summoned on behalf of righteous war-making.

Even someone as aloof and unflappable as Duchamp could not have been immune to the viral emotions of the moment. Practically everyone, including the liberal-progressive president, recognized that entrance into the war would require the restriction of personal liberties and the restraint of free speech.[6] Unpatriotic or un-American behavior would henceforth be subject to criminal prosecution. In short order Congress passed the Espionage Act, which made it illegal to speak, write, or draw in any manner deemed by authorities to be in opposition to the nation's military goals. *Fountain* was Duchamp's way of testing these waters. He was spitting not only at the pretensions of the liberal-progressive wing of the art world, to which he nominally belonged. He was also fulminating at the much broader cultural apparatus, which, as detailed in previous chapters, helped to launch the nation into war.

Because the artist was not a citizen of the United States, he was not guaranteed free-speech protection under the Constitution. Still, it was perfectly safe for him to make an antiwar utterance, inasmuch as the meanings of the piece, especially those extending beyond the realm of artistic debate and aesthetic redefinition into the domain of politics, would have been obscure, even unintelligible, to most viewers. I should add here that in treating Marcel Duchamp, circa 1915–1918, as an American artist, I take my lead from Jane Heap, co-founder and editor of the influential literary magazine *The Little Review*, who explained to her readers in June 1918, "This [issue] is called an

American number not because its contributors are Americans (most of them are not), but because they are all at present living and working in America."[7]

Duchamp's intimate circle would have understood the antiwar animus behind his seemingly anodyne readymade. "The call to arms afflicted the whole world around us," recollected Gabrielle Buffet-Picabia, the wife of Duchamp's close friend and fellow avant-garde artist Francis Picabia. In the summer of 1915, the Picabias had moved from Paris to New York, where they quickly fell in with their compatriot, who had disembarked only weeks earlier. Buffet-Picabia recalled in her memoir, "No sooner had we arrived than we became part of a motley international band which turned night into day, conscientious objectors of all nationalities and walks of life living in an inconceivable orgy of sexuality, jazz and alcohol....An enraged propaganda filled the air....Seen from Broadway, the massacres in France seemed like a colossal advertising stunt for the benefit of some giant corporation."[8]

In 1915 that "inconceivable orgy of sexuality" may have been restricted to members of the artistic, literary, and political avant-garde and their "free love" counterparts in Greenwich Village and other outposts of Bohemia, but a couple of years later America's ratification of war mainstreamed sexual promiscuity, at least among idealistic young men who joined the army and navy. So, in any case, was the opinion of an expert on male sexuality, Nell Kimball, the madam of a highly reputed house of ill repute in Storyville, New Orleans' legendary red-light district.

With the advent of war, she later recalled, "Fornicating became epidemic....I didn't feel too badly when the bugles began to play 'Over There,' and the whores dressed in white as Red Cross gals went around in the afternoons to help the Liberty Loan drive. And pick up an extra five or ten for a quickie with some officer." In tumultuous times such as these, "Every man and boy wanted to have one last fling of screwing before the real war got him. Every farm boy wanted to have one big fuck in a real house before he went off and maybe was killed....the idea of war and dying makes a man raunchy, and wanting to have it as much as he could. It wasn't really pleasure at times but a kind of nervous breakdown that could be treated only with a girl between him and the mattress." This calls to mind the letter a doughboy in France reportedly sent his wife: "Take a long look at the floor, Martha, because when I get home you aren't going to see anything but the ceiling for a long, long time."[9]

With war under way, Kimball's establishment did so much business, she says, that "I dreamed one night the whole city was sinking into a lake of sperm." Military officials, worried about the public health consequences of unrestrained sexuality—as well as the public relations problem they also had on their hands—shut down her house and others like it throughout the country. No matter how idealistic the grounds for embarking on war, wars pollute

the population and breed moral cesspools, a fact that *Fountain* harshly acknowledges.

In Buffet-Picabia's account, young Marcel was anything but Apollonian in his response to the frenzied nationalism of his new country. In those days and nights of "enraged propaganda" (picture the posters *Enlist* and *Destroy This Mad Brute*) and woeful news of massacres back at home, the artist fell into a nihilistic state of mind that his unfailing good humor could disguise but not eradicate. Art-historical mythology has long preferred to characterize Duchamp as an impeccably smooth operator, a cerebral, suave, and puckish trickster who never lost his cool. Buffet-Picabia troubles that tidy stereotype. "Leaving his almost monastic isolation," she remembers, "he flung himself into orgies of drunkenness and every other excess," abandoning his habitual asceticism and self-restraint for "a life of license," colored by the "pitiless pessimism of his mind." He had, she says, an "attitude of abdicating every-thing, even himself." He also, she notes, had an insouciant way of displaying nihilism with charming candor and elaborate puns, which had an intoxicating effect on men and women alike, arousing their curiosity and exciting their attraction.[10]

Taking Buffet-Picabia's reminiscence of her friend's manic fury into ac-count, we have further grounds for seeing that *Fountain* was much more than an intellectual puzzle, a corrosive undermining of Western foundational values, or a spirited *blague*, though it was certainly those things, too. It was an excrescence of the nihilism bred in those, such as Duchamp and his fellow refugee artists, who had successfully managed to elude the war's tentacular reach. But that's still too general, simply a variation of the old saw that Dada sprang from the insanity of the First World War. More specifically, *Fountain* was the insolent response of a resident alien to his adopted homeland's vulgar and disgusting embrace of war.

BUT WHY A TOILET? MORE particularly, why a urinal? Let's take some time to think about the political implications of this mechanical contraption in-vented for the hygienic disposal of male bodily fluids in a public setting. As a Parisian, Duchamp was familiar with urinals. Like fountains, they were ubiquitous in the French capital.

The first urinals were installed in 1834, when the city was staggering under population growth. French officials sought to improve sanitation by locating street-corner urinals throughout the metropolis. These became known as *vespasiennes*, in reference to the first-century A.D. Roman emperor Vespasian, who supported his military campaigns and constructed the Colosseum by levying a tax on urine, which savvy citizens sold to the fullers

who used it for its ammoniac properties in tanning. The Parisian urinals were also called, more vulgarly, *pissoirs* and *pissotières*. At first they were single-user sheds, similar to a sentry box, but before long they were converted for multiple-person use. They were stand-up affairs, intended for men only. The *vespasienne* or *pissoir* was, in this regard, an emblem of male difference and privilege within the public sphere and a symbol of female exclusion. They were also "democratic," in the sense that men of any social rank could use them freely at any time of day or night.[11]

 Pissoirs proliferated during the Second Empire (1852–1870). Under the direction of civic planner Baron Georges-Eugène Haussmann, the French metropolis was radically rebuilt to prevent recurrences of the violent public uprisings that had fomented in the capital since the days of the French Revolution. With politically volatile slum neighborhoods cleared away and boulevards widened to facilitate troop deployment during insurrections, the "beautification" of the city masked its pacification. Haussmann boasted, "We ripped open the belly of old Paris, the neighborhood of revolt and barricades, and cut a large opening through the almost impenetrable maze of alleys, piece by piece."[12]

61. | Lewis Hine, American soldier outside a Parisian *pissoir*, 1918.

Public hygiene was also a concern, as many of the small byways and alleyways of old Paris were filled with the fetid stench of urine. Citizens thought little of relieving themselves against a corner wall. By providing abundantly distributed amenities, albeit exclusively for men, Haussmannization disciplined citizens to urinate in designated areas. Thus the function of the *pissoir* was, again, political as well as hygienic, insofar as it was intended to tame men of their wilder, anarchic impulse to "go" wherever and whenever they pleased. These were not dark, forbidden zones, but rather places of ordinary homosocial interaction, as seen in this 1918 photograph by Lewis Hine, who shot it on speculation as part of a proposed "day in the life" photo story (which was never published) about a doughboy on leave in Paris (Fig. 61).

That was Paris. In New York, public toilets were much less plentiful. The first "comfort stations" were introduced in the 1890s in parks and at major intersections. In 1907, there were eight public comfort stations in Manhattan, with a total of 209 urinals. By 1925, according to the historian Paul Franklin, the city offered eighteen comfort stations, "with hundreds more semi-public toilets located in department stores, libraries, hotels, bathhouses, cinemas, train stations and municipal buildings." Police began staging raids on public toilets to dissuade homosexual liaisons. "By 1921, thirty-eight per cent of the arrests made for male homosexual activity in the city occurred in subway toilets."[13]

In 1917, the year *Fountain* made its brief, controversial appearance, Greenwich Village artists, intellectuals, and free-thinkers avidly followed the writings of the British sexologist Havelock Ellis, who eloquently insisted that homosexual behavior fit well within the acceptable range of human sexuality. "There is not a sexual oddity which he has not labored to make us understand as an exaggeration of some aspect of normal emotional life," recalled Floyd Dell, a denizen of the Village in those years. "He has thus become par excellence the teacher of tolerance to our generation." Among the sexual oddities that Ellis championed was "urolagnia," his term for erotic fascination with urination.[14]

Ellis believed that artists, intellectuals, and other aesthetically sensitive individuals were particularly prone to associate peeing with pleasure and to derive satisfaction from watching their lovers perform it. "There is ample evidence to show," he avers, that "the impulse to bestow a symbolic value on the act of urination in a beloved person, is not extremely uncommon; it has been noted of men of high intellectual distinction; it occurs in women as well as men. . . . it must be regarded as within the normal limits of variation of sexual emotion." In his estimation, the fascination with watching others pee is not perverse; rather, it is universal, although rarely acknowledged because of social and psychological repressions that begin in early childhood. Ellis maintained that mankind has always cherished fountains because they satisfy people's innate desire to see a vigorously healthy human body energetically dispose of urinary fluids.[15]

Thus for Havelock Ellis, writing both before and after the appearance of *Fountain*, peeing is a positive enterprise because it is natural and human, not to be loathed. It merits neither embarrassment nor shame. Still, this was a minority view, and peeing for the most part had negative associations, which helped make *Fountain* so shockingly aggressive. Even otherwise progressive modernists objected to the celebration of peeing as a central fact of human existence and preferred that it not be discussed in public.

Virginia Woolf, for example, rejected an early opportunity to publish James Joyce's *Ulysses* in Great Britain because she disliked his obsessive descriptions of men urinating. After reading the first four chapters of the manuscript, she complained to Lytton Strachey, "First there's a dog that p's— then there's man that forths, and one can be monotonous even on that subject." She said much the same to Roger Fry: "It's interesting as an experiment; he leaves out the narrative, and tries to give the thoughts, but I don't know that he's got anything very interesting to say, and after all the p-ing of a dog isn't very different from the p-ing of a man. Three hundred pages of it might be boring."[16]

In New York, the avant-garde magazine *The Little Review*, edited by Margaret Anderson and Jane Heap, took a chance on *Ulysses*, serializing it from 1918 to 1920, at which point obscenity proceedings forced them to stop. The magazine's subscribers, presumably a liberal-minded lot to begin with, or they wouldn't have been reading *The Little Review*, debated the merits of Joyce's many references to bodily function. A reader from Boston writes: "The mistake you people make is in thinking that we 'prudes' who don't like Joyce are concerned with morals. *Morality* has nothing to do with it. Does morality have anything to do with the average person's desire for privacy concerning the 'natural functions'? Not at all; it is delicacy, lack of vulgarity. I do not think we need to apologize for this delicacy and lack of vulgarity, even to your superior beings."[17]

Today, we can hardly imagine just how deeply offensive it was to most readers and viewers, even progressively minded ones, to come across public mention of "natural functions," be it in the pages of Joyce's *Ulysses* or the contours of Mutt's *Fountain*. That George Bellows, a painter who had himself been attacked by mainstream artists and art critics for miring viewers in the seamy, gritty, "ash can" muck of urban life—that even he would react with such indignation to the submission of a plumbing fixture to an art exhibition shows how profoundly disturbing it was. Bellows is said to have thundered, "You mean to say, if a man sent in horse manure glued to a canvas that we would have to accept it!... It is gross, offensive! There is such a thing as decency."[18]

Our being relatively remote from these delicate sensibilities makes it all the more difficult for us to comprehend how *Fountain* exploited such

deep-seated repugnance, leveraging it to heighten the scorn it lavished on the democratic embrace of war. The obscenity of the former helped stand in metonymically for the obscenity of the latter. In this regard, as antiwar agit-prop, *Fountain* anticipates ironic slogans of the 1960s such as "make love, not war," in which natural functions such as sexual intercourse are considered fine and normal, whereas "unnatural" ones, such as killing in the name of the state, are not. More specifically the artwork—which in this instance refers not simply to the store-bought plumbing device but also to its perfectly timed appearance at the moment that American pro-war rhetoric had reached overflow proportions—anticipates by a dozen years Hemingway's famous anti-rhetorical utterance in *A Farewell to Arms* (1929): "I was always embarrassed by the words sacred, glorious, and sacrifice and the expression in vain.... Abstract words such as glory, honor, courage, or hallow were obscene...."[19]

In this regard, the very crudity of urinals and the primary act associated with them, peeing in the public sphere (a secondary act would be having illicit and anonymous sex in their proximity), contributed to the anti-rhetorical, anti-idealist, and, ultimately, antiwar nature of *Fountain*. Obviously peeing is not always an aggressive, antisocial act, but it can be that, as seen in this droll passage from Gertrude Stein's 1937 autobiography, in which she uses large helpings of alliteration, onomatopoeia, internal rhyme, repetition, and deadpan humor to recount a nocturnal encounter with a stranger in Paris while she was walking her dog, Basket:

> *Anyway one evening we were walking and a man came along and he said in a song as he was passing, Piss you dog piss against the side of a house in passing, if it was my house I would take a gun and shoot you, piss dog piss against the side of the house in passing, Piss he said piss against the lamp-post in passing, a poor street cleaner has to clean the lamp-post that you have pissed against in passing, Piss dog piss against the lamp-post in passing.*[20]

As the passage from Stein reminds us, pissing can be an act of territorial marking. At some primal level of unacknowledged desire, *Fountain* bids its viewer to piss in the pot, whether for the sheer sexual pleasure of release, the venting of anger and contempt, the claiming of ownership, or the desire for subliminal connection to other users.[21] How these variant meanings and associations relate to the World War I context of Duchamp's readymade remains to be considered.

Occasionally the implicit connection between fountains and pissing has been explicit in public art, as in the Brussels tourist attraction known as *Manneken Pis* (Flemish for "little man peeing" or "little pee man" or "little

pisser"). Originally carved in stone in the late fourteenth century, stolen, and then recreated in bronze in 1619 by the Baroque sculptor Jérôme (or in Flemish, Hiëronymus) Duquesnoy the Elder, the statue depicts a chubby, naked little boy with unkempt hair who leans back to pee. He places one hand on his hip and uses the other to angle his penis, from which water jets into a basin at his feet (Fig. 62).[22]

The statue alludes to a legend about an army of foreign invaders who planted explosives at the city gates of Brussels, only to be foiled in their efforts by a brave Belgian lad who managed to douse the ignited fuse by peeing on it. Thus, tourist kitsch aside, there's a tripar-

62. | Jérôme Duquesnoy the Elder, *Manneken Pis*, 1619. Brussels.

tite connection here of fountains, urination, and war that I have been arguing pertains to *Fountain* as well—in a sense, Duchamp's *Fountain* is the Dada version of the *Manneken Pis*, with the "bad boy" or "little pisser" of the readymade the artist himself. At a time when Americans were inundated with war-justifying tales of atrocities committed against modern-day Belgians by their German occupiers, the iconoclastic French artist's hybrid urinal/fountain may at some conscious or unconscious level have been a mocking allusion to his neighboring country's most patriotic icon.

EVEN THOUGH DUCHAMP NEVER SERVED in the military and was himself clearly opposed to any sort of regimented life, it is worth considering *Fountain* in terms of the new public discourse about urination that inevitably resulted from the mass induction of men into the armed services. In the 1910s, according to the cultural historian Cecilia Tichi, the term "waste" was already "a pejorative American byword, virtually the industrial-era devil denounced in

texts of all kinds from literary criticism to advertisements."[23] The new war made human waste an ever greater matter of concern. Health officials, writing in popular magazines, warned of the need to ensure the sanitary disposal of untold quantities of liquid effluvia that were soon to be generated by millions of rapidly deployed soldiers unleashing their torrential streams on an as-yet unprepared sanitation infrastructure. In the army, urinals were at the high end of waste-disposal. Unlike latrines, which were troughs or trenches where men stood or squatted side-by-side as they relieved their bowels or bladders, urinals were a luxury in wartime, a semi-secluded architectural zone wherein a man could retain a modicum of privacy.

In the historically specific context of April 1917, with the United States about to mobilize its fighting force at a speed and scale never previously seen, the discourse of war, waste, and hygiene permeated the public sphere. An examination of several military handbooks published by the United States Army during the First World War shows that hygienic disposal of urine was considered essential to the success of the American Expeditionary Forces.

One such manual, published in 1918, stresses the importance of teaching soldiers to pee in urinals or latrines instead of in the bushes or on the camp grounds and to wash their hands thoroughly after voiding. "The necessity for properly disposing of urine is not generally appreciated because of its comparative inoffensiveness in small quantities. One thousand men, however, void daily 300 gallons."[24]

According to another expert, "Urinals should always be provided in camp, so that the men will neither need to urinate promiscuously through the camp nor to wet and soil the latrine seats." A third cautions that "It is difficult to make men realize the dangers of spreading disease by means of urine." Latrine orderlies should therefore be assigned to make sure enlisted men urinate properly, into prescribed receptacles: "The men must be made to realize that the duties of a sanitary orderly are highly honorable, and that, involving (as they do) the care of the health of all, they are in the highest degree important. If the officers discredit this work, the men will slight it."[25]

On the eve of the largest mobilization of fighting men in the history of the United States, health officials thus insisted that it was critical to regulate and enforce when, where, and how soldiers urinated. With vast numbers of doughboys herded together into confined spaces and constricted living quarters, public peeing, no matter how offensive it might have been as a topic of polite conversation, became a matter of serious social concern. The subject was taken even more seriously at the front. "In the disorder of front-line life," notes one historian, "men relieved themselves everywhere, and the stench of human excrement competed with the smell of poison gas and decaying bodies." A private in the 32nd Division wrote that, "at the battlefront there is no such thing as sanitation." Influenza and dysentery thrived in such conditions.[26]

Privacy was a concern as well, although here the goal of the individual differed from that of the organization. Young American men, like their counterparts in the other armies, were about to be herded together in intimacy-depriving ways that could not help but disrupt the recruit's sense of independence and equilibrium—exactly the intention of military hierarchies intent on breaking men of their recalcitrant vestiges of self. In *All Quiet on the Western Front*, a book that became an international bestseller in 1929 and was seen as revealing the commonality of combat experiences across national lines, Erich Maria Remarque explores the complex meaning that latrines and lavatories had for him and his fellow German soldiers during the war. "I can still recall how embarrassed we were at the beginning, when we were recruits in the barracks and had to use the communal latrines. There were no doors, so that twenty men had to sit side by side as if they were on a train. That way they could all be seen at a glance—soldiers, of course, have to be under supervision at all times."[27]

He notes that once soldiers get over the embarrassment of performing their bodily functions in front of others, they feel liberated from the clutches of lifelong inhibitions. "Being forced to do everything in public means that as far as we are concerned, the natural innocence of the business has returned." Here he is speaking of defecation, not urination, but the principle holds.[28] Elsewhere in the novel, soldiers confined to hospital beds must overcome the embarrassment of having to relieve themselves in bottles, and a character known as a chronic bed-wetter is made to share a bunk with another sufferer from the malady in an unenlightened effort to break both of their habit. Urination, this is to say, was a universal problem for military-age men in 1917, and if *Fountain* did not address it directly, it nonetheless provided a compelling image-symbol for a set of bodily preoccupations that millions of enlisted men throughout the combatant nations were forced to confront.

In this regard, *Fountain* calls to mind Ernst Ludwig Kirchner's disturbing 1915 painting *Artillerymen in the Shower* (Fig. 63). Kirchner, a young expressionist painter, had been inducted into the Germany army but was sent home from training camp because of his emotional instability. As the historian Frank Tipton describes the work, it shows "naked boys crowded together, cringing against the flow of water from the ceiling. One, possibly Kirchner himself, is kneeling, attempting to stoke the boiler. Weak and vulnerable, feminine except for their penises, they are virtually indistinguishable from each other."[29] Richard Cork regards the boys in the shower as "soldiers shorn of all the accoutrements which define and dignify their roles as fighting men.... Some of the men shy away from the shower's impact as if they were threatened by falling bayonets.... The brushstrokes slashing their attenuated bodies reinforce the sense of assault." For Cork, "Sprayed water here becomes a metaphor for the gunfire which will soon decimate so many

63. | Ernst Ludwig Kirchner, *Artillerymen in the Shower*, 1915.
Guggenheim Museum.

of these wan young men. No amount of uniforms and weaponry can save
them, and their pale, forked nakedness signifies an underlying inability to
protect themselves from the savagery of modern warfare."[30]

Fountain does not convey such a direct sense of peril as *Artillerymen in
the Shower* does. It doesn't say anything *directly* about war (or about any-
thing else, for that matter—all must be inferred). Still, when we think about
the enormous psychic costs, the pain and vulnerability, that the war had al-
ready inflicted on millions of young European soldiers, Duchamp's older
brother Jacques among them, we can imagine that the mute piece of
plumbing served for the artist as a rejoinder against the appalling naïveté of
Americans who were ecstatic about sending their young kinsmen to war.

Urination could, at times, save a soldier's life. In Remarque's book, the
men are able to keep a machine gun firing during a skirmish by pissing into
the cooling case, which had run out of water. In *Best o'Luck*, Alexander
McClintock's 1917 novelistic memoir of his experiences in the "death zone"

of the Western front, the narrator says he learned an important trick from Canadian soldiers, who could stave off the toxic fumes of chlorine gas by covering their mouths with urine-soaked handkerchiefs. Summoning his discretion, he writes, "the nearest I can come, in print, to telling you what a soldier is ordered to do in this emergency is to remind you that ammonia fumes oppose chlorine gas as a neutralizing agent, and that certain emanations of the body throw off ammonia fumes."[31]

As noted above, concerns with hygiene agitated the public sphere well before the advent of war. In 1911, Dresden's International Hygiene Exhibition drew more than five million visitors. Those numbers are amazing, considering that two years later the infamous International Exhibition of Modern Art (the Armory Show) mustered only slightly more than 300,000 attendees in New York, Boston and Chicago combined.[32] This suggests that the general public had a more abiding interest in plumbing fixtures than nudes descending staircases, a detail that might not have escaped Duchamp's attention.

The avant-garde Italian poet and art entrepreneur F. T. Marinetti, self-proclaimed inventor of Futurism, drew an explicit, if audacious, connection between art, war, and hygiene. In the first futurist manifesto, published on the front page of *Le Figaro* in February, 1909, Marinetti praised war as a cleansing agent. Notoriously, he called it "the world's only hygiene." By 1917, Duchamp was long past his futurist phase. As America launched itself into war, his pedestaled urinal, a satirical apotheosis of modern hygiene and its discourses, deftly put Marinetti and his ilk in their place.[33]

WHEN THE SOCIETY OF INDEPENDENT ARTISTS refused to display *Fountain*, Alfred Stieglitz, the nation's foremost promoter of modern art, agreed to photograph it at his Fifth Avenue art space, known as Gallery 291 (Fig. 64). At the time, Stieglitz was exhibiting the work of his latest discovery, a young artist named Georgia O'Keeffe. Had he wished, he certainly could have "posed" *Fountain* in front of an O'Keeffe painting then on display. Or he might have set up the urinal in front of a blank, white, art-gallery wall. This, of course, is the way that *Fountain* is usually photographed—in a pure and empty, one might even say antiseptic, white-cube environment. Reproducing it that way has served in the long run to sever the readymade from its messy historical context and deprive it of its crucial wartime contingency. No wonder it has been so highly regarded by its admirers as a philosophical riddle, a brilliant conceptual puzzle, a snippy effrontery, a declaration of artistic rights, or a stunningly enigmatic *noli me tangere*—anything, really, except as a direct response to the specificity of its historical moment.

64. | Alfred Stieglitz, *Fountain*, 1917.

Stieglitz chose neither of these options. Instead, he positioned *Fountain* in front of a Marsden Hartley painting, one of several that remained unsold from a show that Stieglitz had given the artist the previous year. As described above (see pages 6–8), these were cryptic, quasi-cubist oil paintings that Hartley produced while living in Berlin between mid-1913 and late 1915, by which point the Allied blockade of Germany led to starvation conditions and the painter's reluctant return to the United States. The painting that Stieglitz chose for backdrop, *The Warriors* (Fig. 65), presents a buttocks-end view of

65. | Marsden Hartley, *The Warriors*, 1913. Private collection.

horses mounted by Prussian cavalry officers in tight white breeches as they parade away from the viewer. Hartley had painted this in 1913, in the glory days of Prussian militarism, well before the summer of Sarajevo.

Camfield proposes that Stieglitz chose this particular painting by Hartley because of its obvious visual rhyme with *Fountain*—the flanging, curvilinear, quasi-erotic, quasi-mystical flame-like structure that occupies the center of the painting resembles the shape of the urinal. More recent scholars, attending specifically to Hartley's sexual orientation, have given the juxtaposition a queer reading, seeing in it a visual trope for anal intercourse.[34]

While both the formal reading of the juxtaposition and the queer one are convincing—they are not, after all, mutually exclusive—neither should cause us to forget that Stieglitz staged the photograph *at the very moment* that Americans were embarking on war with Germany. To affix a urinal directly in front of a depiction of warriors smacks of the mordantly ironic attitude

toward military regimentation and pretension that came to be known as "trench humor," because it characterized the cynical, bottom-up view that lowly enlisted men had of their vainglorious superiors. As Paul Fussell observes in *The Great War and Modern Memory*, one of the most pervasive effects of the war was to make ironic detachment, formerly the province of intellectuals, aesthetes, and aristocrats, a common frame of mind. Duchamp's *Fountain* and Stieglitz's photograph (also called *Fountain*) both epitomize the new anti-sentimental sensibility, albeit in different registers.[35]

Stieglitz, it should be noted, had strong positive feelings for Germany, which played a continuing role in his life. Born in Hoboken, New Jersey, to German-Jewish immigrants in 1864, he moved with his parents and siblings to Germany when he was sixteen. Three years later, the family returned to America, but he stayed behind to study mechanical engineering in Berlin. There he acquired a camera and took up photography, first as a hobby and then as a lifelong career. His early, prize-winning photograph *Sunlight and Shadows, Paula, Berlin* (1889), displays the same fascination with chiaroscuro lighting that he later used to great effect in rendering *Fountain*.

The photographer's ties to Germany remained strong after his own return to America. He married the heiress to a German-Jewish brewery fortune. While on a transatlantic voyage with his wife, he took a shot of working-class passengers crowded together on the lower deck of a German ocean liner, the *Kaiser Wilhelm II*. This now world-famous image, *The Steerage* (1907), is often thought to be a chronicle of immigrants arriving in the New World, when in fact they were headed in the opposite direction, back to the Old. Ten years later, when the United States declared war on Germany, the US government impounded the *Kaiser Wilhelm II* and converted it into a transport vessel for shipping American soldiers overseas to fight the monarch for whom it was named![36]

An outspoken pacifist, Stieglitz was nonetheless pro-German in his sentiments, and he vehemently defended Germany in arguments with his friends. A permanent break with his longtime creative partner Edward Steichen came in the spring of 1915, when Stieglitz remarked that the civilian victims of the *Lusitania* disaster "got what they deserved" for not heeding the warning provided by the German government to all prospective passengers of the luxury liner a week before its fatal voyage. The war, in fact, initially gave Stieglitz cause for celebration because of its potential to sweep away outworn traditions. As he wrote his friend Annie Brigman, "To me the War, terrible as it may seem to others, is a most wonderful thing." If he had to place his loyalties anywhere, he told her, it would be with Germany, which was "more constructive, more farsighted as a nation" than any other country.[37]

Stieglitz was only one of many artists and intellectuals in the United States, as elsewhere, who counted on the war to wipe away the rot of civiliza-

tion and allow a more progressive society to take root. Harriet Monroe, the founding editor of *Poetry*, the flagship journal of modern American verse, was thrilled to see America leap into the fray: "If we have war, devastating war that shall relieve us of surplus billions and drain some of our most precious hearts' blood, its huge and irresistible flood may wash away much of the accumulated materialism which clogs our souls." Like the new style of poetry she favored, a world war would reinvigorate a moribund society, blasting out the cobwebs.[38]

In this regard, Monroe echoed Marinetti's claim that war is redemptive, the "hygiene" of society. The notion was widespread among cultural progressives, regardless of whether they sided with or against imperial Germany. They actually believed that war would "flush" away the impurities of decadent society. "War," the English critic Edmund Gosse enthusiastically proclaimed at the beginning of hostilities, "is the sovereign disinfectant, and its red stream of blood is the Condy's Fluid [a hygienic product] that cleans out the stagnant pools and clotted channels of the intellect." Flinging itself in the face of those who entertained such fatuous notions, *Fountain* invokes the discourse of war and hygiene with a mixture of wry amusement and icy contempt.[39]

Considerations of war aside, Marsden Hartley shared Stieglitz's high regard for Germany. In 1913, as we have seen, after a frustrating attempt to secure his reputation in bohemian Paris, where he felt snubbed by Pablo Picasso and other cubists whom he idolized, Hartley moved to Munich. There, the expressionist painters Wassily Kandinsky and Franz Marc welcomed him. Had he come but a short while earlier, he might have crossed paths with Duchamp, who had resided in the city for two months during the previous autumn.[40] Both artists were interested in the traditional Bavarian technique of reverse-glass painting, a method that inspired Duchamp's incipient thoughts about a piece he called *The Large Glass*, a complex mixed-media allegorical undertaking that he worked on for nearly a decade without ever completing. The full title is *The Bride Stripped Bare by Her Bachelors, Even* (c. 1915–23, Philadelphia Museum of Art).

From Munich, Hartley moved on to Berlin, a city renowned for its radiant military pageantry and for its openness toward homosexuality. *The Warriors* celebrates the martial spectacle of pre-war Berlin, which aroused the painter erotically as well as aesthetically. He painted the work, he later recalled, at a time when the streets were filled with martial parades, the essence of which he sought to capture in *The Warriors*: "those huge cuirassiers of the Kaiser's special guard, all in white—white leather breeches skin tight, high plain enamel boots." His reverie of the past continues with palpable excitement: "The whole scene was fairly bursting with organized energy and the tension was terrific and somehow most voluptuous in the feeling of power—a sexual

immensity even in it—when passion rises to the full and something must happen to quiet it." Still more: "I have never felt such a sense of voluptuous tension in the air anywhere. It was all so warm to my long chilled New England nature and provided the sense of home always so needed in my life."[41]

The association of horse's rumps, Prussian militarism, and homoeroticism was not exactly new in the arts. A generation earlier, Henri de Toulouse-Lautrec had made precisely this connection in *German Babylon*, a poster advertising a satirical novel by the French writer Victor Joze, who set out to mock German debauchery in the aftermath of the Franco-Prussian War. In Toulouse's poster, which illustrates a scene from Joze's novel, a blond German cavalry officer, mounted on a white steed, takes part in a military parade reviewed by Kaiser Wilhelm II, who focuses his gaze lecherously on the backside of the clip-clopping horse (Fig. 66). The title likens the German capital to the Whore of Babylon. Outraged, the Kaiser's ambassador to France called for the sexually provocative poster to be banned, but his plea was ignored. Magnetized by the homoerotic splendor of perfectly erect cavalry officers wearing tight white breeches and wrapping their muscular legs around horses' pounding flanks, Hartley did not share Toulouse's satirical intentions when he too portrayed mounted men as seen from behind.[42]

The American remained in Berlin for more than a year after the death of Karl von Freyburg, the handsome young cavalry officer who was his dearest soul ("in every way a perfect being—physically—spiritually and mentally," he grieved to Stieglitz), but he was desperate for funds and begged his patron for continued support. Because of the Allied blockade, food was becoming scarce for everyone, and horses, previously an object of veneration in the

66. | Henri Toulouse-Lautrec, *German Babylon*, 1894. Museum of Modern Art.

German capital, no longer possessed the aura they radiate in paintings by Hartley such as *The Warriors*. When a horse would collapse from starvation and die on the street, noted a foreign observer, "Women rushed towards the cadaver as if they had been poised for this moment, knives in their hands. Everyone was shouting, fighting for the best pieces. Blood spattered their faces and their clothes.... When nothing more was left of the horse beyond a bare skeleton, the people vanished, carefully guarding their pieces of bloody meat tight against their chests."[43]

Stieglitz could no longer supply Hartley with the cash he needed to stay in Berlin. The art dealer himself was entering a period of financial hardship, as mounting anti-German sentiment in the United States cut deeply into the profits of the brewing business run by his wife's family. Unable to sustain Hartley abroad, he paid for the artist's passage back to New York in December 1915 and generously accorded him a six-week solo exhibition the following spring.

The response to the show was tepid. Neither the art-viewing public nor the art press was interested in an exhibition of semi-abstract paintings extolling the Junker capital and its military regalia. Even Georgia O'Keeffe, the painter's friend, was not impressed. Finding his Berlin paintings cluttered, noisy, and overwrought, she likened them to "a brass band in a small closet."[44] The New York art establishment was decidedly French in orientation: Paris, not Berlin, was the object of its envy and desire. By choosing for his backdrop one of Hartley's unsold paintings of Berlin—a distinctly military one at that—Stieglitz offered in the first days of America's belligerence against Germany a complex and highly ambiguous merging of three art capitals: his own New York, Hartley's Berlin, and Duchamp's Paris. In effect, the photographer fused into a single visual artifact his and his fellow artists' confused sense of national allegiances at the exact moment that political neutrality had ceased to be an option for any of them.

WHATEVER HAPPENED TO THE ORIGINAL store-bought urinal? No one knows. One account holds that the offending piece was hurled to the ground by an angry artist and broken beyond repair; another that it was stolen by a jealous rival to be kept permanently out of public view, but it's more likely that Duchamp, once his point was made, simply tossed it away. This would have been after Stieglitz photographed it for *The Blind Man*, the avant-garde magazine Duchamp founded and co-edited. A cropped version of the Stieglitz photo was used to illustrate a short but powerful defense of the readymade by Duchamp's friend Louise Norton, a Dada poet later married to the avant-garde French composer Edgard Varèse (see Fig. 60a). Cleverly entitled "Buddha of the

Bathroom," the essay likened *Fountain* to a statue of a seated Buddha. How quickly, then, Duchamp's act of artistic aggression, which reverberated with timely, if veiled, anger against war, was converted into an emblem of serene detachment, timelessness, and peace.[45]

Over time, the urinal attained mythical status, especially among surrealist and neo-dada artists of the 1950s, among them John Cage and Robert Rauschenberg. In the early 1960s, Duchamp authorized a limited number of reproductions (somewhere between eight and fourteen) to be made by Italian ceramicists working under the direction of the young Milanese author and art gallery owner Arturo Schwartz. He added his "R. Mutt" signature to each one. These now occupy places of prominence in leading museums of modern art. In Julian Wasser's deft photograph from 1963, the septuagenarian Duchamp "signs" an already signed *Fountain* reproduction by seating himself slightly to the side of the object and thus directly in front of the actual signature's location (Fig. 67).[46]

The only complete visual document of the original *Fountain* is Stieglitz's photograph—which itself only exists in reproduction, the original negative and prints having been lost. Writes the Stieglitz historian and curator Sarah Greenough, "Curiously, just as Duchamp did not bother to save the original *Fountain*, Stieglitz did not save a print of this photograph, suggesting that neither fully appreciated the significance that history would bestow on this event."[47]

The photograph is more than an art-historical document. It is a work of art in its own right, a collaboration between Duchamp and Stieglitz, two artists then at the peak of their respective powers. Greenough remarks that Stieglitz "displayed his eagerness to stay at the edge of avant-garde experimentation by installing, exhibiting, and photographing" the rejected

67. | Julian Wasser, Marcel Duchamp in front of *Fountain*, 1963. Philadelphia Museum of Art.

Fountain, reverently placing the machine-made object on a pedestal, "carefully lighting it to reveal both its sculptural beauty and enigmatic qualities." The artistic collaboration might even be thought of as three-way, for it included Hartley as well, given that Stieglitz posed the urinal in front of the painter's rapturous tone poem to German military manhood, in which rows and rows of helmeted dragoons in leather boots and skintight trousers ride off in a golden aura, their arms laden with lances. "Playing on its scatological allusions," Greenough comments, Stieglitz "positioned *Fountain* so that it was directly beneath the tail of one of the horses in Hartley's painting."[48]

A photograph of Duchamp's studio apartment on West 67th Street, taken in 1917 by his friend Henri-Pierre Roché (later famous for his novel about the period, *Jules and Jim*, which became an internationally acclaimed French New Wave film in the early 1960s), shows the urinal suspended from an interior doorway; it is one of several readymades casually scattered about the room, with no special aura of its own.[49] In Stieglitz's hands, however, the piece has undergone an astonishing transformation. Subjected to moody Rembrandt lighting and the intimate gaze of a close-up lens, it has been changed from a utilitarian industrial object into a poetic sculptural abstraction. In this regard, the photographer has thwarted Duchamp's anti-aesthetic intentions, endowing the ordinary receptacle for urine with precisely the sort of spiritual transcendence that Dada sought to "strip bare." Stieglitz and Duchamp may have "collaborated" on the making of the photograph, but that hardly means that their divergent social and aesthetic goals coincided.

Fountain, the photograph, shows a three-dimensional sculptural object (*Fountain*, the readymade) seemingly affixed to a flat, two-dimensional painting (*The Warriors*), somewhat like a Rauschenberg "combine painting" from the 1960s. It's a mutt, a cross-breeding of two radically different art objects, Hartley's and Duchamp's, into a third, Stieglitz's. This mongrelizing of artistic media, methods, and intentions confounds meaning. Is Stieglitz inviting the viewer to piss on Hartley? That's unlikely, given his respect and personal concern for the artist. How about on the German military? That's more plausible, considering that he took the photograph days after the declaration of war. Although the photographer never succumbed to the anti-German hysteria that swept the nation, as a pacifist he may have been disturbed by Hartley's celebration of Prussian militarism, and, by extension, militarism of any sort. Maybe he juxtaposed the two objects, *Fountain* and *Warriors*, because he was struck by ways in which they, and the temperamentally dissimilar artists who made them, were kindred spirits.

Today the Hartley painting, hanging in a private collection, is unfamiliar to all but students of early American modernism, and the Stieglitz photograph is known only for its documentation of the lost Duchamp. Amply

illustrated books on Stieglitz abound, but none treats this masterpiece as part of his canon. *Fountain*, on the other hand, is one of the most acclaimed art objects of the past century. This is an irony that surely would have amused Duchamp. His flippantly anti-canonical and, so far as he was concerned, instantly disposable installation piece, which takes, by the way, disposal as its core theme, has become our era's most supremely canonical, and therefore indestructible, work of modern art. To add to the irony, the conceptual piece has become thoroughly detached from its original wartime context and thereby stripped of its extra-artistic political meanings. We admire it for its cheeky modernist rejection of outmoded aesthetic principles, but focusing exclusively on that blinds us to its lightning-bolt anger at America's holier-than-thou declaration of war and the resulting flood of euphoria that threatened to drown everyone who stood in its path.

Over the years, many attempts have been made to decode the meaning, or, more properly meanings, of "R. Mutt" or, alternatively, "Richard Mutt" (as the submission form was signed). Duchamp himself recalled that the signature punned on (1) the name of the plumbing supply house, J. L. Mott Iron Works, where he acquired the urinal, (2) the name of one of the characters in *Mutt and Jeff*, a popular comic strip he admired, and (3) the French slang term for a rich man (*Richard*, meaning money-bags). Others, compounding the sounds of "R" and "Mutt" or "Mutt" and "R," have proposed a play on German words such as *Mutter* (mother), *Urmutter* (archetypal mother), and *Armut* (poverty).[50]

None of these is implausible or irrelevant to the multiple meanings of the readymade, but let us consider a couple of additional possibilities relating to the furor of the wartime moment. The term *mutt* derives from the word mutton, or sheep. By scrawling "R. Mutt 1917" on the urinal in large black letters, Duchamp may have been doing something quite different from cloaking his identity in a pseudonym; he may instead have been making a caustic observation about his fellow artists, if not the American people at large: "[You] R. Mutt"—you are sheep. *Mutt* was also slang for a stupid person, a muttonhead, so the "signature" may have gone a step further in suggesting that the so-called "independent artists," and their fellow citizens, were not only timid conformists (sheep), but stupid ones at that.

In the first decades of the twentieth century, the term *mutt* acquired yet another meaning: a cross-breed animal, particularly a dog. Charlie Chaplin's early masterpiece *A Dog's Life* (1918), for example, featured a mutt—or, as a title card facetiously euphemized, a "thoroughbred mongrel"—that befriends the lonely tramp and saves him from danger. Duchamp had recently rejected oil painting as an outmoded artistic medium overly invested in sensual ("retinal") beauty. He wanted art to challenge the mind rather than soothe or seduce the eye. Art, he believed, should merge philosophy and everyday life instead of sealing them off into disconnected compartments of human experience.

Fountain mongrelized these conventionally separate spheres. The urinal was a common, ordinary, and frequently overlooked (literally so, by its users) object of daily life, but it was also an elegantly curved piece of sculpture. At a time when Americans were being urged to put down their opposition to the war and fall in line with Manichaean government doctrine, which designated Allied nations as good and enemy nations as bad, *Fountain* blew apart such coarse and simplistic thinking. It insisted instead on the "mongrel" nature of all nations and all men and women, as metonymically personified by this blunt reminder of a core bodily function that cuts across all breeds of humankind: regardless of class, sex, race, religion, or national affiliation, everyone has to urinate (although it's true that urinals were not designed for women).

In 1917, *mongrel* and its slang formation *mutt* had particularly racial connotations. As America prepared for war, the head of the United States Army, General Leonard Wood, insisted that training camps be fully segregated. He explained that this would reduce the risk of local white women "producing a breed of mongrels." With its brazen appropriation of the term mutt, *Fountain* implicitly mocks this racist outlook.[51]

After World War II, the German social theorist Theodor Adorno aphoristically observed, "To write poetry after Auschwitz is barbarism." *Fountain* put forth a similar opinion on the obscenity of war: in its looming shadow, art is no longer possible; or, rather, the barbarity of war makes a lie of all strictly aesthetic endeavors. Truth-telling demands that pretty or poetic manifestations of human creativity be replaced by plain, vulgar objects, such as the urinal. Not long after Duchamp insulted idealists with *Fountain*, D. H. Lawrence sarcastically noted that Americans could lay claim to two great specialties—plumbing and saving the world.[52] In comically juxtaposing high-mindedness (saving the world) with base practicality (plumbing), Lawrence cut the former down to size. *Fountain* did the same. It did so, however, with as much the anger of Adorno as the wit of Lawrence.

Viewed from the perspective of the First World War, other works by Duchamp seem potentially laden with intended or unintended references to the conflict: One of his earliest readymades, *Bottle Rack* (1914) is shaped in concentric circles and bristles with inhospitable metal projections, which are spaced at regular intervals, like a coil of barbed wire (Fig. 68). A restraining device that had been invented in the nineteenth-century American west to control wandering livestock, in 1914 barbed wire made its debut as a mass-produced and massively effective means of keeping enemy soldiers, not cattle, under control. Whereas a bottle rack hangs glass up to dry, barbed wire hangs men up to die.[53]

Unexpected resonances of mass death and modern warfare may be discerned in other readymades Duchamp introduced in these years: *Underwood Typewriter Cover* (1916) resembles an undertaker's wooden coffin (verbally

68. | Marcel Duchamp, *Bottle Rack*, 1914 (1961 replica). Philadelphia Museum of Art.

conflated in the word "underwood") covered by a leather or canvas shroud; *50 cc Paris Air* (1919), a small glass ampoule purchased by Duchamp in a Parisian pharmacy and permanently sealed, invokes the limited availability of breathable air to the victims of a poison gas attack; and *Dust Breeding* (1920), the collaborative photograph he made with Man Ray of dust particles accumulating on the surface of *The Large Glass* uncannily resembles an aerial reconnaissance photograph of no man's land (see pages 3–5). The Museum of Modern Art, which owns the architectural construction *Fresh Widow* (1920), links it directly to the war: "By changing a few letters, Duchamp transforms 'French window'—which the work resembles in form—into 'Fresh Widow,' a reference to the recent abundance of widows of World War I fighters."[54]

That Duchamp never referred to these works in terms of the war need not put us off from reading them as material-culture manifestations of his encounter with the perilous history of his times. Dada artists in general embraced the meaninglessness, the logical incoherence, of their endeavors. But simply because they did this does not mean that we must follow their lead when trying to understand those endeavors as part of a larger picture; when viewed historically, "meaninglessness" is anything but meaningless. Lawrence advised in 1923, "Never trust the artist. Trust the tale. The proper function of a critic is to save the tale [or, in the present context, the Duchampian readymade] from the artist who created it." That is, never take an artist's intentions or declarations at face value.[55]

In 1916, Duchamp's brother and noted cubist sculptor Jacques Duchamp-Villon contracted typhoid fever while stationed at a French military base. He was transferred to a hospital in the south of France and died two years later.

One more life pissed away. Duchamp could not bear to be in America during the mobilization for war because a different kind of fever from the one that had struck down his brother afflicted the nation. In August 1918 he booked passage on a steamer to Argentina. He planned on "staying down there a very long time," he wrote a friend; "several years very likely—which is to say basically breaking completely with this part of the world."[56]

On the day before he sailed, he appeared as an extra in a French war film being made in New York. Appropriately for an artist who co-founded the short-lived little magazine *The Blind Man* and who had taken a firm stand against the deceptions and seductions of what he called "retinal art," Duchamp played a soldier who had been wounded in the eyes.[57]

One last note on Duchamp in the matrix of war, specifically the First World War. As happenstance would have it, he lived and worked at the same address on West 67th Street as James Montgomery Flagg, the popular illustrator who, that same year and in the same studio building, produced his iconic image of Uncle Sam demanding enlistment.[58] Flagg's poster, even more so than *Fountain*, is one of the most frequently reproduced visual artifacts to emerge from the United States during the war. As we saw in Chapter 3, Flagg's Uncle Sam, a phallic embodiment of wartime patriotism, points his erect forefinger, his index, directly at the viewer, admonishing service to the state.

Fountain takes on *Uncle Sam*. It is the anti-*Uncle Sam* (Fig. 69). Yes, it, too, is phallic, given its bullet-headed shape. It is indexical as well, pointing a rigid digit (the connector valve) at the viewer. But it also serves as a threshold between the male body and the wall; between, as it were, the animate and inanimate, being and nothingness, life and death. It marks an interstitial space, or, in the language of the day, no man's land. Flagg's poster invited American men to imagine themselves hard, resolute, and glorious, like their mythical Uncle Sam, whereas Duchamp's urinal might have reminded them that war in general, and this war in particular, was an obscene waste.

AS THE PASSIONS OF THOSE first tumultuous days receded from collective memory, *Fountain*'s fierce, guttural response became indiscernible, lost to history. Max Ernst, a friend of Duchamp, made a similar point when he visited a major Dada retrospective in 1967 and complained, "To put the spirit of Dada on exhibition [now] is no more than a weak illustration, like trying to capture the violence of an explosion by presenting the shrapnel."[59]

Restoring *Fountain* to that now all-but-forgotten moment when America overflowed with war fever, we are better able to understand the enraged emotions

69. | *Uncle Sam; Fountain.*

it elicited and see that these were not exclusively derived from a philosophical disagreement over the nature of art and artistic originality. *Fountain* was born at the moment that the neutral United States, abandoning its determination to find a peaceful solution to the war in Europe, excitedly joined the greatest slaughter in the history of mankind. With droll wit and a cool, gleaming detachment, Duchamp's urinal nonetheless howled at the flushing of millions of lives and countless dreams down the collective toilet.

6

TO SEE OR
NOT TO SEE

LITERARY HISTORIANS OF THE FIRST World War have often pointed out the conundrum that writers of the time faced when attempting to find words to convey the massiveness, strangeness, and obscenity of the war. As Pearl James notes, "Many writers and witnesses [of the period] insist on the fundamental inadequacy of language. What matters here is not whether war really is unspeakable but that unspeakability itself becomes a trope for talking about war."[1]

Similarly, artists struggled to find a visual language with which to represent the new variety of war in a meaningful way. They too experienced its profound resistance to representation, be it traditional or modern in style. In this the artists, like the writers, were allied with the generals themselves, and with all others whose job it was to *see* the field of battle. "In the big battles of the early twentieth century," historians Stéphane Audoin-Rouzeau and Annette Becker explain, "commanders could no longer grasp in its entirety the scene of the conflict." Indeed, "The greater range of weapons changed the very conception of 'battlefield': the Somme in 1916—the site of one of the most costly battles of the century—was ten times more spread out than Waterloo." The soldier of modern mechanized warfare, noted George Bernard Shaw, "has no sight or knowledge of what he is doing: He only hands on a shell or pulls a string. And a Beethoven or a baby dies six miles off."[2]

The four artists discussed in this chapter—the painters George Bellows and John Singer Sargent, the photographer Edward Steichen, and the filmmaker D. W. Griffith—were all traditionalists in style, even though each at an earlier stage in his career had been a noteworthy innovator. Three of them were figurative artists to the core; only Steichen, as a master of aerial reconnaissance photography, produced visual objects that appear musical and

abstract to the untrained eye. Nonetheless his goal, far from that of a Kandinsky-like abstractionist, was to produce an *objective* view of reality, one that would allow American artillery squads to train their long-range weapons to devastating effect on a distant and hidden foe; and if a Beethoven or a baby perished along the way, that, he might have said, was an unavoidable tragedy.

Each in his way sought to overcome the difficulty, if not downright impossibility, of seeing what was truly going on "over there": across the sea (Bellows), behind the lines (Sargent), in the trenches (Griffith), or from a few thousand feet above the battlefield (Steichen). Despite the salient differences between these artists, they shared essential similarities. They embraced realist modes of vision; they were not avant-garde modernists, in any sense of the term. They believed in a single, factual, objectively observable reality that it was their primary job as artists to delineate; they did not regard this shared reality as open to subjective interpretation. They could discern in nature, in art, and in humanity itself, or so they thought, a clear-cut distinction between right and wrong and between that which was beautiful and that which was not.

They believed that art—regardless of whether it resulted from the high altitude reconnaissance camera, the earthbound motion picture camera, the etching plate, or the paintbrush—could provide mankind with a greater level of cognition than could be grasped by the naked eye alone. They struggled to *show* or *reveal* reality with a nineteenth-century idealistic belief that this was still possible. The very war they sought to represent made that faith seem naive, indeed, untenably so, to scores of artists who were to follow. True, some of the high modernists of the postwar period (such as Mondrian and Kandinsky) were themselves believers in universal truths, but their utopian desires were a byproduct of war and revolution, an attempt to offset a future debacle by harnessing rationality and spirituality, and in that regard they were very much unlike the four artists who are the subject of this chapter.

GEORGE BELLOWS HAD MADE HIS name with good-natured satires of the urban bourgeoisie and their lower-class counterparts, as seen, for example, in *Cliff Dwellers* (page 78). His lively paintings and drawings of drunks, preachers, wife-beaters, weight-reducers, hoboes, fight fans, and public executioners established his reputation as America's Daumier. The great nineteenth-century French caricaturist Honoré Daumier had skewered the pretensions of the mighty and evoked the plight of the weak. Bellows wanted to do the same for his time and place. A socialist, he viewed the world from a left-wing standpoint, but with a decidedly comic perspective, sometimes subtle and droll and other times brash and bawdy.

Before the war, he gently poked fun at preparedness advocates in a drawing showing a cloddish young man beaming with pride as his girl pins a patriotic button on his chest. As late as the summer of 1917, the satirist mocked the nation's hunger for war, as with the cartoon of Jesus imprisoned for preaching pacifism (page 75). If someone had suggested to Bellows that *Fountain*, too, might be a cry against war, he would have scorned it as weak-kneed formalism—sissy art—incapable of exerting any genuine influence on real-world politics, unlike the acerbic cartoons that he and his associates at *The Masses* produced in the face of the nation's escalating enthusiasm for war.

As noted in the last chapter, Bellows was offended by the anonymous submission of *Fountain* to the Society of Independent Artists exhibition. He had no idea that "R. Mutt" was really Marcel Duchamp, who served with him on the Independents' hanging committee. Beatrice Wood, another of the Independents and an intimate of the Duchamp circle, dramatizes the scene in her autobiography: "Bellows was facing Walter [Arensberg; Duchamp's patron], his body on a menacing slant, his fists doubled, striking at the air in anger.... 'We cannot exhibit it,' Bellows said hotly, taking out a handkerchief and wiping his forehead.... 'It is indecent,' roared Bellows."[3]

When Arensberg lightly touches his arm and says, "It is for the artist to decide what is art, not someone else," Bellows pulls his arm away, protesting, "You mean to say, if a man sent in horse manure glued to a canvas that we would have to accept it!" Wood, whose recollection of the exchange unabashedly favors Duchamp and Arensberg, makes the crude realist Bellows out to be a troglodyte, whose final word on *Fountain* is, "It is gross, offensive! There is such a thing as decency," to which Arensberg, a model of enlightened patience, replies, "Only in the eye of the beholder."

Bellows, it seems, felt personally threatened by Duchamp's—or, as he initially supposed, R. Mutt's—blatant rejection of figuration. "While Bellows was flooding his work with bodies in an attempt to keep the figurative tradition alive," notes the Bellows scholar Charles Brock, "objects such as *Fountain* sought to displace the human body in art with ideas."[4] Thus in the spring of 1917 Bellows was pushed, pulled, and torn in multiple directions and responded with indignation. At some level, the torturous assault of the Germans on innocent Belgian bodies may have coincided in his mind with the barbarous attack of the Arensberg gang on the "innocent" members of the circle of artists surrounding his close friend and mentor Robert Henri. Henri (pronounced "HEN-rye") taught his devoted followers to go out into the streets and paint the irrefutable truth of the eyes, rather than adhere to genteel academic conventions for the depiction of urban life. After a brief period in the sun as America's leading progressive artists, Henri and his followers were surpassed in sophistication by Duchamp and his allies, who disdained "retinal

art"—that which fixated on lush, sensual, and dramatically painted surfaces, exactly the forte of the Henri circle. In addition, their almost religious faith in firsthand observation, the so-called "truth of the eyes," would have made Duchamp and friends roll their eyes.

Not everyone in Henri's orbit felt the same enmity as Bellows did toward Duchamp and company. This can be seen in *Arch Conspirators*, a witty drawing by John Sloan that chronicles an impromptu candlelit dinner party that Sloan, Duchamp, and a small handful of others held for themselves atop the Washington Square Arch in January 1917. Having found a door unlocked, they climbed a spiral staircase to the top, enjoyed a midnight picnic while wrapped in blankets, and mock-solemnly declared that they were forming a separate nation, the "Free and Independent Republic of Washington Square." With that, they playfully called on President Wilson to safeguard them from foreign invasion. Bellows was less adroit than Sloan at mixing with his rivals. He occasionally put in an appearance at the Arensberg salon on West 67th Street, but according to Man Ray, he "walked around with a disdainful and patronizing air, evidently out of place in the surroundings."[5]

As 1917 gave way to 1918, Bellows became convinced that reports of German atrocities were not lies trumped up by the British to win American support but truthful accounts, and he decided it was time to take a principled stand. He broke ranks with his antiwar comrades, many of whom, including Sloan, never forgave his apostasy, and declared his support for American intervention. He even volunteered for the Tank Corps but, at thirty-six, was rejected because of his age. That didn't matter, as there were other, better ways for him to fight the war. "This was not a private obsession—it was as contagious as Spanish influenza," Mahonri Sharp Young reminded his readers in a book about Bellows from the early 1970s. "For that generation, the War was the end of the world, and there was no doubt that it was the Germans' fault. This was the most violent emotion of his life, and it had a bad effect on his art. His war pictures are the worst he ever painted. This was a real firestorm that swept over America."[6]

Despite the seemingly good-natured side of Bellows's satirical drawings, physical violence, brutality even, had always been a key factor in his work. It's what makes him stand out today as the best, the most viewable, the least sentimental of the Ashcan School artists. His gift for portraying violence came to the fore in the boxing paintings; these are what made him famous. He once remarked, "I don't know anything about boxing. I am just painting two men trying to kill each other."[7] In his prime, Bellows was great because his work epitomized a hammer-blow against the genteel tradition; he was doing in the field of art something equivalent to what his one-time roommate Eugene O'Neill was doing in the realm of theater: overturning its obsessive concern with social propriety and neatness of form. His extraordinary series

of excavation pictures, in which the bowels of lower Manhattan are ripped open by men with sledgehammers and earth-chewing machinery, brilliantly convey the menacing but also exciting beauty of modernity.[8]

Less overtly so, his depictions of New York City in winter are laced with violent splendor. Take, for example, *The Lone Tenement* (1909), a stunning architectural portrait of an isolated and dilapidated tenement building stranded at the edge of an icy river and overshadowed by the rusty span of an iron bridge. At its base, puny, ill-clad figures, little more than urban ciphers, huddle for warmth around small fires in the snow. The brushwork shows Bellows at his best as a pugilist with a paintbrush, slashing and jabbing at the canvas with a flurry of bold, decisive strokes. Other urban landscapes, such as *Rain on the River* (1908) or even the at-first-glance anodyne *Blue Snow, The Battery* (1910), wring extraordinary beauty from tumultuous brushwork, harsh color contrasts, and, in the latter painting, the eye-assaulting glare of bright sun on crisp white snow. This was retinal art without apology or shame.

Even in his carefree genre scenes, such as *Forty-two Kids* (1907, National Gallery of Art), there's an undercurrent of aggression. The painting shows a multitude of naked street children diving off a pier into the East River. They splash boisterously in the murky water. Viewers today might reasonably assume that the title quantifies the number of "river rats" at play (it's hard to make an exact count) and leave it at that. But the number in the title isn't random; it alludes to a disturbing episode in the history of childhood frolic. The son of devout Midwestern parents who wanted him to become a Methodist clergyman, Bellows knew his Bible inside out. The title refers to an obscure and rather cruel incident in the Old Testament. In it, a gang of mischievous children mock the aged prophet Elisha, shouting after him, "Go up, thou bald head; go up, thou bald head." Angered by the disrespect shown to His prophet, Jehovah sends "two she bears out of the wood" to slaughter the "forty and two children" (2 Kings 2:23–24). Bellows had gone bald prematurely and was thus himself the object of teasing. This adds another wrinkle to our understanding of the painting, inasmuch as the always-controversial painter might have identified on multiple levels with the verbally abused prophet. Despite its apparent lightheartedness, *Forty-two Kids* seethes with violent subtext, as do many of his best works.

So it was in 1918 that an artist deemed too old to fight embarked on a campaign against the enemy that is extraordinary in its ferocity and rage. No American artistic depiction of war, before or since, has been so fully realized in its attack. With Goya's pungent *Disasters of War* drawings (1810–13) as his model, he feverishly churned out a series of lithographs that describe in ghastly detail the German army's march through neutral Belgium in late summer 1914, raping, pillaging, and torturing large numbers of civilians, whose insurgency they sought to contain.

His primary source of information was the Bryce Committee Report, which appeared in May 1915. Viscount James Bryce, former British ambassador to the United States and member of the International Court at The Hague, headed a war crimes commission that took depositions from twelve hundred eyewitnesses and studied the captured war diaries of German combatants to determine the truth of allegations against the occupiers. Relentlessly, gruesomely explicit, the sixty-one-page report makes for excruciating reading, all the more so because of the matter-of-fact manner in which it is written. Printed in thirty languages and sold in the United States for ten cents a copy, the report was circulated widely. Days after the sinking of the *Lusitania*, the *New York Times* ran an abridgment that filled three pages.

To this day, historians debate the accuracy of the Bryce Report. It does not take training in critical research methods to question its rigor. Names of witnesses are withheld out of respect for their privacy, but without proper attribution, some of the more fantastic claims seem like hearsay or outright invention. The authors of the report do not explain how they assessed the credibility of testimony. After the war, the report was subjected to scathing criticism, and it has been blamed for causing skepticism on the part of those wary about being duped again by government propaganda when accounts of the Nazi mistreatment of Jews in the thirties and forties first appeared. Recent scholarship indicates that, despite the report's flaws and probable exaggerations, it was essentially correct; the German occupiers did commit atrocities systematically.[9]

At least seven of Bellows's war lithographs show how he imagined the crimes outlined in Bryce. Works of technical finesse and formal beauty, with dynamic compositions and rich gradations of tone, they attract the eye but punish it for what it sees. One, *Belgian Farmyard*, depicts a dark outdoor setting, where a bare-shouldered German soldier, pulling on his uniform, stands over the supine body of a young female, whom he has raped and possibly murdered (Fig. 70). In *The Last Victim*, three depraved German soldiers in a middle-class parlor stare hungrily at a distraught young woman, who has entered the room to discover her mother, father, and brother sprawled dead or dying on the floor. The corresponding passage in Bryce: "At Herve some fifty men escaping from the burning houses were seized, taken outside the town and shot. At Melen, a hamlet west of Herve, forty men were shot. In one household alone the father and mother [their names withheld] were shot, the daughter died after being repeatedly outraged, and the son was wounded."[10]

These are among the more reportorial of Bellows's war lithographs. Others in the series seem downright phantasmagoric. *Bacchanal*, for example, depicts German soldiers guzzling wine in a village square while guards bring in a young mother whose hands are tightly bound behind her (Fig. 71).

70. | George Bellows, *Belgian Farmyard*, 1918. Cleveland Museum of Art.

Two small, naked children have been impaled on bayonets and brandished in the air, but no one takes notice, as if this were a common, everyday occurrence. (According to one of Bryce's witnesses, a drunken German soldier in the town of Malines "drove his bayonet with both hands into [a] child's stomach lifting the child into the air on his bayonet and carrying it away on his bayonet, he and his comrades still singing.") Here Bellows has combined two themes familiar from Northern Renaissance painting—the massacre of the innocents and the indifference of soldiers who torture holy martyrs—but updated the costumes and setting.

In *Gott Strafe England* ("May God Punish England"), German soldiers nail captured Canadian soldiers to doors made of rough wooden planks while a crowd looks on and jeers. In *The Cigarette*, a solitary soldier seated in the shadows on the right side of the image scowls while smoking (Fig. 72). On the left, the corpse of a man sags in a window frame, beside a broken shutter. In the center, incandescently lit, a naked woman writhes in agony and shame. Her left arm, drenched in blood, extends high above her head, a bayonet driven through the palm to fasten her to the front door. A gaping hole where one of

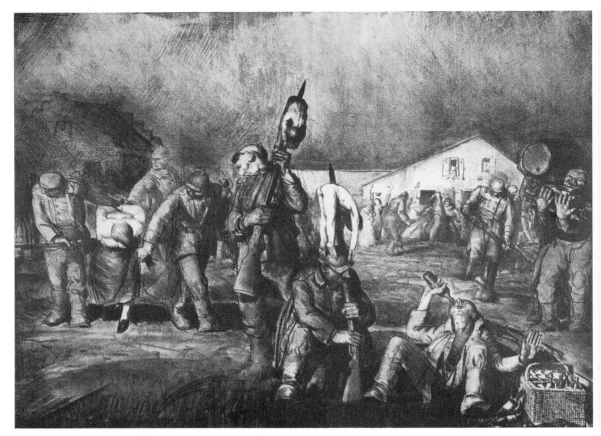

71. | George Bellows, *Bacchanal*, 1918. Art Institute of Chicago.

her breasts should be indicates that the smoker has sundered it from her body. (Bryce on a similar sex crime: "Two young women were lying in the backyard of the house. One had her breasts cut off, the other had been stabbed.")

Could such nightmarish events really have occurred? Or was Bellows feverishly plunging into the depths of sadomasochistic fantasy—if not his own, then that of the collective unconscious, as it has bubbled up from time to time in the martyred-saint paintings and drawings of the Old Masters (Fig. 73), the "miseries of war" prints of the seventeenth-century draftsman Jacques Callot, and especially Goya's etchings, which similarly portray human dismemberment? That the Germans systematically committed atrocities against civilians cannot be disputed. In wartime, rape, pillage, and murder are common. But what about bayoneting babies, nailing prisoners to doors, and cutting the breasts off women?

Bellows believed (or allowed himself to believe) the worst of the enemy. He wanted to bear witness to the torture and killing, though he had not seen

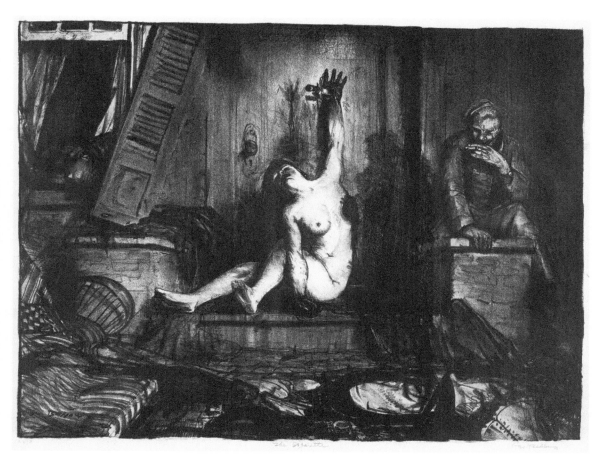

72. | George Bellows, *The Cigarette*, 1918. Harvard Art Museums.

these with his own eyes. It was his artistic responsibility, he insisted, to use his creative imagination to expose crime and injustice, even when his knowledge of them was only secondhand. One of his colleagues criticized his rendering of the death of the English nurse Edith Cavell (whom the Germans had executed for abetting the Belgian insurgents) by asking how he could portray a scene he himself had not seen. Bellows replied that, to his knowledge, Leonardo had not been supplied a ticket of admission to the Last Supper.[11]

His goal was to shake Americans out of their moral lethargy and force them, as Susan Sontag would have it, to regard the pain of others. In this, he belonged to a venerable artistic tradition. Sontag remarks, "The practice of representing atrocious suffering as something to be deplored, and, if possible, stopped, enters the history of images with a specific subject: the sufferings endured by a civilian population at the hands of a victorious army on the rampage." The "ghoulish cruelties" in Goya's series of war etchings, she writes, "are meant to awaken, shock, wound the viewer. . . . That the atrocities

73. | Sebastiano del Piombo, *Martyrdom of Saint Agatha*, 1519. Pitti Palace, Florence.

perpetrated by the French soldiers in Spain didn't happen exactly as pictured...hardly disqualifies *The Disasters of War*. Goya's images are a synthesis. They claim: things like this happened" (Fig. 74). Similarly, Ernest Hemingway once said, "A writer's job is to tell the truth. His standard of fidelity to the truth should be so high that his invention, out of his experience, should produce a truer account than anything factual can be. For facts can be observed badly; but when a good writer is creating something, he has time and scope to make of it an absolute truth."[12]

Though Sontag eloquently champions war photography that wrenches viewers out of their insularity, she is well aware that viewers can be mesmerized by the very images that are meant to serve pacifist ends. Visually stunning representations of man's inhumanity to man made by an engaged artist or photographer to motivate viewers to do something about it may, in the long run, invite passivity, not pacifism. Spectacles of suffering turn viewers into voyeurs. They render them complacent, too much taken with their own

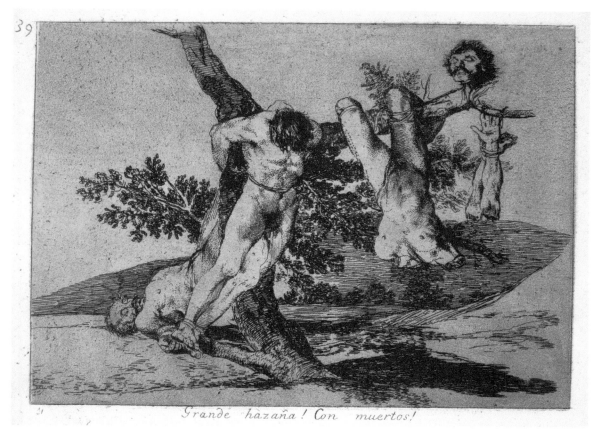

Grande hàzaña! Con muertos!

74. | Francisco Goya, "A Heroic Feat! With Dead Men!" plate 39 from
The Disasters of War series, ca. 1810–1813. British Museum.

moral sensitivity. Paradoxically, imagery that was meant to diminish the
spectator's emotional distance from the suffering of others may actually
increase it.[13]

No doubt Bellows considered his war lithographs consistent with his
left-wing politics and believed he was attacking injustice on the world stage as
he had on the national and local. To the extent, however, that his images fueled
American bellicosity and whipped up anti-German frenzy, they promulgated
war rather than helped create peaceful alternatives to it. Like many other cre-
ative artists then and since who have abandoned their longtime commitment
to pacifism in order to support a "just" war against tyrants, he ended up
feeding the military-industrial giant that he otherwise loathed. The job of
the writer or artist, Sontag observes elsewhere, "is not to have opinions but to
tell the truth... and refuse to be an accomplice of lies or misinformation."[14]

Bellows made his war lithographs in good faith. Before condemning him,
as some have, for his susceptibility to government-sponsored misinformation,

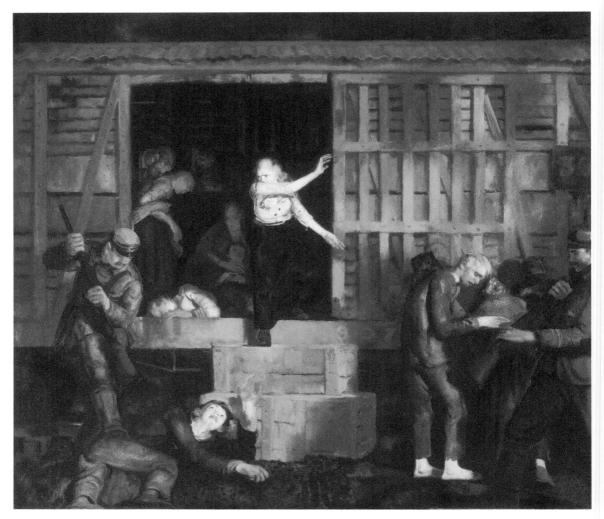

75. | George Bellows, *Return of the Useless*, 1918. Crystal Bridges Museum of American Art.

we should ask ourselves if we are in any better position today to evaluate the veracity of the human-rights violation reports that continually appall us and prick our consciences. When we read about crimes against humanity occurring at a great distance from where we live, how do we, any more than people of conscience in 1918, know that these are real events and not propaganda inventions foisted on us by governments or interest groups determined to manufacture consent and mobilize the population to war?

Bellows felt so strongly about the work that poured out of him in the spring of 1918 that, reversing standard practice, in which lithographs normally derive from paintings, he turned five of his war lithographs into large and richly colored oils. One of these depicts the aforementioned death of

Edith Cavell. Another, *The Barricade*, composed in the manner of a neoclassical frieze, with multiple figures lined up side-by-side in a shallow perspectival space, shows German troops firing from behind a human screen of naked civilians, whose nudity emphasizes their hopeless vulnerability.

The most disturbing of the five paintings, *Return of the Useless* (Fig. 75), which Bellows completed on Armistice Day, alludes to the well-documented fact that the German occupiers had forced Belgian noncombatants into slave labor on the French front, in Belgium, and in Germany itself. When these prisoners became too weak and broken down to work productively (hence "useless"), their captors shipped them home in boxcars. The painting, bathed in queasy red hues and lit theatrically, shows a frightened young blond woman faltering out of the shadows of a cattle car interior, which holds her sick and dying fellow passengers. To her left (our right), a German guard herds disheveled, bloodied prisoners, and to her right another guard stomps on a fallen young man and beats him with the butt of a rifle. It's impossible to look at this painting today without thinking of the Holocaust that lay ahead.[15]

In 1928 the British politician Arthur Ponsonby published a diatribe against propaganda that he entitled *Falsehood in War-Time*. He begins with an unattributed aphorism: "When war is declared, Truth is the first casualty." To this he adds, "There must have been more deliberate lying in the world from 1914 to 1918 than in any other period of the world's history." Bellows's contemporary Pablo Picasso had a more sanguine view of falsehood. "Art," he said, "is a lie that makes us realize the truth." Bellows's war paintings and lithographs fall somewhere into the abyss that separates these two comments.[16]

LIKE BELLOWS, FEW AMERICAN ARTISTS saw the Western front with their own eyes. Sargent, Griffith, and Steichen were notable exceptions. All three, though, kept (or were kept) at too far a remove from the action to be able to convey the main event of war—killing—with insight or verisimilitude. Each of them faced the problem of visually representing the very thing that defied visualization: modern, industrialized, "total" warfare. As Sargent's first biographer, Evan Charteris, bluntly states, "Incidents of the War were not favorable for the production of works of art." Or, as Sargent himself reflected, "The farther forward one goes the more scattered and meagre everything is. The nearer to danger the fewer and the more hidden the men—the more dramatic the situation the more it becomes an empty landscape."[17] Despite his frustration at not finding any "there" there that he could exploit visually, the sixty-two-year-old Anglo-American artist ended up making one of the few

truly unforgettable images of the First World War, a painting of blinded soldiers known simply as *Gassed*.

Sargent may have been as surprised as anyone that he would paint such a work. At the start, the war held little interest for him, and he didn't even bother to read about the build-up in the newspapers or cut short a painting expedition in the Austrian Tyrol when hostilities began. His relationship with his longtime friend and fellow expatriate Henry James, whose portrait Sargent painted before the war, cooled in those early days because James, consumed with concern for the Allied cause, could not countenance Sargent's apparent aloofness. In 1918, however, the painter's mood began to shift. In March of that year, his beloved niece Rose-Marie Ormond André-Michel, who he said had the most beautiful hands he had ever drawn and who had accompanied him on several sketching tours, was killed by a German long-range artillery shell that struck the Parisian church in which she was praying.

Grieving, he accepted an invitation by Great Britain's first Minister of Information, Baron Beaverbrook, to serve his adopted homeland as an official war artist. Sargent traveled to France that summer and, safely stationed behind the front lines, spent hours every day looking for scenes of interest to paint or draw. He depicted soldiers sleeping, bathing, marching, and foraging for food, but these vignettes do not, as such, capture the pain or poignancy of war. Some of them do get at it in an indirect way: Infantrymen rest beside the partially demolished wall of someone's now-exposed private residence; farmworkers go about their business harvesting crops, oblivious to the recent wreckage of a biplane in the field behind them; a sugar refinery has been transformed by bombing into a cruelly twisted metal beast—farewell, it seems to say, without a trace of overt bitterness, to the sweetness and refinement of life that the artist and members of his generation had known before the war.

On an outing near Arras, Sargent caught sight of something that troubled him and aroused his sympathies: a single file of soldiers blinded by mustard gas groping toward a dressing station. The vignette provided him an opportunity to express, through artistic displacement, his frustration at the elusive visibility of modern warfare, its stubborn refusal to accommodate familiar forms of representation. That the men had been blinded by gas was all the more germane to this issue, for the strategic value of gas was not only that it physically debilitated its victims but also visually disoriented them, laying down thick, temporarily impenetrable clouds and vapors through which it was impossible to see.

Since 1914, armies that had previously concerned themselves primarily with wounding, maiming, and killing their opponents now strove as well to shock or overwhelm their senses and in so doing break down the enemy's ability to stand and fight. Armed with a new range of destructive devices such as tanks, machine guns, fighter planes, aerial bombs, search lights,

flares, barbed wire, and poison gas, the armies of the Great War were able to achieve this goal in ways both unimaginable and indescribable. "The western front's interminable trench warfare," writes cultural historian Martin Jay, "created a bewildering landscape of indistinguishable, shadowy shapes, illuminated by lightning flashes of blinding intensity, and then obscured by phantasmagoric, often gas-induced haze.... When all that the soldier could see was the sky above and the mud below, the traditional reliance on visual evidence for survival could no longer be easily maintained."[18]

Of these novel sensory tactics, poison gas was perhaps the most mysterious and terrifying. Invented in the late nineteenth century and banned by the Treaty of The Hague in 1899, poison gas was first put into effective use at the Ypres Salient in Belgium on April 22, 1915. Supporting an infantry advance, the Germans launched greenish clouds of chlorine gas at the unprepared British, Canadian, and French troops amassed against them, causing general panic, chaos, and flight. The German social theorist Peter Sloterdijk calls this the inaugurating moment of modern warfare, because its "essential thought consisted in targeting no longer the body, but the enemy's environment." He explains, "The discovery of the 'environment' took place in the trenches of World War I. Soldiers on both sides had rendered themselves so inaccessible to the bullets and explosives intended for them that the problem of atmospheric war could not but become pressing."[19]

Soon afterward, armies on either side of the trenches employed poison gas as a weapon. It was never, however, quite as successful again, because gas masks became standard issue and the element of surprise less productive. Still, gas attacks were capable of wreaking havoc and causing considerable physical and mental distress. The term *gas* derives from the Greek term *chaos*. Thus, when poison gas routed the enemy, provoking intense pain, disorientation, and death, it fulfilled its etymological origins: It caused chaos. It was a blinding agent in two regards. First, it could literally blind the eyes of its victims for days, weeks, or longer. But it could also, in a more figurative sense, blind even those who were suitably protected from its toxins, by obscuring their view with thick, rolling vapors. Wilfred Owen vividly describes the miasma in *"Dulce et Decorum Est"*:

> Dim, through the misty panes and thick green light,
> As under a green sea, I saw him drowning.[20]

To an aging artist such as Sargent—whose eyes were, in essence, his life—the theme of blindness must have been especially poignant. Returning to London, he painted a mural-like depiction of the harrowing episode he had witnessed and entitled it *Gassed*. An enormous rectangular painting, nine feet high and twenty feet long, *Gassed* has the proportions of the widescreen movies of

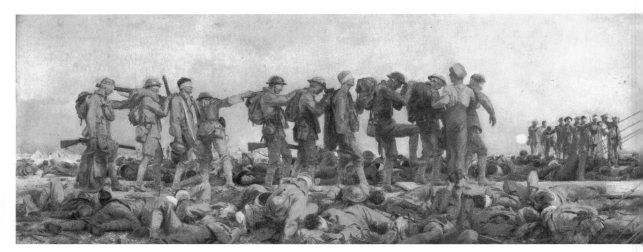

76. | John Singer Sargent, *Gassed*, 1919. Imperial War Museum.

half a century later and is similarly shaped to accommodate motion along the horizontal (Fig. 76). Yet its formal lineage derives from the monumental temple friezes of the ancient Greeks, and accordingly the work smacks of Greek tragedy, where men suffer blindness, madness, and agonizing death at the whim of indifferent gods. But it is less histrionic than that; in fact, it seems quiet, understated, and perhaps even inappropriately calm.[21]

Set against a blank sky tinged with pale lavender, cream, and mustard tones suggestive of the invisible gas that poisoned them, ten sightless soldiers, their eyes bandaged, stumble in a row down a duckboard lane, each steadying himself on the shoulder of the man in front of him—although one of them momentarily lurches out of line, presumably to vomit from gas-induced sickness. Ironically, several of them carry a rifle—a firearm with a built-in *sight*, that is, a mechanism for guiding the eye. That they do so only heightens the painting's aura of futility. An orderly guides them on their way. Approaching a rise in the duckboard, one of the wounded raises his leg in an exaggerated way, as if the orderly has cautioned him to mind his step. In the background, only to be glimpsed through the legs of the blindfolded marchers, healthy soldiers scrimmage in a casual game of football, with one of the players extending his knee in a kick that parallels the exaggerated step of the blind man in line (Fig. 77).

A dozen or so sufferers who also have strips of white cloth wrapped around their eyes sprawl or sit in the foreground, some clutching their heads in wooziness or pain. Across the road many others lie similarly dazed or dying. Far to the right, orderlies herd another column of sightless soldiers toward a hospital tent, which Sargent does not show but suggests by an array of taut guy lines that cross the painting's right-hand corner diagonally. The pale white disk of

77. | Detail from *Gassed*: football scrimmage in background.

the setting sun, lodged in the gap between the two columns of walking blind, burns low on the horizon of this seemingly endless purgatory. In the distant sky, combat planes cluster like marauding insects; though they are hard to see, one can almost hear the whine of their engines and petulant crackle of their rapid-fire weapons.

A nurse's aide who was stationed that year at a similar dressing station complained in a letter home, "I wish those people who write so glibly about this being a holy war, and the orators who talk so much about going on no matter how long the war lasts and what it may mean, could see a case—to say nothing of ten cases of mustard gas in its early stages." She goes on to describe the symptoms of those who were gassed: "the poor things all burnt and blistered all over with great suppurating blisters, with blind eyes… all sticky and stuck together, and always fighting for breath, their voices a mere whisper, saying their throats are closing and they know that they will choke."[22]

Gassed alludes to Pieter Bruegel's *Parable of the Blind Leading the Blind* (Fig. 78), which illustrates Christ's statement, "If the blind lead the blind, both shall fall into the ditch" (Matthew 15:14)—although here a better word than ditch would be *trench*. Whereas the saying by Jesus speaks of a pair of blind individuals, Bruegel expands the number: five blind men pile up behind a sixth, who has crashed to earth. Sargent expands further to ten blindfolded soldiers in one column and many more throughout the composition. In so doing, he universalizes the proverb into a criticism of war or, more specifically perhaps, its instigation and administration by "blind" politicians and generals who have irresponsibly "blinded" those under their command, not to mention the public that foolishly followed them in their wasteful ways. In this regard, the painting reflects the pervasive criticism of wartime leadership that swept through all the combatant nations soon after the war was ended. The British called their generals "donkeys" for the obstinate, thick-headed way they had sent wave after wave of men to the slaughter without seriously considering alternative strategies.

78. | Pieter Bruegel the Elder, *Parable of the Blind Leading the Blind*, 1565. Capodimonte Museum, Naples.

When the Trustees of London's National Portrait Gallery invited Sargent to paint a large group portrait of twenty-two wartime generals, he declined the commission, "with the greatest regret," for he had already announced his retirement from portraiture. ("No more '*paughtraits*,'" he had sneered in private.) But excuses would not do, and he succumbed to pressure to produce what, after more than two years of effort to master the impossible, turned out to be the most lifeless and monotonous group portrait he ever painted (Fig. 79).

Stiff, cold, impersonal, the high-ranking generals stand packed together in a bland and brownish, entirely "generalized" setting at the base of a pair of huge classical columns. In this lofty space, they are little men, almost Lilliputian. The painting forms a pendant to *Gassed*, with its similar size, format, and reference to Greek or Roman antiquity, but has none of the earlier work's pathos or captivating detail. Twenty-two scowling, smiling, or would-be debonair heads, nearly as many mustaches, forty-two eyes (all but two of the assembled generals look straight ahead), dozens of boots, belts, buckles, and leather cross-straps, and a plethora of medals, pins, insignia, ceremonial swords, and silver-tipped batons overwhelm the viewer of today with ennui, as surely they did the painter.

Was Sargent mocking the generals in his own very dignified, eminently polite, highly reticent way? Perhaps not intentionally, yet his distinct lack

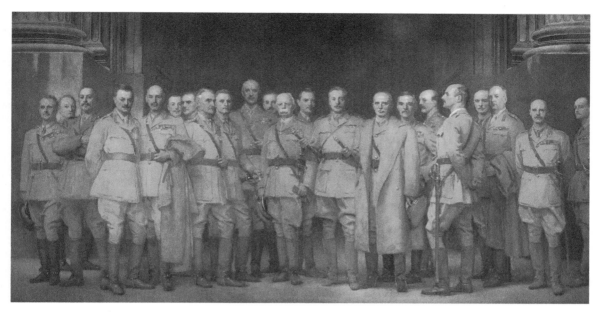

79. | John Singer Sargent, *Some General Officers of the Great War*, 1922. National Portrait Gallery, London.

of enthusiasm for his project may at some level have been generated by his abiding lack of enthusiasm for the war and those who directed it. While *Some General Officers of the Great War*, as this elephantine painting was originally titled, does not indulge in the sort of overt general bashing performed by the postwar German caricaturists Otto Dix and George Grosz, it nonetheless presents a collective portrait of narcissism, conformity, and—the ultimate failing in the world of Sargent's portraiture—rigidity on the part of the High Command. Even the qualifier "Some" of the title seems to hint at a mocking indifference, a faint rejection of his subjects' collective self-aggrandizement.[23]

To be sure, most viewers at the time would not consciously have understood the work this way, and even today visitors to the National Portrait Gallery are more likely to be beaten into submission by the painting, if they notice it at all, than alert to its critical subtext (which a former director of the museum must have grasped when he unofficially referred to it as "Still Life with Boots").[24] All the same, by reducing Britain's best and brightest exemplars of tactical genius to yards of spit-polish gleam and mustachioed vacuity, this lifeless group portrait would easily have fit the new mood of skepticism toward the high and mighty put forward notably in 1918 by Lytton Strachey in his best-selling biographical skewering of the paragons he called, with mock veneration, *Eminent Victorians*. Moreover, it anticipates the scathing attack on military pomposity and incompetence Stanley Kubrick mounted decades

later in the classic antiwar film *Paths of Glory* (1957), which pits the enlisted men against the donkeys and decries the triumph of the latter.

Paths of Glory, based on an antiwar novel of the 1930s and filmed during the Eisenhower years, does not properly fit the time frame of this book. Still, it's worth noting that its contempt for the High Command (in this case French, rather than British) is made manifest in certain themes and stylistic features found in Sargent's much earlier pair of paintings. For example, Kubrick uses grandiose architecture and cavernous, reverberant spaces, with a lot of clicking of heels on marble, to characterize the generals as asinine boors (Fig. 80). He points to their moral impotence by associating them with "blind" seeing, as when they hatch vainglorious battle plans from the rococo drawing room of an eighteenth-century chateau or comfortably look on from a redoubt as a regiment follows their daft orders to attack an impregnable German position.

When a soldier court-martialed for failing to complete this impossible assault explains that he did not push forward into certain death when he could "see" that the attack had failed, the chief prosecutor dismisses the explanation with a phrase that Kubrick, already a master filmmaker, surely found loathsome: "This court is not interested in your visual experience." Standing before a firing squad at the climax of the movie, one convicted

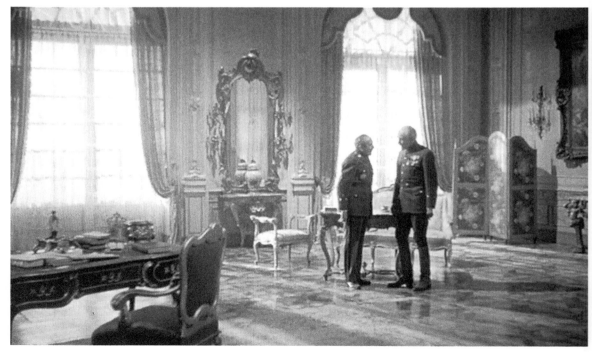

80. | Generals planning an attack, *Paths of Glory*, 1957.

soldier accepts a blindfold that has been offered to him, but another, bristling with defiance, does not. Instead, he stares with unrepentant and unforgiving eyes at the officer who unjustly accused him. In *Paths of Glory*, as in the paired Sargent paintings of three decades earlier, the leaders claim monopolistic privilege over the power of sight, but they are the ones least able to see.[25]

Gassed and *Some General Officers* are fundamentally opposite in every way: an exposed outside setting with declining sun and weapons of death in the distant sky, versus a safe and nondescript interior far from the field of battle; soldiers blinded by gas versus leaders blinded by ambition; men who intimately rest their hands on one another's shoulders, versus men who seem intent on shouldering their way in front of one another; a brotherhood of the weak and wounded, versus an assemblage of the proud and detached. The foreground of *Gassed* is littered with suffering bodies; that of *Generals* with beautifully polished boots.[26]

It is certainly possible to see *Gassed*, too, as a stiff and stodgy work, not all that different, finally, from *Some General Officers of the Great War*, despite the gulf between them in terms of empathy and tone. Classicizing and elegiac, *Gassed* can indeed seem to promote the romantic ideals of valor and self-sacrifice that had thrown these young men and their nation into the inferno in the first place, a sort of Rupert Brooke ode transposed to canvas. In other words, it can seem, by these lights, not a brief *against* chauvinistic blindness but rather a reassertion of it, an inflated formulation of the popular sentiment, still very much alive today, that, yes, war is hell, politicians liars, and generals idiots, but, all the same, those who heed their country's call are good, decent lads (and ladies) who deserve our fervent respect. The painting, in that regard, enjoins us to wring our hands over the pity of war but applaud with those same hands the warriors who fight it.

To its detractors, *Gassed* is full of hot air: gassy, one might say. It relies on outdated pictorial conventions and the socially conservative attitudes behind them, pandering with seductive surfaces and faux gravitas. In defense of the painting, the scholar John Thomas takes exception to this view. *Gassed*, he writes, "is the obverse of beauty and splendor. Sargent's lush Edwardian sensuality . . . is here turned to the service of the very opposite kind of image from that for which it had developed. The same qualities and skills are here seen to display the portrayal of suffering and death just as effectively as, previously, they had provided a lavish vision of opulence and grandeur."[27] In other words, Sargent drew on his phenomenal abilities and decades-long experience as a professional eye-dazzler to make as lyrical and touching an image as possible, the better to lure viewers in and smash their preconceptions about war, lowering their defenses, as it were, in order to provide a sharper sting.

One might go even further in questioning the notion that *Gassed* is a conservative, antediluvian work and consider instead not-immediately obvious structural similarities to the artistic and literary modernism that would seem to be its opposite. Because of its remarkable width and lack of centralized subject, *Gassed* is an afocal painting. One cannot take it in all at once; sightlines veer off in different directions, splintering vision.[28] The foreground roils with bodies twisted and prone, making it psychologically difficult for a viewer who stands before it in real time and space to assume a safe and comfortable vantage point. The painting incurs frustration, providing too many thwarted gazes, including those of the viewer, who is unable to peer into the eyes, and hence the minds, of the actors in this tragic tale. That is, the ubiquitous blindfolds that block light from the eyes of the wounded serve as well to hide their faces, thus depriving viewers of the optical plenitude typically afforded by panoramic scene painting. *Gassed* uses old-fashioned elegiac forms, but disperses, fragments, and serializes them, to put forward strikingly modern claims about the limitations of vision and failure of Cartesian certainty in an incoherent world similar to that which a few years later T. S. Eliot would call "the waste land."[29]

Despite these modernist destabilizers of meaning, Sargent's painting still comes across as a neoclassical dirge to an empire (and, likewise, an artist) in noble decline, as signified by that setting sun. Even so, it would be a mistake to write off *Gassed* as war-mongering by another name. Virginia Woolf, no friend of militarism in any form, saw it on exhibition at the Royal Academy in 1919 and believed that it "pricked some nerve of protest, or perhaps of humanity," in those who stood before it. She admired it for the pain it can provoke. Remarking on the comic pathos of the third soldier in line cocking his knee higher than necessary to negotiate the step he cannot see, she writes, "This little piece of over-emphasis was the final scratch of the surgeon's knife which is said to hurt more than the whole operation."[30]

In his recent study of the emotional intensity of trench life as conveyed by British poetry and letters from the front, Santanu Das finds *Gassed* an exemplary depiction of the "touch and intimacy" engendered among fighting men who might otherwise eschew these supposedly unmanly modes of caring for, and about, one another. In describing the halting forward motion of the men in line, Das says that the sense of touch, as conveyed by the painting, "defines space and guides the rhythm of their movement, as if new eyes have opened at the tip of the fingers."[31] Eyes in the fingertips: a nice way of remembering that there are other types of seeing, of vision, that do not rely on the conventional organs of sight. By thematizing blindness, the inability to see, or at least to see by conventional means, and by suggesting alternative modes of seeing, including those of touch and intimacy, *Gassed* proves to be one of the most complex and multivalent paintings by any artist from any nation to emerge from the cauldron of war.

THE GRANDFATHER OF WORLD WAR I feature films is D. W. Griffith's *Hearts of the World*, made in 1918. It was not the first film about the war, however. Hollywood had released numerous others in the early years of the fighting, holding a virtual monopoly on the subgenre because the war caused a cutback in European film production at this time. Before Griffith took on the subject, American-made movies about the Great War were relatively trite and straightforward as propaganda, whether in support of American neutrality early on (*Be Neutral* was one title, *Let Us Have Peace* another) or subsequently in favor of preparedness (*The Battle Cry of Peace* and *The Fall of a Nation*). By the time the United States entered the war, films such as the sentimental romance *The Little American*, with Mary Pickford, the German-baiting *Kaiser, Beast of Berlin* (audiences were encouraged to fling mud at the movie's poster), and even Charlie Chaplin's zany take on enlistment, *Shoulder Arms* (1918), reveled in, and thereby helped exacerbate, the anti-German consensus.

Griffith himself was by no means immune to militancy, as *The Birth of a Nation* demonstrates, albeit with a different enemy (Yankees rather than Huns). Yet as the self-conscious cinematic genius of his age, he wanted to examine the war in Europe with a depth and gravity not found in the work of any of his contemporaries. During a trip to London in April 1917 for the English premier of *Intolerance*, his follow-up feature to *The Birth of a Nation*, he received an invitation from propaganda minister Beaverbrook, who subsequently netted the painterly services of Sargent, to make an epic film set on the French front—with scenes to be shot there as well. The baron's powers of persuasion proved unnecessary, for Griffith jumped at the chance to make a war film using real war footage. As he told an interviewer after shooting some of that footage, "Promoters often boast of having made motion pictures for which the settings and actors cost a million dollars. The settings of the picture I took cost several billion dollars. . . . I think I will be able to make good the claim that I will use the most expensive stage settings that ever have been or ever will be used in the making of a picture."[32]

The problem, he soon realized, was not in gaining access to the front—Beaverbrook took care of that—but in coming up with a suitable narrative that would allow him to take advantage of this unprecedented opportunity to shoot a war film in the midst of a real war. Lloyd George, the English prime minister, went so far as to arrange a story conference between Griffith and the recently disgraced First Lord of the Admiralty, Winston Churchill, whose foolhardy Dardanelles campaign had turned out to be one of the greatest Allied blunders of the war. Eager to take a turn at Hollywood, Churchill brimmed with movie plots, but none of them suited Griffith.[33]

Searching for inspiration, Griffith traveled to Ypres with a British War Office cinematographer in May 1917. The film historian Kevin Brownlow describes the footage that resulted from this excursion:

The center of Ypres by 1917 has been so heavily shelled that the cathedral-like Cloth Hall has been blasted to a slender Islamic minaret. The other buildings, too, have been knocked into such extraordinarily delicate fingers of stone that there seems no way for them to remain vertical. Into this chilling scene steps a tall, jaunty figure in a smart tweed suit of English cut, a bow tie— and a tin hat. . . . Griffith, dressed for a grouse shoot, appears to be on a thoroughly pleasant afternoon outing in the midst of the bloodiest war in history.[34]

Returning to England, Griffith sent to Hollywood for his favorite star, Lillian Gish, who promptly came over to London with her comic actress sister, Dorothy, and their mother. According to Gish, though this has not been corroborated, they then sojourned for several months in war-torn France, where Griffith put his leading lady in front of the camera and shot a large amount of location footage, even though he still had not worked out a story. Gish recounts in her autobiography that he came back to the hotel one day after searching for new locations and reported that two of his guides had been killed in a German shelling. "During the six months we were overseas," she asserts, "Mr. Griffith made a film record of every type of armament and equipment used at the front. For once he was spared the task of research. He could film battle scenes as history staged them. He photographed actual infantry charges, men horribly wounded, men dying; the mud, the trenches, the machines of destruction."[35]

No evidence supports her claim. Griffith may have shot thousands of feet at or near the front, but, if so, the footage proved unusable. He ended up doing most of the shooting for the resulting picture, *Hearts of the World*, on the Hollywood back lot where he had filmed the famous Babylonian temple sequence for *Intolerance*. He also purchased previously unreleased documentary combat footage that became available and, passing it off as his own, deftly spliced it into his staged battle scenes. Ambiguously, the lobby card for the film boasts of "battle scenes taken on the battle fields of France by special permission of the British and French war office."[36]

In an interview, Griffith complained that modern warfare was simply not conducive to filmmaking: "Viewed as a drama," he said, "the war is in some ways disappointing." Like John Singer Sargent at almost the exact same time, the filmmaker found the front lines difficult, if not impossible, to render visually:

Everyone is hidden away in ditches. As you look out over No-Man's Land, there is literally nothing that meets the eye but an aching desolation of nothingness. . . . It is too colossal to be dramatic. No one can describe it. You might as well try to describe

the ocean or the Milky Way. A very great writer could describe Waterloo. But who could describe the advance of Haig? No one saw it. No one saw a thousandth part of it.[37]

Complaints about the difficulty of *seeing* the new kind of war from up-close were widespread, certainly among the combatants themselves, who hunkered down beneath the ground and risked losing their eyes every time they raised them above trench level. The French artist Fernand Léger, who was gravely wounded at Verdun, later recalled, "Nobody had seen the war—we lived hidden, concealed, stooped and the useless eye saw nothing." During those moments when it was safe to take a look, there was nothing to see, for all recognizable landmarks—trees, hills, vegetation, habitation—had been so thoroughly deformed or erased as to be utterly unrecognizable.[38]

But whereas Sargent did manage to find an objective correlative for the war in his painting of blinded soldiers, Griffith was unable to do the same on-screen. Despite the box-office success of *Hearts of the World* at the time of its release, when Americans hungered for a powerful and coherent cinematic narrative about the war that was claiming the lives of their sons, fathers, and brothers, the movie was a throwback to Victorian melodrama and offered no insight into the nature of war, this one or any other. As reprehensible and dishonest as *The Birth of a Nation* may be in its racial politics, it succeeds as a film narrative because everything in it is wrapped around a core concept grounded in historical reality, that is, that the Civil War was inextricably linked to the question of slavery. Unable to grasp why the Great War was being fought (and in this he was far from alone) and committed to an entirely uncritical view of the Allied cause, Griffith reduced the global conflict to a matter of oversexed Huns lusting for the maidenheads of French virgins.

On its re-release in 1921, *Hearts of the World* failed at the box-office. Audiences, which had rushed into cinemas to see it the first time through, no longer found its story credible, its spectacle engaging, or its emotions compelling. Four years later, however, they would be swept away by the first significant American war film—or, as many have claimed, antiwar film—to emerge from the European conflict. *The Big Parade*, based on an original idea by the novelist and playwright Laurence Stallings, who as a marine had lost a leg at Belleau Wood, showed war and its consequences with a realism not previously found in silent cinema. The director, King Vidor, had not fought in the war, but as a child growing up in Galveston, Texas, he had witnessed equivalent devastation wrought by the Galveston Hurricane of 1900. "Out of a population of twenty-nine thousand people," he wrote, "ten thousand were killed. All the wooden structures were flattened and laid waste. The streets piled high with dead people. It was an indelible experience. You can't fear extinction so closely without lasting effect."[39]

The second-highest-grossing motion picture in the history of silent cinema—*Birth of a Nation* ranks first—*The Big Parade* set the terms by which, forever after, the Great War has been visually imagined. The first half of the movie, concerned with a conventional pastoral romance between an American soldier and French peasant lass, offered nothing new, but stunning images of battle, mutilation, and mass murder punctuate the second half, and the pain suffered by the dying screams out of the cinematic silence. In a nighttime battle sequence, the young American hero ventures into no man's land to tend a wounded comrade who brays in agony. Too late to help his friend and taking a bullet in his leg, he collapses into a bomb crater. When a young German, barely more than a boy, is sent to finish him off, the hero shoots him at close range and grabs a bayonet for the coup de grace but hasn't the stomach for it. As the boy's life seeps away, the hero lights a cigarette for him and places it between his lips, only to finish smoking it himself when his adversary, now his hapless companion, expires.

Earlier in the film, like Griffith before him and countless filmmakers since, Vidor relies on the pathos of lovers wrenched apart by war to intensify the viewer's emotional investment in the narrative. His variation on this familiar theme remains one of the great sequences in the history of cinema. When the Frenchwoman discovers the young American's regiment has suddenly been called into action, she searches for him amid the ensuing dust and chaos, while the youth, refusing to leave before he can declare his love for her, is shoved by his friends onto a troop transport truck advancing to the front. Vidor edits the six-minute sequence with a complexity and verve that even Sergei Eisenstein admired, and its accelerating rhythms left audiences breathless and stunned, as the forces of history—the Big Parade, represented by the endless convoy—completely overwhelm the all-too-fragile flame of personal desire. The lovers unite, momentarily, as the soldier, spotting her at last, leaps from the rear of the slow-moving truck. They embrace in an apotheosis of passion, but an unsympathetic sergeant forces the man back onto the vehicle. In a delirious attempt to hold back history, the woman tugs with all her might on the truck as it grinds relentlessly into the future (Fig. 81).

Yet even when narrative film at its best manages to push viewers to understand wars as large-scale structural events that transcend personal subjectivity and volition, it still comes back almost always (Eisenstein's *Battleship Potemkin* being a rare exception) to individual agency, be it that of the foot soldier, the general, or the head of state. Narrative cinema inevitably resorts to Homeric views of war, but not in the sense that it necessarily portrays combat in terms of personal valor, for antiwar cinema (or literature, from Crane's *Red Badge of Courage* to Remarque's *All Quiet on the Western Front* and beyond) typically stresses the vanity and masculine insecurity that drive men to don uniforms and roust themselves to the battlefield. The war film

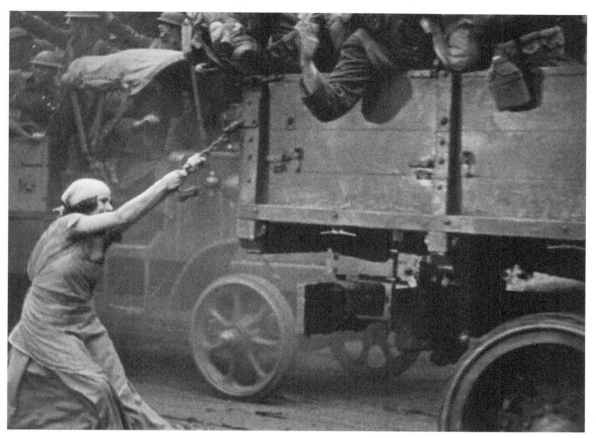

81. | Trying to hold back history in *The Big Parade*, 1925.

remains Homeric in the sense that it can never stray too far from reducing war to a matter of colorful, oversized, and at time agonized personalities in conflict.

As the war-film scholar Guy Westwell has noted, "Most of us are well aware that modern warfare is largely a matter of scientific, industrial and economic dominance through the deployment of air power, mass armies and hi-tech communications." Even so, he continues, "the cultural imagination of war hinges, in almost all its forms and especially in the war movie, on . . . 'archaic images of individual suffering and heroism' that maintain as their central object 'the fighting, running, resting, eating, laughing, dying soldier.'"[40]

THE AMERICAN STILL PHOTOGRAPHER EDWARD Steichen went to war in Europe to capture its personal face, but, even more than Sargent and Griffith, he ended up viewing it from a distance—a great distance, for he became one

of the pioneers of aerial photography. His photographs of the First World War contain no people at all, at least none that can be seen. Photographing from high above the field of battle, he rendered war impersonal and abstract, a matter of force and counter-force played out on panoramas vast beyond human scale or comprehension.

He had begun his career at the turn of the century as an artist-photographer who painted nocturnes in the mode of Whistler while making intricately composed and painstakingly printed photographs of flowers in luxuriant close-up, soaring buildings, fashionable women, and intrepid artists such as the aging sculptor Rodin, whom he venerated, and the Fauve painter Matisse. Sometimes, though not often, his photos had a critical edge to them, as in his notorious portrait of J. P. Morgan (see page 92). In those early years, he and Alfred Stieglitz led the Photo-Secession movement, in which photographers emulated impressionist painters and used devices such as soft-focus lenses, heavy filtering, and darkroom manipulation to convey a romantic, poetic view of the world. In 1905 they co-founded the Little Galleries of the Photo-Secession, which later became Stieglitz's Gallery 291.

By 1915, the two giant egos were no longer on the best of terms. Steichen could not or would not follow Stieglitz in his admiration for the latest in avant-garde abstraction. "The arrival of Picabia from Paris," he later recalled, "marked the beginning of an influx to New York of European artists and their champions, and the exhibitions [at 291] took on a different character." The Dada outlook of Picabia, Duchamp, and others left him cold: "I felt it was not a time for mockery and discouragement, and I took no part in the shows." Rather, with the world at war, he believed that he and his fellow artists "should broaden our work into something that could lead to our becoming a civilizing force in the world."[41]

The break with Stieglitz came with the sinking of the *Lusitania*. Steichen writes, "When Stieglitz said, 'It served them right. They were warned in advance that the ship would be sunk,' I decided then and there that I wanted to get into the war on the American side."[42] Determined to be the Mathew Brady of his generation, he went to Washington to volunteer his services. The government sent him to France and attached him to a British aerial photographer, who showed him the vital importance of aerial photography in the prosecution of modern warfare. Relinquishing his ambition to chronicle life and death on the blood-soaked battlefield in the manner of Brady, he took to the skies instead to record for Allied strategists the location of enemy gun emplacements and the topographic distribution of enemy troops.

Aerial-reconnaissance photography required that its practitioners achieve steady and precise focus with their cameras while bolting through the air in flimsy aircraft targeted by enemy artillery or fighter planes. Its demands radically altered Steichen's visual aesthetic (Fig. 82). "The wartime problem of

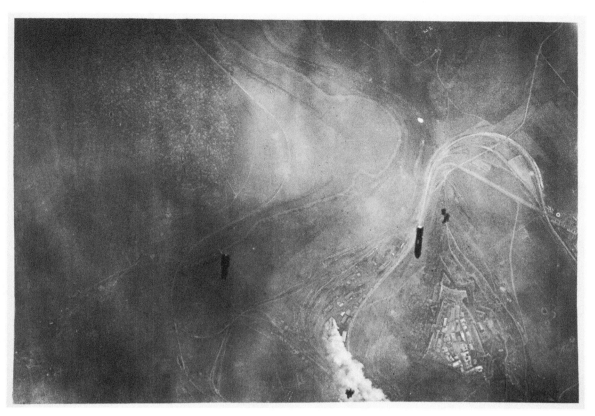

82. | Edward Steichen, *Aerial Bombs Dropping on Montmedy*, 1918. Art Institute of Chicago.

making sharp, clear pictures from a vibrating, speeding airplane ten to twenty thousand feet in the air," he later wrote, "brought me a new kind of technical interest in photography completely different from the pictorial interest" he had previously entertained.[43]

During the next world war and the cold war that followed, various social critics, among them the political theorist Hannah Arendt, pointed out problematic implications for the high-altitude and technologically enhanced seeing that Steichen extolled. "The fact that the decisive shrinkage of the earth was the consequence of the invention of the airplane, that is, of leaving the surface of the earth altogether," she wrote, is "a symbol for the general phenomenon that any decrease of terrestrial distance can be won only at the price of putting a decisive distance between man and earth, of alienating man from his immediate earthly surroundings."[44] Such philosophical or existential concerns would not have troubled Steichen and his associates. In the decade after the war, alienation—that is, a sense of extreme emotional isolation and social

dislocation—beset many war-veterans of the so-called "Lost Generation," Ernest Hemingway and Erich Maria Remarque among them. But during the war, most members that generation, as well as the previous generation, to which Steichen belonged, probably would have considered alienation from others, and from nature itself, a small price to pay for victory.

Taking usable pictures of the front lines from high above was only half the problem of successful military reconnaissance photography. The other half was deciphering the pictures correctly when they emerged from make-shift darkrooms in the field. Ironically, aerial reconnaissance photography necessitated interpretive skills that were not entirely unlike those needed for understanding abstract art. In both cases, a naive reading would not do; the eye, as well as the brain, had to be trained to recognize tangled, nonrepresen-tational patterns and make sense of them, imposing some sort of conceptual order on what to the untrained eye and brain appeared to be disorder, non-sense. To see through the "mess" of a patch of landscape photographed in black and white from fifteen to twenty thousand feet at a precipitous ninety-degree angle, that is, without any oblique lines or stabilizing horizon, the viewer needed to abandon common-sense ways of seeing and replace them with highly sophisticated means of deciphering complex geometric forms.[45]

Moreover, the very young art of aerial reconnaissance photography, which hardly existed before 1914, was constantly being thwarted by a much older military art, camouflage (from the French verb *camoufler*, to disguise). During the French and Indian War in the 1760s, irregular units of scouts or rangers wearing lightweight apparel colored in dark shades of green and brown emerged from the dense woodlands of North America to launch sur-prise attacks on enemy troops. In mid nineteenth-century India, British sol-diers dyed their red tunics a muddy tan color, called *khaki* (from the Urdu word for "dusty"), in order to elude sniper's bullets. The study of camou-flage as a military tool began in earnest with the advent of the World War, as general staffs on both sides of the conflict appointed visual artists, set design-ers, optical scientists, botanists, and zoologists to the task of devising meth-ods of hiding tanks, troops, artillery, and so forth from the eyes of the enemy. In the words of Steichen's British colleague, "The battle between the camera and camouflage was on."[46]

Steichen was so obsessed with winning this battle that he would lie awake far into the night thinking about how to see through enemy camouflage, and even in his dreams he struggled to figure out "how to spot the enemy's posi-tions, how to knock hell out of the opposition and tear the living guts out of him."[47] Only later, when the war ended, did he stop to think about the consequences of his actions, and then he was overcome with grief for what he had done: "The whole monstrous horror of the war seemed to fall down on me and smother me. I smelled the rotting carcasses of dead horses....I had

never had to come face to face with another man and shoot him and see him crumple up and fall, yet I could not deny to myself having played a role in the slaughter."[48]

It did not take him long, however, to emerge from the depression that ensued. Soon he embraced the photographic profession with renewed vigor, taking the plunge into "straight" (as opposed to painterly or manipulated) photography. He dedicated himself to technical experimentation, delineating animate and inanimate objects alike with the microscopic or hyper-precise detail that the close analysis of aerial photography had taught him to appreciate. His mastery of realist technique carried over into portraiture, and he was suddenly very much in demand. In the 1920s, portraying celebrities for *Vanity Fair* and fashion models for *Vogue*, he reigned over New York as the highest-paid contract photographer in America. In 1955, as the curator of photography at the Museum of Modern Art, Steichen organized what was then and to this day remains the most widely seen photography show in history. This was *The Family of Man*, which after leaving MoMA traveled to venues around the world and sold millions of copies in a fully illustrated book, which continued to be a best-seller long after the touring exhibition ended. The point of the show, now often regarded as the acme of Cold War propaganda, was to affirm the unity of mankind: Babies were the same everywhere, so were teenagers and young lovers and loving parents and farmers and fishing folk and age-wizened grandparents. We are all one people, *The Family of Man* proclaimed, and our world one world.

It was a nice sentiment, but observers on the left faulted it for ignoring or papering over with falsely reassuring pictures the many rifts of class, race, sex, region, and national interest that made living in the thermonuclear era a dire enterprise for millions. In a sense, *The Family of Man* was of a piece with, an outgrowth of, Steichen's aerial photography during the First World War. It offered an Olympian view of the globe far below, showing patterns and similarities of human activity across a broad reach, this time with the purpose of celebrating humanity rather than training weapons of war on it. Still, by minimizing social, economic, and geographic differences between people in a way that soothed, rather than honestly addressed, Cold War disparities, the popular exhibition performed its own highly convincing act of camouflage.[49]

IN WARTIME, ACCORDING TO THE CONTEMPORARY PHILOSOPHER Judith Butler, representations of the "evil" Other—enemy soldiers, their leaders, even their civilian populations—dehumanize those who are depicted. Inadvertently, though, such representations dehumanize us, too, by herding

our emotions into narrow channels and swelling our heads with unmerited presumptions of moral superiority. The opposite tactic, hero worship, also dehumanizes us. It does so by encouraging us to project our small, limited selves onto a larger-than-life, self-sacrificing fantasy figure and, in doing so, expand "our own ego boundary ecstatically into that of the nation." Triumphalist images such as these puff us up, seductively offering self-inflating identifications that feed national hubris and put us out of touch with our own personal and collective weaknesses and flaws.[50]

A better, more realistic and ethically honest war representation, she contends, reveals the underlying agony of our condition. A *critical*, as opposed to triumphalist, war image strengthens identification, not between spectators and wish-fulfillment heroes, but between spectators and war's abject victims, regardless of which side they are purportedly on. A morally justifiable war image, Butler proposes, insists on the precariousness of human existence. Such an image makes us hear "the agonized cry" of the Other, including that of the enemy. We should heed this cry, not to absolve aggressors of their guilt, but rather to stay alert to own complicity in aggression and injustice, so as not to absolve *ourselves* without proper self-examination.

Bellows, Sargent, Griffith, and Steichen would probably have imagined that their representations of war passed the ethical test presented by Butler, who was writing nearly a century later, during the war in Iraq. Their respective war scenes showed human suffering (of Belgians, blinded British soldiers, and French villagers) and the obliteration of the landscape. But in at least three of the instances (Bellows, Griffith, and Steichen), the images were themselves acts of anger or violence against a declared enemy. As such, they were triumphalist, for they implicitly favored "their" side over that of the adversary. *Gassed*, however, seems to have a more complicated moral profile. Yes, it came out of Sargent's eventual compliance with Baron Beaverbrook's request that he serve his adopted country as a war artist, and, yes, it shores up the ancient Roman creed expressed in Horace's ode *Dulce et decorum est pro patria mori* ("It is sweet and fitting to die for one's country"), the lofty phrase that Wilfred Owen had quoted and mocked in his poem about death by poison gas.

And yet, by looking so closely at blindness, at the impossibility of seeing everything—of knowing whom to follow and where to step and how big or small a step to take—the painting transcends patriotic cant and sentimental pity. It encourages us, if we are willing to set aside for a moment our condescending assumptions about Sargent as a retrograde or non-innovative artist, to imagine these long lines of maimed soldiers extending across no man's land to the other side of the trenches, and even beyond, to entire populations of civilians starved, wounded, and blinded by the war.

7

BEING THERE

IN 1922, FOUR YEARS AFTER the armistice, Willa Cather published *One of Ours*, a novel about the First World War. The book tells the story of a young farmer from Nebraska, Claude Wheeler, who leads a futile and disappointing life until he joins the army, ships to France, and achieves manly apotheosis in his self-sacrificing death under enemy fire. In 1923 *One of Ours* won the Pulitzer Prize for fiction, taking precedence over Sinclair Lewis's controversial *Babbitt*, a lampoon of American business. Applauding the choice, the *New York Times* praised Cather's novel for showing the recent war to have had a discernible "object," that is, a meaningful purpose. That Cather herself had not been within three thousand miles of the front did not seem to matter in terms of the book's verisimilitude: "She knows as well as any of them [the recent crop of antiwar writers, none of whom is named] that war has 'horrors,' and doubtless she hates it as much as any of them; certainly she does not laud it as among the more commendable of human activities. But she is as little of a pacifist as of a militarist."[1]

Ernest Hemingway, one of the new writers alluded to, privately ridiculed Cather's book. In a letter to his friend Edmund Wilson, the literary critic, he remarked, "Prize, big sale, people taking it seriously.... Wasn't that last scene in the front lines wonderful? Do you know where it came from? The battle scene in *Birth of a Nation*.... Poor woman, she had to get her war experience somewhere."[2] H. L. Mencken made similar claims about the authenticity of Cather's depiction: "The war [she] depicts has its thrills and even its touches of plausibility, but at bottom it is fought out, not in France, but on a Hollywood movie-lot."[3]

A notable American author of an earlier generation would have disputed this view that only eyewitnesses to warfare can depict it honestly. Henry James claimed that a writer—or, by implication, a visual artist—need not

experience something firsthand in order to portray it convincingly and with insight. He himself often wrote from the point of a view of a female protagonist. A true artist, said James, has the "power to guess the unseen from the seen, to trace the implication of things, to judge the whole piece by the pattern" and can therefore, even without direct involvement, know more about a situation than someone who was actually there. "The young lady living in a village has only to be a damsel upon whom nothing is lost to make it quite unfair . . . to declare to her that she shall have nothing to say about the military."[4]

Ironically, Hemingway's signal contribution to World War I literature, *A Farewell to Arms* (1929), was not written from firsthand experience; his artistry simply made it seem that way. The book's famous depiction of the chaotic retreat of the Italian army after its defeat at Caporetto was not based on direct observation. It was based instead on his studious reading of primary and secondary sources, careful perusal of maps, and conscientious borrowing from previous war authors whom he admired, such as Stendhal and Stephen Crane. He witnessed none of the events described, and the first time he saw the mountainous terrain he recreates so brilliantly in his prose was more than a decade after the book was published. Laying out copious evidence, the Hemingway scholar Michael Reynolds has shown that the novelist "went back to someone else's front and recreated the experience from books, maps, and firsthand sources. It is his only novel set on terrain with which he did not have personal experience: In it, his imagination, aided by military histories, has recreated the Austro-Italian front of 1915–1917 more vividly than any other writer."[5]

Harvey Dunn and Claggett Wilson, two professionally trained artists who have long since been forgotten, might have satisfied the moral-aesthetic dictates of both Hemingway and James. Each served on the front lines in France and each was well-equipped with powers of observation *and* imagination; they were participant-observers upon whom nothing was lost. Begun as sketches on the battlefield but not completed until months or even years after the fighting ended, their respective bodies of war-related art are rich in complexity and dark in nuance. Neither provides a straightforwardly factual and prosaic chronicling of daily life at the front, as found in the work of other artist-reporters who were stationed there. Their work is also different from that of the many artists who stayed home and compensated with flag-waving, chest-puffing, and totally imaginary paeans to American military prowess. The eyewitness art that both Dunn and Wilson produced by way of firsthand observation and subsequent recollection—albeit not in Wordsworthian tranquility—provides today's viewer an unparalleled opportunity to see the war from the *perspective* of seasoned artists who made their initial sketches, though not their completed paintings, while under fire.[6]

The same holds true for a third witness-artist, also little-known today, the sculptor Gertrude Vanderbilt Whitney. Unlike the other two, she did not set foot on the battlefield and find bullets whizzing past her head, but, as the founder of a field hospital in France in late 1914, she too saw the carnage with her own eyes and heard the cries of the wounded with her own ears. Her sojourn in the war zone was far briefer than that of either Dunn or Wilson, but it left its mark on her, too, long after the cannons had ceased to roar.

IN 1918, EIGHT CIVILIAN ILLUSTRATORS were inducted as captains in the American Expeditionary Forces. The job of the so-called "AEF Eight," as they were known, was not to fight but to sketch and paint. They were not asked to create propaganda art, a task that the poster designers back home had well in hand. Instead, their job was to portray with as much authenticity as possible the daily life of the American soldier at the front. In modern-day terms, they were embedded journalists. They were quartered with the troops and allowed to roam the front lines, looking for subjects to depict, but they were specifically ordered to stand clear of combat. This was not for their own safety but that of the soldiers who bore arms. General John J. Pershing, commander in chief of the AEF, asserted "It is out of the question to have any artist at work in front line trenches or anywhere near them during active engagement."[7]

The best-known member of the AEF Eight was Harvey Dunn, a tall, strapping, former farm boy from the Great Plains—ironically, the same milieu that produced Willa Cather's Claude Wheeler. Dunn studied at the Art Institute of Chicago in the early 1900s and, moving to Delaware, became an avid follower of the adventure-book author, illustrator, and art educator Howard Pyle. After Pyle died in 1911, Dunn carried on his inspirational teaching by establishing an art academy of his own. When America declared war on Germany, Dunn was too old to enlist, but as soon as the AEF art program was announced, he volunteered his services. At age thirty-four, leaving behind his wife and two small children, he headed to France, determined to use his skills to show the war "as it really is" to those who would never see it for themselves. He would be their eyes on the ground, conveying pictorially "the shock and loss and bitterness and blood of it."[8]

Dunn was a fast-working artist who sketched multiple scenes of doughboy life, most of them from a vantage point that appears to have been remarkably close to the action, despite Pershing's explicit orders that the AEF artists maintain a safe distance from the battlefield. He portrays men in trenches, men firing machine guns, snipers occupying lonely outposts, and stretcher-bearers risking their lives to retrieve the wounded from no man's

land. He worked in charcoal, rather than the more stable but painstaking medium of pen and ink, so that he could set down his impressions in a rapid-fire manner. To that end, he devised a large flat wooden box containing an unbroken roll of sketch paper that he could advance with a turn of the knob, thus enabling him to bring forth a fresh drawing surface as quickly as needed.

Dunn's most famous AEF drawing, reproduced in books and on dust jackets, is *The Machine Gunner* (1918) (Fig. 83). It gives us a rough-tough Army doughboy, or the Marine Corps equivalent, a leatherneck; it's hard to say which branch is being represented, because the combat uniforms were essentially identical at the time. The gunner stands his ground with his sturdy hands planted firmly on hips girded by an ammunition belt. Turned in three-quarters profile, his prominent jaw jutting forward, he sizes up the task before him with rock-solid focus. Dunn, who was tall and physically imposing, probably used himself as the model for this stalwart man of war.[9] A portrait of pragmatic bravery, it's drawn with panache appropriate to the everyman being portrayed: raw-boned, manly, devoid of vanity or self-concern, but full of flair, nonetheless. It glamorizes its subject by eschewing glamour. Here is a man with a job to do and the grit to get it done, like the legendary lawman of film and fiction about the Old West. It told Americans what they wanted to hear, see, and believe about the heroes of their adventure abroad. Conspicuously, the machine gunner is shown without his gun, perhaps as a way of reassuring viewers back home that Americans, unlike their German counterparts, were not cold-blooded killers.

Dunn's fellow AEF artists resented his swaggering self-confidence and need to call attention to himself. One of them, Harry Townsend,

83. | Harvey Dunn, *The Machine Gunner*, 1918. National Museum of American History.

wrote, "This pose of Dunn's of having seen more of the actual fighting than any one of the rest, and of being the only one who has really gone over the top, is unbearable, sometimes." Despite the posturing that annoyed his colleagues, Dunn's visual rendering of the war was generally more compelling than theirs. As the combat-art historian Kevin Louis Nibbe concludes, "If one decides that war is what men feel when they fight and war art is measured by what people feel when they view it, then Dunn is by far the best AEF artist."[10]

The more Dunn saw of the war and its effects on the minds as well as the bodies of combatants, the less satisfied he was to portray them as larger-than-life heroes. His change of heart had ramifications. The cultural historian Steven Trout suggests that Dunn failed to please his sponsors in the War Department because his work increasingly de-heroicized the American soldier and occasionally committed the even graver sin of making the enemy humane, and thus worthy of sympathy. *Prisoners and Wounded*, painted in October 1918 during the Meuse-Argonne campaign, shows a mixed company of wounded doughboys and captive German soldiers trudging beneath a wet gray sky (Fig. 84). Trout calls this Dunn's masterpiece, a painting "that explodes from its frame with brutal honesty and power." The rendering

84. | Harvey Dunn, *Prisoners and Wounded*, 1918. National Museum of American History.

85. | Harvey Dunn, *The Sentry (In the Front Line at Early Morning).*
1918. National Archives and Records Administration.

suggests that, regardless of their uniform or the nation for which they
fought, combat soldiers were alike in suffering the same fatigue, sadness, and
bewilderment. "Nothing," Trout notes, "could have been further from the
kind of art that the War Department hoped to receive from Dunn." In an-
other painting, mordantly entitled *Harvest Moon,* enemy cadavers litter a
moonlit battlefield like mown-down wheat. They are pitiable victims of the
Grim Reaper, not its evil agents. In death, all that distinguishes them from
their American counterparts is the shape of their backpacks and contour of
their helmets.[11]

In this regard, *Harvest Moon* expresses a concept articulated by the lit-
erary scholar Elaine Scarry, who points out that in war all severely injured or
dead bodies are alike beneath the superficial distinctions provided by their
uniforms and the partisan flags under which they fell: "When the Irishman's
chest is shattered, when the Armenian boy is shot through the legs and groin,
when a Russian woman dies in a burning village, when an American medic is
blown apart on the field, their wounds are not Irish, Armenian, Russian, or
American," Scarry observes. The lifelong socialization that inculcates a person

with the values and perspectives of his or her national order is summarily undone by death, which constitutes, in this regard, "the unmaking of ... civilization as it resides in each of these bodies."[12]

At the end of the war, Dunn fell into a funk. Coming home was painful and anticlimactic for him, a let-down from a time that had been enormously productive and exciting—but which also, given the suffering he had seen, left him emotionally depleted. His former goal of becoming America's number one commercial artist now seemed empty. He wanted to succeed as a fine artist instead. Specifically, he wanted to convert his unfinished sketches of the war into a coherent body of paintings. To this end, he

86. | Tom Lea, *The Marines Call It the 2000 Yard Stare*, 1944. U.S. Army Center of Military History.

looked to the army to fund his plan, but, with the war ended, the army no longer needed artists. Army officials allowed Captain Dunn to return to the United States with a trunkful of military souvenirs—helmets, rifles, trench shovels, defused hand grenades—to use as props in studio recreations of the combat he had witnessed, but he got little more from them than that, no subvention for more war paintings or an instructorship at the war college in Pennsylvania.

Continuing to earn his living as an illustrator and private teacher, whose students revered him, much as he had Pyle, Dunn put aside the war as his chief subject matter and turned instead to memories of his youth in the Dakota Territory. He painted a series of beautiful, sun-drenched scenes of American frontier women, their sleeves rolled up, carving a hardscrabble existence for themselves and their families amid windswept fields strewn with rocks and wildflowers. This was a world similar to that portrayed in Cather's novels of the Great Plains such as *O Pioneers!* (1913), *The Song of the Lark* (1915), and *My Ántonia* (1918), in which life on the prairies, for all its hardship and heartache, unfolds among landscapes of primal beauty.

87. | Harvey Dunn, cover image for *American Legion Monthly*, April 1937.

In 1928, the editor of *American Legion Monthly* asked Dunn to become the lead illustrator of the magazine, which was booming in circulation. The American Legion had come into existence in 1919. A decade later its ranks were thick with veterans of the First World War.[13] American Legion posts, segregated by race as well as gender, sprang up in cities across the United States. They were havens for ex-soldiers, who could always hope to find in their precincts a version of the male camaraderie that was probably the only thing about trench life they missed. As a powerful lobby organization, the American Legion, founded by Theodore Roosevelt, Jr., was politically and socially conservative, but its local posts were anything but Sunday schools for grownups. Among themselves, out of the public eye, legion members gathered to play cards, smoke cigars, shout raucously at stag films, and exchange war stories.[14]

The invitation to provide art for the Legion's monthly magazine suited Dunn perfectly, as it gave him the opportunity, the psychological pretext, he needed to return to his war sketches and convert them into oil paintings. What was emotionally salving for the artist proved to be for the magazine's readers as well. Over the next ten years, including throughout most of the Great Depression, Dunn supplied the publication with bright, vivid, lovingly detailed memory/fantasy scenes of doughboys, leathernecks, and sailors serving their country with commendable bravery. His images afforded tens of thousands of AEF veterans across the country a safe and satisfying means to "relive" or "remember" their glory days in France. Dunn's paintings of action on the western front were as nostalgic as his recollections of the Dakota plains. They pictured war not as it was, at least not as envisioned in the sketches and paintings he made at the front, but as it appeared in the minds of fellow veterans looking back, some ten or twenty years later, from a present that was anything but sanguine.

The most telling contrast between Dunn's work as a frontline artist and his reworking of those earlier images for the *American Legion Monthly* can

be seen in a comparison of his wartime painting *The Sentry* (also known as *In the Front Line at Early Morning*) (1918) to his cover painting for the April 1937 issue of the magazine. *The Sentry* shows a thin, almost gaunt American soldier nervously stationed in a hole in the ground, his Springfield rifle set before him, its bayonet fixed, ready for use (Fig. 85). The earth is caked and dry, with patches of sharp, scruffy weeds adding to the general inhospitality of the setting. Eight hand grenades are neatly arrayed beside his rifle, six of them American "Mills bombs" and two of them German stick grenades, humorously referred to as "potato mashers" because of their resemblance to the kitchen utensil. Gazing straight ahead, the whites of his eyes gleaming beneath the brim of his helmet, the young soldier at first appears to be steeled for action.[15]

On closer inspection he seems lost and dazed. The look in his eyes suggests not so much determination as alienation. Soldiers referred to this as a "thousand-yard stare." During World War II, *Life* magazine upped the yardage, designating this distressed and dislocated look the "two-thousand-yard stare." In a feature article on the battle for Peleliu, a Pacific island, *Life* reproduced combat artist Tom Lea's oil painting *The Marines Call It the 2000 Yard Stare* (1944) (Fig. 86). In the foreground, a dark, stubble-cheeked G.I. peers out from under the brim of his dented helmet with a blank, distracted gaze while heavy artillery rips into the jungle behind him. Smoke churns the sky and fighter planes careen overhead. The caption reads, "Two-thirds of his company has been killed or wounded but he is still standing. So he will return to attack this morning. How much can a human being endure?"[16] Dunn's 1918 stunned doughboy anticipates Lea's 1944 leatherneck.

When Dunn repainted *The Sentry* for *American Legion Monthly* nearly two decades later, he narrowed the field of view, removing the inhospitable terrain around the doughboy (Fig. 87). He made the outpost stronger, more protected, and gave the fighter a larger number of grenades at his disposal—five potato mashers instead of two. The doughboy himself seems stronger, both physically and mentally, his neck thicker, shoulders broader, and face stouter. The vacant stare is less overt in the later image; indeed, much to the contrary, it can now be understood as the look of determination or, more sentimentally, as the distant gaze of a youthful soldier thinking of his loved ones back home. In any case, it no longer betrays temporary or incipient mental sickness on the part of the isolated fighter.

In the end, Dunn never became the independent, self-sustaining war artist he yearned to be, for his war scenes were always made on commission: that of the United States Army for his first go-around and the American Legion for his second. Either way, his vision was compromised by the needs of his clients.

He had to temper what he saw with what he believed to be the implicit demands of those who hired him to do the seeing. In that regard, Dunn's work, both during the war and a decade or so later, puts paid to the simplistic notion that eyewitness art about war is necessarily more "truthful" than art made without the benefit of firsthand experience.

Unlike Harvey Dunn, the soldier-artist Claggett Wilson came to France not to draw but to fight. He didn't make art on commission. He painted for himself. His goal in doing so was not to sell art or achieve acclaim, though both of those, no doubt, he would have liked. He painted instead to clear his mind of the terrible things he had seen.

THE GREATEST VISUAL ARTIST, ANYWHERE, to emerge from the killing fields of the First World War was the German painter and printmaker Otto Dix. An artillery gunner who fought at the Somme and then on the eastern front, Dix gathered his scathing memories and torturous nightmares of the war into a 1924 portfolio of fifty etchings that he entitled *Der Krieg ("War")*. These are modernist masterpieces, violent, acerbic, dowsed in bitterness, and yet also sublimely beautiful, even in their embrace of wretchedness. A monumental triptych that he also entitled *Der Krieg* (1929–1932, Albertinum Museum, Dresden), painted in the style of the Old Masters, is one of the most blistering summations of war imaginable; no wonder the Nazis labeled Dix a "degenerate" artist and sought to burn his paintings.[17]

Late in life, Dix tried to explain his motivation for joining the army at the earliest opportunity and searching out danger at the front. "I had to see it for myself," he said, switching back and forth between past tense and present: "I am a realist to such a degree that I have to see it with my own eyes to be able to confirm that it is how it is." In the face of an artillery barrage, he recalled, "The further you advanced, the less afraid you were. And at the very front, you were not afraid at all anymore!" With the pursuit of artistic excellence trumping all else, including his own personal safety, he had wanted "to experience how someone beside me suddenly falls over—done—and the bullet has hit him squarely. I had to experience all that closely.... I had to see all that with my own eyes.... I have to see everything. All the depths of life I have to experience myself, this is why I go to war. This is why I volunteered."[18]

World War I did not produce an American artist of Dix's brilliance and depth, but Claggett Wilson was the closest equivalent. As a second lieutenant in the Marines, Wilson fought in the Battle of Belleau Wood in June 1918 and was severely wounded. He was cited for bravery under fire. After the armistice, while posted on the Rhine in occupied Germany, he painted a portfolio of battle scenes and hospital vignettes from Belleau Wood that measure up to Dix's later war etchings in terms of creative freshness and intensity.

Unfortunately, the portfolio was lost in transit when Wilson returned from Germany in April 1919 and never recovered. The following summer and fall, in a white hot flash, he repainted two dozen of the lost works, and these simulacra of the original watercolors are all that remain of his war scenes. They are memories of memories: recreations of earlier recreations of disturbing occurrences that he saw or feared seeing or wished he had not seen while serving at the front.[19]

The unabashedly mediated nature of these works, their unmistakably filtered quality, their uneasy and at times awkward balance of realism, romanticism, and expressionistic modernism, makes them unique as "windows" on the American expeditionary experience. Unlike virtually all other American artists who served at the front, Wilson possessed credentials as a bona fide modernist. After receiving instruction at the Art Students League in New York, where he studied with the Uruguayan-born figurative painter F. Luis Mora, he moved to Paris in 1910 and enrolled at the Académie Julian, known at the time for its advanced outlook in the arts. It had been the training ground for Nabi ("prophet") artists of the previous generation such as Maurice Denis, Pierre Bonnard, and Félix Vallotton. The Nabis favored simple designs, dynamic compositions, sharp lighting contrasts, and broad flat planes of vibrant color, sometimes thrown together in jarring juxtapositions. Their late nineteenth-century modernist style, inspired by the work of Paul Gaugin, had an obvious impact on Wilson's war scenes, which he painted about half a dozen years after his departure from the academy.

More recently, the Académie Julian had turned out artists of the cubist generation such as Fernand Léger, but cubism itself does not seem to have caught Wilson's attention. He did, however, absorb lessons from the Italian futurist and German expressionist art he encountered during his extended travels in Europe. On his return to the United States in 1912 he was hired as an art instructor at Columbia University's progressive Teachers College, which was favorably disposed toward modern art. One of his paintings, now lost, was exhibited at the Armory Show in 1913. Four years later, in April 1917, he showed work in the Society of Independent Artists exhibition—the same one from which Duchamp's *Fountain* was rejected.

With the declaration of war, Wilson enlisted in the Marines. This put his artistic career on hold, but, as he wrote to a colleague at the Teachers College from "somewhere in France" in March 1918, everything he saw and did as his unit approached the front was fodder for his imagination. Daily life near the front had already given him "a new and certainly stronger vision than ever I thought I should have." Not unlike Otto Dix on the other side, he was certain that the "scourging purification" of combat, once faced, would enhance his artistic vision in the future—if, that is, he survived.[20]

This was not a given. At Belleau Wood, he was drenched in poison gas and spent three hellish days stranded in no man's land before he could be

88. | Claggett Wilson, *Runner through the Barrage*, 1919. Smithsonian American Art Museum.

evacuated to a hospital in Dijon. Injury is the primary motif of Wilson's war paintings. It appears in multiple forms. He repeatedly, almost obsessively, shows the wounding of bodies, landscapes, and minds—sometimes all three at once. *Runner through the Barrage*, for instance, presents a slender, blue-eyed young American soldier standing in the midst of a forest, the whites of his eyes conveying a blank, unseeing gaze (Fig. 88). All around him, trunks and limbs have fallen.

The soldier has lost a limb of his own. It hangs lifelessly at his side. The title identifies him as a runner; that is, a soldier assigned the task of conveying messages from one sector of a battlefield to another. Runners had notoriously dangerous assignments, for they were exposed more than others to enemy fire. This runner does not run. He has stopped in his tracks. With Hemingwayesque understatement, but almost a decade before Hemingway became known for a similarly laconic means of expression, Wilson captioned the painting "Bois de Belleau, Château-Thierry Sector. His arm shot away, his mind gone."

Interlocking geometries fix the runner in place. Two slim tree trunks hem him in, while other trunks, blasted by artillery, have collapsed at diagonal

angles, forming a series of chevrons that converge on his body. The serrated edges of the shattered trees and tree limbs form hand-like shapes that reach out toward him. In their plaintiveness, they betray a vulnerability, a cry for help, that the shell shocked boy seems incapable of uttering on his own. These arboreal forms, recalling amputated arms and hands, recur in many of Wilson's paintings, most of which, after all, are set in Belleau Wood, the site of the longest, most intense, and bloodiest Marine Corps battle of the war.

Wilson does not commit the so-called "pathetic fallacy" of ascribing human-like emotions to the severed trees and ravaged hillsides of his paintings. All the same, these motifs drive home the environmental destructiveness of the First World War. In this regard, he shows himself to be an heir of early nineteenth-century Romantic landscape painters such as Caspar David Friedrich, a German who endowed deep, dark forests with spiritual animism, and Thomas Cole, founder of the Hudson River School, who typically included in his resplendent panoramic views a so-called "blasted tree" in the foreground as a reminder of human mortality. Among Wilson's contemporaries, the artist who most shared his sense of the forest as a living, writhing, suffering force was the visionary watercolorist Charles Burchfield, who did not serve in the army during the war but similarly concerned himself to show nature in distress by means of windblown trees and tortured, upturned soil.

In one of Wilson's more delicate watercolors, *Early June Morning— Bois de Belleau*, the sun slants through slender trees to find a German sniper hanging upside down from a treetop (Fig. 89). The caption reads: "Sniper who had been potted during the night." At either side of the dead soldier, trees have been blasted; they too have been "potted." Wilson would have known the work of the late nineteenth-century nature painter Winslow Homer, who began his career as an art-journalist during the American Civil War. One of Homer's earliest successes as an artist, reproduced as an engraving in *Harper's Weekly* magazine, shows a Union sharpshooter poised in the treetops, his legs stretched out for balance, as he carefully takes aim at an unseen target with a rifle that extends from his body like a prosthesis. *Early Morning—Bois de Belleau* effectively "speaks" to Homer's *Sharpshooter*; it upends it or de-romanticizes it or, at the very least, engages in dialogue with it.

The terseness of Wilson's caption anticipates Hemingway's brief dramatic monologue from *In Our Time* (1925), in which the unidentified first-person narrator, an army sniper, says with little ado, "We were in a garden at Mons.... The first German I saw climbed up over the garden wall. We waited till he got one leg over and then potted him. He had so much equipment on and looked awfully surprised and fell down into the garden. Then three more came over further down the wall. We shot them. They all came just like that."[21] The matter-of-factness of this recitation suggests either a complete

89. | Claggett Wilson, *Early June Morning—Bois de Belleau*, 1919.
Smithsonian American Art Museum.

absence of emotion on the part of the man who "potted" (sent to burial)
other men or, to the contrary, a depth of emotion that is too difficult to coun-
tenance and thus in itself requires potting.

If each of Wilson's watercolors combines in some manner American-
style realism with fin-de-siècle European modernism, the painting that is
most clearly marked by the anti-naturalistic and emotionally expressive dic-
tates of the latter school is *Flower of Death* (Fig. 90). Depicting the impact of
an explosion on the surrounding landscape, the painting throbs with violent
energy. Its strongest stylistic resemblance is to Italian futurism or its English
variation, Vorticism. Wilson's caption, written on the back, explains: "The
bursting of a heavy shell—not as it looks, but as it feels and sounds and
smells." On the right side of the painting, a sheet of corrugated metal, per-
haps a fragment of roof, blows by with propulsive force. Rays of light from
the explosion pierce through the small apertures that perforate the metal.
Elsewhere smoke and cinders pollute the brilliant white, yellow, and orange
tones of the explosion. The concentrated light rays and sweeping vectors of
color call to mind *Explosion* (1916) by the Vorticist Christopher Nevinson

90. | Claggett Wilson, *Flower of Death*, 1919. Smithsonian American Art Museum.

and *Verdun, an Interpreted Picture of War* (1917) by the Nabi artist Félix Vallotton, but, typically for Wilson, his version of an explosive sky includes the human element, whereas Nevinson's and Vallotton's more distinctly impersonal works do not.

In the lower left foreground, a strangely distorted, bare-chested man seems to be carrying another equally distorted comrade on his back, their skin blanched and gray. Above them the top of a ridge is coiled in barbed wire, a signifier of the war's destructive brutality. And yet, in a disorienting or, if you will, defamiliarizing manner, the barbed wire's delicate filigree echoes the churning smoke as it pours into the sky. Wilson thereby transforms barbed wire, an icon of ugliness, into a thing of beauty. The semi-human figures at the bottom of the ridge are not fully recognizable as men because they too are part of the overall deformation and disintegration that the painting portrays.

The Baudelarian title that Wilson gave the work, *Flower of Death*, seems ironic at one level, for this scene of nature's devastation is anything but floral, but almost literal at another, for the painting depicts death's flowering or effulgence. War, as generations of artists and filmmakers have known, can be visually beautiful, or, more properly stated, sublime, and

Wilson won't deny this. He uses modernist techniques to convey the simultaneous repulsion and attraction of "the battlefield sublime" in the age of mechanized warfare. But unlike the futurists, who extolled war and acclaimed its purgative power ("the world's only hygiene," in Marinetti's words), Wilson retains, by means of those two desperate, blasted human figures, a sense of its calamitous effects on nature and humanity alike.

IF *FLOWER OF DEATH* SHOWS WILSON on the modernist side of the spectrum, he takes the reverse direction, toward realism, in *First Attack on the Bois de Belleau* (Fig. 91). Five doughboys in Marine uniform advance across a bright yellow wheat field. Lavender hatch marks indicate their looming shadows. The early morning exhilaration of the scene is offset by the silent death we witness, as the first soldier in line falls backward, clutching the pack affixed to his

91. | Claggett Wilson, *First Attack on the Bois de Belleau,* 1919.
Smithsonian American Art Museum.

stomach; the second strides ahead, not yet hit; the third pitches forward, reaching awkwardly behind his shoulder to clasp a wound we cannot see; the fourth also falls forward, staring in disbelief, it seems, at his left hand; and the last of them, off in the distance, blurs as he hits the ground, looking more like a frog than a man.

To certify the eyewitness accuracy of what he shows, Wilson appends a dry, unemotional notation of date, time, and personnel: "June 6, 1918, at five o'clock; 3rd Battalion, 5th Regiment of Marines advancing." Again, this is the bare-bones language of military utility later to be employed to great effect by Hemingway. As his war-weary first-person narrator Lieutenant Frederic Henry was to recall in *A Farewell to Arms*: "There were many words that you could not stand to hear and finally only the names of places had dignity. . . . Abstract words such as glory, honor, courage, or hallow were obscene beside the concrete names of villages, the numbers of roads, the names of rivers, the numbers of regiments and the dates."[22] In *First Attack*, Wilson embraces the astringent factuality that Hemingway, within a few years would craft into a bluntly effective prose style.

When Wilson's war paintings were published in 1928, the influential art critic Henry McBride admired them for resembling movies. That was an unusual way of praising the work of a fine artist. Normally, any similarity between fine art and motion pictures would have been shunned if the critic wished to make a favorable comment on the art, as was the case here. That didn't stop McBride. Wilson's work *is* cinematic, in the sense that it exploits dynamic visual angles and highlights salient details to convey a feeling of intensely lived experience.[23]

In King Vidor's *The Big Parade* (discussed in Chapter 6), a scene similar to that portrayed in *First Attack* takes place, as marines in Belleau Wood, moving slowly forward with fixed bayonets, are picked off one by one by unseen enemy snipers. In this sequence, the element of time plays an important role. Vidor draws out the killings in an agony of suspense for the viewer, who can't help but wonder if the heroes of the tale will be among the casualties, or if they will survive to fight in the next segment of battle (they do). In later years, Vidor proudly remembered that he filmed the Belleau Wood scene in a small forest near Los Angeles with AEF veterans, who claimed that he had gotten the rhythm of the advance all wrong, saying that it was far too slow. Despite their objections, he persisted in synchronizing it to a dirge-like cadence, sounded out for the actors by a drummer he had hired for the occasion. As a result, "the viewing audience was gripped by this scene far beyond my wildest hopes." In other words, his deliberate deviation from fact achieved an emotional authenticity that a strict adherence to accuracy could not have produced. Wilson's watercolor, painted six years earlier, practically storyboards this sequence, which Vidor refers to as "a ballet of death."[24]

The treatment for *The Big Parade* was provided by the novelist, jour-nalist, and playwright Laurence Stallings. Like Wilson, Stallings had served as a second lieutenant in the 3rd Battalion of the 5th Marine Regiment, and he too was wounded in action at Belleau Wood. On the last day of the battle, as he heaved a grenade into a German machine-gun nest, a bullet shattered his right knee. The leg had to be amputated and, four years later, because of complications resulting from repeated falls on his remaining leg, that one, too, required amputation. Stallings was embittered, and in 1924 he published an autobiographical novel, *Plumes*. It mounted a relentless attack on roman-tic and patriotic idealisms that had sent American youth to the slaughter. Stallings would have shared Hemingway's contempt for Cather's *One of Ours* and its redemptive ending, for in *Plumes*, no good whatsoever comes out of the war.

In the novel's powerful concluding scene, set in Arlington National Cemetery on the day before the Tomb of the Unknown Soldier is to be con-secrated, thus furthering what Stallings believed to be the illusion-mongering essential to the perpetuation of war, a little boy, overhearing a conversation between adults, asks what a general is. A disabled and disillusioned veteran answers him: A general is a man "who makes little boys sleep in graves."[25] The book's protagonist, Richard Plume, an amputee, had joined the Marines believing that war turns boys into men, but over the course of the novel he comes to believe precisely the opposite, that war turns men into boys. It ren-ders them dependent, afraid, and—in his case literally—unable to stand on their own two feet. Wilson's paintings similarly emphasize the weakening ef-fects of war on the minds and bodies of its participants.

In 1924, the year he published *Plumes*, Stallings became famous when he and his pacifist friend Maxwell Anderson co-authored a hit Broadway play about the war, *What Price Glory*. It shocked and titillated audiences with its unprecedented use of crude language bordering on the obscene. The playbill warned theater-goers: "*What Price Glory* is a play of war as it is, not as it has been presented theatrically for thousands of years. The soldiers talk and act much as soldiers the world over. The speech of men under arms is universally and consistently interlarded with profanity." More was at stake, though, than simply language. The play, the authors claimed, provided a new, more honest way of depicting men at war: "In a theatre where war has been lied about, romantically, effectively—and in a city where the war play has usually meant sugary dissimulation—*What Price Glory* may seem bold."[26] A review of the silent film version of *What Price Glory* (1926) praised its authenticity by noting that Stallings "lost a leg and won years of pain as a result of Belleau Wood. He ought to know."[27]

One of the two protagonists of *What Price Glory*, a battle-weary captain named Flagg, introduces himself to two green lieutenants reporting for duty:

*My name is Flagg, gentlemen, and I'm the sinkhole and cesspool
of this regiment, frowned on in the Y.M.C.A. huts and sneered at
by divisional Beau Brummells. I am a lousy, good-for-nothing
company commander. I corrupt youth and lead little boys astray
into the black shadows between the lines of hell, killing more
men than any other company commander in the regiment, and
drawing all the dirty jobs in the world. I take chocolate soldiers
and make dead heroes out of them. . . . We are all dirt, and we pro-
pose to die in order that corps headquarters may be decorated.*[28]

Claggett Wilson's war paintings do not evidence this much cynicism, but
they too seek to deglamorize the recently ended war. Like *What Price Glory*,
they uncovered "dirty" aspects of the war that had largely been kept from
public view. Unlike Europeans, who could do little to avoid the ceaseless pro-
fanity of total war waged on home soil, Americans had been spared the brutal
facts. *Plumes*, *What Price Glory*, and *The Big Parade*, along with John Dos
Passos's *Three Soldiers* (1921), Hemingway's *In Our Time* and *A Farewell to
Arms*, William Faulkner's *Soldiers' Pay* (1926), and E. E. Cummings's
Enormous Room (1922), were efforts to wash away the "sugary dissimulation"
that had deluded the public in its earlier enthusiasm for the war. Wilson's
watercolors were a harbinger of this cultural move by Lost Generation au-
thors toward realism and anti-illusionism in their backward gaze at the war.

Through the Wheat, a 1923 novel by Thomas Boyd, another marine who
fought at Belleau Wood, makes for an apt comparison with Wilson's work.
Unlike Wilson and Stallings, who were sidelined because of their wounds,
Boyd went on to fight in subsequent battles in the Saint-Mihiel salient and
the Meuse-Argonne. After the armistice, he, like Wilson, was stationed on the
Rhine in the army of occupation. When his tour of duty was over and he
returned to the United States, Boyd, like millions of other demobilized
soldiers who had difficulty finding jobs, drifted from city to city. His brief
literary career was born from a chance encounter with Sinclair Lewis in
a St. Paul bookshop and helped along by encouragement from F. Scott
Fitzgerald, who urged him to write of his war experiences. Boyd was twenty-
five when he published *Through the Wheat*. He went on to publish a second
novel and a collection of short stories and unsuccessfully ran as a Socialist
candidate for the governorship of Vermont. Never fully recovered from his
war wounds, he died of a stroke at age thirty-six.

In rich and vivid but mostly unadorned language, *Through the Wheat*
provides close-grained accounts of the Marines in battle. Boyd paints word
pictures that are similar to Wilson's watercolors: "In the early morning light
the outlines of the objects in front of the ravine were crisply apparent. The
strands of barbed wire were blackly filigreed against the opaque light of the

horizon. An aluminum moon hung waveringly in the sky. The stalks of wheat stood stiffly erect, their yellowness merging in the distance with the shadowy green of the trees."[29]

To these visual details, Boyd adds an olfactory one: "On the breath of the morning wind was carried the sweet, sickening smell of decayed cadavers." In another passage he notes "the odor of stinking canned meat and of dead bodies made alive again by the heat of the day." This hyper-alertness to the scent of battle and its aftermath is one of the qualities Wilson's admirer Alexander Woollcott, *The New Yorker* and *Smart Set* critic, appreciated about Wilson's war paintings—that they "have in them the smell of carrion in the June sun," along with other evocations of primal sensual experience: "the cold of trench-ooze, the intolerable shock of a bursting shell, the tearing rendezvous of bayonet and belly."[30]

At the end of *Through the Wheat*, wounded soldiers litter a battlefield, moaning or crying for help. Boyd's protagonist, named Hicks, ignores these calls, because he himself is in a stupor. The narrator comments, "The bodies would remain alone until to-morrow or the day after to-morrow, when they would be furnishing a festival for the bugs which only now inquisitively inspected them." With Hicks tramping through the field, barely conscious of the misery around him, the novel reaches its bitter finale: "No longer did anything matter, neither the bayonets, the bullets, the barbed wire, the dead, nor the living. The soul of Hicks was numb."[31]

Wilson's protagonists display a variety of emotions; numbness, as in *Runner through the Barrage*, only one of them. Sometimes he telegraphs these emotions through extreme facial expressions that lock into place with the fixity of Noh masks. Undoubtedly, like many modernists of the late nineteenth and early twentieth centuries, Wilson undoubtedly drew inspiration from traditional Japanese art and theater. Other, more proximate sources are evident as well. The faces of Wilson's warriors, be they American or German, bring to mind the melodramatic acting typical of silent film, and in particular that of German expressionist cinema. A good example of this is *Grenadier Cut Off in the Flaming Woods* (Fig. 92). A German soldier reacts with a stunned expression on his face as the slender tree trunk before him splinters in two. The grenadier holds a potato masher in his hands; it's not clear if he has already armed the fuse or is about to do so, but the look in his eyes and twisting of his mouth identify him as neither hero nor villain but rather as a hapless and befuddled youth who sees no way out of the conflagration about to subsume him.

Like Wilson, Otto Dix had a "comic book" proclivity for facial exaggeration, as can been seen in the war etchings *Wounded Soldier* and *Assault Troops Advance under Gas* (page 236). Dix also used stylization and exaggeration in a manner that borrows from caricature without

92. | Claggett Wilson, *Grenadier Cut Off in the Flaming Woods*, 1919. Smithsonian American Art Museum.

exactly being caricature. His works, and Wilson's too, occupy a marginal space—a no man's land—between the "real" and the grotesque. One can especially see similarities between Dix and Wilson when comparing the former's India ink drawing *That's What I Looked Like as a Soldier* (Fig. 93) with Wilson's *Grenadier Cut Off in the Flaming Woods*. Dix's image shows an unshaven, square-jawed, furrow-browed fighting man with a cigarette hanging from his mouth and a massive machine gun propped against his chest. A hole in his steel helmet allows the artist-warrior to stake a retroactive claim to authenticity; *make no mistake*, the bullet hole announces on the part of the soldier whom the helmet was meant to protect, *I was there and saw with my own eyes the death and dying I show now with pen and ink.*

One might make a gallery of helmeted heroes and antiheroes out of Dix's self-portrait as a machine gunner, Wilson's *Grenadier*, Harvey Dunn's *Machine Gunner*, and Tom Lea's battle-fatigued marine with the two-thousand-yard stare. Added to this roster of steel-helmeted heroes or antiheroes would be Sergeant Zack (Gene Evans), the hard-bitten but ultimately tender-hearted

93. | Otto Dix, *That's What I Looked Like as a Soldier*, 1924. Berlinische Galerie, Berlin.

G.I. of Sam Fuller's 1951 Korean War action film *Steel Helmet*, and Robert Kanigher and Joe Kubert's comic book hero from the late fifties, Sergeant Rock, an adolescent boy's fantasy of possessing a steel-tempered body and mind (Fig. 94). Sergeant Rock has more in common with Dix's tough-guy self-portrait than he does with Wilson's depiction of a stunned and frightened grenadier. Wilson rejects codes of machismo that would depict the modern warrior as a man of steel. His work provides an alternative (and thereby less marketable) vision of combat soldiers: tough, but not superhumanly so, and liable to shatter emotionally, as well as physically, at any moment, like the trees that are incapable of protecting them.

As noted earlier, Henry McBride, an influential New York art critic who welcomed modern art in its various manifestations, celebrated Wilson's work for its "pop" characteristics, though McBride wouldn't have used that term, as it wasn't invented yet. "What counts for merit" in Wilson's watercolors, writes McBride, "is their use of contemporary idioms." He notes that they were produced before Hollywood in the second half of the 1920s "fought the war all over again, but they speak in accents that are frequently similar." He singles out *Front Line Stuff*, a picture of three soldiers caught in a nighttime bombardment (Fig. 95). One infantryman howls in pain, a second curls in fetal position, and the third, unusually heroic for Wilson, thrusts an outstretched arm toward the unseen enemy while heaving a grenade. In McBride's estimation, the soldier "who puts out his hand to ward off a terrific splash of shrapnel in the night is pure movie." And, indeed, the scene Wilson depicted in this watercolor from 1919 is nearly identical in look and feel to passages in the great nighttime battle in the final third of *The Big Parade*.[32]

94. | Joe Kubert, Sgt. Rock carrying machine gun. From *Our Army at War*, no. 81, April 1959.

95. | Claggett Wilson, *Front Line Stuff*, 1919. Smithsonian American Art Museum.

McBride continues the analogy to cinema by referencing another Wilson watercolor that he considers "pure movie." It shows a soldier with a pistol "sneaking across the foreground of a print with legs so outstretched he covers the page in a single stride." Here the picture in question is *Marine Scout on the Lucy-Torcy Road at Dusk* (Fig. 96), but it seems to me not so much pure movie as pure comic strip, occupying a place somewhere between the exaggeratedly attenuated figures created by the political satirist and future Bauhaus artist Lyonel Feininger in the first decade of the twentieth century (such as *The White Man*, 1907) and the loose-jointed, "keep on truckin'" swaggerers and shufflers of R. Crumb's *Zap Comix* in the late 1960s. He also resembles "the Pink Panther," a cool cat cartoon figure who slinked insouciantly across movie screens to Henry Mancini's infectious jazz beat in the title sequence of a 1963 comic detective film by that name. Wilson's scout, a grenade in one hand and pistol in the other, is all arms and legs, a human pinwheel ready to spin around the hub of the composition, which is located near the joining of his thighs.[33]

Similarly to Feininger before him and Crumb much later, Wilson eschews realistic depiction of the human form and makes hash of classical figuration. But Wilson's image is more dynamic than theirs: his oblong figure

96. | Claggett Wilson, *Marine Scout on the Lucy-Torcy Road at Dusk, Château-Thierry Sector*, 1919. Smithsonian American Art Museum.

is hemmed in on all sides by the black borders of the watercolor paper and the decorative foliage of the trees, and this external pressure adds a note of tension to the scene, despite its comical, even satirical tone. Wilson plays here with elongation, compression, and distortion to convey, lightly but insistently, war's penchant for deformation.

In another painting, *Dance of Death*, the artist provides a trench-eye view of three German infantrymen entangled in a mesh of barbed wire that sprouts every which way in a riot of curlicues. The hapless Germans, faceless and dead or dying, enact a St. Vitus's Dance of flailing arms and limbs (Fig. 97). The man in the center, pitched backward into a horizontal position, grabs a fistful of spikey wire, as does the tottering, bow-shaped soldier beside him, all twisted and tangled, his canteen dangling purposelessly from his shoulder. Ghoulish in its humor, likening these poor souls to dancers, the painting is a heartless and heartbreaking image of meaningless sacrifice. A scene such as this made an unforgettable impression on Field Commander Douglas MacArthur during his first combat action in France, after he and his men had lured the enemy into a trap and massacred them. What haunted him long afterward, he later recalled, was "the vision of those writhing bodies hanging from the barbed wire."[34]

97. | Claggett Wilson, *Dance of Death*, 1919. Smithsonian American Art Museum.

Wilson's title is again both ironic and non-ironic. The men are dying, not dancing. Yet death contorts them into rhythmic, expressive shapes, as if they were indeed flinging themselves about a dance floor in the jazz steps of the day. Wilson's macabre image alludes to late medieval allegories about mortality, for example, the "Dance of Death" woodcut in the *Nuremberg Chronicle* of 1493. Otto Dix treats a similar subject in his 1924 war etching *Dance of Death 1917: Dead Man's Hill*, which is more visually complex and discombobulated than Wilson's 1919 watercolor. This is not to say that Dix's variation on the theme is more effective than Wilson's in the view of human futility that it provides, but it is different in emphasis. Dix's etching shows some dozen or more German soldiers hung up on the wire—because of the jumbling of body parts, it's difficult to make an exact count of the deceased, but that's the point: war strips individuals of their personal boundaries and mocks their illusions of uniqueness. Wilson, an eliminative artist, restricts his allegorical embodiment of ignominious suffering and death to three clearly delineated figures, but he does so with a spark of black humor that is lacking in Dix. In this regard, at least, Wilson is the more modern of the two.

As a graphic artist, Wilson enjoyed the ornamental possibilities provided by barbed wire—again, no shortage of irony there. He treats it calligraphically, a series of fine, rolling, interconnected strokes. They lend an oddly inappropriate, and therefore subversive, rococo sensibility to his depictions of death, destruction, and dying. For Wilson, barbed wire is a symbol of death but also, from the point of view of a graphic artist, an endlessly swirling stream of visual effervescence, irresistible to the hand that simulates it on paper. Years later, in the 1990s, the poet and novelist James Dickey remarked, "All that is needed to understand World War I in its philosophical and historical meaning is to examine barbed wire—a single strand will do—and to meditate on who made it, what it is for, why it is like it is."[35] By scrawling barbed wire shapes, patterns, and forms across not a few of his images, messily but decoratively, brutally but also beautifully, Wilson shows he would have agreed with Dickey's insight. As a manmade, mechanically reproduced, and endlessly repeatable weapon of defense and destruction that trapped millions of men in its meshes and sadistically shredded millions of lives, barbed wire is a paradigmatic symbol of the First World War. Wilson uses it in his art as a means of pricking viewers, getting under their skin.

Not all Wilson's war vignettes take place in the open. One of the most starkly rendered paintings in the series, *Underground Dressing Station*, shows a mustached medical officer peering intently through rimless glasses at a bare male torso, which he wraps with gauze (Fig. 98). The patient's face is not shown, nor are those of the two orderlies, who hold him aloft in a cruciform position. Wilson's caption reads, "The flesh is the thing crucified, pale, in the dirt and darkness." Drawing on medieval iconography of a gaunt

98. | Claggett Wilson, *Underground Dressing Station*, 1919. Smithsonian American Art Museum.

and suffering Jesus hanging from the Cross, it is a scary, haunting image, the anonymity of the patient and the attendants contributing to the sense of desecration and mortification. The one face that is visible, that of the doctor, seems hard and inspectorial. Blood seeps through the bandages, suggesting that the patient's wounds—and perhaps those of the artist, as well—are too deep to heal. *Underground Dressing Station* combines the traditional visual language of religious passion with the modern clinical language of dispassionate science. It also treats the lean but well-built torso of the naked patient with a fetishistic gaze, the genitals mostly hidden but also partially shown by a vertical strip of gauze that descends to the bottom of the composition. This is a remarkably beautiful and controlled image, with its restricted palette, rhythmic repetitions of form and color, and haunting rendition of human suffering, healing, and desire.

Despite the spare captions, with their bare-bones factual recitation of place, time, and date, Wilson's war paintings never pretend to be documentary records of wartime reality. They announce themselves instead as artistic constructs that rely on both mimetic realism and modern design, though

these are typically thought to be at odds with one another, in order to portray the war "as it feels and sounds and smells" to one who suffered through it— and who, by his own actions as a combat soldier, brought pain and suffering to others, on the other side. Those others, the enemy, were in a sense his spiritual comrades, insofar as they too, and only they, saw the horrors that he and his own comrades saw. Wilson's war paintings portray no enemy, other than war itself. He aestheticizes war not to sugarcoat it or disavow its depravity, but rather to make its calamitous effects on both humanity and nature more strikingly apparent.

The one watercolor in the series that shows direct, hand-to-hand combat between a German and an American is the eerie *Encounter in the Darkness* (Fig. 99). Set up in such a way as to be patently theatrical—we look at the "onstage" action as if through a proscenium arch made from ruined timbers of a shelled farmhouse—the painting discloses two figures silhouetted against an inky-blue and starless sky. The doughboy lunges with his bayonet into the buckling body of his adversary. The image is as sexual as it is violent,

99. | Claggett Wilson, *Encounter in the Darkness*, 1919. Smithsonian American Art Museum.

and one might wonder if Wilson, who never married and was a member of gay-friendly art and theater circles in postwar Manhattan, is alluding here to illicit sexual encounters braved by strangers in parks and public restrooms, of the sort described in Chapter 5 in the discussion of *Fountain*.[36]

The eroticism or, more specifically, homoeroticism of the watercolor seems evident, but personal considerations aside, the artist seems fascinated here to work out contrasts of light and dark, straight lines and curves, positive space and negative space. The painting amounts to a modernist redo of a notorious British war-bond poster, Frank Brangwyn's *Put Strength in The Final Blow* (1918), which shows a Tommy thrusting his bayonet into a stunned German soldier, knocking him backward from the blow with such force as to make him fly helplessly off his feet (Fig. 100). In a delicious absurdity from a period so full of them, the Kaiser himself put a price on Brangwyn's head because he was outraged by the violence of ... the *poster*! A monarch who consigned millions of his own people to untold suffering and death apparently felt that the British poster failed to observe the rules of representational decorum, and thus didn't play fair. Today it seems stiff and stodgy, a holdover from prewar visual literalism, whereas Wilson's watercolor, dispensing with details of costume and setting, seems positively vibrant in its depiction of death. It reduces the mise-en-scène to essential elements of stasis and dynamism, conveying, in an intentionally reductive, Nabi-like manner, the unacknowledged erotic underpinnings of war, aggression, and death-lust.[37]

Let us remember, Wilson was not making pictures simply, or even primarily, to cry out against the physical and mental damage he had witnessed, inflicted, and sustained. At the peak of his powers as a modern artist, he wanted to make pictures first and foremost as *pictures*: that is, to defy conventional habits of seeing and discover fresh, unconventional ways of relaying insights and emotions *pictorially*. Take two of the more seemingly opposite paintings in the war portfolio, *Underground Dressing Station* and *Grenadier Cut off in the Flaming Woods*. One is set indoors, the other outdoors; one multi-figure, the other single figure; one is soft, dark, and quiet, concerned with healing, the other loud,

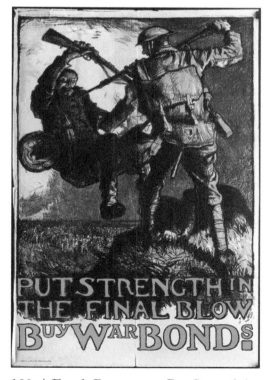

100. | Frank Brangwyn, *Put Strength in the Final Blow*, 1918.

bright, and focused on destruction. But in both, Wilson resorts to a similar pictorial device, placing a long narrow vertical column in or near the center of the composition: the slender wounded body of the patient in the one instance, the slender wounded body of the tree in the other. Very different versions of war, focused on different aspects of its larger entailments, the two paintings taken together form part of Wilson's "camera-eye" (to invoke Dos Passos) view of the ravenous Moloch that he, as a combatant, had helped to feed.

Wilson exhibited his war paintings in 1920 at the prestigious Knoedler Galleries in New York and at the Whitney Studio Club. They did not sell, despite favorable reviews. When they were gathered in a sumptuously printed edition in 1928, *Time* magazine acclaimed them: "Most startling of all are his battle paintings, which were published last week amid explosive praise. During the World War he was a Lieutenant of Marines. He did not forget horrible beauties compounded of corpses spitted on barbed wire, the atrocious shine of bayonets, the bright agony of lacerated flesh."[38]

But even with *Time*'s help, the war paintings did not attract buyers. Wilson shifted his attention to theater design and interior decoration, and his war scenes were forgotten. Perhaps this was because they said something about the war, and their formerly avid support of it, that the public preferred not to hear. While the cynical and grimly realistic antiwar literature of Lost Generation authors flourished in the literary marketplace, Wilson's analogous paintings found no home in the art market. American artists and art patrons abandoned the war as subject or topic, and Wilson himself had no more to say about it. In 1935 an article in a magazine devoted to graphic arts noted that Wilson's once-acclaimed war paintings now languished in storage: "Like the bursting of a shell, an arresting brilliance, then silence, is the fate of these paintings which were once considered America's most ambitious contribution in art to the memory of the Great War."[39]

ANOTHER AMERICAN ARTIST WHO SERVED in France during the war was the sculptor Gertrude Vanderbilt Whitney. She was not a member of the AEF, she didn't wear a uniform, and she didn't face bullets on the front lines. But she too was an artist-witness. At a base hospital close to the war zone, she saw men suffer the agonies of their wounds. She was there because she had created the hospital, drawing on her own wealth, which was considerable, but also on her impressive organizational skills and impassioned desire to be of service to others.[40]

That was in the late fall of 1914. By then she was already an internationally prominent sculptor, whose design for a memorial to the victims of the *Titanic* disaster two years earlier had won a nationwide competition for a statue to be erected in Washington, D.C.[41] She was also an acclaimed art collector who

had begun showing the work of modern artists in a studio space she owned in Greenwich Village. The Whitney Studio Club, as it was known, later became the Whitney Museum of American Art. In 1916, Robert Henri painted a dazzling portrait of her on a divan, wearing a brightly colored "Oriental" silk tunic and jacket, with turquoise slacks gathered at the ankles; she was the epitome of the New Woman: bold, sensual, self-assured (Fig. 101). Intimately involved in the progressive art world of her day, she helped underwrite the cost of the Armory Show and four years later showed work (specifically, an eighteen-foot model for the *Titanic* monument) at the Society for Independent Artists exhibition, while also silently underwriting the cost of Marcel Duchamp's magazine *The Blind Man*, which justified "R. Mutt"'s submission of a signed urinal to the same show.

Whitney was spectacularly rich. In the early nineteenth century, her great-grandfather Cornelius Vanderbilt had amassed the largest personal fortune in America, and at his death in 1877 (when Gertrude was two), his estate was valued at over a hundred million dollars. Her husband, Harry Payne Whitney, a

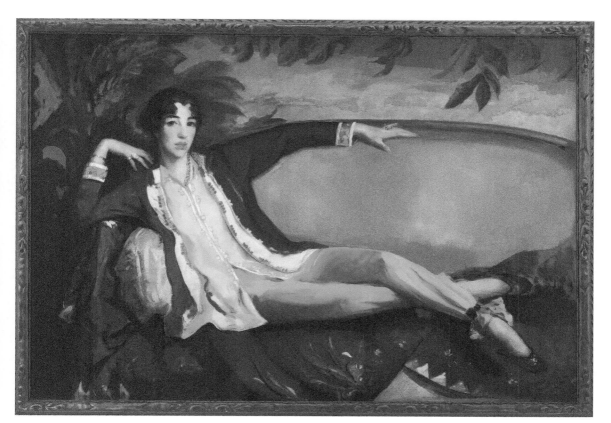

101. | Robert Henri, *Gertrude Vanderbilt Whitney*, 1916. Whitney Museum of American Art.

polo-playing yachtsman who owned a stable of prize-winning thoroughbreds, had also inherited fabulous wealth. Like a character in an Edith Wharton novel, Gertrude recoiled from the privileged life that her rank and pedigree afforded her; she felt stifled by it instead. Restless, yearning to give meaning to her life, she dedicated herself to the art of sculpture, which proved to be a lifelong outlet for intense personal emotions she could not otherwise express.

It was difficult enough in those days for a woman to earn respect as an artist, but even more so for a wealthy woman. In the early years of Whitney's professional career, she struggled against what a friend described as "a wall of money" that prevented her from achieving recognition.[42] While working in Paris, she received helpful criticism from Rodin, whose voluptuously romantic sculptural style deeply influenced her own. He acknowledged the obstacle presented by her extraordinary wealth.

"I see many foreign artists who come to show me their sketches and ask my advice," the French master commented. "Among them are women and sometimes fashionable women, whom I distrust. They think they are making sculpture to amuse themselves and astonish their friends but they have not got the moral courage necessary to truly liberate themselves from the prejudices of their milieu. There is one of them, however, who is an exception. Aristocratic and very rich, she works with the sincerity and fervor of a poor artist whose ideals are the only luxury. She despises snobbishness. She has renounced everything for our so hard yet so beautiful profession. She is an American called Gertrude Whitney. She has the gift."[43]

The world war gave further purpose to Whitney's life. At its start in August 1914, she was ensconced at the family compound in Tupper Lake, New York. When she told her husband she wanted to help alleviate the suffering in Belgium and France, he was not responsive. His indifference to her promptings fueled her desire to put personal safety aside and go where the fighting was: "I want to be a part of it, an infinitesimal speck to be sure, but still a speck in the great colossal upheaval," she confided to her diary. Writing hefty checks to war relief agencies was not enough. She was determined to start her own hospital, and as close to the front lines as possible.[44]

In November, she traveled to France to put her plan into operation. With the approval of French authorities and in the company of friends connected to the American embassy, including the former ambassador, she headed to the front in search of a viable location for the hospital. They passed through territory recently held by the Germans. "The first indications of war which I saw were trenches, and these dotted the fields close to Paris. Some were finished and deserted, others were in course of construction." The dugouts reminded her of golf bunkers. Passing convoys of French soldiers, bridges that had been dismantled to prevent the enemy from crossing, machine-gun encampments on the side of the road, and suspicious sentries who could not fathom why a woman such as she would be motoring toward the inferno, she

fell into bed each night exhausted and afraid but also "very happy and rather exhilarated" in knowing that her mission was worthwhile.

The result of her efforts was that she successfully opened a hospital with 225 beds in the small Marne town of Juilly, in the evacuated Collège de Juilly, a prestigious boys' school which had been founded in the seventeenth century. She financed a staff of doctors, nurses, and orderlies and purchased a score of ambulances. In the wards, she observed the torment of the wounded, watching and listening to men die, sometimes holding their hands as they expired. She booked passage to New York to be with her family for Christmas 1914, assuming she would return to the hospital in the spring, but she never saw it again, unable to return to France until the war was over. She stayed very much involved from a distance, receiving detailed reports from doctors and administrators and continuing to send badly needed funds. Despite the brevity of her stay in Juilly, the experience had an incalculable effect on her and her art. Meanwhile, the tragedy of war struck close to home. In May 1915, her beloved brother Alfred Vanderbilt was among the passengers who died on the *Lusitania*. Her daughter Flora, only twenty, became engaged to Quentin Roosevelt, the youngest son of Theodore Roosevelt and an ace pilot. Famed for his gallantry in the sky, Flora's fiancé was killed on Bastille Day, 1918, in a dogfight over France.[45]

Between 1917 and 1919, Whitney created a remarkable series of more than twenty war sculptures—"emotions gouged in clay," she called them.[46] Impressionistically modeled with only minimal detail, they are relatively brutal and direct, despite their old-fashioned anecdotal and sentimental qualities, and, as such, they are unlike any work she had made previously. *Honorably Discharged* depicts a young soldier leaning on a crutch, his cap in his hand, his face baffled, as if asking, now what? *Private of the Fifteenth*— the "Fifteenth" being the New York National Guard regiment that later became the 369th Infantry, known as the Harlem Hellfighters—

102. | Gertrude Vanderbilt Whitney, *Private of the Fifteenth*, ca. 1919.

103. | Gertrude Vanderbilt Whitney, *His Last Charge*, ca. 1919.

shows an African American soldier issuing a crisp salute (Fig. 102). In *His Bunkie*, a wounded soldier is being dragged to safety by a comrade. *His Last Charge* shows an infantryman simultaneously spilling forward and snapping backward in a convulsive spasm as he takes a fatal bullet (Fig. 103). In *Found*, a caped angel of mercy, or perhaps of death, hovers ominously over a dying soldier, gathering him into its enfolding darkness (Fig. 104).

A portrait of Whitney by the society photographer Jean de Strélecki shows her in her studio modeling *Over the Top*, a representation of a wounded soldier, his arm in a sling, clutching a fallen comrade (Fig. 105). A bronze figure group called *Spirit of the Red Cross*, one of her more unabashedly idealistic works, depicts a beautiful female nurse standing on a mound between an aviator and a wounded soldier, around whom she protectively casts an arm (Fig. 106). The piece anticipates Hollywood's lavishly romantic adaptation, more than a dozen years later, of *A Farewell to Arms*, itself a romance about a love affair between a Red Cross nurse and a hospitalized doughboy.[47] Whitney showed the war pieces in 1919 at her Studio Club under the collective title *Impressions of War* and then exhibited them in London, where they were praised in the press. Rodin-like in their rough-hewn expressiveness but not otherwise modernist, none of the war sculptures conveys a sense of violent disjunction or radical rupture, but all of them, notwithstanding their sentimental, anecdotal nature, emphasize the damage or pain inflicted by war on the male body.

After the opening of *Impressions of War*, a *New York Times* profile on Whitney pointed out that she is "the only American sculptor who has given any considerable study to the part our soldiers played in the fighting." The piece has little to say about the work itself. The eye-grabbing headline is "Poor Little Rich Girl and Her Art: Mrs. Harry Payne Whitney's Struggles to

Be Taken Seriously as a Sculptor without Having Starved in a Garret." It tells how in the early stages of her career she was either rejected from shows because she was too wealthy to be considered an artist or invited to shows because the organizers expected her to prop up the endeavor financially (she never accepted under those conditions). The article raises questions about women not being thought capable of engaging in the heavy physical labor of sculpting or deserving of a separate space, a studio, of their own. By saying virtually nothing about her sculpture and a great deal about how readily she was dismissed as an artist because of the belief that "wealth and talent are alien to each other," the arti-

104. | Gertrude Vanderbilt Whitney, *Found*, ca. 1919.

cle reproduces the very problem it decries: it ignores Whitney's art in order to focus on her wealth.[48]

When New Yorkers erected a temporary Victory Arch at Madison Square through which AEF regiments triumphantly paraded on their return from abroad, a handful of leading sculptors were enlisted to craft decorative relief panels.[49] Whitney was the only woman among them. She drew on her various war pieces for the bronze panels she contributed to the Arch. One was called *Doughboys*, the other *America at War* (Fig. 107).

The latter includes the African American soldier from *Private of the Fifteenth*. While the other eight figures in the panel are engaged in some form of combat, this ninth figure, set off to the side, stands at attention, holding his respectful salute. As we will see in Chapter 9, the AEF was racially segregated, and the army did its best to keep African American troops off the battlefield to avoid intermixing them with white soldiers. Instead black units were mostly assigned to menial tasks or hard manual labor, or they were seconded to French battalions that desperately needed reinforcement. That Whitney would sculpturally include a black soldier among his white counterparts

105. | Jean de Strélecki, *Gertrude Vanderbilt Whitney Sculpting "Over the Top,"* ca. 1919. Whitney Museum of American Art.

in *America at War* suggests a certain amount of white liberalism on her part, but that this figure would be pushed to the edge of the panel, where he is kept apart from the battlefield heroics of the others, and that in standing rigidly at attention and saluting he displays total respect for his superiors, indicates that the sculptor abided by the dominant racial conventions of the day.

Whitney won commissions for other memorial sculptures, including the Washington Heights Memorial (also called the Inwood Monument) at Broadway between 167th and 168th Streets (Fig. 108). It shows, in the words of her biographer, "a soldier, sailor, and marine in a rather stiff and contorted composition of mutual aid" atop "a white marble layer-cake base." At the dedication ceremony, Whitney was surrounded by clergymen of various denominations, politicians in frock coats, veterans in uniforms that no longer fit them properly, and a much-decorated corporal whose face had been blown away on the field of battle. She was inducted by this ravaged man as an honorary member of the American Legion. The event, she recorded afterward, left her "hot, embarrassed and upset."[50]

Now regarded as an important figure in the field of public sculpture, Whitney took a stand on the zeal for war memorials that burgeoned in the postwar era. At a time when municipalities increasingly believed that a war memorial should serve a practical function, doubling as a stadium, auditorium, or hospital, she contended that the most fitting way to commemorate the loss of lives was to erect non-utilitarian works of art that would inspire introspection rather than also serve as commodities or testaments to civic self-aggrandizement. Granted, as a very wealthy woman who owned several

homes, including a spacious estate on Long Island, she could afford to call for commerce-free zones of civic space dedicated exclusively to spiritual and moral regeneration. Hers was a minority voice, and it was mostly disregarded.[51]

By the early 1930s, with the onset of the Great Depression, the civic-memorial building boom was over. Whitney, now well into her fifties, continued to garner sculptural commissions. Her public works became more and more grandiose, lacking the raw emotional power of her intimate war sculptures. Her energies were channeled in other directions. One was the development of the art museum bearing her name,

106. | Gertrude Vanderbilt Whitney, *Spirit of the Red Cross*, ca. 1919.

as overseen by her brilliant private secretary Juliana Force. She was also swept into a tabloid scandal, one of the most high-profile court battles of the decade, in which she fought for custody of her ten-year-old niece Gloria Vanderbilt, whose father, Gertrude's brother Reginald, had died of cirrhosis and whose mother, in Gertrude's view, was a drug-and-sex-addicted wastrel. Gertrude won custody, and "the poor little rich girl," as the press delighted in calling her, came to live in splendid solitude on the Long Island estate with her aging Aunt Gertrude and a retinue of servants and groundskeepers.

Whitney's last major public commission was for an allegorical statue of a United States soldier positioned on a giant pediment overlooking Saint-Nazaire harbor in Brittany. The monument was dedicated in 1926. With tears in her eyes, Whitney accepted the medal of the French Legion of Honor before a crowd of 30,000 cheering French citizens waving American flags. A speechmaker likened her winged colossus to the Statue of Liberty, calling it America's reciprocal gift to France.[52]

When the Germans overran France in 1940, they quickly assumed control of Saint-Nazaire and used it as a submarine base. The port became a site

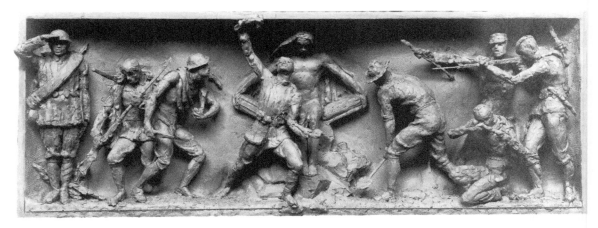

107. | Gertrude Vanderbilt Whitney, *America at War*, 1918–1919.

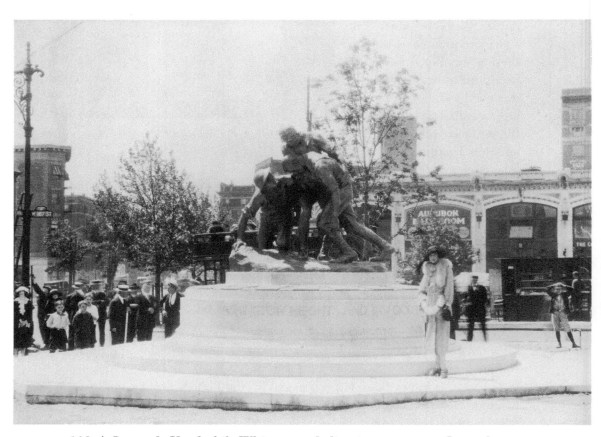

108. | Gertrude Vanderbilt Whitney at dedication ceremony, *Inwood Monument*, Washington Heights, New York, 1923.

109. | Gertrude Vanderbilt Whitney, *Saint-Nazaire Monument*, 1926; destroyed 1941, reconstructed 2004.

of contention, attacked by Allied bombers and squadrons of British commandos. With America's entry into the war in December 1941, the Germans set about destroying Whitney's tribute to Franco-American friendship. Severing the gargantuan bronze statue from its granite base was no easy task. It was so massive that it took Wehrmacht engineers three attempts to dynamite it into the harbor.[53] In 2004 the city of Saint-Nazaire erected a reconstructed version (Fig. 109). Gertrude Vanderbilt Whitney's epic monument to friendship and peace thus lives on, although, like most civic monuments, it remains more seen than noticed.

8

BEHIND THE MASK

IN AUGUST 1928, *VANITY FAIR* magazine sent the highest-paid photographer in the world, Edward Steichen, to Hollywood to photograph the most beautiful woman in the world, Greta Garbo. Notoriously private, restricting her film sets to all but essential personnel, the Swedish Sphinx, also known as The Face, was prepared to grant Steichen five minutes of her time during an interval in the shooting of a potboiler entitled *A Woman of Affairs*.

In preparation for his brief audience with her, Steichen later recalled, he improvised a small photographic studio in an adjoining room and draped a dark cloth over a kitchen chair. While waiting for his sitter to appear, he peeked voyeuristically through a crack in the wall to watch her shoot a scene. It was not going well, and the director called for numerous retakes of what would prove to be one of the longest and most intense passages in the film. Garbo's character, clad in widow's weeds, endures the ordeal of an inquest into the death of her husband, who had flung himself from a window, allegedly because of her infidelity. Garbo seethes with conflicting emotions— those demanded by her role, but also, perhaps, by her frustration and anger with her director. It was at this point that he called for a break and that Garbo, still in costume, entered the makeshift studio and sat for Steichen.

She straddled the chair, resting her arms on its back, and Steichen quickly made five or six exposures. But something was not right. He was bothered by her hair, which looked like a movie hairdo, and dared to mention it. "At that," he writes in his autobiography, "she put her hands up to her forehead and pushed every strand of hair back away from her face.... The full beauty of her magnificent face was revealed" (Fig. 110). Liberated from her feminine hairdo and attired entirely in black, with no jewelry or other softening accoutrements, Garbo seems severe and masculine, almost militantly

110. | Edward Steichen, *Greta Garbo*, 1928. George Eastman House.

so—except, perhaps, for the largeness and luminosity of her eyes, which look directly at, if not through, the viewer. According to Steichen biographer Penelope Niven, "The haunting picture that emerged from that revealing instant is one of Steichen's best-known images, as well as the single picture by which many movie fans came to remember Greta Garbo."[1]

A decade after the end of the Great War, no face was more iconic, more fetishized and invested with collective fantasy, than that of Greta Garbo. As reproduced in fashion and news magazines and on posters, billboards, and movie screens, Garbo's face embodied a sort of perfection beyond perfection. The essence of Garbo's image and the reason it had such power over viewers was that it amalgamated a flawless, godlike exterior with a deeply flawed, all-too-human, pain-ridden psychological interior. She was the transcendent movie star of her age because her face seemed to reveal dimensions of inner torment that were palpably real, not faked for the camera. The best moment in any Garbo film was the one in which her fixed, masklike perfection suddenly, but only fleetingly, crumbled into helplessness and pain. Her emotional vulnerability onscreen was frightening and beguiling.

"Was there ever a more melancholy star than Greta Garbo?" the German scholar Klaus-Jürgen Sembach has asked. "What a feeling of loss she conveys, even in a smile. The older this woman grows, the more intense the aura of suffering around her. Deep-rooted pain shimmers through the glamour." For Garbo, Sembach observes, "Melancholy is an essential ingredient. It is this melancholy which tells us that we are confronted with a case without redemption. How else could we—living out our everyday lives—feel that there was something more, if not through that mute reproach? Cheery secrets are unimaginable. The forest is darker than dark, the ruins are more

maze-like than a maze, and the princess is terribly fragile, enchanted and wide-eyed."[2]

Steichen's photo of Garbo captures this feeling of a forest darker than dark. It is contrapuntal in its rhythms of gray, black, and white, its asymmetrical angles, and massing of forms. The black, cloth-covered back of the chair creates an earthlike mound or bulwark from which her forearms, also sheathed in black, rise up like frames around her extraordinarily beautiful face, set at a slight angle against the broad swath of incoming light. Her lips, darkened with lipstick, compress themselves above her chin; her eyes are moist and searching, her eyebrows plucked, lined, and arched, her forehead high and broad, sculpted with light and shadow, her hair, in its pulled-back state, like that of a young man, and her hands, which were praised by adoring fans almost as much as her face, fold over her scalp in a protective, helmet-like manner.

This is not a typical glamour portrait. A glamour portrait is meant to elicit envy on the part of the viewer and to represent a highly desirable but virtually unattainable happiness and success.[3] Here, the sitter appears almost despondent; this is a picture not of glamour but depression. Like Edvard Munch's *The Scream*, it uses a hands-to-head gesture to convey despair. Garbo seems sad beyond words, clutching at herself, holding herself together, her face a tragic mask that, the photograph suggests, mirrors the tormented inner reality of its wearer.

Steichen's portrait of Garbo provides a powerful emblem of America in the aftermath of the Great War. It is a mourning picture. Perhaps it was not intended as such by the sitter or the photographer or the readers of *Vanity Fair*. Nonetheless, let us regard it as a sort of war memorial, a testament to loneliness and alienation, beauty and death, and the inevitable loss of ideals. It may seem far-fetched to think of it in that way, but in the broader context of the postwar era, it is not inconceivable.

After all, both the photographer and his model were attuned to the major art currents of their time. Steichen was a sophisticated, internationally renowned painter and art-photographer before he ventured into fashion photography, and he was almost evangelical in his devotion to European modernism. Garbo, meanwhile, had starred in *The Joyless Street* (1925), G. W. Pabst's dark masterpiece of Weimar realism, before moving to Hollywood, and she too was determined as an artist to convey depths of meaning beyond surface appearance. Pabst's film, the story of a country girl who struggles morally and physically to survive when she moves to the city, combines German expressionism, a cinematic style reliant on an extreme externalization of inner mood, with New Objectivity (*Neue Sachlichkeit*), a more detached and distant, but not necessarily less socially critical, way of observing human activity and tragedy. In the role of the emotionally tormented country girl,

Garbo amalgamated these antithetical modes in a manner that electrified viewers. Steichen was well-aware of these competing currents in modern visual representation, and his photo of Garbo beautifully draws on both of them.

Despite his accomplishments in war as the commander of an aerial reconnaissance unit and in peace as an acclaimed fashion photographer, Steichen was haunted by violence he had witnessed. Years later he recalled the debilitating depression that beset him at the end of the war. While others in camp were drunkenly celebrating the end to "wholesale murdering," he had retreated into his barracks and flung himself on his bed:

> *The whole monstrous horror of the war seemed to fall down and smother me. I smelled the rotting carcasses of dead horses, saw the three white faces of the first American dead that I had seen. I could hear the rat-a-tat-tat of machine-gun fire as one lay flat on one's belly trying to dig into the earth to escape it, and the ping-ping-ping of the bullets coming through the leaves overhead. I saw the dried blood around the bullet hole in a young soldier's head. And he was only one of hundreds of thousands. What was life for if it had to end like this? What was the use of living?*[4]

Recoiling from the horrors he had witnessed on and above the battlefield—and to which he himself had contributed ("I could not deny to myself having played a role in the slaughter"), Steichen eventually made his way back to New York and, within a few years, launched himself as America's leading fashion photographer. It was during this period that he photographed Garbo clad in black, her clothing androgynous, her mode of seating masculine, and her hair cropped by her hands and pressed close to her scalp, like that of a young recruit. Ten years after suffering through the personal anguish of that armistice night, he photographed The Face as if she were a widow in mourning (consonant with her film role), but even more so in a manner suggestive of a dead person rising from the grave or a haunted soldier peering over a trench embankment or a tormented witness who, like he himself a decade earlier, had stared into the empty eye-sockets of death more than once, only to ask himself what was the use of living?

Let us use Steichen's photographic rendering of The Face as a jumping off point to contemplate the fate of men's faces, and women's faces, too, in the armed struggle of the preceding decade. The brutality of that worldwide upheaval affected the disposition of faces—their ideological significance, aesthetic value, and material reality—as never before in the history of combat. The Great War, after all, was the first major conflict to rely on trench warfare.

The battle lines ran for five hundred miles, from the English Channel to the foothills of the French Alps. While these trenches protected combatants' bodies, they often left their heads exposed; in Ezra Pound's evocative phrase, the soldiers stood "eye-deep in hell." A sniper's bullet could shear off the jaw or tear away the nose of a man who had the misfortune to raise his head at the wrong moment.[5]

Advances in battlefield medicine and transport services proved remarkable in saving the lives of those who in previous wars would have succumbed immediately or within days. As never before, soldiers could have their faces pulverized beyond recognition and yet not die from their wounds. A British nurse, writing a letter home about her duties at the front, reported "I have seen [survivors] without faces, without eyes, without limbs, men almost disemboweled, men with hideous truncated stumps of bodies." An ambulance driver recalled the time she looked down on her stretcher to see a "gibbering, unbelievable, unbandaged thing, a wagging lump of raw flesh on a neck that was a face a short time ago."[6]

Long before America entered the war, Americans were aware of the severe damage being done to men's faces by the new brand of warfare. A 1916 article in the *New York Times Magazine*, "Miracles of Surgery on Men Mutilated in War," quoted society matron Virginia Fair Vanderbilt (aunt by marriage of Gertrude Vanderbilt Whitney), who had helped establish the American Ambulance Hospital in Neuilly, France, and worked there in a nursing capacity. The surgical staff, she said, "takes these torn, mutilated beings, without any faces, who would otherwise be unbearably repulsive and . . . turns them into normal men again."[7]

Too often, smashed faces were beyond repair. Ellen La Motte, an American nurse and journalist who volunteered her services in France before the United States entered the war, tells of a young French quadruple amputee with "a hideous flabby heap, called a nose, fashioned to unique skill out of the flesh of his breast. . . . The mouth [his surgeons] had done little with. All the front teeth were gone, but these could doubtless be replaced later, and in his pocket there was an address from which artificial eyes might be purchased." On being sent home, the youth, "not appreciating that he was a surgical triumph, kept sobbing, kept weeping out of his sightless eyes, kept jerking his four stumps in supplication, kept begging in agony, 'Kill me, Papa!'"[8]

Whenever possible, those who had been defaced were crudely patched up in military hospitals and hurried back to the trenches as soon as they were able to stand. Not surprisingly, troop morale suffered from the presence of the grievously disfigured. If facially injured soldiers were to return to the front without frightening and appalling their comrades, their faces needed to be put back together. Hence, modern plastic surgery was born out of wartime necessity.

Military surgeons, working in extreme conditions, developed ingenious methods for reconstructing obliterated faces. When surgical intervention came up short and faces proved to be too damaged to restore, prostheses were devised: artificial chins, cheeks, and noses that could be affixed to a shattered face by means of a pair of eyeglasses and a false moustache.

It was one thing to mend faces so that soldiers could return to battle. But returning home presented new challenges. The public recoiled from the sight of men with mangled faces, since no one wanted to be reminded of the terrible war and the human sacrifices it had entailed. Despite shortcomings, the improvements wrought through plastic surgery were impressive. They demonstrated that the face was malleable and that appearances could be changed for the better. Women in particular picked up the charge; if faces that were half blown-away could be made more palatable, how much more could be done with theirs?

The presence of defaced veterans affected the realm of modern art as well. Artists reacted to the war's lingering brutality in aesthetically opposed directions. Some sought to expunge all ugliness and impurity from art, while others, primarily from the defeated nations, reveled in violent, misshapen forms. Either way, the conflict left its mark.

Commentators have often noted the hedonism and beauty obsession of a decade variously known as the Roaring Twenties, Jazz Age, and Flapper Era, where female subjects in particular were urged by manufacturers, retailers, advertisers, and the entertainment industry to enhance their aesthetic appearance, and thus their lives, by means of material acquisitions, beauty regimens, and fanatical devotion to fashion trends. No better sign exists of the new beauty fetish of the period than the Miss America pageant, which originated in 1921.[9]

Even the modern art elite took note of the trend. Florine Stettheimer, an American painter, poet, and set designer who maintained a modernist salon with her sisters Carrie and Ettie, satirized the physical-appearance frenzy of the day with *Beauty Contest: To the Memory of P. T. Barnum* (1924, Wadsworth Atheneum, Harford, CT). The invocation of Barnum, long-favored as a whipping boy for Americans' love affair with vulgar entertainment, suggests what Stettheimer thought of beauty contests, which she characterized as "a B.L.O.T." on American civilization. Yet the painting, which she made during her annual summer sojourn in the epicenter of beauty pageants, Atlantic City, shows her garbed in a translucent dress while looking on at the competition in the presence of the poet Carl Sandburg, the literary critic Edna Kenton, and no less an authority on female beauty than Edward Steichen, who photographs the proceedings with a large box camera. African American musicians garbed in red livery emit jazz from a bandstand, while

white-haired judges sashed in ribbons like heads of state appraise contestants from a review box festooned with American flag bunting.[10]

Men, too, embraced the new imperative to be beautiful or, in their case, handsome, as evidenced by the sudden growth in bodybuilding programs, weight-lifting competitions, muscle magazines, and male dieting plans. Even suntans, which previously marked a man as lower-class, a farmer or manual laborer rather than a gentleman, now had desirable connotations. A tan signified robust masculine health and perhaps patriotism as well, suggesting that it had been acquired during maneuvers on the parade ground or, even more honorably, in the trenches, where soldiers were exposed to the sun for prolonged stretches of time.[11]

We can only speculate that the all-too-visible "ugliness" of defaced or refaced veterans gave rise to, or at least intensified, the beauty obsession of the postwar decade. Listing synonyms for the word "ugly"—grotesque, hideous, homely, monstrous, unappealing, and vile—helps us to see that the war, an international orgy of ugliness that blighted cities, landscapes, and bodies, as well as minds and ideals, led to a powerful and sustained aversion to unattractiveness in any form, and hence to a counter-orgy, so to speak, of pulchritude.

Not that the aversion to ugliness was entirely a product of the First World War. Half a century earlier, after the Civil War, several American cities passed ordinances aimed at preventing physically "disgusting" persons, including wounded veterans, from begging in public places because of the repugnance that their unsightly presence might stir. This was taking the logic of the City Beautiful movement to its extreme. The so-called ugly laws remained on the books until the passage of the Americans with Disabilities Act in 1990.[12]

In the wake of the world war, the renewed reaction on the part of the American public to war-induced injuries, scars, and deformities resulted in a compulsive search for beauty. Or, to put this formulaically: Mutilation drove beautification. The ability of women, and men, too, to be satisfied with the "plain" appearance of their own faces suffered because of the war; their relative peace of mind in this regard was seriously eroded and can even be regarded as collateral damage of the war, though not recognized as such. And yet, because a variety of American industries, including film, advertising, publishing, medicine, psychiatry, and cosmetics, profited enormously from this newfound and widespread sense of insecurity about physical appearance, it amounted to a war dividend as well.

In Garbo's face we detect both aspects: damage and dividend. So ubiquitously seen in magazines, posters, and movies of the day, so much talked about in the press, and so much idealized and imitated through various modes of consumption, Garbo's face was a perfect emblem for the era, attesting at once

to a craving for flawless, ageless, unblemished beauty and to the unremitting anxiety that such craving fails to keep at bay.

Near the close of the Second World War and writing from Moscow, where he had taken refuge from the Nazis, the Hungarian filmmaker, librettist, and film theorist Béla Belázs asked himself why should Garbo's "strange sort of beauty affect millions more deeply than some bright and sparkling pin-up girl?" In keeping with his Marxist convictions, he decided that the secret lay in her "sad and suffering beauty" and her "gestures expressing horror at the touch of an unclean world." Even "the usually insensitive person," Belázs contends, can understand and appreciate her sadness "as an expression of opposition to the world of to-day." He concludes, "Millions see in her face a protest against this world, millions who may perhaps not even be conscious as yet of their own suffering."[13] Garbo's sad, beautiful, mask-like face eloquently bespoke the intolerable losses of a war that, a decade or more after its conclusion, the public could sanitize, memorialize, and repress but never entirely forget.

DURING THE SIX-MONTH-LONG BATTLE OF the Somme in 1916, an ear, nose, and throat surgeon from New Zealand, Harold Delf Gillies, treated more than two thousand cases of facial injury at his clinic in Britain. His surgical exploits made him legendary among fellow wartime physicians, and he was knighted for his service to the crown. Later in life, when he was in his sixties, Gillies pioneered sex reassignment surgery and in 1946 performed the first successful female-to-male operation, developing a successful male-to-female procedure five years later. As in his previous explorations in reconstructive plastic surgery, the doctor was motivated by a profound sympathy for the psychological suffering of his patients.

To Gillies, the grief caused by the loss of a face was impossible to ignore. In his memoirs, he writes of a patient who had been quite handsome before he was wounded: "We had done a reasonable job, considering the amount of tissue lost. Mirrors were banned from the ward but that boy had a small shaving glass in his locker. At the sight of himself he collapsed. All hope of allowing his girl to visit him died with that forbidden glimpse. From then on he insisted on being screened from the rest of the ward patients. When at long last he went home it was to lead the life of a recluse." The surgeon adds dryly, "Only the blind kept their spirits up."[14]

Sometimes, as he notes elsewhere, plastic surgery simply managed to make a horrible face ridiculous. In his memoir of Paris in the twenties, Ernest Hemingway recalled *les gueules cassées* (the broken faces), men whose reconstructed flesh possessed "an almost iridescent shiny cast...rather like that

of a well-packed ski run." French director Abel Gance's epic antiwar melodrama *J'Accuse*, filmed in the late stages of the war, released in 1919, and remade in 1937 with some of the original footage incorporated, climaxes with a terrifying march of resurrected war dead, the parts played by actual *mutilés de guerre* and *gueules cassées*.[15]

In 1916 the *New York Times* piece mentioned above reported that "It was the frightfulness of the men who had got quite well, who were distorted, made unforgettably terrible, whose faces were half gone," that most unnerved those who encountered them in the street. For that reason they generally kept to themselves, forming, in at least one postwar instance, a "ruined faces club." To use a term popularized in Paris in the mid-twenties, albeit not in reference to them, the men with broken faces were "surreal."[16]

After the armistice, teams of American surgeons who had observed Gillies's techniques at close range during the war invited him on a ten-week lecture tour of the United States. In those days plastic surgery was considered a minor, even aberrant, medical practice, the province of charlatans and quacks, and they wanted to demonstrate to their skeptical medical colleagues the marvels that modern plastic surgery had accomplished. Gillies illustrated his lectures with numerous before-and-after clinical photographs of his patients, recording their facial injuries and the subsequent stages of reconstruction. He published many of these photos in his landmark medical textbook *Plastic Surgery of the Face*.[17]

The pictures labeled "after" are often as grotesque as the ones captioned "before." The patients come across as human gargoyles. Take, for example, William M. Spreckley, who lost his entire nose to a grenade blast during the defense of Ypres (Fig. 111). After nearly two years in hospital and multiple surgical interventions (see Fig. 112), he acquired a new nose and an almost normal appearance (Fig. 113). According to his granddaughter, however, his physical scars healed but not the psychological ones, and to the end of his days—he lived into his sixties—he considered his appearance hideous (Fig. 114).[18]

Gillies commissioned Henry Tonks, a Royal Academy artist who had trained as a physician, to make pastel drawings of his patients. Tonks's renderings are beautiful objects in their own right, even though, or perhaps because, they disclose human suffering in vivid color, showing individuals who in many cases had to endure not only grievous wounds, multiple surgical interventions, and months or years of virtual imprisonment in hospital wards, but a lifetime ahead of causing strangers to turn away from them in fear, if not outright disgust.[19]

Later in the war, Tonks was at the front with his friend John Singer Sargent when they spotted the blindfolded mustard-gas victims that Sargent used as the subject for *Gassed*. "He immediately began making sketches,"

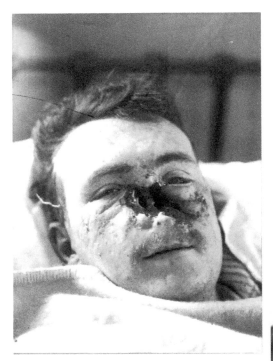

111. | William M. Spreckley without a nose, February 22, 1917.

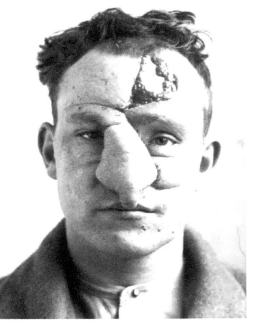

112. | Spreckley during reconstruction of nose, 29 December, 1917.

Tonks recalled, "and a little later asked if I would not mind his making this essentially medical subject his, and I told him I did not in the least mind." By and large, though, Sargent was far more squeamish than Tonks when it came to facing the ravages of flesh. An American officer who was assigned to Sargent wrote to a friend that "some wise guy" from a nearby base hospital had assumed that the artist "would be interested in painting those terrible faces that have been shot away and then good men build up but they look nothing human. That was too much for Sargent. Of course I had to telephone that he was dead or the light was bad or any damn thing but he couldn't come."[20]

What makes Tonks's medical pastel portraits and the photographs in Gillies's book particularly unsettling—more so, perhaps, than in a medical textbook chronicling grievous wounds to the body—is that the patients often look perfectly normal in the parts of their faces that did not sustain damage. Take, for example, the portrait of a mutilated serviceman (Fig. 115). Cover over the lower part of his face with your hand, and he seems normal, even handsome. Reverse the process, and he is alarmingly distorted. The discrepancy

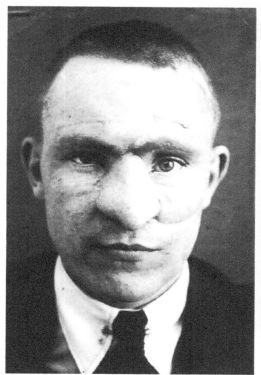

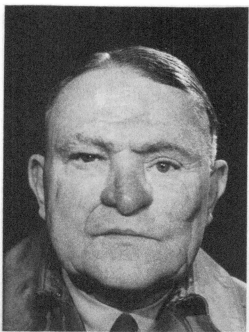

114. | Spreckley in later life.

113. | Further along, 23 August, 1918.

between the normal and the monstrous within the same face can seem uncanny. Were the flesh thoroughly removed or the bones completely crushed, one would be less likely to recognize the humanity within these faces. But instead, troublingly, the markers of the men's human agency remain intact. It is thus impossible to protect one's own feelings by viewing the mangled and distorted countenances coldly and objectively as lifeless, insensate, inhuman matter.

PLASTIC SURGERY OF THE FACE had limited circulation and was intended only for the eyes of clinicians. Such was not the case with another postwar volume filled with visual evidence of the war's capacity to inflict pain and suffering. This was *War against War!*, a photo album first published in Berlin in 1924 and multiply reprinted during the remainder of the decade. With its ironic juxtapositions and acerbic captions, the book circulated worldwide under the

115. | Henry Tonks, portrait of a
blue-eyed serviceman, ca. 1917.
Hunterian Museum at the Royal College
of Surgeons of England.

auspices of the international trade union movement. More than a million copies are said to have found their way into workshops and homes around the globe.[21]

The volume is filled with page after page of sprawling corpses and cadaverous survivors. Human remains are strewn across barren fields watched over by feral dogs. Bodies swing from ropes, and severed heads adorn the tips of bayonet blades. Armies of amputees hobble on makeshift crutches. This circus of horrors is climaxed by a succession of disfigured faces, some with deadpan captions: "Nose blown away and restored with flesh from upper thigh"; "Mouth and teeth torn away"; "Lower jaw and teeth blown away" (Fig. 116). Other captions are sarcastic: "A noble gift of heaven is the light of the eye" declares the text beside a photo of a man with empty eye sockets.[22]

These photos call to mind the much later work of the Anglo-Irish modernist Francis Bacon, as seen in a self-portrait from 1969 (Fig. 117). Bacon, who hoarded grisly photographs, may well have owned a copy of the book; in any case it is probable that he ran across it during the two months he spent in Berlin in 1927, deeply absorbed in the radical art, photography, and film that was pouring into and out of Weimar Germany at that time. To be sure, cubism and surrealism, both of which profoundly affected him as an artist, and his firsthand experience of the Blitz at the start of World War II, factor into the mortified-flesh aspects of his work much more than any single book would have done, and yet it is nonetheless likely that his febrile imagination fed off images such as those contained in this bitter compendium of banned atrocity images.[23]

The creator of *War against War!* was a young German anarchist named Ernst Friedrich who, during the course of the global conflict, was initially confined to a mental institution and then sent to prison for his outspoken pacifism. On his release at the end of the war, he began gathering photographic evidence of the atrocities committed on all sides. Before the publication of this book, the public was largely unaware of these atrocities. Government

116. | Wounded agricultural worker from Friedrich, *War against War!*

117. | Francis Bacon, *Self-Portrait,* 1969. The Estate of Francis Bacon.

censorship had successfully blocked the use of photographs depicting dead or wounded soldiers unless they were *enemy* soldiers—and even then usually only photographed from a distance, to prevent their being seen as objects of concern or pity. For those who had not witnessed the ravages of war with their own eyes, Friedrich's photo collection was a first look at the devastation inflicted on villages, towns, countryside, and, most shockingly, human flesh.

Friedrich wanted to repel—indeed, create physical revulsion in—ignorant idealists, who remained convinced of the moral justness of war, and cynical pragmatists, who profited from it economically, by confronting them with unmistakable evidence of its ugliness. The images in *War against War!* treat the men's face wounds in a fetishistic manner, eliciting from the viewer an almost voyeuristic compulsion to look and look away at the same time. Like pornography, these visceral images toy with the viewer's sense of boundary and taboo. "It seems that the appetite for pictures showing bodies in pain is as keen, almost, as the desire for ones that show bodies naked," Susan Sontag observes in her final book, *Regarding the Pain of Others.* What we might call "pornographic pacifism," like pornographic sexuality, ultimately has a depoliticizing effect, causing viewers to become mired in or mesmerized by the carnality of abject flesh. Andy Warhol pointed out the problem

of overexposure to violent imagery: "When you see a gruesome picture over and over again, it doesn't really have any effect." By these lights, Friedrich's effort was doomed to fail, regardless of its laudable intentions.[24]

War against War! emerged from a specific culture, postwar Berlin, in which amputation and disfigurement were common sights. Men who bore their stigma were easily overlooked by ordinary Berliners rushing about their business or pleasure. At an earlier time, they would have been shocked by what they saw on the street, but by now they were inured to the presence of the war-deformed and defaced.

It is difficult to find in the art of Germany's former adversaries an equivalent expression of outrage about the war and its human cost. During the postwar period, artists in the victorious nations danced around the subject of the recent war or ignored it altogether. The governing aesthetic, known as "the return to order," called for art to be cool, even Apollonian. Many avant-garde artists abandoned the formal or emotional radicalism typical of the prewar years and embraced instead the tranquilities of neoclassicism, lauded the intricate beauty of machinery, explored hard-edged geometry, found refuge in regionalism, or delved into dreams, sexuality, and the baffling logic of the unconscious. They left the war as far behind as possible. To refer to it directly and explicitly was to commit an artistic faux pas. Let the losers harp on the destruction, the victors may have concluded—after all, hadn't they caused it?[25]

Still, some artists seemed incapable of forgetting the war. One of these was Ivan Albright, a painter who is little known today, except perhaps for his monstrously ugly portrait of Dorian Gray, which appears at the climax of a 1943 Hollywood murder melodrama based on Oscar Wilde's allegorical tale. Albright specialized in pictures of corrupted, putrescent, repulsive flesh and thus was the perfect choice of an artist to envision for screen viewers the magical painting that absorbs and reflects the inner ugliness of the tale's preternaturally ageless and morally reprehensible title character. As an impressionable twenty-year-old, Albright had served as a medical illustrator in an army hospital in France, where his job was to record in meticulous and unemotional detail the travails of the body in pain. He never managed to shake this experience, and it seems to have informed his outlook. He is merciless in his depiction of humanity. *Into the World There Came a Soul Called Ida* (1929–30), shows a corpulent and decrepit middle-aged lady, clad in lingerie, seated at her makeup table as she gazes into a handheld mirror, her sagging flesh, low-hanging breasts, and purplish mottled legs examples of what Albright referred to as the "corrugated mush" of the human body (Fig. 118). The painting's model, Ida Rogers, was then an attractive twenty-year-old.[26]

The portrait is a modern-day version of the traditional *vanitas* painting that draws attention to the inexorable passage of time and the inevitability of

death. But also, in its own way, it as much a testament to the ugliness of the recent war and the decadence it spawned as the ugly-prostitute paintings of German artists Otto Dix and George Grosz, who, not without misogyny, treated fat and flabby female flesh as a metaphor for social decay. Working slowly and on his own in a small Illinois town, not a part of any art movement, Albright was less direct than they, but he too testified through paint to the savagery he had witnessed on or near the battlefield and the hopelessness that he and many others of his generation continued to endure long after the armistice was signed.

118. | Ivan Albright, *Into the World There Came a Soul Called Ida*, 1929–30. Art Institute of Chicago.

IN THE MIDDLE OF THE WAR, a handful of British, French, and American artists became involved in sculpting life masks for men with irreparably mutilated faces; that is, faces so badly broken that they were beyond surgical repair. The masks were meant to create the illusion that those who wore them resembled themselves as they had looked before they lost their faces. This marked a major change of attitude toward masks in general, which were previously regarded as symbols of immorality and deception, the accoutrement of bank robbers and licentious libertines. In the new climate brought on by war, masks could be seen instead as humanitarian technologies, prosthetic devices that would allow a severely disfigured veteran to walk again among the living.[27]

In an effort to offset the manifest deficiencies of plastic surgery, Gillies's colleague Captain Derwent Wood, a sculptor in peacetime, devised the first modern facial prostheses. As he explained in an article written for the medical journal *The Lancet*: "My work begins when the work of the surgeon is completed. When the surgeon has done all he can to restore function, to heal

wounds, to support flesh tissues by bone grafting, to cover areas by skin graft-
ing, I endeavour by means of the skill I happen to possess as a sculptor
to make a man's face as near as possible to what it looked like before he was
wounded."[28]

In late 1917, the American Red Cross established a Studio for Portrait
Masks on the Left Bank in Paris. The studio was conceived, created, and di-
rected by a socially prominent novelist and sculptor from Boston named Anna
Coleman Ladd. Ladd's Henry Jamesian second novel, *The Candid Adventurer*
(1913), concerns a proper Bostonian, Mary Osborne, who is unable to coun-
tenance honest emotions because of her overadherence to social convention.
"All her life, even when mixing in a cosmopolitan world," Ladd writes, "she
had kept her skirts away from the touch of life, from humanity in its gross-
ness, its evil, its suffering. . . . She had compassion. She helped, as far as in her
lay, from afar. But she had always remained aloof." It takes Mary Osborne's
fifteen-year-old daughter, Muriel, to "tear away the veil" from her mother's
eyes: "her little girl, her only child, who she had guarded so carefully, had
gone down into the depths alone, had laid her hand . . . on the bare facts
of life." Ladd, the novelist, probably identified less with Mary Osborne, the
privileged Bostonian, than with young Muriel, who wanted to explore the

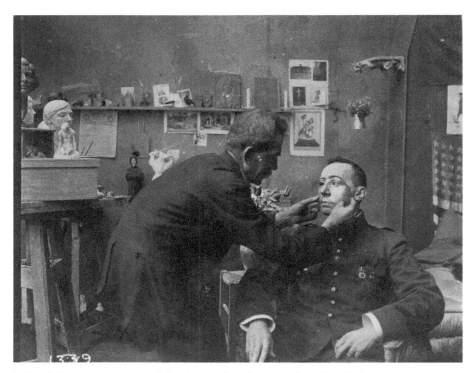

119. | Trying on a mask before it has been painted, 1918.

depths, the "grossness," of humanity and lay her hand "on the bare facts of life." Hearing of the plight of the *gueules cassées* and reading Derwent Wood's comments in *The Lancet*, Ladd approached the American Red Cross with her plan and successfully campaigned for its funding.[29]

Ladd's team in Paris consisted of an American, Diana Blair, from the Harvard Medical Unit, a young French sculptor named Jane Poupelet, and two English sculptors, Louise Brent and Robert Vlerick. Fervently committed to their task, they created a total of ninety-seven life masks during their eleven months in operation. That amounts to almost nine masks per month, a high degree of productivity for such a small, labor-intensive workshop (Fig. 119).[30] And yet, for all of that, the number seemed woefully inadequate. Industrialized modern warfare was producing deformities on a scale well beyond the recuperative means of nineteenth-century-style artisanship. To borrow a phrase from Ellen La Motte, the previously mentioned nurse and journalist who served at the front, "the science of healing stood baffled before the science of destroying."[31]

Nonetheless, Ladd and her colleagues pressed ahead. They understood their job to be more than that of creating masks so lifelike as to be virtually invisible. They sought also to help the newly masked regain a sense of dignity. To that end, their studio on the Left Bank was designed as a warm and inviting place, where *les gueules cassés* who came in for fittings could feel pleasantly at home.

Previously, when these broken-faced men had gone on supervised forays into the city accompanied by their nurses, onlookers gawked at them and sometimes even fainted. The men called this the Medusa effect. Supplied now with tin and copper masks, they could—in theory, at least—walk down a Parisian boulevard without startling others or eliciting stares (Fig. 120). After the war, Ladd proudly asserted that "many of these soldiers have returned back to wife, children or family, slipping back into their former places in society, able to work and derive a bit of happiness out of life." One can't help but wonder if she was overly optimistic about their chances for social reintegration. I think instead of those melancholy

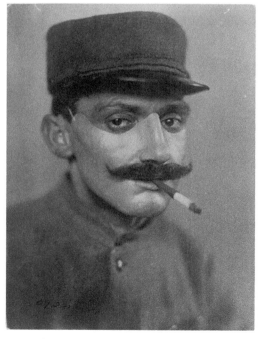

120. | French soldier with mutilated face protected by one of Anna Coleman Ladd's masks, 1918.

121. | *Red Cross Work on Mutilés, at Paris*, 1918. From promotional film showing Ladd's facial masks studio in operation.

lines from T. S. Eliot's *The Waste Land*: "I could not / Speak, and my eyes failed, I was neither / Living nor dead, and I knew nothing."[32]

A four-minute silent film made in 1918 by the American Red Cross, available on YouTube, shows Ladd, garbed in a Red Cross military uniform, as she puts finishing touches on her masks and fits them onto wearers, each of whom bears a row of medals on his chest. One soldier with a pros-thetic chin puffs jauntily on a cigarette, demonstrating the versatility of the contraption strapped to his face. Another, whose wound is not identi-fiable, sports a classically rugged jaw. An assistant with a fine-tipped paint-brush fills in the false moustache that artfully disguises the seam between mask and face. A third soldier looks relatively normal until his mask is re-moved for readjustments by Ladd's assistant, and we see that he has lost his nose. An instant later the mask is reattached, held in place by eyeglass frames secured around his ears, and the patient resumes his conventionally hand-some appearance (Fig. 121).[33]

"The overriding principle was that of a return to normality," notes the scholar Claudine Mitchell. The purpose of the plastic surgeons and mask-makers was that "The mutilated would smoothly fall back into the social space they had occupied before the war, that of work and family." Unfortunately, when the war ended, convalescents were quickly discharged from military hospitals, and public funding for the continuation of costly facial surgery disappeared. The portrait mask studios were disbanded.[34]

Nonetheless, a sea change had occurred. Masking, by way of cosmetic surgery or cosmetic makeup, rapidly gained ground as a legitimate form of therapeutic behavior. If modern techniques of appearance-alteration were suitable for wounded soldiers, why shouldn't everyone, maimed or otherwise, enjoy their benefits? Face lifts, nose jobs, chin tucks, and, further down the map of the body, breast augmentations, breast reductions, and the reshaping of calves were now increasingly taken to be improvements not only of the individual who undertook them but of the body politic itself.

NOWHERE WAS THIS MORE THE CASE than in America. Between the end of the First World War and beginning of the Second, there were only four full-time plastic surgeons in Great Britain but sixty in the United States.[35] Why would postwar Americans have embraced cosmetic surgery more ardently than did their counterparts in Europe? Perhaps Europeans, routinely encountering evidence of plastic surgery's inability to make shattered faces whole again, lacked the Americans' optimistic faith in the power of the surgical blade to restore health and beauty. Moreover, the land of pilgrims and immigrants had been founded on principles of self-invention and self-revision, of forsaking the old in search of the new and leaving behind the encumbrances of the past, including those of the sick, aging, or unattractive body. Ivan Albright's contrarian view took him in the opposite direction; instead of idealizing his attractive young model Ida Rogers on canvas, he made her old and time-ravaged, her body as badly pocked and cratered as no man's land, as if to protest the can-do, anything-is-possible, make-yourself-new youth fetish of the booming twenties.

As noted, this current in American thinking goes back well before the twenties, and it extends well into today. From Ralph Waldo Emerson in the 1840s ("All life is an experiment. The more experiments you make the better") to the motivational speaker Zig Ziglar in the 2000s ("Building a better you is the first step to building a better America"), Americans have extolled the gospel of self-renewal. Plasticity, or the quality of being flexible and open to change, is an integral quality for a nation that has regarded itself from the start as mankind's "great experiment" in democratic governance.

The modifier "plastic" comes from the Greek word *plastikos*, meaning to form, mold, or sculpt, and hence it was an appropriate way of describing the complex medical procedures required to reshape the face. At the same time this word entered the medical lexicon, it acquired cultural and industrial meanings as well. Percy Marks's best-selling novel *The Plastic Age* (1924) told a coming-of-age (hence "plastic") tale of college life, where "flaming youth," in rebellion against the conservative rigidities of an earlier generation, partied and petted to excess. Hollywood's adaptation of the book, released in 1925, made a star of a baby-faced actress named Clara Bow. Known as the "hottest jazz baby on film" and the quintessential flapper, she was later dubbed the "It Girl" (or, as a Freudian might have said, *id* girl). Her face was remarkably plastic, changing with every mood that passed across her brow. In this, hers was the antithesis of Garbo's inelastic face, which looked to be carved from marble.[36]

Also in the mid-twenties a synthetic compound called plastic swept American industrial design. First patented in the 1850s but of little commercial value, plastic became much-improved and widely available thanks to advances in chemical research pursued under the aegis of the war. Plastic offered unlimited possibilities for the cheap and semi-durable manufacture

of consumer goods. Previously, designers were compelled to work from solid substances such as wood, metal, stone, and glass, but now, according to one enthusiast, "From all these limitations, imposed by the nature of materials, the designer is now free. Plastics have given him a new and almost unbelievable liberty for experiment and expression." The term was so in vogue in advanced art circles during the 1920s, with endless talk of "plastic quality" and "plastic form," that Georgia O'Keeffe, looking back, grumbled, "I never did understand what they meant by 'plastic.'" The historian Robert Sklar, noting the ferment, change, and reinvention of Americans on multiple levels during the dozen or so years from the Great War to the Great Depression, entitled the period "The Plastic Age."[37]

Cosmetic surgery, loftily renamed aesthetic surgery, was a subset of plastic surgery. As cosmetic surgery gained credibility, so too did the use of cosmetic makeup. During the previous century, the application of makeup by proper women—as opposed to actresses and prostitutes—was frowned on. Americans associated makeup with falsehood, insincerity, vanity, and deception, as exemplified by John Singer Sargent's notorious 1884 portrait of a heavily made-up society woman whose flagrant effort to alter her everyday appearance through cosmetics and costume aroused such indignation on the part of the public that she was called "Madame X" to protect her identity. Thus American women were caught in a double bind: Society expected them to be fetching and pretty, especially when young, but to be so "naturally," without providing any telltale evidence of having put their minds to it. Charles Baudelaire had praised women for wearing makeup precisely because, in doing so, they resisted the dictates of nature, thus refusing to be "natural," and celebrated artifice instead, making them, in his view, "painters of modern life," like the artists and poets he most admired: "Woman is quite within her rights, indeed she is even accomplishing a kind of duty, when she devotes herself to appearing magical and supernatural; she has to astonish and charm us; as an idol, she is obliged to adorn herself in order to be adored."[38]

Suffice it to say, Baudelaire did not have a large following in prewar America. There, beauty was expected to spring from within, an emanation of spiritual harmony. Those who manipulated their appearance with cosmetics were deemed "painted women" and likened to the Biblical idolatress Jezebel, a figure of ill repute. Even though women wore makeup throughout these years, the expectation was that they do so modestly and discreetly, without calling attention to the home-brewed or locally prepared "complexion remedies" that they employed.[39]

The dubious morality of women who wore makeup was the theme of filmmaker D. W. Griffith's postwar melodrama *True Heart Susie: The Story of a Plain Girl* (1919). Lillian Gish, playing a rosy-cheeked, small-town lass, refuses to wear makeup and fashionable clothing because they are meant to

deceive (Fig. 122). Susie's beau is almost snatched away from her by a seductress who uses makeup and sexy apparel to catch his attention. A title card decries the situation: "Do men look for the true heart in women? Or are most of them caught by the net of paint, powder and suggestive clothes?" Gish retaliates by prettying herself up, but not to the extent of masking her true self, as the other woman had done. Another title card specifically invokes military terminology by characterizing makeup as the artillery a woman uses for laying siege to the heart of a man.

An artist of multiple self-contradictions, Griffith rails against makeup from his position as a conservative, moralistic, anti-urban, anti-feminist, anti-modern, neo-Victorian. And yet, as a former stage actor and ongoing cinematic innovator who continually thirsted for commercial success,

122. | Lillian Gish, star of *True Heart Susie*, 1919.

he also valued makeup ("grease paint"; "war paint") for its rhetorical power. At no point during *True Heart Susie* does Lillian Gish appear onscreen *without* makeup, even though the movie takes a stand against the vanity that its usage is said to imply.

On a more direct level, WWI contributed to the American makeup revolution by driving the Polish-Jewish beauty-entrepreneur Helena Rubinstein away from her home in Paris to the safe haven of New York. Rubinstein was despondent at having to leave France for America, fearing the demise of her lucrative beauty-salon business. As she motored down Fifth Avenue and observed the pale faces and gray lips of female pedestrians, her mood lifted. She saw stretching before her a virgin continent of women who had yet to be introduced to the charms of wearing makeup. "So, I said to myself," she recounts in her autobiography, "here is not only a new country but a huge new market for my products."[40]

Rubinstein played to the desire of postwar American women to indulge themselves, through their daily makeup rituals, in "foreign" intrigue and exoticism, be it European or Middle Eastern in nature. One of Rubinstein's most famous clients was the silent screen star Theda Bara, formerly Cincinnati's Theodosia Goodman, the daughter of a Jewish immigrant tailor. Studio publicists reinvented her as the Cairo-born daughter of a French sculptor and an Arabian princess.

Both Rubinstein and her rival, Elizabeth Arden, discreetly provided in-house face lifts and nose jobs. Arden was herself a friend and confidante of Sir Harold Gillies, who performed skin peels for members of her circle, including the pioneering American interior decorator Elsie de Wolfe, who had won a Croix de Guerre and a Legion of Honor medal for her nursing efforts with gas-burn victims in France during the war. Most customers were satisfied with the less painful and less costly, if also less effective, treatment afforded by the application of a so-called "beauty masque," in which a woman's face was thoroughly covered for several hours with therapeutic mud or steamed and aromatized cloth bandages. Rubinstein in particular was drawn to the mask aesthetic. An avid art collector, she assembled a world-class collection of African face masks.[41]

Two other leading cosmetics entrepreneurs of the period were Max Factor, a Russian-Jewish immigrant who became a prominent Hollywood makeup artist and built an empire on his beauty know-how, and Sarah Breedlove, the daughter of freed slaves. Under the name Madam C. J. Walker, Breedlove oversaw a global enterprise manufacturing and distributing makeup, skin bleaches, and hair-straightening products for women of African descent. In 1916, Madam Walker, who is thought to be America's first female self-made millionaire, moved her base of operations from Indianapolis to New York, where she and her daughter A'Lelia Walker became prominent patrons of the emerging Harlem Renaissance.

Madam Walker was also a civil rights activist who opposed discrimination against African American soldiers in the military, petitioned the federal government for anti-lynching legislation, and helped organize a silent protest march in New York after some three dozen black citizens of East St. Louis were killed by a white mob in the summer of 1917. At the conclusion of the war, she and other black leaders formed the International League of Darker Peoples, intending to send a delegation to the Paris Peace Conference to lobby on behalf of African freedom from colonial domination. Since this objective did not accord with Woodrow Wilson's plans for the conference, the State Department denied them travel visas and placed Madam Walker under surveillance as a possible subversive.[42]

Her hair-straightening and skin-lightening products were sometimes criticized as tools for "masking" black women, helping them downplay or disguise their corporeal markers as members of the African diaspora so that they could "pass" for white and thus engage in a self-disrespecting lie about themselves. Another, arguably more progressive, view holds that Madam Walker offered her devoted followers a means of controlling their appearance and, through that, exerting a heightened degree of personal agency in a racially hostile environment. In this regard, Walker, like Rubinstein, Arden, and Factor, made cosmetic masking an instrument of personal empowerment for women at precisely the time that they were also seeking it in the economic and political realms.

MODERNISTS WERE INFATUATED WITH MASKS. In the late nineteenth century, aesthetes such as Algernon Charles Swinburne, James McNeill Whistler, and Oscar Wilde had advocated, and in their own lives embodied, artificiality in personal appearance. Wilde, for instance, praised "the truth of masks," claiming that "a mask tells us more than a face" and "Man is least himself when he talks in his own person. Give him a mask, and he will tell you the truth." Elsewhere, he announced, "The first duty in life is to be as artificial as possible," and he added, "What the second duty is no one has as yet discovered." Friedrich Nietzsche declared in *Beyond Good and Evil* that "Every profound spirit needs a mask."[43]

Early in the twentieth century, praise of metaphorical masks turned into an obsession with literal ones. Proudly displayed in ethnographic museums in Paris, Berlin, and other European capitals enriched by African colonization, tribal face masks caught the attention of avant-garde artists because they seemed so shockingly *primitive* and other-worldly. With their exaggerated and violent forms, they were the antithesis of the conventional realist art favored by the bourgeoisie. In 1907 Pablo Picasso included African masks in his designs for *Les Demoiselles d'Avignon*, and in 1908 the innovative British theater director Gordon Craig began publishing a journal entitled *The Mask*, which celebrated theatrical artifice and attacked naturalistic representation ("It is this sense of beyond reality which permeates all great art"). In these same prewar years, Igor Stravinsky in music, Sergei Diaghilev in dance, and Luigi Pirandello in drama shared the aesthetic fascination with masks for their potential to disrupt settled ways of thinking and feeling. Americans, as of yet, seemed less enthralled by masks—apart from those worn by bank robbers in the movies—but that changed quickly with the advent of war.[44]

In a book about the proliferation of masks across the arts of the early twentieth century, the dance critic Walter Sorell claims that the collapse of values instigated by the war made the avant-garde's prewar fascination with masks widespread after the guns went silent: "The mask returned, reflecting and revealing the savage instincts of man let loose again, the old demonic spirits in new clothing, the spirits man feared and tried to escape while falling prey to them." It was then, after the war, that America's artistic innovators began sharing their European counterparts' reverence for masks. For example, in a 1932 manifesto calling for the use of masks onstage, Eugene O'Neill extolled the mask as "a symbol of inner reality" and asked, "What, at bottom, is the new psychological insight into human cause and effect but a study in masks, an exercise in unmasking?"[45]

The obsession with masks penetrated popular and scientific cultures as well. As the historian Alys Eve Weinbaum points out, "The 1920s and early 1930s witnessed a veritable explosion of representations and discourses of masks and masquerade. In the United States motifs, themes, figurations, and literary and visual representations of masks and masquerade pervaded fiction,

art photography, Hollywood film, social scientific theory, popular periodicals, and mass advertising." A 1922 issue of *Vanity Fair* enthusiastically informed readers that the "Age of Masks" had arrived. In a Coca Cola advertisement from 1933, captioned "Don't Wear a Tired Thirsty Face: Refresh yourself, Bounce back to normal," a beautiful, rosy-cheeked young woman exudes good health. She holds a glass of Coke in one hand and in the other a gray, anxious-looking mask that the effervescent beverage has enabled her to peel away, revealing the true and happy self within.[46]

Surrealist poets, painters, and photographers regarded masks as a doorway to the instinctual realm of dreams, fantasies, and hidden desires. Man Ray's 1926 photograph *Noire et blanche (Black and White)* juxtaposes the heavily made-up face of his lover, Kiki of Montparnasse, with an ebony face mask (Fig. 123). The composition and lighting oppose her European whiteness to the mask's African blackness but also suggest similarities and overlap between them. Her moist black hair gleams with white highlights, as does the mask, and both faces cast oblong shadows that spill across the neutral gray tabletop on which they rest. With her eyes closed, the woman appears to be asleep. Is the mask she holds upright in her hand an indication of the "primitive" dream state that resides within her, or is it instead an

123. | Man Ray, *Noire et blanche (Black and White)*, 1926. Museum of Modern Art.

expression of the reified existence, the "false front" social armor, that she is only able to shed while in a state of profound slumber?

Helena Rubinstein's husband at the time, Edward Titus, a denizen of the Montparnasse café scene, privately published an English translation of Kiki's memoirs, with full-page photographs of her by Man Ray and others, including *Noire et blanche*. In his introduction to the book, Ernest Hemingway writes of the model, "She was wonderful to look at. Having a fine face to start with, she had made of it a work of art." On publication in New York, the book was banned by the United States government on grounds of obscenity, as several of the pictures of Kiki were in the nude.[47]

Another memorable surrealist photograph that plays on the notion of masking is Edward Weston's *Civilian Defense* (Fig. 124). Made in early 1942, shortly after the United States had returned to a state of war, it shows a naked model stretched out on a divan. She looks like a nineteenth-century academic nude framed by palm fronds, except that she happens to be wearing a gas mask. The absurd juxtaposition of female flesh and inorganic military materials is meant to be humorous or shocking or both. While clearly playful in tone, not an overt expression of the anguish of war, it seeks nonetheless to

124. | Edward Weston, *Civilian Defense*, 1942. Art Institute of Chicago.

make war ridiculous, as absurd as an odalisque wearing a modern breathing apparatus.[48]

Weston's photo, that is, throws together signifiers of beauty and barbarity. In doing so it confounds gender categories, for the model's body is clearly feminine, but her face is clad in a symbol of masculine military might, the gas mask. Gas masks had been invented before the First World War, but they only came into widespread use after the first chlorine gas attack, which the Germans launched at the Second Battle of Ypres in 1915. After that, breathing masks were standard issue on the western front. Making the humans who wore them appear inhuman, gas masks entered the public consciousness as icons par excellence of the brutal, self-alienating aspects of war in the modern era. Their fearsomeness is best conveyed by Otto Dix's 1924 etching and aquatint, *Assault Troops Advance under Gas* (Fig. 125).

What was it about masks, whether ritualistic and tribal or military and mechanical, that cast a spell on so many modern artists? Perhaps it had to do

125. | Otto Dix, *Assault Troops Advance under Gas*, 1924. Harvard University Art Museums.

with a shared conviction that in bourgeois society everyone wears a mask anyway. Social science and its offshoots seemed to confirm this view. Freud and Jung, for example, asserted that common, ordinary individuals were weighed down by internal masks that they themselves were little equipped to recognize and remove. In 1929 Freud's British translator Joan Riviere, a psychoanalyst and feminist, observed that the more women advance socially and politically, the greater their need to reassure men. This in turn obliges them to stage a daily "masquerade" of femininity that often entails rituals of facial adornment.[49]

Popular culture also evinced a heightened fascination with masks and masking. In *The Mark of Zorro* (1920), based on a pulp fiction hero created in 1919, Douglas Fairbanks became the most popular leading man of the day as the masked swordsman of Old California. Less innocently, the newly revived Ku Klux Klan, which surged in popularity during the 1920s, made white hoods—a sort of all-over face mask—into a much-feared but also much-revered sign of racial superiority. In the *The Jazz Singer* (1927), the first motion picture with fully synchronized sound, Al Jolson famously performed the number "My Mammy" in blackface—yet another type of mask (Fig. 126). To be sure, African American artists and intellectuals of the Harlem Renaissance were already critically conversant with the notion of race as a mask or construct, as expressed in Paul Laurence Dunbar's canonical poem of a quarter of a century earlier lamenting the need for black people to "wear the mask that grins and lies" in order to appease dominant white culture.[50]

In other words, moderns were fascinated by masks and recognized their potential both for evil and for good. Tribal masks might seem curious and strange and gas masks at once terrifying and ludicrous, but nothing was worse than those invisible masks inside that alienated individuals both from others and from themselves. Then again, gas masks were able to protect soldiers from toxic vapors, tin masks could allow broken-faced veterans to reenter society, cosmetic surgery could help patients gain or regain their sense of self-worth, and even well-applied makeup

126. | Advertising poster for *The Jazz Singer*, 1927.

could give women increased self-confidence in public. Indeed, American women fully embraced the mask aesthetic every time they put on their mascara, which was first mass-produced and mass-marketed in 1917, not knowing, perhaps, that the term for brushed-on eyelash thickener comes from the Italian word *maschera*, or mask.

If conservative Americans such as D. W. Griffith decried the use of makeup, scorning it as nothing more than "artillery" in the battle of the sexes, modernizers saw it as artillery that served distinctly patriotic purposes. In their view, American women had a responsibility to make themselves as pretty as possible for the men who had faced the horrors of war. Under the banner "Beauty as a Duty," a 1918 advertisement for Rubinstein cosmetics states unequivocally that a woman's husband, brother, or friend "deserves to be surrounded with brightness and beauty, which cheers and heartens—not by depressing unattractiveness." This notion gained such wide acceptance that by the start of the Second World War it didn't even need to be argued. The government went so far as to decree the manufacture of lipstick a wartime necessity, but that changed with the military's increased demand for the oil used in lipstick production. The reddening of lips declined in America, but only temporarily, until peace was restored.[51]

LET US RETURN NOW TO GRETA GARBO. As noted earlier, the legendary beauty was renowned for her mask-like features and fixed countenance. Many attempts, including those quoted above, have been made to explain her almost mystical appeal to viewers. Perhaps the best-known of these is "The Face of Garbo," an essay written in the early 1950s by the French literary critic Roland Barthes in his studies of modern-day "mythologies."

Barthes argues that Garbo's face was an "absolute mask" that "offered to one's gaze a sort of Platonic idea of the human creature." Her visage, he writes, "has the snowy thickness of a mask: It is not a painted face, but one set in plaster." This calls to mind Hemingway's description of *les gueules cassées*, the Great War veterans whose surgically reconstructed faces had the texture and density of "a well-packed ski run." According to Barthes, what made the face of Garbo so compelling to watch was that, "Amid all this snow at once fragile and compact, the eyes alone, black like strange soft flesh...are two faintly tremulous wounds." Or as the German art theorist and film writer Rudolph Arnheim, an enthralled follower of Garbo, wrote in 1928, "We see through the darkly shadowed eyes as though we were gazing miles-deep into the interior of a crater." The power of Garbo's face, and the reason it exerted such a magnetic pull on silent-era viewers, is that

it was simultaneously hard, cold, and rigid but also throbbing with life, pain, and yearning.[52]

Considering the metallic countenance of Greta Garbo, we might recall the tin and copper masks provided by the likes of Anna Coleman Ladd. Rigid, sculptural, mechanical, these masks, too, like Garbo's face, were Platonic artifacts, attesting to idealized, socially sanctioned conceptions of gender-appropriate beauty. The inescapable evidence of life and feeling pulsating beneath the frozen immobility of her flawless features made Garbo's face hypnotically compelling. What must have made the masked men, on the other hand, so awful to encounter on the street or in a streetcar was that same dialectic between stasis and movement, hardness and softness, deathlike perfection and lifelike pain.

Only here their counterpart in the silent cinema was not Greta Garbo with her mask of perfection but rather that great pathetic movie monster, the Phantom of the Opera (Fig. 127). The sudden revelation of the Phantom's badly disfigured face two-thirds of the way into the 1925 thriller named for him was horrifying to audiences, but not as dreadful, surely, as the long, slow build-up to that climax, when they were forced to imagine what *might* lurk beneath his mask.

Garbo's exceptional beauty, it should now be noted, was carefully constructed at the behest of her studio, MGM. The makeup artists, hair stylists, and hair colorists assigned to her were the best in the business, as were

127. | Lon Chaney in *The Phantom of the Opera*, 1925.

128. | Greta Garbo in *The Kiss*, 1929.

her cinematographer and lighting specialists. She also secretly engaged in a series of surgical interventions to remove incipient wrinkles, widen her eyes, and reshape her nose. In this regard, she was the antithesis of Ida Rogers (see Fig. 118), the pretty young model for Ivan Albright who was transformed through his creative artifice in the opposite direction, made into a signifier of dismal decrepitude. Not Garbo (Fig. 128). According to one historian: "Her hairline was evened out, her nose seems to be made narrower and her lips were sloped differently. The studios worked with cosmetic surgeons and employed a dentist full-time to correct the star's teeth. Garbo's previously dark and crooked teeth were capped. [She] was thus brought into line with an existing ideal of beauty."[53]

Garbo's face, with its smooth, clean, aerodynamic lines and symmetrical shapes, was Art Deco with soul, mechanization with heart.[54] It offered audiences, locked in the darkness of the silent cinema and eager to escape the harsh light of postwar reality, a fleeting glimpse of perfection, of stainless-steel smoothness and strength, but tempered with humanizing melancholy (Fig. 129). Perhaps, as discussed earlier in this chapter, they sensed that beyond the Platonic harmonies of her face, in the depths of her mournful eyes, seethed a grief that was not hers alone, but shared by millions everywhere who had recently emerged from the abyss of war, shaken and scathed.

IN AND OF ITSELF, the First World War did not cause the modern beauty revolution. That was already underway when it began. But the war accelerated the transformation by leading directly to the development of cosmetic plastic surgery and medical facial prostheses and indirectly to the widespread

129. | Greta Garbo in *Anna Christie*, 1930.

use of commercial makeup and other industrially produced technologies for the adornment of the female face. Masks of one form or another proliferated. Overwhelming onlookers with its unprecedented carnage and haunting their dreams with maimed and unsightly survivors, the war drove peacetime populations into a compulsive search for physical beauty. In the face of ugliness, beauty was redefined.

9

MONSTERS IN OUR MIDST

FROM THE START, AMERICANS WERE aware of the horrors of the European war. Newspapers, magazines, official publications such as the Bryce Report, ubiquitous war posters, and stunning photographs of devastated European cities, towns, and landscapes offered them continually provocative reminders of the ongoing struggle. Occasionally they laid eyes on men who were severely wounded, or heard about it from friends and neighbors who had, and this too made them grasp the gravity of the conflict. By the time the war was over, most American communities had been touched by the loss of American lives and limbs. Of 2.4 million soldiers and sailors who left the continental United States to fight in the Great War, a twentieth of them—some 112,000—did not come home alive. Of these, 55,000 died of war wounds; most of the rest fatally succumbed to the influenza epidemic or other deadly diseases.

Approximately 205,000 AEF soldiers and sailors sustained significant injuries. About 70,000 doughboys were evacuated from the line because of the war-induced nervous breakdown that came to be known as shell shock. More than half (36,000) of those sufferers were hospitalized for long periods of time, and, all told, 159,000 American soldiers were inactivated because of paralyzing depression. In 1919, the overall population of the country was 105 million, so these numbers may seem insignificant, especially compared to the enormous casualty rates endured by the British, French, Germans, and Russians, or, to switch metrics, to the 600,000 deaths incurred during the Civil War. Even so, despite their geographic distance from the fray and the proportionately small number of casualties they sustained, modern-day Americans were anything but immune to the sting of this most recent cataclysm.[1]

Still, they were slow to realize how truly ugly and awful the conflict had been. Various reasons caused this delayed understanding. During the war, dominant culture—not only government bureaus and civic organizations, but

also news media, the entertainment industry, corporate advertising, schools, and clergy—had been spectacularly successful in teaching Americans to avert their gaze; in that regard, seeing what was going on "over there" was as problematic for ordinary Americans as it was for the artists discussed in Chapter 6. Even though the press was zealous in reporting (or misreporting) atrocities committed by the enemy against civilian populations, most accounts from France painted a relatively rosy picture of the daily lives of doughboys.

The letters home written by the doughboys themselves, the playful snapshots taken by them on leave, and the upbeat stories and even staged "combat" photos printed in the army's in-house publication, *Stars and Stripes*, many of which were syndicated in hometown newspapers across the country, created a benign impression of the soldier's life abroad. These might, for example, comment jokingly on the strangeness of a gas mask or humorously show a doughboy chucking a hand grenade from a trench as if he were pitching a baseball from the mound (Fig. 130). Compare these to Otto Dix's

FRANCE, FRIDAY, FEBRUARY 22, 1918.

WORLD'S SERIES OPENED—BATTER UP!

The outfield is a-creepin' in to catch the Kaiser's pop, and here's a southpaw twirler with a lot of vim and hop!

He's tossed the horsehide far away to plug the hand grenade;
What matter if on muddy grounds this game of war is played?
He'll last through extra innings and he'll hit as well as pitch;
His smoking Texas Leaguers'll make the Fritzies seek the ditch!

He's just about to groove it toward a ducking Fritzy's bean,
His cross-fire is the puzzlingest that ever yet was seen,
His spitter is a deadly thing; his little inshoot curve
Will graze some Heinie's heaving ribs and make him lose his nerve.

Up in the air he never goes; he always cuts the plate,
No matter if the bleachers rise and start "The Hymn of Hate";
And pacifistic coaching never once has got his goat—
Just watch him heave across the top the latest Yankee note!

The Boches claim the Umpire is a-sidin' with their nine,
But we are not the boobs to fall for such a phony line;
We know the game is fair and square, decisions on the level;
The only boost the Kaiser gets is from his pal, the Devil!

The series now is opened, and the band begins to play,
The batteries are warming up; the crowd shouts, "Hip-Hurray!"
The catcher is a-wingin' 'em to second, third and first,
And if a Heinie tries to steal, he's sure to get the worst.

So watch the southpaw twirler in his uniform O.D.
Retire to the players' bench the Boches—one, two, three!
He'll never walk a bloomin' one, nor let 'em hit it out—
Just watch him make 'em fan the air and put the Hun to rout!

130. | "World's Series Opened—Batter Up!" *Stars and Stripes*, February 22, 1918.

expressionist *Assault Troops Advance under Gas* (page 236) or Claggett Wilson's hallucinatory *Front Line Stuff* (page 193), and their refusal to take war seriously is evident, even though, or particularly because, the intended readers were soldiers who had already been in battle or were likely to be headed in that direction.[2]

To be sure, censorship played a key role in maintaining Americans' general naïveté about the lives and sometimes deaths of their fighting men abroad. Soldiers were not permitted to write letters about the disturbing things they had seen (or done), and civilians were not allowed to read books, magazines, or newspapers, or view art or photography, that challenged in any way the goodness and decency of America's war effort. After the armistice, censorship ended, and previously suppressed information and images could now circulate freely. Nevertheless, as the historian David Kennedy has observed, even though the former doughboys could now say whatever they pleased about their wartime experiences, they tended to recall them in almost exclusively positive terms, persistently displaying the upbeat emotions that were expected of them: pride at what they had accomplished militarily and pride as well—often conveyed with a wink and a nod—for the good times they had enjoyed in "gay Paree." Kennedy notes that the AEF veterans phrased their memories in a mix of discourses borrowed from wisecrack humor, tourist brochures, and popular romantic fiction; they did not, by and large, dwell on, or in many cases even mention, the violence they had encountered first- or secondhand. In more than a few instances, the light-heartedness of their recollections may have been a means of masking from others, if not themselves, the psychic pain they had experienced.[3]

Only rarely, it seems, did letters from the front express as much "gall and wormwood" as that conveyed by the twenty-one-year-old volunteer ambulance driver, stretcher-bearer, and future novelist John Dos Passos to a friend back home in the summer of 1917, before strict censorship was yet in place: "The war is utter damn nonsense—a vast cancer fed by lies and self seeking malignity on the part of those who don't do the fighting.... None of the poor devils whose mangled bodies I take to the hospital in my ambulance really give a damn about any of the aims of this ridiculous affair—They fight because they are too cowardly & too unimaginative not to see what way they ought to turn their guns—For God's sake, Rummy boy, put this in your pipe and smoke it—everything said & written & and thought in America about the war is lies—God! They choke one like poison gas—."[4]

As an ambulance driver, Dos Passos literally saw more blood and guts than most soldiers did, for his job entailed transporting buckets of body parts and scrubbing away viscera when the day was done. His disgust with patriotic rhetoric was typical of those who came in close contact with the carnage. What, they typically wondered, would death on this scale do to the minds of the survivors? An English nurse working around the clock at a battlefield

hospital in Belgium pondered the long-term effect of continual exposure to violence. "If death becomes cheap it is the watcher, not the dying, who is poisoned," she concluded.[5]

After the armistice, dictates of taste continued to exclude violent imagery from the verbal and visual fields, yet some of it inevitably filtered into the public realm, and Americans were shocked and angry to discover what had been kept hidden from them. Another way awareness was raised is simply that not a few (we can never know how many) of the soldiers and sailors who had gone off to Europe full of high hopes and grand illusions came back to their home towns with a certain edge of estrangement about them. It would have been difficult for their families and neighbors not to notice the change in disposition or wonder what unspoken grief had caused it.

Often it took a while for the deeper disturbances of war to manifest themselves in the behavior of veterans. Writing in the mid-1930s, the poet, memoirist, and battlefield veteran Siegfried Sassoon wondered, "How many a brief bombardment had its long delayed after effect in the minds of these survivors, many of whom had looked at their companions and laughed while inferno did its best to destroy them. Not then was the evil hour, but now; now, in the sweating suffocation of nightmare, in paralysis of limbs, in the stammering of dislocated speech."[6] Sassoon was British, not American, but his books were critically acclaimed in the United States, enough so that he was invited on a cross-country lecture tour. This would suggest that large numbers of ex-doughboys and their families had seen the emotional time-delay he describes.

As detailed in the previous chapter, some veterans were so badly disfigured or disabled by their wounds that strangers found it difficult to look at them without repulsion, a reaction that was painfully obvious to those whose aberrant appearance had triggered it. A British physician quoted in a *New York Times* piece on the need for public assistance for disabled soldiers said, "It's the poor devils without noses and jaws, the unfortunate of the trenches who come back without the faces of men, that form the most depressing part of the work. Their wives may love them…but there's something about a man with his face gone that hurts the eyes.…You see, the race is only human, and people who look as some of those creatures look haven't much of a chance."[7] Again, the commentator is English, not American, and the extent and conspicuousness of facial deformity would have been much greater in Britain than in the United States, with its far smaller casualty rate and far larger population. Even so, most Americans would have heard or read about, if not personally encountered, the sometimes monstrous effects of the war on male bodies.

In the United States, as in every other nation that saw the return of millions of war-weary fighters, homecoming required painful adjustments for

everyone. Although the war ended in November 1918, it was another three months to a year before Johnny came marching or limping home. By that time, psychological defense mechanisms had locked into place. As noted above, combat veterans were hesitant to talk about terrible things they had seen, faced, or done while overseas. Returning doughboys were expected to be chipper and glad, ready to "play ball" again with the world they had temporarily forsaken and which now, in some ways, threatened to forsake them. As reported by a gunnery sergeant who served in the army of the occupation, "Much was done in Germany to infuse in the men the zeal that was theirs upon entering the service. Baseball, football, track, and etc. But the men seemed indifferent, and I believed then that the zest for such things was sapped out of them by the war."[8]

Another returning serviceman confided, "Before the war I was an innocent, ignorant child, while now I feel that I could easily go insane by permitting my mind to recall and dwell upon the horrors of my experience."[9] Explaining the emotional struggles of repatriation, a marine colonel reported: "I was getting more restless and more nervous every day...then it dawned on me that it didn't matter where I was...I began waking up at night, shuddering, from dreams of the rain and the cold and the mud. In nightmares, the rats in the trenches kept jumping on me."[10] Another marine stated, "I know how we all cried to get back to the States...but now that we are here, I must admit for myself at least that I am lost and somehow strangely lonesome."[11]

Ernest Hemingway caught the mood of this estrangement in his short story "Soldier's Home" (1925). "By the time Krebs returned to his home town in Oklahoma," writes Hemingway, "the greeting of heroes was over. He came back much too late. The men from the town who had been drafted had all been welcomed elaborately on their return. There had been a great deal of hysteria. Now the reaction had set in." Public desire not to know what had really happened at the battlefront heightened the inability of the veterans to give an honest account of the trauma they had experienced. Krebs exemplifies a widespread reluctance—if not downright inability—on the part of AEF veterans to communicate their frontline experiences to those who had not left home. Krebs "did not want to talk about the war at all. Later he felt the need to talk but no one wanted to hear about it." When Krebs's mother, anguished by his silent detachment, asks him point blank, "Don't you love your mother, dear boy?" he at first answers truthfully, "No...I don't love anybody," but then recants under the pressure of her tears.[12]

Krebs had vowed that he would tell no more lies, but his mother, embodying peacetime repression at large, forces him to break his promise to himself. One of the protagonists of Dos Passos's novel *Three Soldiers* (1921) experiences a similar revulsion against socially sanctioned lies: Civilization, in his view, was "nothing but a vast edifice of sham, and the war itself,

instead of its crumbling, was its fullest and most ultimate expression." As to the lofty sentiments that had driven America to war: "Were they all shams, too, these gigantic phrases that floated like gaudy kites high above mankind?"[13]

In *How We Advertised America*, published in 1920, George Creel looked back with pride at the way his "information" agency had saturated the nation's visual and verbal environments with countless persuasive posters, drawings, movies, lectures, pamphlets, badges, and books, all for one purpose: defeating the enemy. According to Creel, during the two years the CPI (Committee on Public Information) was in operation, its twenty divisions produced 755,190 patriotism-building, enemy-defying speeches, each of them lasting for approximately four minutes. These were delivered at schools, factories, hospitals, civic clubs, and during reel-changes at the movies by 75,000 speakers in 5,200 communities to 14,454,514 listeners. Each of these mini speeches, boasted Creel, had "the carry of shrapnel."[14]

Not all Americans shared Creel's pride in the bacchanalia of patriotic images and invocations that his agency, as well as numerous others public and private, had fostered. Public opinion on the matter changed slowly at first, then turned into a torrent of disapproval. In a memoir published in the mid 1930s, the investigative journalist George Seldes wrote ruefully, "I now realize that we were told nothing but buncombe, that we were shown nothing of the realities of war, that we were, in short, merely part of the great Allied propaganda machine whose purpose was to sustain morale at all costs and help draw unwilling America into the slaughter." Buncombe, also spelled bunkum, and shorted to bunk, as in Henry Ford's declaration "History is bunk," was a watchword of the era.[15]

The homecoming of millions of mildly to severely disaffected soldiers created aliens, as it were, on both sides: veterans like Krebs, whose emotions had been cauterized, and civilians who lacked understanding of, or empathy for, what the veterans had been through. The horrors of the Civil War had also been great, maybe even greater, than those to which Americans were subjected during the First World War; certainly the number of casualties was much higher in the earlier instance. But because that earlier war was contested on American soil, the civilian population, whether northern or southern, was bound to be more tolerant of the soldiers' inner ordeal, more connected to the veterans emotionally, than was the civilian population during and after the 1917–18 war. Unlike civilians in 1861–1865, the civilians of 1917–18 had been so heavily inundated with patriotic propaganda and trumped-up heroics concerning the boys "over there" that they had difficulty making cognitive or emotional sense of the ugly realities their husbands, brothers, and sons had encountered. These simply did not conform to the paradigms they had learned.[16]

Moreover, those husbands, brothers, and sons were often, like Hemingway's Krebs, reluctant to recount their experiences in battle. Laurence Stallings's best-selling autobiographical novel, *Plumes* (1924), concerns a previously idealistic marine whose leg is shattered at Belleau Wood and eventually requires amputation. The narrator points out that postwar Americans quickly lost interest in veterans who had made "the supreme sacrifice" for their country. Some of these veterans "would be ex-soldiers until death," whereas the bulk of them "returned to industrial pursuits where they said nothing about the war, fearing lest they class themselves on the one hand among the permanent ex-soldiers, and on the other among those bores who prattle of war and continually embarrass" their families and coworkers by their compulsive rehearsal of military memories.[17]

The disabled men had the hardest time of all, Stallings suggests, because they had ruined their bodies, and with them their lives, for no good reason. Had the Versailles peace treaty not devolved into a punitive mess, and had the United States not rejected the League of Nations, the Americans who forfeited the wholeness of their bodies could at least take comfort in knowing they had done so for a worthwhile cause and a practical outcome. But by the early 1920s, it was clear that their physical and mental sacrifices had done little to build a better world, and the old idealisms that had sent them to war in the first place seemed at best nothing more than childish fantasy.

The novel's protagonist, Richard Plume, a stand-in for Stallings, who himself was forced to endure multiple excruciating operations on his leg and prolonged sojourns in Walter Reed Hospital, resents the "diet of shining swords" that had been fed to him by his elders before he left his young wife to join the Marines. He wants to "lash out in fury against any one who supported the system in which he had been victimized," and in particular he wishes that one of his college professors, who had filled his head with dreams of glory, would admit he was wrong and say, "Well, Plume, you've made a hell of a mess of your life, but I'm damned if I ever permit another man to romance about war as long as I can prevent him." The young veteran fantasizes "tearing down the flagstaff on the campus, and removing the silly field gun, and masking all the statues of soldiers," but he is too impotent to do any such thing.[18]

Modernist writers about the war such as Hemingway, Dos Passos, and E. E. Cummings, as well as more mainstream authors such as Stallings and lesser-known fiction writers Thomas Boyd and William March—both of whom, like Stallings, had been wounded in combat—set out to disturb the complacency of readers by rejecting traditional modes of narrative address. (Claggett Wilson, another combat marine wounded in action, appears to have had similar intentions.) In Hemingway's 1929 best-selling novel *A Farewell to Arms*, the first-person narrator, Lieutenant Frederic Henry, deploys simple, concrete,

and non-rhetorical language to recount the night he and his Italian comrades were caught in an Austrian bombardment:

> *There was a great splashing and I saw the star-shells go up and burst and float whitely and rockets going up and heard the bombs, all this in a moment, and then I heard...some one saying "Mama Mia! Oh, mama Mia!"...It was Passini and when I touched him he screamed. His legs were toward me and I saw in the dark and the light that they were both smashed above the knee. One leg was gone and the other was held by tendons and part of the trouser and the stump twitched and jerked as though it were not connected.*[19]

This was—and still is—strong stuff, shocking because of its immediacy, but also because we are made to see and hear mutilation without the protective intervention of flowery phrases. Before the reader's eyes, a normal, healthy body transforms into something hideous and grotesque. The bombardment creates a monster, but not an enemy monster. This makes him all the more frightening, because the reader *identifies* with him and thus can't so easily erect an emotional barrier to his suffering.

Far less acclaimed than Hemingway was William March (William Edward Campbell), who in 1933 turned his wartime experiences into *Company K*, a brilliant but little-noticed volume of 113 short, interconnected interior monologues by marines who fought as a unit at Château-Thierry, Belleau Wood, and the Meuse-Argonne. Along the way, the reader realizes (for it is not stated directly) that the captain of the company has ordered his men to lead prisoners into a ravine and gun them down. The perpetrators have differing reactions to the atrocity they commit. A corporal rationalizes the shooting spree: "'Christ almighty!—This is war! What did you think it was? A Sunday-school picnic? Take these Germans now.—Burning churches and dashing out the brains of innocent babies—You've got to fight fire with fire,' I said. 'This is the only sort of treatment a German can understand....'" A private, sickened by what he is ordered to do, throws down his rifle and runs into the woods, knowing he will be apprehended as a deserter and sentenced to twenty years in military prison. Another private, though troubled by the beseeching blue eyes of one his captives, proceeds to follow orders: "I stood there spraying bullets from side to side in accordance with instructions...'Everything I was ever taught to believe about mercy, justice and virtue is a lie,' I thought.... 'But the biggest lie of all are the words, "God is Love." That is really the most terrible lie that man ever thought of.' "[20]

After the slaughter is complete, another member of the detail goes back to the scene of the crime: "The prisoners lay where we had left them, face

131. | Claggett Wilson, *Salad—A Cleaned-Up Machine-Gun Nest, Bois de Belleau*, 1919. Smithsonian American Art Museum.

upward mostly, twisted in grotesque knots like angle-worms in a can." March's description calls to mind a Claggett Wilson watercolor depicting a pair of leaden-eyed doughboys who peer down at a "cleaned-up machine gun nest" in Belleau Wood (Fig. 131). Sardonically entitled *Salad*, the painting reveals what the American soldiers see: a mélange of twisted and tangled German corpses interspersed with boots, helmets, a machine gun barrel, and shattered tree limbs. Remorse overwhelms the private in *Company K*: "A peculiar feeling that I could not understand came over me. I fell to the ground and pressed my face in the fallen leaves.... 'I'll never hurt anything again as long as I live,' I said.... 'Never again, as long as I live.... Never!... Never!... Never!...'"

Besides providing readers with their first truly graphic depictions of battlefield agony and violence, American authors such as Dos Passos, Stallings, Boyd, Hemingway, and March and the German novelist Erich Maria Remarque, who was widely read in translation, raised important questions about the difficult reentry of designated killers into the peacetime economy. "What do they expect from us when a time comes in which there is no more war?" Remarque's soldier-narrator demands in *All Quiet on the Western*

Front (1929), an anti-war novel that appeared in twenty-five languages within eighteen months of its original publication in Germany and was the best-selling novel in America in 1929 (surpassing sales of *A Farewell to Arms* for that distinction). Its protagonist, Paul Bäumer, observes that "For years our occupation has been killing—that was the first experience we had. Our knowledge of life is limited to death. What will happen afterwards? And what can possibly become of us?"[21]

More recently, after the American invasion of Iraq, the veteran war correspondent Chris Hedges put the problem this way: "The inhuman qualities drilled into soldiers and marines in wartime defeat them in peacetime. This is what Homer taught us in *The Iliad*, the great book on war, and *The Odyssey*, the great book on the long journey to recovery by professional killers. Many never readjust. They cannot connect again with wives, children, parents, or friends, retreating into personal hells of self-destructive anguish and rage."[22]

Such challenges beset every homeland to which the combat veterans returned. What was to be done with the millions of men who had been trained by their sergeants to overcome lifelong inhibitions against brutality and killing or who, in the heat of battle and in the agony of seeing their closest friends taken down by the enemy, had found within themselves depths of aggressive rage they had never known existed? What monsters had they themselves become, and how could they be reabsorbed into peacetime society without radically disrupting it? Would they poison the small-town values they had abandoned, corrupting the innocence of those who had not left home? The returning warriors, experts in lethal fighting, must have instilled fear in those who had remained behind, but just as likely the warriors feared those homebodies, who could not understand what it meant to face terror in the trenches. Veterans' lodges became places of refuge and commiseration, where retired soldiers sought to retrieve the male camaraderie and knowing sympathy that was otherwise missing from their lives. In some sense, each social group was potentially monstrous in the eyes of the other.

In the late 1930s, the politically conservative and isolationist Kansas painter John Steuart Curry, a former student of Harvey Dunn, a protégé of Gertrude Vanderbilt Whitney, and one of America's foremost Regionalists, painted what must be his most disturbing image, a depiction of American soldiers marching to war.[23] Called *Parade to War, An Allegory*, it is based, in some measure it seems to me, on Peter Paul Rubens's allegorical *Consequences of War* (ca. 1638–39, Pitti Palace), in which a ferocious-looking Mars storms angrily into action while a voluptuous Venus tries to restrain him. Here Curry shows America's helmeted and bayonet-bearing youth sweeping down Main Street while streamers fill the air, excited boys run alongside the parade, and a slender young woman garbed in a flowing white dress clings to a marching soldier who wraps his arm around her waist (Fig. 132). She may be a modern-day Venus,

but she makes no attempt to restrain her Mars. The heroes of all this adulation, dressed in their go-to-war uniforms are cadaverous, skull-faced figures of death. Is Curry, from his isolationist, antiwar perspective, warning against involvement in another foreign venture, which will again needlessly ravage young American lives, or is he saying instead that war makes monsters of men, even "our" men, regardless of their initial innocence? In either case, the painting emphatically refutes the bound-for-glory energies of the parading troops depicted in *Women of Britain Say—"Go!"*, *On the Hudson at Newburgh*, and *On Which Side of the Window Are You?*, as examined above in Chapter 3, and recreated in popular films such as *The Big Parade*, as described in Chapter 6.

Half a century ago, the historian Barbara Tuchman concluded *The Guns of August* (1962), her much-lauded account of the beginnings of the First World War, with the acerbic comment that "When at last it was over the war had many diverse results and one dominant one transcending all others: disillusion." More recently, scholars have challenged that view, suggesting that

132. | John Steuart Curry, *Parade to War, An Allegory*, 1938. Gift of Barnett Banks, Inc. The Cummer Museum of Art and Gardens, Jacksonville.

rancorous disillusionment in the interwar period was mostly the preserve of elite writers, artists, and intellectuals but not the currency of the common, everyday person, especially in America, where the golden glow of victory provided a sense of well-earned satisfaction for mission accomplished. But this is not a new claim. Also half a century ago, the Hemingway scholar Philip Young addressed the question of how representative were the experiences detailed in *A Farewell to Arms*. The novel's main character, he points out, "had a somewhat special time of it" during the war, "But it is not important that these aspects of his army experience are highly atypical. Nor does it matter on the other hand that women usually survive childbirth, and many men are discharged from armies in good shape, and then life goes on as before." What made the book valuable to its readers, Young contends, was precisely its "intensification of life," wherein they saw their own inner emotional and intellectual struggles accurately reflected and cathartically released.[24]

It is impossible to know with any sort of precision whether the anomie described by the Lost Generation writers was confined to their rarefied circles or actually caught the mood of the broader population. The robust sales of books such as *Three Soldiers*, *Plumes* (which was reprinted nine times in the first year of its release), *A Farewell to Arms*, and *All Quiet on the Western Front* might suggest the latter to be the case—that these books, though written by intellectuals, spoke meaningfully to the population at large. Perhaps it's best simply to acknowledge that remembrance of the war during the interwar years was distinctly mixed, dividing into strongly opposed camps, much as the nation itself had been divided before entering the war.

For a brief time, national solidarity had prevailed, thanks to the deluge of morale-boosting propaganda and the vigorous enforcement of sedition laws, but once it was over, over there, old antagonisms reemerged. The era of good feelings that the nation (allegedly) enjoyed during the war vanished when it ended. Bitterly contested amendments to the Constitution concerning prohibition and women's suffrage, along with dramatic shifts in the nation's pronounced rural/urban split, opened up new fissures in the body politic. How Americans looked back at the war—as a golden age of unity and self-sacrifice or as an outrageous triumph of chicanery over common sense—depended on which side of the divide they stood.

IF WHITE SOLDIERS FOUND IT DIFFICULT to reintegrate with American society, black soldiers, who had never been integrated in the first place, had an even harder time of it. True, young whites had been taught to kill and could be feared for inadvertently carrying the virus of violent aggression back to their home towns, whereas most black soldiers had been relegated to lowly support positions and thus not trained in the arts of deadly attack.

Nonetheless the dread of violence by returning African American veterans was greater than it was for their white counterparts. This is because most whites believed blacks to be members of an inherently violent race, unable to suppress primal passions. In the numerous race riots that erupted across the United States in the homecoming year of 1919, a common assumption among white observers was that blacks were creatures of the jungle, primitive and childish, incapable of self-restraint.

Before America entered the war, black leaders such as W. E. B. Du Bois had hoped for the opposite outcome: that black soldiers would earn the respect of their white brethren and show Americans that black people deserved a place at the table of democracy, with equal access to its bounties. To that end, Du Bois and other African American leaders urged young blacks to enlist in the segregated armed forces. Despite the bigotry they were sure to encounter, fighting for their nation and, if need be, dying for it would lead to increased racial justice and equality at home.[25]

Once they reached France, African American units were not initially sent into combat. Military officials believed that white soldiers could not be asked to risk mingling their spilled blood with that of blacks. Black battalions were assigned the most menial and least glorious responsibilities, such as cooking, cleaning, hauling, and grave-digging. When the French 161st Division, desperate for reinforcements, requested help from General Pershing in the spring of 1918, he seconded to them the 369th Colored Infantry, thus at last allowing black Americans a combat role, albeit not with U.S. troops. The regiment attracted international attention for the valor and tenacity with which it fought. The men of the 369th were in the battle zone for an unprecedented 191 days without relief; a record unmatched by any other American regiment during the course of the war. Their German adversaries, not without racist tendencies of their own, referred to the armed black men as "demons from hell" or "hellfighters." Proudly, the regiment adopted the nickname "Harlem Hellfighters," and it stuck.

The most honored member of the regiment was Private (later Sergeant) Henry L. Johnson of Albany, the first American of any color to win the French *Croix de Guerre*. During a nighttime raid by a twenty-four-man detachment of Germans against the isolated outpost where he was keeping watch, Johnson sustained numerous injuries while rushing to the defense of his fellow sentry, Private Needham Roberts. After Roberts collapsed from wounds of his own, Johnson single-handedly drove off the enemy in a fierce struggle. As word of the engagement spread, Johnson and Roberts quickly became America's most famous black war heroes, and even notoriously racist white Southern journalists praised them for their bravery.

When the Hellfighters, some three thousand strong, returned from France and marched in triumph up Fifth Avenue from 23rd Street to 145th and Lenox on February 17, 1919, an estimated crowd of two million New

Yorkers, many of them white, enthusiastically greeted Harlem's parading heroes. "Up the wide avenue they swung," reported the *New York Tribune*. "Their smiles outshone the golden sunlight. In every line proud chests expanded beneath the medals valor had won. The impassioned cheering of the crowds massed along the way drowned the blaring cadence of their former jazz band. The old 15th [New York (Colored) Regiment, absorbed into the 369th Infantry] was on parade and New York turned out to tender its dark-skinned heroes a New York welcome."[26]

Looking back, this was the apogee of their fame, a short-lived era of good feelings in the racial domain—only an instant, in fact, rather than an anything worthy of being called an era. The echelon of heroes, advancing up the avenue with a remarkable display of self-discipline and group synchronization, filled onlookers with pride. One veteran who marched in the parade wryly recalled, "All the soldiers that had been complaining about rheumatism and other ailments that heretofore had caused them to be limp and crippled, were now standing erect and in the best marching conditions." The crowd showered the regiment with cigarettes, candy, and silver coins, and war hero Henry Johnson stood in an open car, proudly displaying his *Croix de Guerre* to delirious cries of "Oh, you Henry Johnson!" and "Oh, you Black Death!"[27]

Soon thereafter, the studio photographer James VanDerZee photographed the two battle-tested doughboys Johnson and Roberts in his Harlem studio (Fig. 133). Born to parents who were once slaves and had both served in the household of President Ulysses S. Grant, VanDerZee had become the preeminent photographic chronicler of the Harlem Renaissance. With ingenuity and artistry, he portrayed the hopes and dreams and middle-class aspirations of his mostly bourgeois clientele.[28]

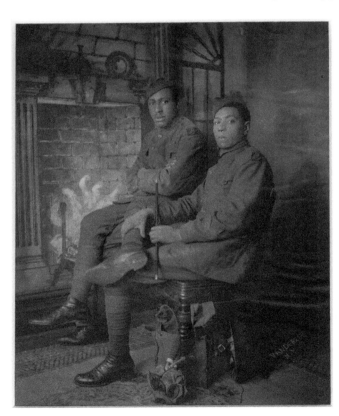

133. | James VanDerZee, *Two Soldiers* (Henry Johnson, left, and Needham Roberts, right), ca. 1919. Prairie View A&M University, Texas.

His double portrait of Johnson and Roberts is remarkable for its repression of the physical force for which these young warriors were acclaimed. Though dressed in military uniform, they sit together on a bench like a married couple in an eighteenth-century domestic portrait. Roberts, who had bashed in German skulls with the stock of his rifle before losing consciousness, appears the more masculine of the two, his legs crossed in manly fashion and a metal-tipped swagger stick propped against his lap. Johnson, who disemboweled one of the enemy raiders with his bolo knife, folds his arms and demurely crosses his legs. A conspicuously fake fireplace, familiar from other VanDer-Zee studio shots, including one of a beautiful female nude and another of a pair of newlyweds, warms them with its painted flames. One can't help noticing reserve or even misgiving on the faces of the two

134. | W. A. Rodgers, "Two First Class Americans!" *New York Herald* cartoon of Henry Johnson (with knife) and Needham Roberts, 1918.

soldiers, a look that seems to pose the question, *What in the world are we doing here?*[29]

Surely VanDerZee knew exactly what they were doing there. His self-appointed task was to represent them exactly as he did his more typical, middle-class sitters. He hoped to thwart the thuggish stereotype that white society, and perhaps black society as well, had ready and waiting for black men who fought and killed with their hands. Domesticating these two war heroes by every trick in his book, VanDerZee feminized or, one might even say, "boy-ified" them. As Richard Slotkin observes of Johnson's concurrent depiction in the white press:

> *The terms in which Henry Johnson's heroism was praised suggested that the African-American as hero retained the essential qualities of the Negro as "nigger." The line-cut on the front page of the New York Herald, designed to emphasize and glorify the initial account of "The Battle of Henry Johnson," captured the idea perfectly. Henry Johnson stands ankle-deep among the dead, a blood-dripping knife in his hand. His frowning mouth is white in his Black face—he is at one and the same time a "first-class American" hero and a blackface minstrel.*[30] *(Fig. 134)*

In 1919, even as Henry Johnson was being applauded by whites for killing Germans, sixty-three of his fellow African Americans were lynched for alleged violence against whites. Ten of these lynch victims were soldiers still in uniform. James Baldwin, in his semi-autobiographical novel *Go Tell It on the Mountain* (1953), graphically describes the aftermath of one such lynching: "There had been found that morning, just outside town, the dead body of a soldier, his uniform shredded where he had been flogged, and, turned upward through the black skin, raw, red meat. He lay face downward at the base of a tree, his fingernails digging into the scuffed earth. When he was turned over, his eyeballs stared upward in amazement and horror."[31]

Not all victims of lynching were men. In rural Georgia in the spring of 1918, a young black woman named Mary Turner, enraged by her husband's death at the hands of a mob, flung invective at the townspeople who had stood by and watched. For her intemperate remarks, she was marched into the woods, stripped, hung upside down, doused with gasoline, and set ablaze. She was eight months pregnant, the *Atlanta Constitution* reported.[32]

Such accounts suggest that the Germans were not alone in their capacity for committing atrocity, although the fine points of such a comparison were generally not spelled out in the white press. Blacks, however, noted the irony. As Richard Wright put it, "Our black boys do not die for liberty in Flanders. They die in Texas and Georgia. Atlanta is our Marne. Brownsville, Texas, is our Château-Thierry." Black soldiers could be decorated with France's *Croix de Guerre*, but on their return to the United States, an editorial in a black newspaper dryly observed, their "particular decoration is to be the 'double-cross.'"[33]

135. | Charles Dana Gibson, "*Peace Preliminaries.*" Reprinted in *Stars and Stripes*, February 15, 1918.

In France near the end of the war, the journalist Dorothy Canfield Fisher overheard an American soldier say to his comrades, "We took the whole lot of 'em prisoners, and passed 'em back to the rear, but out of the fifteen we took, eight died of sudden heart-disease before they got back to the prisoners' camp." She adds: "I tried not to believe this, but the fact that it was told with a laugh reminded me gruesomely that we are the nation that permits lynching of helpless men by the mob." So normalized was the concept of lynching for many Americans that the inaugural issue of *Stars and Stripes*, the doughboy weekly printed in France, featured a semi-realistic line drawing by Charles Dana Gibson of Uncle Sam throwing a

noose over the Kaiser to hang him from a tree; this the caption gleefully described as "Peace Preliminaries." (Fig. 135).[34]

As it happens, neither Johnson nor Roberts came to a happy end. Johnson, having gained a sense of pride and self-respect from his wartime experiences, went on a lecture tour, but the audiences that stood and cheered when he came onstage with medals blazoned across his chest were angered by his defiant words. He was called uppity and ungrateful and stopped receiving invitations as a platform speaker. Prevented by his crippling war wounds from returning to his former employment as a baggage porter, he sank into alcoholism, and in 1929 he died at a VA hospital, divorced, bitter, and utterly alone. It was only in 2015, some ninety-seven years after his remarkable display of courage under fire, that he was awarded the Congressional Medal of Honor.[35]

Oddly, Johnson's thwarted life resembled that of a fictional character with the same name created by Stephen Crane in his 1898 novella *The Monster*. Crane's Henry Johnson, a handyman employed by a white doctor in a small town, runs into a burning house to save the life of his employer's son. In the course of rescuing the boy, Johnson is badly injured, and his face is seared beyond recognition or repair. Initially grateful to him for his heroic effort on their behalf, the townspeople are repulsed by his ugliness and shun him as a monster. Even Jimmie, the boy he rescued from the flames, taunts him brutally in order to "save face" with his playmates.[36]

Needham Roberts, also crippled by war wounds, lived off meager earnings from a succession of menial jobs and served time in a federal prison for violating the law against wearing an army uniform more than three months after demobilization. In 1949, when an eight-year-old girl in a movie theater complained that he was bothering her, authorities were summoned, and he was charged with molestation. The next day a neighbor found Roberts and his wife hanged by clothesline nooses in their small apartment. The suicide note, written by Mrs. Roberts, said, "This is a very hard letter to write. Needham and I are going together. It is best that way. He is innocent of any charge against him."[37]

VanDerZee's second photographic portrait of Johnson and Roberts, made approximately a decade after the first (despite the misleading date printed on it, 1916), seems—with our knowledge of their later lives—both comic and tragic in its presentation of the famed duo (Fig. 136). Garbed in an elegant double-breasted suit, Roberts relaxes with studied casualness in an ornately upholstered chair, his legs crossed nonchalantly, his fingers curling elegantly around a lit cigarette. Johnson, similarly dressed in a handsome dark business suit, a double row of ribbons and medals pinned to his chest, props one arm on the edge of a piano, the other on the side of his comrade's chair. They exude sophistication and worldly success.

The strange "thought-bubble" vignette inserted in the space between the two middle-aged war heroes calls attention to the wish-fulfillment quality of the photograph. This vignette, which resembles a still from a low-budget war movie

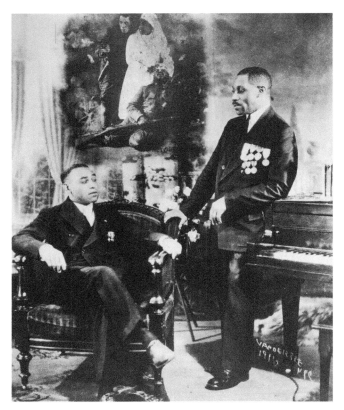

136. | James VanDerZee, *Looking Backward* (Needham Roberts, left, and Henry Johnson, right), ca. 1929. David C. Driskell Center at theUniversity of Maryland.

that probably never existed, other than in VanDerZee's mind, shows a wounded black soldier seated on the ground, a rifle in his lap. He leans against a stalwart woman of color, who wears the white habit of the Black Cross nurses (an organization not founded until after World War I). She reaches down in a gesture of comfort and healing, cradling his bandaged head in her capable hands.[38] Behind her stands another soldier, who fires a revolver at an off-camera enemy. Text inscribed at the bottom of the vignette reads, "They fought for humanity." Besides posing as themselves, Johnson and Roberts may also have posed for the vignette, but the faces look different and it seems unlikely. The weirdly contrived nature of the composite photograph, its melding of distinctive visual languages, in this case society portraiture and B-movie theatrics, calls to mind the self-consciously cinematic styling of contemporary art photographers such as Jeff Wall and Gregory Crewdson.

Some years earlier, when the returning Harlem Hellfighters had marched triumphantly up Fifth Avenue in February of 1919, cheered on by a quarter of a million New Yorkers, Du Bois reported on the event with a note of caution: "This country of ours, despite all its better souls have done and dreamed, is yet a shameful land," he said. The injustices and inequities that had marred society when the soldiers left for the front remained in place, and he admonished these brave troops to fight as hard for democracy in America as they had for it in France. "We return from fighting," he declared, and then, pointedly dropping the preposition to change the meaning, he added, "We return fighting." The struggle for democracy, in other words, must go on. But with these black heroes increasingly depicted as lust-ridden monsters drooling like the angry ape in the anti-Hun poster, the fullness of their

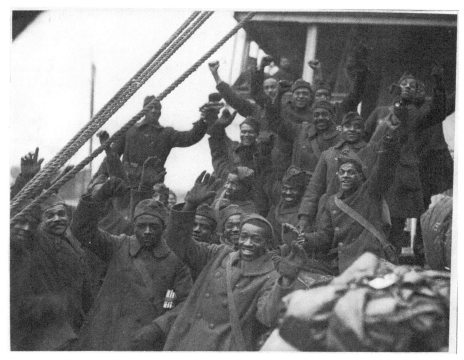

137. | "The Famous 369th Arrive in New York City," 1919.

humanity—so richly visible in photos of them beaming with delight at their safe return from war—was more than ever called into question (Fig. 137).[39]

AROUND THE TIME JOHNSON AND ROBERTS were initially photographed by James VanDerZee as innocent young soldiers warming themselves at the hearth, Horace Pippin, another member of the famed 369th Infantry, was struggling to make sense of his own wartime experiences. Pippin was a self-taught painter, what today we call an "outsider" artist. Although he had been skillful at drawing as a child, he had dropped out of school as a young teenager. Working a series of menial jobs before entering the army, he had put drawing permanently aside. Then he was shot in the shoulder during the Meuse-Argonne offensive. As part of his hospital therapy, he was told to pick up his pencil again and start drawing. He never regained full use of his right arm, but he did regain his love of drawing, which eventually turned into a love of painting.

Living on a disability pension of $22.50 per month, which was supplemented by the money his wife earned by taking in laundry, Pippin devoted himself to his art. In the mid-1920s, he started making primitive drawings by using his left hand to drag a hot poker held in his right along the backs of

cigar box containers. Once he perfected the technique of burning-in the outlines of figures and objects with the hot poker (a technique called pyrography), he set his sights on painting in oil. The first such work, which he began around 1930 and completed three years later, after repainting it more than a hundred times, is a reminiscence of the war years. He called it *The End of the War: Starting Home* (Fig. 138).

It is a suggestive title, indicating, perhaps, that Pippin needed to work through the war, psychologically and obsessively, for an extended period of time before he was ready to "start home" in his mind and finally be at peace. Years later, Pippin disclosed, "I can never forget suffering . . . so I came home with all of it in my mind and I Paint from it to-day."[40] His first biographer, the art critic Selden Rodman, writes, "The war had been a shattering experience to Horace Pippin. He would not have admitted it. He may not even have 'known' it. But the drawings, and to a far greater degree the war paintings

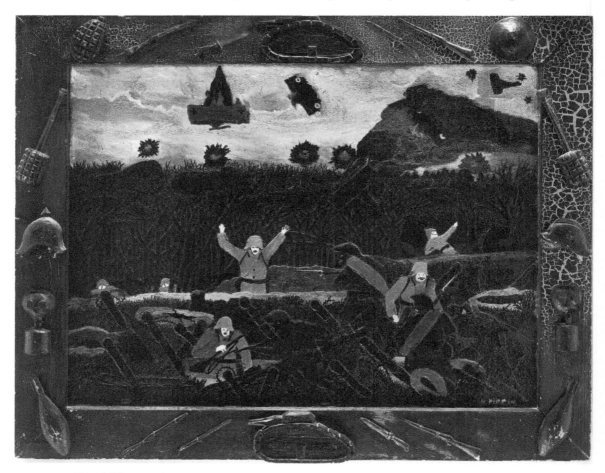

138. | Horace Pippin, *The End of the War: Starting Home*, 1930–33. Philadelphia Museum of Art.

that grew out of them, are evidence that cannot be denied. He had seen the desolation of earth, the ruin of cities, the inhumanity of man."[41]

Amply displaying what was to become Pippin's signature "naive" style, *The End of the War* shows some half a dozen German soldiers in field-gray uniform surrendering to the black American soldiers who have bested them in battle. The black men, in their dark uniforms, blend into the dark foreground of the painting and are harder to make out than their fair-skinned foe. Indeed, in most reproductions of the painting, they are virtually invisible. They point their bayonetted rifles at the adversary; in one case, a Hellfighter actually seems to be bayonetting a surrendering German. Above the painting's bleak, forested landscape, a German biplane plunges from the sky in flames, shot down by its American opponent. Bombs burst along the horizon. The painting has a Dantesque or Day of Judgment quality about it: Lost souls rise from the underworld (in this case, trenches or shell holes), Luciferian machines plummet to earth, and hellish demons—Hellfighters—exert their power over fair-skinned captives. Rodman writes of this early work by Pippin, "No other picture that he painted afterward is so loaded with paint, so crowded with figures and objects and events, so full of a sense of tortured earth and violent movement."[42]

Even the painting's frame, constructed by Pippin, conveys a sense of "total war," for he has glued onto it a series of miniature German and American hand grenades, aerial bombs, rifles, tanks, and helmets sculpted from wood. Implements of modern warfare, they form a militarized zone around the figures—German and American, white and black, losers and winners—trapping all of them within its deadly perimeter. Perhaps for the artist the relative "invisibility" of the black soldiers in this heavily over-painted and much-reworked tableau signified their relative invisibility in American culture at large, in which, after the initial flurry of homecoming glory, they were either ignored or reviled by dominant society, their true nature as loyal Americans sadly forgotten or denied and their humanity unseen.

Another of Pippin's earliest paintings, *Shell Holes and Observation Balloon, Champagne Sector* (ca. 1931, Baltimore Museum of Art), lacks figures altogether, but man's capacity for destruction is everywhere in sight. Shell holes in the foreground gape like raw wounds in the earth. A row of farmhouse buildings has been cracked and shattered, and the dirt road that winds through the countryside is pocked with the myriad boot prints of troops that passed this way earlier. In the sky, a friendly "sausage"—as observation balloons were called—seems as innocent as a child's toy, unless you understand that aerial outposts such as the one shown here radioed artillery units on the ground, informing them where to direct their withering fire. Despite the place-name "Champagne" in the painting's title, little to nothing about this scene is shimmering, effervescent, or cause for celebratory inebriation.

In the colorful, almost whimsical *Dogfight over the Trenches* (ca. 1935, Hirschhorn Museum, Washington, DC), soldiers in a trench are transfixed by a death struggle in the sky, not noting the humble terrestrial elements behind them: a jagged tree stump, a cross marking a grave, and a clump of wildflowers. Pippin seems to be saying that the spectacle of violence distracts us from the larger cycle of death, destruction, and regrowth that unfolds all around us, regardless of whether we notice it or not. He was a deeply religious man, and the open doorway in the mound-like bunker to the side of the soldiers perhaps recalled for him Christ's sepulcher after He was risen. In *Outpost Raid: Champagne Sector*, beneath a pale wintry sky, a black infantryman, holding his bayoneted rifle aloft, confronts a German sentry, whose observation post has been overrun by a small contingent of Hellfighters (Fig. 139). In this modest painting, an American has bested a German—and a black man a white one— but the picture is grim and serious in tone, anything but gloating or triumphal.

After painting these and a few other war scenes in the early to mid-1930s, Pippin summarily dropped the subject, as if he had finally cleared his mind of it. War occasionally enters into later paintings, as when he depicts the fiery abolitionist John Brown, whose execution helped to ignite the Civil War, but

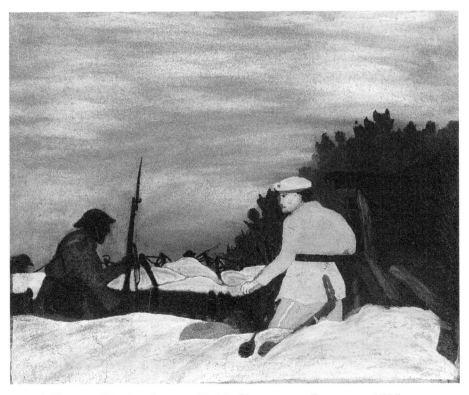

139. | Horace Pippin, *Outpost Raid: Champagne Sector*, ca. 1935. American Folk Art Museum.

for the most part he was done with violence on canvas and ready to move on. Still, it was thanks to his troubling memories of war that Pippin developed from an art hobbyist to an artist. As the scholar Kevin Louis Nibbe has commented, "Pippin could not really come home until he expressed himself artistically, thereby coming to terms with his nightmares by giving them form, by telling the truth about the war—a soldier's truth. Pippin remained patriotic, and wore his decorations proudly, but he detested the brutality of war. He reveals in his pictures what many [written] war narratives, including his own, failed to convey—that the Great War was a shattering experience." Pippin exemplifies art historian Richard Cork's assertion that "The need to exorcise the evil spirit of war should never be underestimated among artists who had fought at the Front."[43]

In his notebooks, Pippin recalled the incident that had left him disabled. He and a comrade were racing from shell hole to shell hole under fire. The comrade was killed. Pippin was hit in the shoulder but managed to find cover. A French soldier tried to take refuge in the same hole. As he was climbing in, a bullet whistled through his head "and it didn't even knock his helmet off." The dead man remained standing for about ten seconds before toppling over, landing on Pippin, who was too weak from loss of blood to push him aside. A day later, Pippin was rescued and carried off to a field hospital. In the meantime he had managed to shrug off the dead man's weight, but for the remainder of his life he could not do the same with the weight of his own memory. The incident was seared permanently into his mind, as if with a white-hot poker.[44]

CERTAINLY MANY OTHER AEF VETERANS besides Pippin were mentally scarred by the war, even if it had left their bodies unscathed. Having to confront the uncertainty of survival for prolonged periods of time during field deployment was enough to cause recurring nightmares for veterans, even though they were now in the comfort and safety of their own beds. While most of the nightmares probably arose from lingering fears of extinction, they may sometimes also have been prompted by unwelcome and unprocessed memories of violent acts that the former doughboys had committed in the name of war. American soldiers had been brought up in a Judeo-Christian culture that regarded killing as the most serious of sins, and no amount of patriotic flag-waving or name-calling of the enemy could entirely efface the troublesome emotions that murdering other men inevitably raised.

To be sure, the resurgence of the Ku Klux Klan and other secret vigilante organizations in the postwar period suggests that a significant number of former AEF fighters, who were represented in such groups, had acquired a taste for violence that was transferable to the domestic front. All the same,

most former doughboys were glad to be done with the violence that had been demanded of them.[45]

The problem of reconciling religious sensibilities with military imperatives was broached, and given patriotic resolution, in the 1941 hit film *Sergeant York*, a Hollywood biopic directed by Howard Hawks and starring Gary Cooper. At the onset of World War II, the movie assured viewers that even a dedicated pacifist, such as the real-life Sergeant Alvin York, who had contemplated sitting out the earlier war as a conscientious objector because of his religious leanings, could become a bona fide war hero when answering his nation's call to arms. The picture received eleven Academy Award nominations and remains one of the highest-grossing movies of all time.

Pro-war narratives such as *Sergeant York* were less ready to hand in the first fifteen or twenty years after the armistice. To be sure, lofty books such as Willa Cather's Pulitzer Prize–winning 1922 novel *One of Ours*, not to mention popular fiction in general, reassured veterans and their families that inflicting pain and death on the enemy had been morally justified. Nonetheless, in the corrosive disillusionment of the postwar decades, questions about the legitimacy of that violence surfaced in various forms of art and entertainment, none more so, perhaps, than the movies.

A trend-setting German film that appeared early in the 1920s treated these matters allegorically. In so doing, it became one of the great successes of international cinema. Though not the first monster movie in motion picture history, *The Cabinet of Dr. Caligari* (1920) was the most influential of its day. (Fig. 140). It was to the genre of fantasy-horror what *The Birth of a Nation* was to historical melodrama. In his magisterial *Rise of the American Film* (1939), Lewis Jacobs recalls that

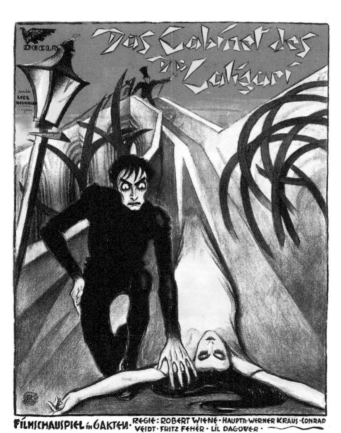

140. | Advertising poster for *The Cabinet of Dr. Caligari*, 1920.

Caligari was "the most widely discussed film of the time." He quotes a 1921 trade publication that states "It is a matter of record that no picture, not even *The Birth of a Nation*, ever created quite as much comment, argument and speculation in one month's time as did *The Cabinet of Dr. Caligari*."[46]

Caligari explores the theme of killing by proxy. An innocent but suggestible youth becomes a murderer at the behest of an authority figure, Dr. Caligari, who hypnotizes him into committing violence. The writers of the original screenplay, two embittered veterans of the German army, conceived their story as a parable that lays blame for the disastrous war at the feet of the political leaders who had authorized it. Notoriously, the film's producer subverted this radical theme by adding a denouement in which the mad scientist, Caligari, proves to be a benign figure after all; the character who has been narrating the saga of the doctor's nefarious designs turns out to be an inmate in an insane asylum benevolently run by the good doctor.[47]

The film thrilled and frightened audiences worldwide. In the United States, where it was released in March 1921, critics praised it for its weirdly eccentric set design, dazzling pace of action, and thematic exploration of moral relativity in a world destabilized by violence-on-command. The film blurs the line between sanity and insanity and conveys a writhing, seething, expressionistic universe. As one of its American admirers averred, it "constitutes a valuable offset to the American tendency to oversureness of intellectual values."[48]

Not all Americans welcomed *Caligari* so enthusiastically. In Hollywood, a crowd of nearly two thousand angry protesters, many of them wounded or disabled members of the local chapter of the American Legion, staged a demonstration against the film, which they termed "Hun propaganda." Most probably, they objected on protectionist grounds, for *Caligari* was clearly spearheading a challenge by foreign filmmakers to Hollywood's domination of the international market. Even more galling, the nation leading the attack on the American film industry was the same one responsible for the deaths of so many Americans.[49]

No doubt the boycotters were responding as well to the modernist alienation and moral uncertainty for which critics back east, such as the anonymous reviewer cited above, had so lavishly praised it. In attacking the film before its West Coast premiere, the protesters were taking part in a larger national movement to reject dangerous foreign, Jewish, modernist, and relativist points of view, all of which were thought to be contagious and bred in the moral swamp of the American Northeast.

With their boycott of *Caligari*, that is, Hollywood's American Legion members resisted not only this one landmark motion picture and the rival film industry that it represented. They also sought to protect themselves from a whole ensemble of adversaries, both foreign and domestic, whom they

believed threatened the safety and sanctity of American conservative traditions. Although the Red Scare of the late teens had petered out by 1921, xenophobia remained an active force throughout the United States. Americans had long feared an influx of foreign-born anarchists, communists, and labor agitators, but those earlier anxieties, rife since the late nineteenth century, were greatly magnified by the war and the radical uprisings, mostly abroad but also at home, that followed in its wake.

Even the many race riots and racially motivated lynch-mob killings that swept through the United States in the early postwar years can, in part, be seen as a cultural byproduct of the war. As noted above, African American war veterans, the best-known of whom were Johnson and Roberts, had hoped that the military valor they displayed in the American Expeditionary Forces would prove to white Americans that they merited equality and respect. When this desired change in public perception failed to materialize, many black Americans felt betrayed by leaders, both white and black, who had promised them otherwise. Paired with concern on the part of whites about "uppity" blacks disrupting the racial and economic status quo, such frustrations exploded in interracial violence.

Also as noted, many white Americans, egged on by racist politicians and a sensationalist press, worried that these black veterans represented a greater threat to civil society after the war than they had been before departing for overseas, precisely because they had been taught to kill. Humiliation, intimidation, and outright preemptive violence were measures that whites, primarily but not at all solely in the South, used to meet the imagined threat.[50]

Other aspects of the postwar experience frightened Americans. A deadly influenza epidemic—thought to have been transmitted by infected soldiers returning from abroad—consumed millions of lives. Recent epidemiological history suggests that the disease originated in Kansas, the heartland of the United States, and thus was transferred to, not from, Europe by doughboy carriers. In 1924, the chilling Leopold and Loeb case centered on a young pair of homosexual Jewish intellectuals (three strikes against them from the start!) who were convicted of murdering a fourteen-year-old boy for the cold-blooded thrill they took in organizing his demise. The following year, the sensational Scopes "monkey" trial not only subjected traditional biblical values to ridicule but also made it difficult for Americans to avoid the distressing thought that they and their kind were descended from apes; that they, in fact, were the offspring of the "mad brute" they had previously been advised to destroy. A common term for the postwar decade, the "Roaring Twenties," usually evokes its unprecedented social, cultural, and economic dynamism, but, to expand on the metaphor, we might consider that some of this roar came as well from the period's many designated monsters—or, just as loudly, from those who abhorred them.

NEARLY A MILLION (930,000) AMERICAN VETERANS of the war—Horace Pippin among them—applied to the United States government for disability benefits relating to permanent or long-term physical or psychological impairments that compromised their ability to earn a living.[51] Though politicians were reluctant to offer more than pretty promises and empty phrases on behalf of the grievously wounded, the unavoidable presence of these men within the population at large proved embarrassing to those who proudly proclaimed American "normalcy," a term in wide use at the time, popularized by Warren G. Harding while successfully campaigning for the White House. The plight of the maimed and mangled found symbolic, but at times also literal, expression in crime and horror melodramas produced by Hollywood. The twenties were the heyday of disability on film, or what disability studies scholar Martin Norden calls "the cinema of isolation."[52]

The two most important figures here were the film director Tod Browning, who specialized in movies about "cripples" and "freaks," and the actor Lon Chaney, "the Man of a Thousand Faces" (Fig. 141). Though able-bodied himself, Chaney played an assortment of armless, legless, or grotesquely disfigured heroes and villains, including the title characters of *The Hunchback of Notre Dame* (1923) and *The Phantom of the Opera* (1925). His

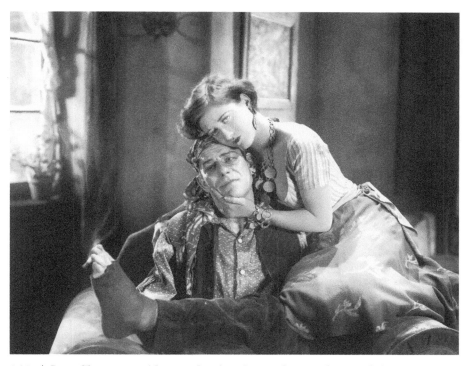

141. | Lon Chaney as Alonzo the Armless, who smokes with his toes, in *The Unknown*, 1927.

repellant yet sympathetic monsters amplified, distorted, or embellished at the level of fantasy the real-life individuals who came home from the war with troubling disabilities—troubling not only to the afflicted but also to onlookers who preferred not to think or talk about them. In exploring the outer reaches of disability and impairment, Chaney gave expression to the problematic emotions raised—or repressed—by the presence of maimed veterans in the new social order. He died of a throat hemorrhage in 1930, while still at the peak of his career.

Browning, who directed the 1932 revenge tale *Freaks*, about a group of physically anomalous sideshow performers, reached his own pinnacle with the first horror tale of the sound era, *Dracula* (1931). Silent horror movies, among them *The Cabinet of Dr. Caligari*, *The Hunchback of Notre Dame*, and *The Phantom of the Opera*, all featuring monsters of one sort or another, had certainly spooked audiences, but the addition of sound brought with it a new layer of creepiness, suspense, and outright terror that the earlier films lacked.

Like their silent predecessors, the horror films of the early thirties also connected metaphorically to the war. While today they are usually viewed by historians as either expressions of Depression-era despair or escapist holidays from it, they can equally well be viewed as belated responses to the First World War. They put onto the screen and into movie houses the deferred reaction described at the beginning of this chapter: "How many a brief bombardment had its long delayed after-effect in the minds of these survivors. . . . Not then was the evil hour, but now; now, in the sweating suffocation of nightmare, in paralysis of limbs, in the stammering of dislocated speech."[53]

142. | Boris Karloff with patched-together face in *Bride of Frankenstein*, 1932.

The war lurks as an unacknowledged presence throughout these horror fantasies. The decadent aristocrat Count Dracula, for example, hails from the Balkans, the very region that had initiated the global conflict that sucked dry the lifeblood of millions. In *Frankenstein* (1931) and its sequel, *Bride of Frankenstein* (1932), another deadly monster emerges from the benighted Old World (Fig. 142). His creator, Dr. Frankenstein, like Dr. Caligari of the earlier film and the flawed political leadership *he* was originally intended to represent, embodies rational authority gone mad. In hubristic miscalculation, parallel

to that of the arrogant European powers on the eve of the cataclysm, he sets loose a murdering giant, portrayed in this instance by Boris Karloff.

Frankenstein's British director, James Whale, lured to Hollywood after the triumph of *Journey's End* (1927), a searing World War I drama he had staged in London to great critical acclaim and box-office success, had been an officer captured by the Germans. The time he spent as a POW was a bitter experience he never forgot and which, together with his outsider status as a semi-closeted homosexual, increased his sympathy for the "monster" and bitterness toward the film's monstrous Germans, who torment the creature and literally hound him to death.[54]

The title character of *The Mummy* (1932), again played by Karloff, is another reanimated corpse, this one swathed in bandages from head to toe, like a hideously burned victim of trench warfare. The vengeful character depicted in *The Invisible Man* (1933) is also covered in bandages. Once they are removed, it is impossible to see him—a common complaint of impaired veterans, who, as we have seen, found themselves ignored by society or sequestered from it. In *Dr. Jekyll and Mr. Hyde* (1931), a peaceful, upstanding member of the community gives way to his evil inner self, a brutal monster whom no one, not even the good doctor himself, can control.

Lesser known horror films of the period can also be read in terms of the epochal war and its resounding aftershocks. *The White Zombie* (1932) conveys the emotional distress of finding a beloved family member (in this instance, a young wife) transformed into a cold and alien automaton. In *Island of Lost Souls* (1932), based on an H. G. Wells novel from 1896, an obsessed plastic surgeon who works clandestinely on a remote tropical island cruelly vivisects animals in his "house of pain" to transform them into brutish human beings whom he can subjugate. The tormented half-beast, half-human monsters he creates eventually rise against him in a mutiny that might well have encapsulated the revenge fantasies of the "beast of burden" foot soldiers dehumanized by the masters of war. Universal Studios' biggest box-office hit of 1934, *The Black Cat*, stars Karloff as a former Eastern European prisoner-of-war who, some years afterward, returns to the fortress where he was imprisoned to confront—and eventually skin alive—the commandant (Lugosi), who tortured prisoners, sent thousands of soldiers to their deaths in battle, and is now a serial killer who keeps the bodies of the young women he murders trussed up in glass display cases.

The Black Cat specifically alluded to the war, but most horror "talkies" did not. In the mid-1930s, the *New York Times* film critic Andre Sennwald was moved by such films to comment on "the increasing emphasis the cinema is placing on the shocking details of physical torture and brutality." Noting that "Hollywood has been treating us to emotional horror orgies" in recent years, he conjectured that "the box-office audience shows that we have been

deriving from them a satisfaction that perhaps is not too distantly related" to "the unbridled ferocity and ethical imbecility of the war years."[55]

Even the beloved turn-of-the-century fantasy book *The Wizard of Oz*, made into a lavish MGM musical on the eve of the Second World War, can be seen as having a metaphorical relationship to the First World War. It tells of an expeditionary force from the American heartland that intervenes "over there" against a ruthless dictatorial leader with apelike followers. The face of one member of Dorothy's retinue, the Scarecrow, has been patched together from disparate pieces and that of another, the Tin Man, is as metallic as anything devised by Anna Coleman Ladd.

Although the literary sources for many of these monster movies, including *The Wizard of Oz*, originated in the nineteenth century, the films adapted from them had contemporary resonances, reverberating with reminders of the recent international upheaval that had not yet faded from memory. They gave audiovisual substance to terrors that the war had awakened in the American population fifteen or twenty years earlier and which had not yet been put to rest.

In his powerful "biography" of post-traumatic stress disorder, David Morris, an American war correspondent and former marine who was nearly killed by a roadside bomb in Baghdad, has written, "For most of human history, interpreting trauma has been the preserve of artists, poets, and shamans. The ways in which a nation deals with trauma are as revealing as its politics and language. The ancient Greeks staged plays that were written and performed by war veterans as a communal method for achieving catharsis....In the classical world, the ancients in the wake of trauma might look for answers in epic poetry, such as *The Iliad* or *The Odyssey*. Today, we turn to the most current edition of the *Diagnostic and Statistical Manual of Mental Disorders*."[56]

While they are certainly not equivalent to *The Iliad* or *The Odyssey*, the horror films of the early 1930s gave mythic form to lingering memories from the war and mourning that was never adequately addressed. As Sennwald, the *New York Times* critic, suggested, the monster movies and gangster films gratified sadistic energies that the war had stirred in the public but not resolved. The demons of the recruitment posters and atrocity reports—mad brutes and evil Huns—had come home to roost, lodging themselves in the collective imagination. This was the golden age of the horror film. World War II, the so-called "good war," produced nothing comparable. Not until another major conflict—specifically, the Cold War, with its threat of thermonuclear annihilation—would monsters parade so prolifically and poetically across cinema screens. Still reeling from the Pacific war and its apocalyptic conclusion, Japan contributed mightily to this international revival of monster movies with *Godzilla* (1954) and a host of other science fiction tales about nuclear-spawned creatures from the ocean, the sky, or outer space.

Alternatively, it could be argued that the Hollywood horror films of the 1930s were not so much the culmination of the post-WWI age of monsters as an indication that the war and its terrors could finally be laid to rest. By turning the never-forgotten trauma of the war into formulaic allegories of dismemberment and disfiguration, gruesome death, premature burial, barbarous cruelty, defiled innocence, and murder-on-command, the monster movies of the early sound era may actually have made the unspeakable "speakable" and normalized the abnormal. In this reading, they commodified the sublime; they sublimated it in popular culture. Emotions that had been too great to bear or forget—hatred, dread, and grief on a world-historical scale—could now be downsized to the dimensions of mass entertainment. That which had defied representation could now be packaged conveniently within the tidy confines of generic horror.

Either way—whether as nightmarish outcroppings of unresolved trauma or as formulaic resolutions of the same—the horror films of the interwar years allegorized the recent past. Count Dracula and Dr. Frankenstein were the paradigmatic evil figures of the First World War, one a bloodsucking European aristocrat and the other a mad scientist/misguided idealist who created a homicidal giant and set him loose. The Mummy, though, may have been the true icon of the postwar period: a man disinterred from the past yet alienated from the present, neither dead nor alive, wrapped in layers of protective swaddling, insulated, isolated, and angry, a monster to others, if not also to himself. The anthropologist Victor Turner has written, "The liminal persona, in this case the returning veteran, is not alive, not dead, but somehow both and neither." To quote *The Waste Land* again: "I could not / Speak, and my eyes failed, I was neither / Living nor dead, and I knew nothing."[57]

Before entering the First World War, the United States maintained a policy of neutrality, but after the war the nation became explicitly isolationist, as if it could quarantine itself from a pestilential world. Americans in general sought insulation from terrors rampant abroad. Escape seemed increasingly futile, hopeless even, as fascism, communism, and diseased capitalism reared their ugly heads. A new set of monsters stalked the horizon.

OTHER POPULAR FILMS of the early 1930s were more explicit in addressing the legacy of the Great War. Mervyn LeRoy's *Gold Diggers of 1933* caught Depression audiences off guard with its unexpected final sequence, a bluesy six-minute number entitled "Remember My Forgotten Man." The staging was by Hollywood's inimitable dance choreographer Busby Berkeley, famed to this day for his astonishing kaleidoscopic concatenations of chorus girl arms, legs, faces, and other body parts joined together with machine-like precision

and rhythmically configured into ever-shifting geometric patterns, as seen from below, beside, and above by swooping cameras. The classic Busby Berkeley dance number was in some ways a symbolic reconstitution of large-scale troop maneuvers on the parade ground (but not the battlefield) during the World War, and the sightlines he provided were the peacetime equivalent of looking up from a submarine or down from an observation balloon.

The sequence here is far less fetishistic than most of those for which Berkeley was known. It is instead a soulful but also cautionary paean to the hundreds of thousands of lost, lonely, unemployed, and physically or emotionally damaged veterans whose lives were made worse by the Great Depression. Silhouetted doughboys—representing the forgotten men's former, idealized selves—parade up and down a giant clocklike structure, which looms over their lowly present-day counterparts, jobless workers huddled in seething masses (Fig. 143). The female singer laments this shocking negligence: "Remember my forgotten man / You put a rifle in his hand / You sent him far away / You shouted 'Hip-hooray!' / But look at him today."[58]

143. | "Remember My Forgotten Man" sequence from *Gold Diggers of 1933.*

Not part of the original 1919 Broadway hit on which the movie was based, the "Forgotten Man" number was inspired by the 1932 Bonus March on Washington. On that occasion, some seventeen thousand AEF veterans and their families, converging from all over the country, set up temporary camp on the National Mall to pressure Congress to make good on its promise, enacted in 1924 but as yet unfulfilled, to give each veteran a small cash bonus for services rendered the nation. The District of Columbia declared the tent city a public nuisance, and Army Chief of Staff Douglas MacArthur ordered federal troops, led by future World War II hero George S. Patton, to clear out the protestors. Patton and his men did so with a vengeance. It was an ugly scene, an embarrassment to the United States, and though it was several more years before the veterans received their promised cash allocation, the plight of America's "lost" or "forgotten" men was made wrenchingly real to millions of onlookers. Warner Brothers capitalized, in a brilliant and timely manner, on the public's indignation.

Another social-problem film that addressed the forgotten-man theme is William Wellman's *Heroes for Sale* (1933), a movie that has itself been forgotten. It's the tale of a WWI soldier, Tom Holmes, who is wounded on a night patrol in France while performing a heroic action. His recovery requires months in hospital, during which he becomes hooked on pain-killing drugs. The story charts a series of disasters that befall this archetypal combat veteran: morphine addiction, unemployment, break-up of his family, swindling by those who promised to help him, and being beaten and chased out of town by anti-red vigilantes and union-busting thugs. Refusing to provide a happy ending, the movie fades out on a disquieting note: Tom, now homeless, drifts among the masses, seething with anger at the injustices done to him and his brethren.

Though "ripped from the headlines," *Heroes for Sale* lacks punch because it was quickly and cheaply made, and the returning soldier's odyssey is melodramatic from start to finish. A finer, more disturbing forgotten-man movie is William Dieterle's *The Last Flight* (1931). Dieterle, an actor and director from the golden age of German silent cinema, immigrated to the United States in 1930. The film was written by John Monk Saunders, the novelist and screenwriter who conceived *Wings*, *The Dawn Patrol*, and *Ace of Aces*, the antiwar aviation film we discussed in Chapter 4. *The Last Flight* follows four friends who served together in an air squadron in France. Each of them has sustained the psychological damage we now call PTSD, and none of them can face return to the United States on his discharge from the Air Corps.

Instead they move to Paris, where they have no greater purpose in life than to "get tight and stay tight." They meet and befriend a beautiful young woman who is herself a lost soul in flight from sober reality, and together they plummet. Clearly Hemingway's novel *The Sun Also Rises* (1926) was a model for *The Last Flight*, and the influence of Hemingway as well as

F. Scott Fitzgerald and William Faulkner shows throughout in the glittering dialogue and crushing dissipation of the characters. In its sexual candor, and also perhaps in its frankness about the nihilism that ravages these veterans who answered their country's call, the film could not have been made after the advent of the regulatory Hays Code in 1934.[59]

The most acclaimed of the forgotten man movies was *I Am a Fugitive from a Chain Gang* (1932), directed by Warner Brothers stalwart LeRoy shortly before he took on the *Gold Diggers of 1933* assignment. Returning from war, the film's hero, Jim Allen, drifts across America, unable to find meaningful work. Hungry and desperate for funds, he tries pawning his *Croix de Guerre*, but the pawnbroker refuses to take it, pointing to a glass display case piled high with similarly worthless medals. Finding himself in the wrong place at the wrong time, Jim is mistakenly arrested as an accomplice to a hold-up, convicted, and sentenced to ten years' hard labor in a Southern work camp, where sadistic guards go out of their way to inflict suffering on the men under their command. Life on a chain gang is as brutal, degrading, and dangerous as anything he experienced on the front lines in France; indeed, it is the war brought home.

After a daring escape, during which he is pursued through a swamp by bloodhounds, Jim changes his identity and begins a successful career as an industrial engineer—until his past catches up and he is forced to run away yet again, hiding in the shadows wherever he goes. In the film's famous closing scene, the once-innocent fugitive is asked how he lives. The screen goes black as he slips into the night, leaving behind only his resonating final words: "I steal."

The criminal ex-soldier is not a monster, the film polemically argues. The society that produced him is.

10
EPILOGUE

WHEN THE UNITED STATES DECLARED war on Germany, Americans took to heart the message thrust at them in countless speeches, sermons, and posters: that America's God-given mission was to save the Old World from itself. Their job was to "make the world safe for democracy," as President Wilson loftily intoned, and to ensure that future wars of territorial aggression would no longer be waged. They were jubilant at the end of the war. The streets filled with confetti to welcome the returning heroes. Then, almost abruptly, the jubilation ended. The confetti was swept away. Americans experienced a collective hangover. Through the blur, they could see that not much had changed for the better, despite their gallant intentions, and despite all the young lives and hard cash they had surrendered to the cause. Americans felt deceived by their leaders, even duped or betrayed. Swindled. They rejected wartime idealism en masse, replacing it, depending on where they lived and what politics they embraced, with isolationism, factionalism, fundamentalism, or rampant hedonism, the last of these embodied by flappers, speakeasies, and hip flasks filled with illegal booze.

No longer marching to war on behalf of the flag, they made a sport of flagpole-sitting, that faddish activity in which a single individual—WWI naval veteran Alvin "Shipwreck" Kelly was the most famous—perched alone for hours, days, or even weeks on a jerry-rigged platform high above the ground to set an endurance record or promote a product. In 1929 Kelly sat atop a pole in Baltimore for twenty-three days and seven hours; the following year twenty thousand spectators watched him break his own record when he nested above the Atlantic City boardwalk for 49 consecutive nights and days. It's hard to imagine a better metaphor than this for an era characterized by isolationism and self-absorption, for disconnection from the world at large.[1]

America, in short, had lurched from feverish support of the war effort to frenzied recoil from its idealistic tenets. "His was a great sin who first invented

consciousness," joked F. Scott Fitzgerald, chronicler of the Jazz Age. "Let us lose it for a few hours." Temporary oblivion, he ventured, was the only viable response to the questionable benefit bequeathed to Americans by the war: "the shabby gift of disillusion."[2]

Not everyone was disillusioned, of course. One who held onto his ideals was the photographer Lewis Hine. Before the war, Hine was America's foremost social documentarian, repeatedly calling the public's attention to the hardships and injustices faced by immigrants, African Americans, factory workers, and, most poignantly, child laborers. In a series of prewar photographs taken in a cotton mill in rural North Carolina, he showed reed-thin, preadolescent female textile workers engulfed in the iron cage of the mechanized looms. Hine had a sophisticated understanding of photography's potential to plead for a cause but also mislead. "The average person believes implicitly that the photograph cannot falsify," he observed, and yet, "while photographs may not lie, liars may photograph." Images are too slippery on their own, he believed; they have to be backed up by careful research and thorough contextualization. Nonetheless, he devoted his life to social (rather than commercial) photography because, despite its potential for misuse, he trusted its capacity to expand our knowledge of the world and widen our range of sympathies.[3]

In 1918 and 1919, Hine served as a photographer for the American Red Cross, recording the devastation of the war on towns that looked as if hurricanes had blown through, leaving nothing standing except for the one or two

144. | Lewis Hine, *Red Cross nurse and patient with artificial arms,* ca. 1918. George Eastman House.

human figures whose presence provides scale, but also pathos. He traveled to the Balkans, where the war had erupted five years earlier, to document the return of homeless refugees and the devastation the upheaval had wrought on the bodies of malnourished children. Back in Paris, one of the most quietly affecting photos he made shows a comely Red Cross nurse, garbed in white, standing over a *mutilé de guerre* who sits at a table in a hospital garden. He has two artificial arms and balances a pencil in one of his leather-clad mechanical hands (Fig. 144).[4]

Hine's exposure to war-devastated Europe changed his outlook but not his ideals. Instead of turning his lens, as he had before, on those who were brutalized by the destructiveness of industrial modernity, he sought out

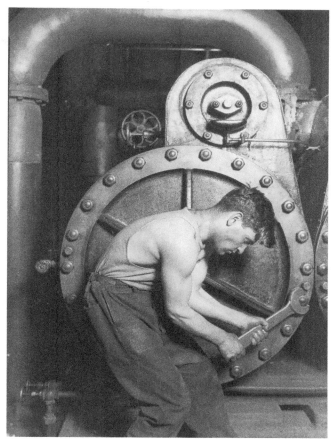

145. | Lewis Hine, *Power House Mechanic Working on a Steam Pump*, 1920. National Archives and Records Administration.

working-class heroes, men or women who demonstrated competence and strength in their relationships with the machine. We might think of these heroic "work portraits," as he called them, as compensatory images, providing him with therapeutic relief from the terrible things he had seen while traveling through landscapes of mass destruction. The most famous of the series, *Power House Mechanic Working on a Steam Pump* (1920), shows a muscular, bare-armed proletarian hunched in front of a massive piece of industrial equipment (Fig. 145). He wields a heavy steel wrench, holding it firmly in his hands (unlike the precariously grasped pencil in the Red Cross rehabilitation scene). In the rivalry between man and machine that the photo stages, the machine may be bigger, but the man is clearly in charge.

Hine's work portraits were pro-labor, but they were also, in essence, pro-industry, celebrations rather than condemnations of a machine-made world. Images such as *Power House Mechanic* led to Hine receiving the last important commission of his career, a series recording the construction of the Empire

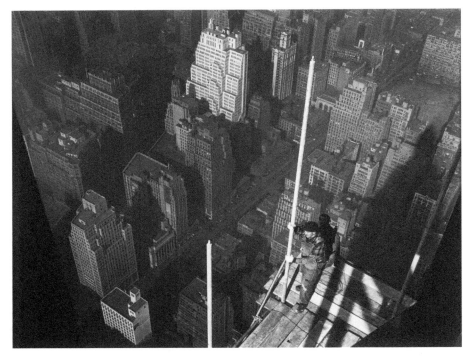

146. | Lewis Hine, *Raising the Mast, Empire State Building*, 1932. Yale University Art Gallery.

State Building in 1930. These awe-inspiring photographs show construction workers balanced gracefully on steel girders and iron cables hundreds of feet above New York City. They go about their business fearlessly, it seems, not at all daunted by the heights to which they have ascended in the fulfillment of an honest day's labor. Gods in dungarees, they soar above the metropolis (Fig. 146).[5]

Ironically, the First World War gave birth to the building they erect. The chief financial backer of the project was the General Motors Corporation, which was in turn a financial offshoot of the E. I. du Pont de Nemours Powder Company, America's chief munitions supplier during the war. DuPont, a wealthy corporation to begin with, reaped unprecedented profits by supplying high-powered explosives to America's allies while also enjoying virtually monopolistic contracts with the US Army. The company manufactured 40 percent of all the munitions used by the Allies during the war, and its revenues from the sale of power and explosives rose from $25 million in 1914 to $319 million in 1918. Between 1914 and 1919, the company generated an amazing $1.25 billion in munitions sales. In 1929, a third of all GM stock was owned by DuPont, and the automobile company's revenues provided half of DuPont's annual earnings. The chemicals used in GM car interiors and external body paint were supplied by DuPont. All this money had to go somewhere, and much of it went into the cost of erecting what

was then to be the world's tallest building. This was the aspirational construction project that Hine's photography romantically documents.[6]

The construction of the 103-story Art Deco skyscraper in midtown Manhattan, begun in February 1930 and completed an astonishing fourteen months later, required the efforts of some 3,400 workers, most of them immigrants from Europe, who blasted through fifty-five feet of solid rock to lay the skyscraper's foundation and then began welding into place fifty thousand steel beams and columns, each weighing upwards of a ton. The analogy to recent history was not lost on admirers of the mammoth tower's construction. "Building skyscrapers is the nearest peacetime equivalent of war," an architect declared. "In fact, the analogy is startling, even to the occasional grim reality of a building accident, where maimed bodies and even death, remind us that we are fighting a war of construction against the forces of nature."[7]

Hine's photos convey the superhuman quality of the workers as they defy gravity and straddle the sky. Seen at great heights and set off against a background of distant landscape—the Hudson River and beyond that, the vast American continent—the man who wraps himself around a taut metal cable in the middle of nowhere is a modern Icarus, flying perilously close to the sun (Fig. 147). Hine's aerial steelworkers are the antithesis of Shipwreck Kelly

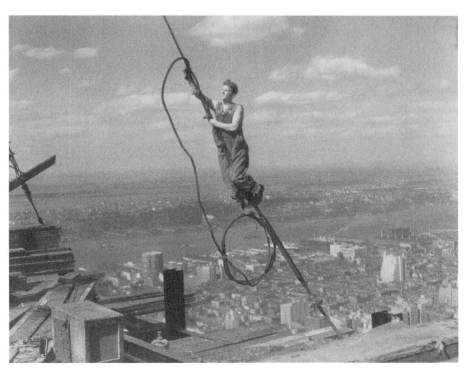

147. | Lewis Hine, *Icarus, Empire State Building*, 1931. New York Public Library.

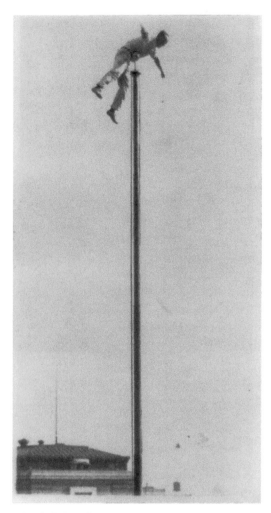

148. | John Reynolds atop a flagpole in Washington, D.C., 1924.

and his ilk—here, for example, the "human fly" John Reynolds (Fig. 148)—for Hine's airborne proletarians serve, or so he implicitly suggests, a greater cause than stunt-making and publicity-seeking. Even before the building was completed in 1931, its mythic proportions were recognized, and it promptly became as much an icon of America as the Stature of Liberty in nearby New York Harbor. The soaring tower epitomized national achievement in the face of worldwide depression; it symbolized American sovereignty.

The Hollywood film producer Merian C. Cooper conceived the idea of using the skyscraper as the climactic setting for his 1933 fantasy-adventure film *King Kong* (Fig. 149). He had piloted a bomber during the war until he was shot down by the Germans and relegated to a POW camp. His wartime experiences, or day-dreams of how they should have gone, appear in the story's denouement, in which the enemy ape is dislodged from his aerie by modern technology (airplanes) augmented by additional technology (machine guns). Mechanization takes command and triumphs over savage nature, although not without a note of wistfulness for the demise of primitive authenticity, as represented by the "beauty and the beast" ape who is infatuated with his species superior.[8]

In the film, the showman-producer Carl Denham is modeled on Cooper, and he gives himself an onscreen cameo as the daring pilot who brings down Kong. His creative team drew inspiration from two of the most notorious posters of the First World War, H. R. Hopps's *Destroy This Mad Brute*, with its raging ape who clutches a fair-haired female in his arms, and Joseph Pennell's *That Liberty Shall Not Perish from the Earth*, which envisions Manhattan aflame under an enemy attack. Adolf Hitler's propaganda minister Joseph Goebbels was infuriated by *Destroy This Mad Brute* and appropriated it for his own anti-American propaganda at the start of the Second World War. Hitler, on the other hand, relished *King Kong* and kept a print of it in his personal film library.[9]

149. | King Kong swats at a fighter plane, from *King Kong*, 1933.

Like Hine's steelworkers suspended in the sky, far from their base on terra firma, Kong on top of the Empire State Building occupied no man's land. He was caught outside his trench. As so many millions of combatants had been in the Great War, he was helpless against machines dedicated to his destruction. Though a monster, he was also a figure of pathos. His plunge into the abyss at the end of the movie symbolized that of millions of men, on both sides of the conflict, who never returned home.

The same year King Kong stormed onto the world stage, Hitler seized control of Germany. It didn't take a crystal ball to recognize that a sequel to World War I was in the works. That year as well, Laurence Stallings, the double-amputee author of *Plumes* and co-author of *What Price Glory*, published a compilation of some five hundred war photographs with subjective, often ironic captions. Stallings called his book *The First World War*. This was the first time that the ordinal identification of the 1914–1918 war, now standard, was used in print. Before that, it was simply the Great War or the World's War. Stallings coined the term as a way of cynically acknowledging what was already painfully evident. A new global catastrophe was on its way.[10]

NOTES

Preface

1. Rupert Brooke, "Nineteen Fourteen: The Soldier" (1915), lines 1–3, in *The Complete Poems* (1932; rpt. New York: AMS Press, 1977), 150. On the memorializing of America's First World War dead, see Lisa M. Budreau, *Bodies of War: World War I and the Politics of Commemoration in America, 1919–1933* (New York: New York University Press, 2011), Steven Trout, *On the Battlefield of Memory: The First World War and American Remembrance, 1919–1941* (Tuscaloosa: University of Alabama Press, 2010), and Jennifer Wingate, *Sculpting Doughboys: Memory, Gender, and Taste in America's World War I Memorials* (Burlington, VT: Ashgate, 2013). Two outstanding studies of British cemeteries and memorials of the Great War, though very different from one another, are David Crane, *Empires of the Dead: How One Man's Vision Led to the Creation of WWI's War Graves* (London: William Collins, 2013), and Geoff Dyer, *The Missing of the Somme* (London: Hamish Hamilton, 1994). See also David W. Lloyd, *Battlefield Tourism: Pilgrimage and the Commemoration of the Great War in Britain, Australia, and Canada, 1919–1939* (New York: Berg, 1998). Taking a transnational perspective on World War I and memory are two classics that have generated much further research: George L. Mosse, *Fallen Soldiers: Reshaping the Memory of the World Wars* (New York: Oxford University Press, 1990), and J. M. Winter, *Sites of Memory, Sites of Mourning: The Great War in European Cultural Memory* (Cambridge: Cambridge University Press, 1995).

2. Paul Virilio, interviewed in John Armitage, ed., *Paul Virilio: From Modernism to Hypermodernism and Beyond* (London: Sage, 2000), 45. See Virilio's provocative *War and Cinema: The Logistics of Perception* (1984), trans. Patrick Camiller (New York: Verso, 1989).

3. As categorically stated half a century ago by Milton W. Brown in *American Painting from the Armory Show to the Depression* (Princeton, NJ: Princeton University Press, 1955), 76: "The total effect of the war on American art was not great. It was more an interlude than anything else." In Brown's influential view, all that American art of the First World War bequeathed to posterity were "completely mediocre posters, a few isolated paintings and prints, and ... a series of sculptural memorials which are indeed war atrocities" (71).

4. The touring exhibition *World War I and American Art*, opening at the Pennsylvania Academy of Fine Arts in 2016, will provide a large number of art objects and artifacts produced in, or in response to, the war years. See the accompanying exhibition catalogue *World War I and American Art*, ed. Robert Cozzolino, Anne Knutson, and David M. Lubin (Princeton, NJ: the Pennsylvania Academy of Fine Arts in association with Princeton University Press, 2016).

5. Frank Furedi, *First World War: Still No End in Sight* (London: Bloomsbury, 2014); see also David Reynolds, *The Long Shadow: The Legacies of The Great War in the Twentieth Century* (New York: Norton, 2014).

6. George Orwell, *Nineteen Eighty-Four* (New York: Harcourt, Brace, 1949); the adage appears twice in the novel: 35 (Part One, Chapter III) and 251 (Part Three, Chapter II).

Chapter 1 "War, Modernism, and the Academic Spirit"

1. Man Ray, *Self-Portrait* (Boston: Little, Brown, 1963), 49.
2. Man Ray, 50.
3. Allan Antliff, *Anarchist Modernism: Art, Politics, and the First American Avant-Garde* (Chicago: University of Chicago Press, 2001), 73–94, details Man Ray's engagement with anarchism. See also Francis Naumann, "Man Ray and the Ferrer Center: Art and Anarchy in the Pre-Dada Period," in *New York Dada*, ed. Rudolf E. Kuenzli (New York: Willis Locker & Owens, 1986), 10–30. For selections from *Mother Earth*, see Peter Glassgold, ed., *Anarchy! An Anthology of Emma Goldman's* Mother Earth (Washington, DC: Counterpoint, 2001).
4. Man Ray, 91.
5. September 2, 1914, in James Timothy Voorhies, ed., *My Dear Stieglitz: Letters of Marsden Hartley and Alfred Stieglitz, 1912–1915* (Columbia: University of South Carolina Press, 2002), 157; and October 29, 1914, in Voorhies, 166. For biographical information on Hartley, his Berlin period in particular, I have relied on Townsend Ludington, *Marsden Hartley: The Biography of an American Artist* (Boston: Little, Brown, 1992), Patricia McDonnell, *Marsden Hartley, American Modern* (Minneapolis: Frederick R. Weisman Art Museum, University of Minnesota, 1997), and Bruce Robertson, *Marsden Hartley* (New York: Harry N. Abrams in association with the National Museum of American Art, Smithsonian Institution, 1995). See also Hartley, *Somehow a Past: The Autobiography of Marsden Hartley*, compiled and edited by Susan Elizabeth Ryan (Cambridge, MA: MIT Press, 1997), and McDonnell, *Painting Berlin Stories: Marsden Hartley, Oscar Bluemner, and the First American Avant-Garde in Expressionist Berlin* (New York: Peter Lang, 2003), 63–108. Other insightful works include the exhibition catalogues *Marsden Hartley*, ed. Elizabeth Mankin Kornhauser (New Haven, CT: Wadsworth Atheneum Museum of Art in association with Yale University Press, 2003), and *Marsden Hartley: The German Paintings, 1913–1915*, ed. Dieter Scholz (New York: D.A.P./ Distributed Art Publishers, for Neue Nationalgalerie, Berlin, and Los Angeles County Museum of Art, 2014), and Jonathan Weinberg's pathbreaking *Speaking for Vice: Homosexuality in the Art of Charles Demuth, Marsden Hartley, and the First American Avant-Garde* (New Haven, CT: Yale University Press, 1993).
6. Also from letter of October 29, 1914, in Voorhies, 166.
7. Quoted in David J. Morris, *The Evil Hours: A Biography of Post-Traumatic Stress Disorder* (Boston: Houghton Mifflin Harcourt, 2015), 72.
8. Marsden Hartley, "1916 Catalogue Statement, 291," in *On Art*, ed. Gail R. Scott (New York: Horizon, 1982), 67.
9. My chief sources for the life and career of Romaine Brooks are Whitney Chadwick, with an essay by Joe Lucchesi, *Amazons in the Drawing Room: The Art of Romaine Brooks* (Berkeley: University of California Press, in association with the National Museum of Women in the Arts, 2000), Meryle Secrest, *Between Me and Life: A Biography of Romaine Brooks* (Garden City, NY: Doubleday, 1974), Diana Souhami, *Wild Girls: Paris, Sappho and Art: The*

Lives and Loves of Natalie Barney and Romaine Brooks (New York: St. Martin's Press, 2004), and "No Pleasant Memories," Brooks's unpublished typescript autobiography in the Archives of American Art, Smithsonian Institution, Washington, DC. See also Adelyn D. Breeskin, *Romaine Brooks in the National Museum of American Art* (Washington, DC: Smithsonian Institution Press, 1971), and Shari Benstock, *Women of the Left Bank: Paris 1900–1940* (Austin: University of Texas Press, 1986), esp. 304–306.

10. Ida Rubinstein's career as a dancer and artist is covered by Toni Bentley in *Sisters of Salome* (New Haven, CT: Yale University Press, 2002), 129–66.

11. Liane de Pougy, *My Blue Notebooks*, trans. Diana Athill (New York: Tarcher, 2002), 72, quoted in Souhami, *Wild Girls*, 125. Barney's comment is paraphrased also in Souhami, 125. Brooks's comment is from an undated letter to D'Annunzio, quoted in John Woodhouse, *Gabriele D'Annunzio: Defiant Archangel* (Oxford: Clarendon Press, 1998), 256. Ciro Sandomenico, *Romaine Brooks, la "Cinerina" di D'Annunzio: Itinerari d'amore e d'arte fra Parigi, Venezia e Capri* (Napoli: Liguori Editore, 2013), provides a biographical examination of the relationship between Brooks and D'Annunzio. For D'Annunzio in depth, see Lucy Hughes-Hallett, *Gabriele D'Annunzio: Poet, Seducer, and Preacher of War* (New York: Knopf, 2013), and on his hyper-enthusiasm for war, see Alfredo Bonadeo, *D'Annunzio and the Great War* (Teaneck, NJ: Fairleigh Dickinson University Press, 1995). The poet's friend and biographer Tommaso Antongini proudly states that women were "hypnotized" by his "persuasive eloquence," adding, "Countless times, women who have been subjected to it have raved to me about the irresistible magnetism of D'Annunzio's words and voice when he is intent on *amour*. . . . It is difficult to explain exactly what he tells these women or how he tells it. The fact remains that he always gains his point." Antongini, *D'Annunzio*, trans. from the Italian (Boston: Little, Brown and Company, 1938), 79.

12. Gertrude Stein, *Picasso* (1938), in *Gertrude Stein on Picasso* (New York: Liveright, 1970), 18; 45. The quotations in the next two paragraphs are from pages 46 and 47, respectively.

13. Gertrude Stein, *Everybody's Autobiography* (New York: Random House, 1937), 92.

14. Stein, *Picasso*, 44–45.

15. Stein, *Picasso*, 18–19.

16. Edward, Viscount Grey of Fallodon, *Twenty-Five Years, 1892–1916*, vol. 2 (New York: Frederick A. Stokes, 1925), 20. Lord Grey's memoir was one of the best-selling books in America in 1925.

17. John H. Lienhard, *Inventing Modern: Growing Up with X-rays, Skyscrapers, and Tailfins* (New York: Oxford University Press, 2003), 127.

18. Gertrude Stein, *Autobiography of Alice B. Toklas* (New York: Harcourt, Brace, 1933), 213–14; see James R. Mellow, *Charmed Circle: Gertrude Stein & Company* (New York: Praeger, 1974), 274–77.

19. Mellow, 283–84, provides the recollection from Braque; on Stein's use of "costume as metaphor," see Benstock, *Women of the Left Bank*, 177–84; also Susan Gubar, "Blessings in Disguise: Cross-Dressing as Re-Dressing for Female Modernists," *Massachusetts Review* 22 (1981), 477–508. The fullest exploration of Stein's performative dressing is Wanda M. Corn and Tirza True Latimer,

Seeing Gertrude Stein: Five Stories (Berkeley: University of California Press, 2011), published in conjunction with an exhibition jointly organized by the Contemporary Jewish Museum in San Francisco and the National Portrait Gallery, Smithsonian Institution, Washington, D.C.

20. See Mellow, 327–29, and Ernest Hemingway, *A Moveable Feast* (New York: Scribner, 1964), 29. Hemingway first popularized the term "lost generation" when he used it as a epigraph for *The Sun Also Rises* (1926).

Chapter 2 "Women in Peril"

1. For well illustrated and annotated compendiums of WWI posters, see Peter Paret, Beth Irwin Lewis, and Paul Paret, *Persuasive Images: Posters of War and Revolution* (Princeton, NJ: Princeton University Press for the Hoover Institution on War, Revolution, and Peace, 1992), and Walton Rawls, *Wake Up, America: World War I and the American Poster* (New York: Abbeville, 1988). Other useful collections include Libby Chenault, *Battlelines: World War I Posters from the Bowman Gray Collection* (Chapel Hill: The Rare Book Collection, Wilson Library, University of North Carolina, 1988), and Frédérick Hadley and Martin Pegler, *Posters of the Great War* (Barnsley, South Yorkshire: Pen & Sword, in association with Historical Museum of the Great War, Péronne, France, 2013). For historical-critical perspectives, see James Auerlich and John Hewitt, *Seduction or Instruction? First World War Posters in Britain and France* (New York: Manchester University Press, 2007), Pearl James, ed., *Picture This: World War I and Visual Culture* (Lincoln: University of Nebraska Press, 2009), and Anne Classen Knutson, "Breasts, Brawn and Selling a War: American World War I Propaganda Posters 1917–1918," PhD dissertation, University of Pittsburgh, 1997.

2. Quoted in Rawls, 81.

3. For historical studies of American advertising, see Stephen Fox, *The Mirror Makers: A History of American Advertising and Its Creators* (New York: William Morrow, 1984), Charles A. Goodrum and Helen Dalrymple, *Advertising in America: The First Two Hundred Years* (New York: Harry N. Abrams, 1990), Daniel Delis Hills, *Advertising to the American Woman, 1900–1999* (Columbus: Ohio State University Press, 2002), T. J. Jackson Lears, *Fables of Abundance: A Cultural History of Advertising in America* (New York: Basic Books, 1994), and Roland Marchand, *Advertising the American Dream: Making Way for Modernity, 1920–1940* (Berkeley: University of California Press, 1985).

4. Joseph Darracott, *The First World War in Posters, from the Imperial War Museum, London* (New York: Dover, 1974), 53.

5. Maurice Rickards, *Posters of the First World War* (London: Evelyn, Adams & Mackay, 1968), 21.

6. Charles C. Eldredge, *American Imagination and Symbolist Painting* (New York: Grey Art Gallery and Study Center, New York University, 1979), 62.

7. Michael A. Morrison, "Shakespeare in North America," in *Cambridge Companion to Shakespeare on Stage*, ed. Stanley Wells and Sarah Stanton (New York: Cambridge University Press, 2002), 230–58, quotation on 241–42; *Hamlet* film productions cited in IMDb (Internet Movie Database). See also Lawrence W. Levine, *Highbrow/Lowbrow* (Cambridge, MA: Harvard University Press, 1988).

8. William Shakespeare, *Hamlet*, ed. G. R. Hibbard (New York: Oxford University Press, 1987), 319 (Act IV, sc. 7: 150–58).

9. First quotation from *Hamlet* Act I, sc. 5: 29–31; second from Act III, sc. 3: 70–71.

10. See Jules D. Prown, "Winslow Homer in His Art," *Smithsonian Studies in American Art* 1(1) (Spring 1987), 30–45.

11. Ann Uhry Abrams, "Frozen Goddess: The Image of Woman in Turn-of-the-Century American Art," in Mary Kelley, ed., *Woman's Being, Woman's Place: Female Identity and Vocation in American History* (Boston: G. K. Hall, 1979), 93–108, quotations from 94. See also Gail Bederman, *Manliness & Civilization: A Cultural History of Gender and Race in the United States, 1880–1917* (Chicago: University of Chicago Press, 1995). On aestheticized images of Anglo-Saxon American women and girls, see Martha Banta's magisterial *Imaging American Women: Idea and Ideals in Cultural History* (New York: Columbia University Press, 1987), and Bailey Van Hook, *Angels of Art: Women and Art in American Society, 1876–1914* (University Park: Pennsylvania State University Press, 1996). An influential essay on this topic is Bernice Kramer Leader, "Antifeminism in the Paintings of the Boston School," *Arts Magazine* 56 (January 1982), 112–19. My thinking on the subject has also been informed by Angela L. Miller, unpublished conference paper, "The Mirror Has Two Faces: Men, Women, and the Reflected Self," delivered at the American Studies Association meetings, November 1998, and Zachary Ross et al., *Women on the Verge: The Culture of Neurasthenia in Nineteenth-Century America*, with introduction Wanda M. Corn (Palo Alto, CA: Iris & B. Gerald Cantor Center for Visual Arts at Stanford University, 2004).

12. Susan A. Hobbs with Barbara Dayer Gallati, *The Art of Thomas Wilmer Dewing: Beauty Reconfigured* (Washington, DC: Smithsonian Institution Press, 1996).

13. On the Ten American Artists (a self-designated group of genteel American impressionists from New York and Boston), see William H. Gerdts, *Ten American Painters* (New York: Spanierman Gallery, 1990), and Ulrich W. Hiesinger, *Impressionism in America: The Ten American Painters* (Munich: Prestel, 1991). On Thayer and camouflage, see Alexander Nemerov, "Vanishing Americans: Abbott Thayer, Theodore Roosevelt, and the Attraction of Camouflage," *American Art* 11(2) (Summer 1997), 50–58; also, Henry Adams, "Ornithology, Infantry and Abstraction," *Art and Antiques* (March 2011); Ross Anderson, *Abbott Handerson Thayer* (Syracuse, NY: Everson Museum of Art, 1982); Roy R. Behrens, *False Colors: Art, Design and Modern Camouflage* (Iowa City: Bobolink Books, 2002); Elizabeth Lee, "Therapeutic Beauty: Abbott Thayer, Antimodernism, and the Fear of Disease," *American Art* 18(3) (2004), 32–51; Tim Newark, *Camouflage* (New York: Thames and Hudson, 2007); Ari Post, *Abbott Handerson Thayer: A Beautiful Law of Nature* (Washington, DC: Gold Leaf Studios, 2014); and Hanna Rose Shell, "The Crucial Moment of Deception," *Cabinet* 33, Deception issue, Spring 2009: http://cabinetmagazine.org/issues/33/shell.php.

14. Barbara Welter, "The Cult of True Womanhood, 1820–1860" *American Quarterly* 18(2) (1966), 151–74; William Ross Wallace, "The Hand That Rocks the Cradle," originally entitled "What Rules the World" (1865).

15. Melvyn Stokes, *D.W. Griffith's "The Birth of a Nation": A History of "The Most Controversial Motion Picture of All Time"* (New York: Oxford University Press, 2007), Dick Lehr, *"The Birth of a Nation": How a Legendary Filmmaker and a Crusading Editor Reignited America's Civil War* (New York: Public Affairs, 2014), and Paul McEwan, *The Birth of a Nation* (London: Palgrave on behalf of the British Film Institute, 2015). See also, Michael Paul Rogin, "'The Sword Becoming a Flashing Vision': D. W. Griffith's *The Birth of a Nation*," in *Ronald Reagan, the Movie: and Other Episodes in Political Demonology* (Berkeley: University of California Press, 1987), 190–235, and J. Hoberman's review of Stokes, "First Movie in the White House," *London Review of Books* 31(3) (February 12, 2009), 26–27.

16. "Biggest Money Pictures: Sound Films Shy Big Silent Sums," *Variety* (June 21, 1932), 1, lists the fifteen highest-grossing films to play on American movie screens during the silent era. *Birth of a Nation* (1915) was tops by far with a $10 million box-office; *The Big Parade* (1925) came second at $6.4 million; *Ben-Hur* (1925) was third at $5.5 million, Griffith's *Way Down East* (1920) fourth at $5 million, Charlie Chaplin's *Gold Rush* (1925) fifth at $4.25 million, and Rudolph Valentino's WWI romance *The Four Horsemen of the Apocalypse* (1921) sixth at $4 million.

17. See, for example, Tim Bergfelder and Sarah Street, The Titanic *in Myth and Memory* (London: I. B. Tauris, 2004); see also Kathleen A. Foster, *Shipwreck! Winslow Homer and "The Life Line"* (New Haven: Yale University Press in association with Philadelphia Museum of Art, 2012), which includes numerous examples of the shipwreck genre from various historical periods and media. On Griffith's innovations in cinematic psychological realism, see Tom Gunning, *D. W. Griffith and the Origins of American Narrative Film: The Early Years at Biograph* (Urbana: University of Illinois Press, 1991), and Joyce E. Jesionowski, *Thinking in Pictures: Dramatic Structure in D. W. Griffith's Biograph Films* (Berkeley: University of California Press, 1987). More generally on Griffith, see William Martin, *Griffith, First Artist of the Movies* (New York: Oxford University Press, 1980), and Richard Schickel, *D. W. Griffith: An American Life* (New York: Simon and Schuster, 1984).

18. See, for example, Vincent Vinikas, *Soft Soap, Hard Sell: American Hygiene in an Age of Advertisement* (Ames: Iowa State University Press, 1992).

19. Hannah Arendt, *The Origins of Totalitarism* (New York: Harcourt, Brace, 1951), 336. She refers the reader to Hitler's analysis of "war propaganda" in *Mein Kampf* (1925–26), Book I, chapter VI ("The World War").

20. John Canemaker, *Winsor McCay* (New York: Abbeville Press, 1987), 149–56; Donald Crafton, *Before Mickey: The Animated Film, 1898–1928* (Cambridge, MA: MIT Press, 1982), 116–17.

21. Winsor McCay, *Sinking of the Lusitania* (1918), available on the DVD *Winsor McCay: The Master Edition* (Milestone Film & Video, 2004) and on YouTube.

22. François Truffaut, *Hitchcock* (New York: Simon and Schuster, 1967), 63.

23. See Paret et al., *Persuasive Images*, 144–45.

24. Exceptions include Harry Stoner's *Official United States War Films*, ca. 1918, which shows doughboys advancing across no man's land beneath an inflamed night sky, and Edwin Howland Blashfield's *U.S.A.* (1918), a ridiculously old-fashioned depiction of American combat troops charging heroically through an explosion-lit darkness while Liberty hovers over them with unfurled Old Glory in one hand and an unsheathed sword in the other. For good

measure, a bald eagle screams in fury! Walter Whitehead's *Come On!—Buy More Liberty Bonds* (1918) depicts a wounded but resolute doughboy, his helmet dented, his jaw squared, stepping over the corpse of a German soldier and defiantly taking on the next enemy. (For Stoner's poster, see Rawls, 142; for Blashfield and Whitehead, see Paret et al., 32 and 48.)

25. Little is known about H. R. Hopps (1869–1937); for the few available details, see Edan Milton Hughes, *Artists in California, 1786–1940*, vol. 1, 3rd. ed. (Sacramento, CA: Crocker Art Museum, 2002), 545.

26. See Ronald B. Tobias, *Film and the American Moral Vision: Theodore Roosevelt to Walt Disney* (East Lansing: Michigan State University Press, 2011), 168–69, on *Ingagi* and, more generally on early Hollywood and the raging ape motif, 157–72.

27. Thomas Jefferson, *Notes on the State of Virginia* (1785) (New York: Penguin, 1990), 145. On Frémiet, see Ted Gott, "Clutch of the Beast: Emmanuel Frémiet, Gorilla-Sculptor," in *Kiss of the Beast: From Paris Salon to King Kong* (Queensland, Australia: Queensland Art Gallery, 2005), 14–57. Also Ted Gott and Kathryn Weir, *Gorilla* (London: Reaktion Books, 2013), 39–41, Gott, "Stowed Away: Emmanuel Frémiet's Gorilla Carrying Off a Woman," available online in *Art Bulletin of the National Gallery of Victoria* 45 (2005), and Marek Zgórniak, "Fremiet's [*sic*] *Gorillas*: Why Do They Carry Off Women?" *Artibus et Historiae*, 27(54) (2006), 219–37. The only modern study of Frémiet is Catherine Chevillot, *Emmanuel Frémiet, 1824–1910: Le Main et le multiple*, exhibition catalogue (Dijon: Musée des Beaux-Arts, 1988). On King Kong's successors in popular culture, see Meaghan Morris, "Great Moments in Social Climbing: King Kong and the Human Fly," in *Too Soon, Too Late: History in Popular Culture* (Bloomington: Indiana University Press, 1998), 123–57.

28. Joseph Conrad, *Heart of Darkness*, ed. Robert Kimbrough (New York: Norton, 1988), 51; for those using a different edition, the "brutes" passage appears in Section II.

29. Josiah C. Nott and George Glidden, *Types of Mankind: or, Ethiological Researches, Based Upon the Ancient Monuments, Paintings, Sculptures, and Crania of Races, and Upon Their Natural, Geographical, Philological and Biblical History* (Philadelphia: J. B. Lippincott, 8th ed., 1857). See also Reginald Horsman, *Josiah Nott of Mobile: Southerner, Physician, and Racial Theorist* (Baton Rouge: Louisiana State University Press, 1987), 81–92. Charles Carroll, *The Negro a Beast; or, In the Image of God: The Bible as It Is! The Negro and His Relation to the Human Family!* (Saint Louis: American Book and Bible House, 1900); see Estelle B. Freedman, *Redefining Rape: Sexual Violence in the Era of Suffrage and Segregation* (Cambridge, MA: Harvard University Press, 2013), 231. Winthrop D. Jordan identifies eighteenth-century conflations of Negroes and apes in *White over Black: American Attitudes toward the Negro, 1550–1812*, 2nd. ed. (1968; Chapel Hill: University of North Carolina Press, 2012), 228–34.

30. On racism as a WWI recruitment strategy, see Anne Classen Knutson, "The Enemy Imagined: Visual Configurations of Race and Ethnicity in World War I Propaganda Posters," in Reynolds J. Scott-Childress, ed., *Race and the Production of Modern American Nationalism* (New York: Garland Publishing, 1999), 195–220. Hitler's enjoyment of *King Kong* in Ian Kershaw, *Hitler,*

1889–1936: Hubris (New York: Norton, 1999), 485, and Ben Urwand, *The Collaboration: Hollywood's Pact with Hitler* (Cambridge, MA: Harvard University Press, 2013), 1–7.

31. Andrew Erish, "Illegitimate Dad of 'Kong': One of the Depression's Highest-Grossing Films Was an Outrageous Fabrication, a Scandalous and Suggestive Gorilla Epic That Set Box Office Records across the Country," *Los Angeles Times* (January 8, 2006), E6. On *Ingagi*, Tobias, as in n. 26; also Wikipedia entry and Gerald Perry: http://www.geraldpeary.com/essays/jkl/kingkong-1.html.

32. Jan Nederveen Pieterse, *White on Black: Images of Africa and Blacks in Western Culture* (New Haven: Yale University Press, 1992), 85 and 228.

33. See Steve Oney, *And the Dead Shall Rise: The Murder of Mary Phagan and the Lynching of Leo Frank* (New York: Random House, 2003).

34. Noel Ignatiev, *How the Irish Became White* (New York: Routledge, 1995), and Matthew Frye Jacobson, *Whiteness of a Different Color: European Immigrants and the Alchemy of Race* (Cambridge, MA: Harvard University Press, 1998). On Nast, see Fiona Deans Halloran, *Thomas Nast: The Father of Modern Political Cartoons* (Chapel Hill: University of North Carolina Press, 2012), and for a wide-ranging display of Nast's cartoons, see Morton Keller, *The Art and Politics of Thomas Nast* (New York: Oxford University Press, 1968), especially fig. 155 (p. 238), "The Ignorant Vote—Honors Are Easy" (from *Harper's Weekly*, Dec. 9, 1876), showing a chimp-faced black man, representing the South, and an ape-faced Irishman, representing the North, balancing on a scale. On the use of the ape as a trope in recent political caricature, see Alexis Clark, "Noble Savage or Naughty Monkey? Primitivism and Portrayals of the George W. Bush Presidency," in *Lines of Attack: Conflicts in Caricature*, ed. Neil McWilliam (Durham, NC: Nasher Museum of Art at Duke University, 2010), 26–33.

35. See Michael Lundblad, *The Birth of a Jungle: Animality in Progressive-Era U.S. Literature and Culture* (New York: Oxford University Press, 2014), 132–33. Rebecca Latimer Felton, "Needs of the Farmers' Wives and Daughters," *Atlanta Journal* (August 12, 1897), reprinted in *Lynching in America: A History in Documents*, ed. Christopher Waldrep (New York: New York University Press, 2006), 143–44; "half-civilized gorillas" remark quoted in Leon F. Litwack, *Trouble in Mind: Black Southerners in the Age of Jim Crow* (New York: Knopf, 1998), 213, from ca. 1894 newspaper clipping in Rebecca Felton Papers, University of Georgia Library.

36. Stuart Ewen, *PR! A Social History of Spin* (New York: Basic Books, 1996), and Larry Tye, *Father of Spin: Edward L. Bernays and the Birth of Public Relations* (New York: Crown, 1988). See also Scott M. Cutlip, *The Unseen Power: Public Relations, A History* (Hillsdale, NJ: Lawrence Erlbaum Associates, 1994).

37. On Tarzan and masculinity, see John F. Kasson, *Houdini, Tarzan, and the Perfect Man: The White Male Body and the Challenge of Modernity in America* (New York: Hill and Wang, 2002), 157–223, and Bederman, *Manliness & Civilization*, 218–32. On Tarzan, animality, and rape, see Lundblad, *Birth of the Jungle*, 139–56, and on the Nazi banning of MGM's *Tarzan the Ape Man* (1934) because it evoked interracial and interspecies sexual mixing, see Urwand, *Collaboration*, 128–31. On the imbrications of gender, nationalism, and race in nineteenth and early twentieth century British

colonialism, see Anne McClintock, *Imperial Leather: Race, Gender, and Sexuality in the Colonial Context* (New York: Routledge, 1995).

38. There are no modern biographies of June Mathis. On Frances Marion, see Cari Beauchamp, *Without Lying Down: Frances Marion and the Powerful Women of Early Hollywood* (New York: Lisa Drew/Scribner, 1997). Lizzie Francke, *Script Girls: Women Screenwriters in Hollywood* (London: British Film Institute, 1994), 5–28, supplies background on a number of female screenwriters of the silent era. Frances Marion lays out her screenwriting principles in a classic of the genre, *How to Write and Sell Film Stories* (1937; rpt. New York: Garland, 1978).

39. Vincent Tajiri, *Valentino: The True Life Story* (New York: Bantam, 1977), 63, as quoted in Miriam Hansen, *Babel and Babylon: Spectatorship in American Silent Film* (Cambridge, MA: Harvard University Press, 1991), 285. I'd like to acknowledge here "The New Woman's Fascination: Rudolph Valentino and the Tango," an independent study research paper written for me in the spring of 2008 by my student Mary Beth Ballard.

40. Bederman, *Masculinity & Civilization*, 235.

41. On the sadomasochistic appeal of Valentino, see Hansen, *Babel and Babylon*, and Gaylyn Studlar, *This Mad Masquerade: Stardom and Masculinity in the Jazz Age* (New York: Columbia University Press, 1996); quotations from Mae Tinnee, "Come to Mother," undated newspaper clipping excerpted in Hansen, 262; *Screenland* (January 1923), in Hansen, 259 n. 45; and Winifred Van Duzer in the *Pittsburgh Times Gazette* (March 4, 1923), also in Hansen, 259 n. 45. On rape fantasy in cinema and other popular forms of representation, see Lynne A. Higgins and Brenda R. Silver, *Rape and Representation* (New York: Columbia University Press, 1991), Tanya Horeck, *Public Rape: Representing Violation in Fiction and Film* (New York: Routledge, 2004), Sarah Projansky, *Watching Rape: Film and Television in Postfeminist Culture* (New York: New York University Press, 2001), and Dominique Russell, ed., *Rape in Art Cinema* (New York: Continuum, 2010).

42. Elizabeth Cowie, "Pornography and Fantasy: Psychoanalytic Perspectives," in Lynne Segal and Mary McIntosh, eds., *Sex Exposed: Sexuality and the Pornography Debate* (New Brunswick, NJ: Rutgers University Press, 1992), 142–43. My thanks to Grace McLaughlin for her incisive critical responses to this part of the chapter.

43. See Linda Nochlin, *Bathers, Bodies, Beauty: The Visceral Eye* (Cambridge, MA: Harvard University Press, 2006), 168–69.

44. "Reversion to Primitive Emotions as a Result of War," *Current Opinion* 65(2) (Aug. 1918), 109–10; quoting from Sigmund Freud, "The Disillusionment of War" and "Our Attitudes toward Death" (both 1915). I learned of the *Current Opinion* essay from Linda R. Robertson, *The Dream of Civilized Warfare: World War I Flying Aces and the American Imagination* (Minneapolis: University of Minnesota Press, 2003), 310ff. In n. 11 for chapter 10, she suggests that the anonymous author was Edward Bernays.

45. For a powerful account of British conscientious objectors in the war, see Adam Hochschild, *To End All Wars: A Story of Protest and Patriotism in the First World War* (London: Macmillan, 2011; the subtitle of the American version [Boston: Houghton Mifflin, 2011] is less evocative: *A Story of Loyalty and Rebellion, 1914–18*). The literature on shell shock and its latter-day manifestation

as PTSD is vast. A superb starting place is David J. Morris, *The Evil Hours: A Biography of Post-Traumatic Stress Disorder* (Boston: Houghton Mifflin, 2015). On reverberations of shell shock in the post-WWI cultural realm, specifically in Germany, see Anton Kaes, *Shell Shock Cinema: Weimar Culture and the Wounds of War* (Princeton, NJ: Princeton University Press, 2009), and, more broadly, Jay Winter, "Shell-Shock and the Cultural History of the Great War," *Journal of Contemporary History* 35 (2000), 7–11. On correlations between trauma suffered in war and in domestic violence or abuse, see Judith Lewis Herman's influential study *Trauma and Recovery: The Aftermath of Violence from Domestic Abuse to Political Terror*, rev. ed. (New York: Basic Books, 1997).

46. Lt. Hervey Allen and Corp. Harold W. Pierce, quoted in Ronald Shaffer, *America and the Great War: The Rise of the War Welfare State* (New York: Oxford University Press, 1991), 158–59.

47. Walter Benjamin, "Experience and Poverty," in *Selected Writings*, general editor, Michael W. Jennings, 4 vols. (Cambridge, MA: Harvard University Press, Belknap Press, 1996–2003), 2:732, quoted in Uwe Steiner, *Walter Benjamin: An Introduction to His Work and Thought*, trans. Michael Winkler (Chicago: University of Chicago Press, 2010).

48. See George Santayana, "The Genteel Tradition in American Philosophy" (1911), in *The Genteel Tradition in American Philosophy and Character and Opinion in the United States*, ed. James Seaton (New Haven, CT: Yale University Press, 2009), Santayana, *The Genteel Tradition at Bay* (New York: Scribner, 1931), and Malcolm Cowley, *After the Genteel Tradition: American Writers Since 1910* (Gloucester, MA: P. Smith, 1959).

49. Eugene O'Neill, *The Hairy Ape* (1922), in *Nine Plays by Eugene O'Neill* (New York: Modern Library, 1993), 78–81. Yank says to the gorilla, "Ain't we both members of de same club—de Hairy Apes?" (78), and liberates him from his cage. This is not a good idea. "*With a spring [the gorilla] wraps his huge arms around YANK in a murderous hug*" (80).

50. From *Outing* magazine (1888), quoted in Lena Lenček and Gideon Bosker, *Making Waves: Swimsuits and the Undressing of America* (San Francisco: Chronicle Books, 1989), 34.

51. Lenček and Bosker, *Making Waves*, 40.

52. *New York Times* (June 21, 1917), 1:5. Recent studies of Paul include Katherine H. Adams and Michael L. Keene, *Alice Paul and the American Suffrage Campaign* (Urbana: University of Illinois Press, 2008), Christine A. Lunardini, *Alice Paul: Equality for Women* (Philadelphia: Westview Press, 2013), and J. D. Zahniser and Amelia R. Fry, *Alice Paul: Claiming Power* (New York: Oxford University Press, 2014). On political and cultural feminism more broadly during this period, see Nancy F. Cott, *The Grounding of Modern Feminism* (New Haven, CT: Yale University Press, 1987).

53. Jeannette Rankin, "Two Votes Against War: 1917 and 1941," *Liberation* 3 (March 1958), 4–6, as quoted in *Antiwar Dissent and Peace Activism in World War I America*, ed. with introduction Scott H. Bennett and Charles F. Howlett (Lincoln: University of Nebraska Press, 2014), 156. On Rankin, see the pair of essays by Joan Hoff Wilson, "'Peace is a Woman's Job...' Jeannette Rankin and American Foreign Policy: The Origins of Her Pacifism," and "'Peace is a Woman's Job...' Jeannette Rankin and American Foreign Policy: Her Lifework as a Pacifist," in *History of Women in the United States: Historical*

Articles on Women's Lives and Activities, vol. 15, *Women and War*, ed. Nancy F. Cott (Munich: K. G. Saur, 1993), 236–69 and 270–307. On the conjunction of feminism, pacifism, and conscientious objection, see Frances H. Early, *A World Without War: How U. S. Feminists and Pacifists Resisted World War I* (Syracuse, NY: Syracuse University Press, 1997).

54. Lois W. Banner, *American Beauty* (New York: Knopf, 1983), 266–70. On Christy, see Knutson, "Breasts, Brawn and Selling a War," 163–72 (as in n. 1 above), and Mary Ellen Gomrad, "Visual and Verbal Rhetoric in Howard Chandler Christy's War-Related Posters of Women during the World War I Era: A Feminist Perspective" (MA thesis, University South Florida, 2007, available online).

55. For Roosevelt's views on masculinity and war, as well as other pertinent topics, see Theodore Roosevelt, *The Strenuous Life: Essays and Addresses* (New York: Century, 1901), *Fear God and Take Your Own Part* (New York: George H. Doran, 1916), and *The Foes of Our Own Household* (New York: George H. Doran, 1917); Sarah Watts castigates him for war-mongering in *Rough Rider in the White House: Theodore Roosevelt and the Politics of Desire* (Chicago: University of Chicago Press, 2003).

56. On women's expanded job opportunities in war-related organizations, see Lettie Gavin, *American Women in World War I: They Also Served* (Niwot, CO: University Press of Colorado, 1997), Kimberly Jensen, *Mobilizing Minerva: American Women in the First World War* (Urbana University of Illinois Press, 2008), and Susan Zeiger, *In Uncle Sam's Service: Women Workers with the American Expeditionary Force, 1917–1919* (Ithaca, NY: Cornell University Press, 1999).

57. "An Artist Who Paints Some of Our Covers," *American Magazine* 82 (July 1916), 36. On McMein's life and career, see Brian Gallagher, *Anything Goes: The Jazz Age Adventures of Neysa McMein and Her Extravagent Circle of Friends* (New York: Times Books, 1987), and, for plentiful illustration of her magazine and advertising work, see Norman I. Platnick, *The Lady Seldom Smiles: A Collector's Guide to Neysa McMein* (Bayshore, NY: Enchantment Ink, 2006). On McMein's professional milieu, see Carolyn Kitch, *The Girl on the Magazine Cover: The Origins of Visual Stereotypes in American Mass Media* (Chapel Hill: University of North Carolina Press, 2001). For a good online introduction to McMein, see John Simkin's essay for Spartacus International, "Neysa McMein," http://spartacus-educational.com/Aneysa_mcMein.htm. I thank Nancy Cott for bringing Neysa McMein to my attention.

58. "20,000 March in Suffrage Line; President's Indorsement [*sic*] on Banners Carried in Fifth Avenue Parade," *New York Times* (October 28, 1917), 1, 18. According to the front-page report, "The patriotism of women, their sacrifices and contributions since America went to war, and the argument that a country fighting for democracy should establish democracy at home by giving the vote to women were emphasized in every way." Consider the following comment from the *Times* in light of our discussion above about suffragists such as Alice Paul picketing the White House and pacifists such as Congresswoman Jeannette Rankin voting against the declaration of war: "To emphasize their loyalty to the nation at war, the suffragists carried banners repudiating the Washington pickets. 'We are opposed to the picketing of the White House. We stand by our country and our President,' and 'The Woman Suffrage Party does not picket at the White House,' were the words on two of the banners."

59. Quoted in Gallagher, *Anything Goes*, 48.
60. Alexander Woollcott, "Neysa McMein," in *Enchanted Aisles*, 2nd ed. (New York: G. P. Putnam, 1924), 33–38; "The New Star," *Motion Picture Magazine*, 22(12) (January 1922), 55.
61. Helen Ferris and Virginia Moore, *Girls Who Did: Stories of Real Girls and Their Careers* (NY: Dutton, 1927), 109; Maude Martin Ellis, "Neysa M'Mein recalls her art struggles here: From 75 Cents a Drawing to $1,500 Her Stride," *Chicago Daily Tribune* (September 17, 1921), 13; Gallagher, *Anything Goes*, 112.
62. "Neysa M'Mein Dies; Portrait Painter: Noted Artist Created Posters for Use in World Wars—Did Magazine Covers," *New York Times* (May 13, 1949), 23.

Chapter 3 "Mirroring Masculinity"

1. George Orwell, *Nineteen Eighty-Four* (New York: Harcourt, Brace, 1949), 3.
2. Philip Magnus, *Kitchener: Portrait of an Imperialist* (New York: Dutton, 1959), 115.
3. Toby Clark, *Art and Propaganda in the Twentieth Century: The Political Image in the Age of Mass Culture* (New York: Harry N. Abrams, 1997), 105.
4. Clark, 105–6. Carlo Ginzburg also comments on the effectiveness of Leete's poster and provides detailed art-historical analysis in " 'Your Country Needs You': A Case Study in Political Iconography," *History Workshop Journal* 52 (Autumn 2001), 1–22.
5. Nicholas Hiley, " 'Kitchener Wants You' and 'Daddy, what did *YOU* do in the Great War?' The Myth of British Recruiting Posters," *Imperial War Museum Review* 11 (1997), 41. See also James Aulich and John Hewitt, *Seduction or Instruction? First World War Posters in Britain and Europe* (New York: Manchester University Press, 2007).
6. Melissa Hall, "Militarism, Gender, and the Imagery of the First World War," *Phoebe* 3(2) (Fall 1991), 36.
7. Quoted in Gary S. Messinger, *British Propaganda and the State in the First World War* (New York: Manchester University Press, 1992), 33.
8. Kerry Segrave, *Endorsements in Advertising: A Social History* (Jefferson, NC: McFarland, 2005), 3–33. See also Marlis Schweitzer and Marina Moskowitz, eds., *Testimonial Advertising in the American Marketplace: Emulation, Identity, Community* (New York: Palgrave Macmillan, 2009).
9. Hall, "Militarism," 36; Sigmund Freud, "The Uncanny" (1919), in *The Standard Edition of the Complete Psychological Works of Sigmund Freud: An Infantile Neurosis and Other Works*, vol. 17, trans. James Strachey (London: Hogarth Press and the Institute of Psycho-Analysis, 1955), 231.
10. James Montgomery Flagg, *Roses and Buckshot* (New York: G. P. Putnam's Sons, 1946), 158. See also Susan E. Meyer, *James Montgomery Flagg* (New York: Watson-Guptill, 1975), 36–45, and Christopher Capozzola, *Uncle Sam Wants You: World War I and the Making of the Modern American Citizen* (New York: Oxford University Press, 2008), 3–11.
11. *Literary Digest* 54 (April 14, 1917), 1061; see David M. Kennedy, *Over Here: The First World War and American Society*, 25th anniversary edition (New York: Oxford University Press, 2004), 41.

12. See Alton Ketchum, *Uncle Sam: The Man and the Legend* (New York: Hill and Wang, 1959).

13. Flagg, 158.

14. Max Horkheimer and Theodor W. Adorno, "The Culture Industry: Enlightenment as Mass Deception," in *Dialectic of Enlightenment* (1944), trans. John Cumming (New York: Seabury Press, 1972), 167.

15. See, for example, Susan Harris Smith, "The Surrealists' Windows," *Dada/ Surrealism* 13 (1984), 48–69.

16. Peter Paret, Beth Irwin Lewis, and Paul Paret refer to the "double message of the text—directed simultaneously at women and by women at their men" in *Persuasive Images: Posters of War and Revolution from the Hoover Institution Archives* (Princeton, NJ: Princeton University Press, 1992), 52.

17. See Nicoletta F. Gullace, *"The Blood of Our Sons": Men, Women, and the Regeneration of British Citizenship During the Great War* (New York: Palgrave Macmillan, 2002), chapter 4, and Erika A. Kuhlman, *Petticoats and White Feathers: Gender Conformity, Race, the Progressive Peace Movement, and the Debate over War, 1895–1919* (Westport, CT: Greenwood Press, 1997), 1.

18. Gullace, *"Blood of Our Sons,"* 82–83.

19. Peter Buitenhuis, *The Great War of Words: British, American, and Canadian Propaganda and Fiction, 1914–1933* (Vancouver: University of British Columbia Press, 1987), 16–18. On the impact of British propaganda in America, see also Stewart Halsey Ross, *Propaganda for War: How the United States Was Conditioned to Fight the Great War of 1914–1918* (Jefferson, NC: McFarland, 1996).

20. "Women Students Win Poster Prizes," *The Poster*, 8:7 (July 1917), quoted in *Art and Propaganda: Images of Ourselves and Our Enemies, 1914–1918*, University of Missouri-Kansas City Gallery of Art, n.d., 34. My thanks to Kent Minturn for providing this source. See also Anne Classen Knutson, "Breasts, Brawn and Selling a War: American World War I Propaganda Posters 1917–1918," PhD dissertation, University of Pittsburgh, 1997, 88.

21. T. S. Eliot, "The Love Song of J. Alfred Prufrock" (1917), line 51.

22. See David M. Lubin, "Psychological Portraiture in the Work of Thomas Eakins," in Joel Pfister and Nancy Schnog, eds., *Inventing the Psychological: Toward a Cultural History of Emotional Life in America* (New Haven, CT: Yale University Press, 1997), 145–47 and 155–59. Also Lubin, "Projecting an Image: The Contested Cultural Identity of Thomas Eakins," *Art Bulletin* 84(3) (September 2002), 513–14, for the reception of Eakins's psychological portraiture in the early twentieth century.

23. Carole Turbin, "Fashioning the American Man: The Arrow Collar Man, 1907–1931." *Gender & History* 14(3) (November 2002), 470–91. For abundant examples of Leyendecker's work, see Laurence S. Cutler, Judy Goffman Cutler, and the National Museum of American Illustration, *J. C. Leyendecker: American Imagist* (New York: Harry N. Abrams, 2008), and Michael Schau, *J. C. Leyendecker* (New York: Watson-Guptill, 1974). Ronald Paulson writes perceptively on Leyendecker, Flagg, and Maxfield Parrish in an untitled review essay in *Georgia Review* 29(4) (Winter 1975), 957–64.

24. Henry James, *Notes of a Son and Brother* (London: Macmillan, 1914), 349, 290. On the "crisis of masculinity" and the First World War, see Joanna Bourke, *Dismembering the Male: Men's Bodies, Britain and the Great War*

(Chicago: University of Chicago Press, 1996), Peter G. Filene, *Him/Her/Self: Gender Identities in Modern America*, 3rd ed. (Baltimore, MD: The Johns Hopkins University Press, 1998), 100–20, Gullace, *"Blood of Our Sons"*, Eric J. Leed, *No Man's Land: Combat & Identity in World War I* (London: Cambridge University Press, 1979), and Elaine Showalter, *Hystories: Hysterical Epidemics and Modern Culture* (New York: Columbia University Press, 1997), 72–75. See also Sandra M. Gilbert and Susan Gubar, "Soldier's Heart: Literary Men, Literary Women, and the Great War," in *No Man's Land: The Place of the Woman Writer in the Twentieth Century*, vol. 2: *Sexchanges* (New Haven, CT: Yale University Press, 1989), 258–323.

25. William Shakespeare, *Henry V* (ca. 1599), ed. Gary Taylor (Oxford: Clarendon Press, 1982), Act IV, scene 3: 64–67.

26. Hiley, 53–54.

27. Sigmund Freud, *Beyond the Pleasure Principle* (1920), in *The Standard Edition of the Complete Psychological Works of Sigmund Freud*, vol. 18, trans. James Strachey (London: Hogarth Press and the Institute of Psycho-Analysis, 1955). Paul Johnson proposes that psychoanalysis flourished in the wake of the First World War precisely because Freud's theories offered a way of understanding the residual effects of the war on the minds and emotions of middle-class veterans. See Johnson, *Modern Times: The World from the Twenties to the Eighties* (New York: Harper & Row, 1983), 5–8. The Rivers quotation is from W. H. R. Rivers, "The Repression of War Experience" (a medical paper presented in 1917 and published in 1918), reprinted in *The Great War Reader*, ed. James Hannah (College Station: Texas A&M University Press, 2000), 473–87, quotation on 486. Rivers is sympathetically portrayed in Pat Barker's *Regeneration Trilogy*, a series of three novels published between 1991 and 1995. David J. Morris, *The Evil Hours: A Biography of Post-Traumatic Stress Disorder* (Boston: Houghton Mifflin Harcourt, 2015), provides a moving and insightful history of professional attempts to identify and ameliorate the lingering effects of war-induced mental stress.

28. See "Gifford Beal: A New Discovery," *American Art Review* 11(5) (September–October 1999), 184–85, and Carol Vogel, "Circus Parade Hid Another," *New York Times* (June 4, 1999), E30.

Chapter 4 "Opposing Visions"

1. George Creel, *How We Advertised America: The First Telling of the Amazing Story of the Committee on Public Information that Carried the Gospel of Americanism to Every Corner of the Globe* (1920; rpt. New York: Arno Press, 1972).

2. David M. Kennedy, *Over Here: The First World War and American Society*, 25th anniversary edition (New York: Oxford University Press, 2004), 76–78.

3. Barbara S. Kraft, *The Peace Ship: Henry Ford's Pacifist Adventure in the First World War* (New York: Macmillan, 1978).

4. Susan Ilene Fort, *Flag Paintings of Childe Hassam* (Los Angeles: Los Angeles County Museum of Art, 1988), 9–10. See also H. Barbara Weinberg et al., *Childe Hassam: American Impressionist* (New York: Metropolitan Museum of Art, 2004), 216–26.

5. Roosevelt gave his "Hyphenated Americans" speech in Carnegie Hall on Columbus Day, October 12, 1915, to the Knights of Columbus. See "Roosevelt

Bars the Hyphenated," *New York Times* (October 13, 1915), 1, 5; and John Higham, *Strangers in the Land: Patterns of American Nativism, 1860–1925* (New Brunswick, NJ: Rutgers University Press, 1955), 195ff. The speech is reprinted as Appendix B, "Americanism," in Roosevelt, *Fear God and Take Your Own Part* (New York: George Doran, 1916), 357–76.

6. See Rebecca Zurier, *Art for "The Masses": A Radical Magazine and Its Graphics* (Philadelphia: Temple Univ. Press, 1988), for a thorough discussion of the art program for this publication, and William O'Neill, ed., *Echoes of Revolt: "The Masses," 1911–1917* (New York: Quadrangle Books, 1966). See also Richard Fitzgerald, *Art and Politics: Cartoonists of the "Masses" and "Liberator"* (Westport, CT: Greenwood Press, 1973). Zurier's *Picturing the City: Urban Vision and the Ashcan School* (Berkeley: University of California Press, 2006) provides in-depth analysis of the visual and political world of the Ashcan artists. More specifically on the politics of editorial cartoons, see Victor S. Navasky, *The Art of Controversy: Political Cartoons and Their Enduring Power* (New York: Knopf, 2013), Robert Phillippe, *Political Graphics: Art as Weapon* (New York: Abbeville, 1982), and Charles Press, *The Political Cartoon* (Rutherford, NJ: Fairleigh Dickinson University Press, 1981); for World War I cartooning with an international perspective, see Mark Bryant, *World War I in Cartoons* (London: Grub Street, 2006), and Roy Douglas, *The Great War, 1914–1918: The Cartoonist's Vision* (New York: Routledge, 1995). The Billy Ireland Cartoon Library at The Ohio State University in Columbus, Ohio, offers researchers a superlative collection of WWI-era American cartoons.

7. Mike Moser, "When Jesus Was Left: Christians, Socialists, and the Masses," in *Bad Subjects* 72 (February 2005) http://bad.eserver.org/issues/2005/72/mosher.html. For a comprehensive view of Bellows's careers as an artist, see Charles Brock et al., *George Bellows* (Washington, DC: National Gallery of Art, 2012).

8. See, for example, *New York Times* (May 9, 1917), 12, "Marshal Joffre Due Here Today," with its subheadings, "The City Gay with Colors" and "Thousands of Buildings Draped with Flags of United States, Britain, and France," and May 10, 1917, 3, "Flags Bedeck City as If For Victory: Fifth Avenue and Broadway a Marvelous Mass of Flaunting Colors."

9. Fort, *Flag Paintings of Childe Hassam*, 109; for greater detail on this topic, see Elizabeth Broun, "Hassam's Pride in His Ancestry," in Weinberg et al., *Childe Hassam*, 285–94.

10. For an excellent discussion of "cultures colliding" in the American art world over the question of intervention, see Patricia Junker, "Childe Hassam, Marsden Hartley, and the Spirit of 1916," *American Art* 24(3) (Fall 2010), 26–51. Regarding Hassam's disingenuous claims that his flag paintings were not meant to inspire patriotic fervor, she writes: "Implying, as Hassam did years later, that the effect of these flag displays could be purely aesthetic and not emotional and psychological is like saying that the impact of seeing Manhattan awash in American flags in the fall of 2001 could be purely visual" (35).

11. Both quoted in Philip S. Foner, *History of the Labor Movement in the United States*, vol. 7, *Labor and World War I, 1914–1918* (New York: International Publishers, 1947), 68.

12. Harold D. Lasswell, "The Garrison State," *American Journal of Sociology* 46(4) (January 1941), 455–68, reprinted in Lasswell, *On Political Sociology*, ed. Dwaine Marvick (Chicago: University of Chicago Press, 1977), 165–76. Christopher Capozzola, *Uncle Sam Wants You: World War I and the Making of the Modern American Citizen* (New York: Oxford University Press, 2008), shows in great detail how mobilization for war fundamentally transformed the relationship between Americans and the state, increasing their dependence on federal government for protection from violence, whether foreign or domestic.

13. Henry L. Stimson and MacGeorge Bundy, *On Active Service in Peace and War* (New York: Harper, 1948), 624–33, which quotes at length from "The Decision to Use the Atomic Bomb," Stimson's article in *Harper's Magazine* (February 1947), 97–107, providing his justification for the nuclear assault on Japan. See Geoffrey Hodgson, *The Colonel: The Life and Times of Henry Stimson, 1867–1950* (New York: Knopf, 1990), esp. 330–32, and Sean L. Malloy, *Atomic Tragedy: Henry L. Stimson and the Decision to Use the Bomb against Japan* (Ithaca, NY: Cornell University Press, 2008).

14. On Stimson's role in the DC suffrage parade, see Kimberly Jensen, *Mobilizing Minerva: American Women in the First World War* (Urbana: University of Illinois Press, 2008), 3–5. The quotation in the following paragraph is from page 5.

15. The best studies of this topic are Pearl James, "Images of Femininity in American World War I Posters," in James, ed., *Picture This: World War I Posters and Visual Culture* (Lincoln: University of Nebraska Press, 2009), 273–311, Celia Malone Kingsbury, *For Home and Country: World War I Propaganda on the Home Front* (Lincoln: University of Nebraska Press, 2010), esp. chapter 5, "The Hun is at the Gate: Protecting the Innocents," 218–61, and Anne Classen Knutson, "Beast, Brawn and Selling a War: American World War I Propaganda Posters 1917-1918," PhD dissertation, University of Pittsburgh, 1997 (Ann Arbor, MI: University Microfilms International, 1998). For the British context, see Nicoletta F. Gullace, "Sexual Violence and Family Honor: British Propaganda and International Law during the First World War," *American Historical Review* 103(3) (June 1997), 714–47.

16. Ernest Haskell, "Introduction," in *Childe Hassam*, compiled by Nathaniel Pousette-Dart (New York: Frederick A. Stokes, 1922), vii. Quoted in Ilene Susan Fort, *Childe Hassam's New York* (San Francisco: Pomegranate Artbooks, 1993), n.p.

17. Under the subheading "Hits at a Popular Song," the *New York Times* report on Roosevelt's "Hyphenated Americans" speech notes that, "While talking of preparedness, he broke in also with this bit of sarcasm, which pleased the crowd immensely: 'I want to call the attention of individuals who sing about the mother who didn't bring up her boy to be a soldier, to the fact that if the song had been popular between 1776 and 1781, there wouldn't be anyone to sing it today.'" In "Roosevelt Bars the Hyphenated," as in n. 5 above, 1.

18. See Glenn Watkins, *Proof through the Night: Music and the Great War* (Berkeley: University of California Press, 2002), which offers a rich cultural history of European and American music during the war years. Soldiers in the field occasionally subverted the swaggering lyrics of "Over There" from "we

won't come back 'til it's over, over there" to "we won't come back, *we'll be buried* over here." See Christina Gier, "Gender, Politics, and the Fighting Soldier's Song in American during World War I," *Music and Politics* 2, no. 1 (2008): 20–21. Thanks to Richard Leppert for this reference.

19. Hopkinson quotation from William Rea Furlong and Byron McCandless, *So Proudly We Hail: The History of the United States Flag* (Washington, DC: Smithsonian Institution Press, 1981), 100. See also Scot M. Guenter, *The American Flag, 1977–1924* (Rutherford, NJ: Fairleigh-Dickinson University Press, 1990), and Marc Leepson, *Flag: an American Biography* (New York: Thomas Dunne Books/St. Martin's Press, 2005). A detailed and polemical view of the American flag in history and art is provided in Albert Boime, *The Unveiling of the National Icons: A Plea for Patriotic Iconoclasm in a Nationalist Era* (New York: Cambridge University Press, 1998), chapter 1 ("Patriotism and Protest: Reconstituting Old Glory"), 18–81.

20. Cecilia Elizabeth O'Leary covers this ground well in *To Die For: The Paradox of American Patriotism* (Princeton, NJ: Princeton University Press, 1999).

21. Robert Justin Goldstein, *Saving "Old Glory": The History of the American Flag Desecration Controversy* (Boulder, CO: Westview Press, 1994), 73, citing S. S. Condo, *Our Flag and the Red Flag* (Marion, IN: S. S. Condo, 1915), 9–10, 13, 15–16.

22. Maurice Becker, "Patriotism," *The Masses* 8(6) (April, 1916), 10 (online from various archival sources). Zurier, *Art for "The Masses,"* 176, notes that Becker, declaring himself a conscientious objector when the United States went to war the following year, decamped to Mexico; on his return in 1919 he was tried on charges of draft evasion, convicted, and sentenced to twenty-five years of hard labor in Leavenworth Prison, where he served four months before receiving pardon.

23. On the Prager incident, see Jay Feldman, *Manufacturing Hysteria: A History of Scapegoating, Surveillance, and Secrecy in Modern America* (New York: Pantheon, 2011), xi–xvii; also Frederick C. Luebke, *Bonds of Loyalty: German-Americans and WWI* (DeKalb: Northern Illinois University Press, 1974), 3–26.

24. Muck's story is relayed in Watkins, *Proof through the Night*, 300–305.

25. My chief sources on Münsterberg's life and career are Matthew Hale, Jr., *Human Science and Social Order: Hugo Münsterberg and the Origins of Applied Psychology* (Philadelphia: Temple University Press, 1980), and Phyllis Keller, *States of Belonging: German-American Intellectuals and the First World War* (Cambridge, MA: Harvard University Press, 1979). At the end of the semester in which he instructed her, Münsterberg sent Stein a note thanking her for the "model-work you have done in the laboratory" and added, "if in later years you look into printed discussions which I have in mind to publish about students in America, I hope you will pardon me if you recognize some features of the ideal student picture as your own." Quoted in James R. Mellow, *Charmed Circle: Gertrude Stein & Company* (New York: Avon Books, 1974), 47.

26. Münsterberg's *Boston Herald* letter as summarized in Luebke, *Bonds of Loyalty*, 90. For an account of the Teutonic nationalism embraced at the outset of the war by Münsterberg's countryman Carl Rungius, a German-American artist residing in Brooklyn, see Alexander Nemerov, "Haunted Supermasculinity: Strength and Death in Carl Rungius's *Wary Game*," *American Art* 13 (Fall 1999), 8–10.

27. On Münsterberg and film, see Richard Griffith's foreword to Hugo
Münsterberg, *The Film: A Psychological Study* (1916; rpt. New York: Dover,
1970), v–xv [the title updated from *The Photoplay: A Psychological Study*],
and Donald Laurence Fredericksen, *The Aesthetic of Isolation in Film
Theory: Hugo Münsterberg* (PhD dissertation, 1973; New York: Arno Press,
1977). In his excellent introduction to *Hugo Münsterberg on Film: "The
Photoplay: A Psychological Study" and Other Writings* (New York:
Routledge, 2002), 1–41, editor Allan Langdale considers Münsterberg's
thoughts on the psychology of film viewing in terms of more recent develop-
ments in film theory and spectatorship studies. Included in the volume is an
extract from Margaret Münsterberg's 1922 biography of her father, stating that
he started going to the movies in the summer of 1915 because he "sought
distraction . . . from the wearing anxieties caused by the international stress"
(165). On Kellerman, see Angela Woollacott, *Race and the Modern Exotic:
Three "Australian" Women on Global Display* (Clayton, Victoria: Monash
University, 2011), 1–48; the "clad only in a fish tail" comment, made in 1919,
appears on 27. The artist Florine Stettheimer records in her diary that she and
her friend Marcel Duchamp went to see a Kellerman film in 1916 and were
impressed with the swimmer's amazing fitness and enviable good looks; see
Parker Tyler, *Florine Stettheimer: A Life in Art* (New York: Farrar, Straus,
1963), 136. Hollywood gave Kellerman the biopic treatment in the MGM
acquatic extravaganza *Million Dollar Mermaid* (1952), which starred her
protégée Esther Williams as Kellerman.
28. Comments on Münsterberg's death quoted in Keller, *States of Belonging*,
112–13.
29. Sigmund Freud, *Beyond the Pleasure Principle* (1920), in *The Standard
Edition of the Complete Psychological Works of Sigmund Freud*, vol. 18,
trans. James Strachey *(*London: Hogarth Press and the Institute of Psycho-
Analysis, 1955); more readily available in the Norton Library paperback
edition (New York: Norton, 1989), quotation on 10.
30. W. J. Gordon, *Flags of the World, Past and Present: Their Story and
Associations* (London: F. Warne, 1915), 1.
31. John P. Diggins introduces the term Lyrical Left in *The American Left in the
Twentieth Century* (New York: Harcourt Brace Jovanovich, 1973), 7, 17, and
74, adapting it from Floyd Dell's use of the term Lyrical Year in his euphoric
recollections of the period; Dell, in turn, references a 1912 poetry anthology
called *The Lyric Year*, which contained Edna St. Vincent Millay's prize-
winning poem "Renascence." See *The Lyric Year: One Hundred Poems*, ed.
Ferdinand Earle (New York: Mitchell Kennerley, 1912), and Floyd Dell,
Homecoming: An Autobiography (New York: Farrar & Rinehart, 1933), 218.
Other classic accounts of this period include Van Wyck Brooks, *America's
Coming-of-Age* (New York: B. W. Huebsch, 1915) and *An Autobiography* (New
York: E. P. Dutton, 1965), Henry Farnham May, *The End of American
Innocence: A Study of the First Years of Our Own Time, 1912–1917* (New York:
Knopf, 1959), and Arthur Frank Wertheim, *The New York Little Renaissance:
Iconoclasm, Modernism, and Nationalism in American Culture, 1908–1917*
(New York: New York University Press, 1976). See also Edward Abrahams,
The Lyrical Left: Randolph Bourne, Alfred Stieglitz, and the Origins of

Cultural Radicalism in America (Charlottesville: University of Virginia Press, 1986).

32. Susan M. Schweik, *The Ugly Laws: Disability in Public* (New York: New York University Press, 2009), describes municipal ordinances that attempted to keep impoverished or disabled people off the streets so as not to spoil the sightlines of the City Beautiful or trouble the consciences of its middle-class inhabitants.

33. See Edward Steichen, *A Life in Photography* (Garden City, NY: Doubleday, 1963), n.p., chapter 3 (second and third pages after plate 28), and Jean Strouse, *Morgan: American Financier* (New York: Random House, 1999), 650–51.

34. Glyn Davis, "Photography and Film," in *Exploring Visual Culture: Definitions, Concepts, Contexts*, ed. Matthew Rampley (Edinburgh: Edinburgh University Press, 2005), 91–92.

35. The aphorism is often attributed to the Viennese writer-provocateur Karl Kraus. I thank Joseph Imorde, University of Siegen, for bringing it to my attention.

36. Strand interviewed by Calvin Tomkins, June 30, 1973, as quoted in Maria Morris Hambourg, *Paul Strand, circa 1916* (New York: Metropolitan Museum of Art, 1998), 28–29. Six years after taking *Wall Street*, Strand re-created it in motion-picture form when he and fellow artist Charles Sheeler collaborated on an avant-garde documentary film entitled *Manhatta* (1921).

37. Hambourg, 29, quoting letter from Strand to Walter Rosenblum, May 21, 1951.

38. Jotham Sederstrom, "J. P. Morgan's Fortress, Long Vacant, Looks for Upscale Tenants," *New York Times* (Aug. 24, 2011), B-9; on the bank and the war, see Ron Chernow, *The House of Morgan: An American Banking Dynasty and the Rise of Modern Finance* (New York: Atlantic Monthly Press, 1990), Lewis Corey, *The House of Morgan: A Social Biography of the Masters of Money* (New York: G. H. Watt, 1930), and P. Hoyt, Jr., *The House of Morgan* (New York: Dodd, Mead, 1966).

39. See Thomas A. Bailey and Paul B. Ryan, *The* Lusitania *Disaster: An Episode in Modern Warfare and Diplomacy* (New York: Free Press, 1975), 96–102, 165–66, and 178, and Colin Simpson, *The* Lusitania (Boston: Little, Brown, 1973), 157–58. Most recently, the nonfiction writer Erik Larson has told the story of the sinking in his best-seller *Dead Wake: The Last Crossing of the* Lusitania (New York: Crown, 2015).

40. Zechariah Chafee, Jr., *Free Speech in the United States* (Cambridge, MA: Harvard University Press, 1941), 74–75, n. 10. Chafee, on 79, reports that under the Espionage Act, "Our judges condemned at least eleven persons to prison for ten years, six for fifteen years, and twenty-four for twenty years." See Kennedy, *Over Here*, 78–79.

41. For a vivid description of the affair, see Chernow, *House of Morgan*, 212–14. For a thorough assessment of the incident and its place in the history of modern terrorism, see Beverly Gage, *The Day Wall Street Exploded*: *A Story of America in Its First Age of Terror* (New York: Oxford University Press, 2009).

42. Randolph Bourne, "Below the Battle," *Seven Arts Chronicle* 2 (July 1917), 270–77, first reprinted in Bourne, *Untimely Papers*, ed. James Oppenheim (New York: B. W. Huebsch, 1919), 47–60.

43. O. W. Riegel, Introduction, in Anthony R. Crawford, ed., *Posters of World War I and World War II in the George C. Marshall Research Foundation* (Charlottesville: University Press of Virginia, 1979), 13.

44. Important studies of American advertising in historical context include Stephen R. Fox, *The Mirror Makers: A History of American Advertising and Its Creators* (New York: Morrow, 1984), T. J. Jackson Lears, *Fables of Abundance: A Cultural History of Advertising in America* (New York: Basic Books, 1994), Roland Marchand, *Advertising the American Dream: Making Way for Modernity, 1920–1940* (Berkeley: University of California Press, 1985), and Michael Schudson, *Advertising, the Uneasy Persuasion: Its Dubious Impact on American Society* (New York: Basic Books, 1984). On links between war posters and advertising, see James Aulich, *War Posters: Weapons of Mass Communication* (New York: Thames and Hudson, 2007).

45. Both comments quoted in William Leach, *Land of Desire: Merchants, Power, and the Rise of a New American Culture* (New York: Pantheon, 1993), 43.

46. On Bernays and his fellow pioneers in modern public relations, see Stuart Ewen, *PR! A Social History of Spin* (New York: Basic Books, 1996), and Larry Tye, *The Father of Spin: Edward L. Bernays and the Birth of Public Relations* (New York: Henry Holt, 2002); see also Mark Crispin Miller's introduction to Edward Bernays, *Propaganda* (1928; New York: Ig Publishing, 2005), 9–33, Leach, *Land of Desire*, 319–22, and Adam Curtis's excellent 2002 four-part television miniseries *The Century of the Self*, episodes 1 ("Happiness Machines") and 2 ("The Engineering of Consent").

47. Walter Lippmann, *Public Opinion* (1922; New York: Free Press, 1965); on Lippmann's evolving views, see Ronald Steel, *Walter Lippmann and the American Century* (Boston: Little, Brown, 1980). Chris Hedges furnishes an incisive account of American WWI propaganda and its adverse effect on American democracy in *Death of the Liberal Class* (New York: Nation Books, 2010); see especially chapter 3, "Dismantling the Liberal Class."

48. Edmund Wilson, *Patriotic Gore: Studies in the Literature of the American Civil War* (New York: Oxford University Press, 1962), xxxii.

49. See Adolf Hitler, *Mein Kampf* (1925; New York: Reynal & Hitchcock, 1940), vol. 1, chapter 6, "War Propaganda": "Compared with [Austrian and German propaganda], the war propaganda of the British and the Americans was psychologically right" (234); "There, propaganda was considered a weapon of the first order" (240).

50. Figures from *New York Times Magazine* (March 10, 1918), cited in Wikipedia entry for "Liberty Bond."

51. Charles Chaplin, *My Autobiography* (New York: Simon and Schuster, 1964), 218–19; 225.

52. George Gallup and Claude Robinson, "American Institute of Public Opinion—Surveys, 1935–38; Part II: Armament Program, War and Peace, Foreign Affairs" (April 1937), reported in *Public Opinion Quarterly* 2(3) (July 1938), 388. By April 1941, as WWII was already under way in Europe, the percentage of Americans who believed it was a mistake for the United States to enter the last war dropped to 39 percent, as reported by Gallup and Robinsoon in *Public Opinion Quarterly* 5(3) (Autumn, 1941), 477.

53. The executive producer of *Ace of Aces* was Merian C. Cooper, a former WWI aviator who also produced *King Kong* in 1933. The script was written by John Monk Saunders, a former Rhodes Scholar who served in WWI as a flight instructor but never saw combat action, which was a source of shame to him. After the war he wrote novels, short stories, and film scripts, including one for *Wings* (1927), the first movie to win an Academy Award for Best Picture. Saunders received a Best Story award from the Academy for *Dawn Patrol* (1930). He was married to Fay Wray, the star of *King Kong*. He hanged himself in 1940.

54. Walton Rawls, *Wake Up America!: World War I and the American Poster* (New York: Abbeville Press, 1988), 226. Pennell himself offers a history of this poster and its reception in *Joseph Pennell's Liberty Loan Poster: A Text-Book for Artists and Amateurs, Governments and Teachers and Printers* (Philadelphia: Lippincott, 1918; currently available in print-on-demand edition).

55. "Childe Hassam Arrested; Policeman Congratulated by Artist for His Alertness in Riverside Park," *New York Times* (April 17, 1918), 24. See Hassam's lithograph *Camouflage* (1918, New York Public Library) in Elizabeth E. Barker, " 'A truly learned weaving of light and dark': Hassam's Prints," in Weinberg et al., *Childe Hassam*, 277.

56. These location specifics emerged during the course of a five-way email exchange I enjoyed in August 2011 with art museum curators Anne Knutson, Barbara Weinberg, and Sylvia Yount and the architectural historian and licensed New York City guide Matt Postal. Fort, *Flag Paintings of Childe Hassam*, 102, notes that this is the only one of Hassam's flag paintings to include a sweeping vista and rooftops. It is also one of the only ones in the series to depict a hanging, still, almost furled flag.

Chapter 5 "Opening the Floodgates"

1. Unsigned editorial, "The Richard Mutt Case," *Blind Man* 2 (May 1917), 1. Initially Duchamp disclaimed authorship of *Fountain*; in a letter to his sister Suzanne in Paris, he wrote that "One of my female friends under a masculine pseudonym, Richard Mutt, sent in a porcelain urinal as a sculpture" to the Independents exhibition. This has led to speculation that the real author of *Fountain* was Duchamp's friend and fellow Dada provocateur Baroness Elsa von Freytag-Loringhoven, a bona fide eccentric who made (and sometimes wore) sculpture from junk. See Irene Gammel, *Baroness Elsa: Gender, Dada, and Everyday Modernity: A Cultural Biography* (Cambridge, MA: MIT Press, 2002), 222–27, and an earlier, briefer, study, Robert Reiss, " 'My Baroness': Elsa von Freytag-Loringhoven," in *New York Dada*, ed. Rudolf E. Kuenzli (New York: Willis Locker & Owens, 1986), 81–101. Duchamp's letter is quoted in Calvin Tomkins, *Duchamp: A Biography* (New York: Henry Holt, 1996), 184. Baroness Elsa's outrageous destabilizations of gender norms are explored in Amelia Jones, *Irrational Modernism: A Neurasthenic History of New York Dada* (Cambridge, MA: MIT Press, 2004).

2. William A. Camfield, *Marcel Duchamp*, "Fountain" introduction Walter Hopps (Houston: The Menil Collection and Houston Fine Arts Press, 1989), 88. My earliest ruminations on *Fountain* as a direct response to America's entry into World War I were enhanced by the following sources: Camfield's *Marcel Duchamp*, "Fountain," Wanda Corn, *The Great American Thing: Modern Art*

and National Identity, 1915–1935 (Berkeley: University of California Press, 1999), Francis M. Naumann, *New York Dada, 1915–1923* (New York: Harry N. Abrams, 1994), and Tomkins, *Duchamp: A Biography*. Also important for me were Jones, *Irrational Modernism*, which astutely regards *Fountain* in terms of the First World War (the only book I found that does so), and Jonathan Weinberg, "Urination and Its Discontents," in *Gay and Lesbian Studies in Art History*, ed. Whitney Davis (Binghamton, NY: Haworth Press, 1994), 225–43, an essay that takes seriously the social, sexual, and cultural politics of urination in art. A dated but still valuable compendium of essays on Duchamp is Rudolf E. Kuenzli and Francis M. Naumann, *Marcel Duchamp: Artist of the Century* (Cambridge, MA: MIT Press, 1990); it contains a condensed version of Camfield's above-cited volume on *Fountain* as William A. Camfield, "Marcel Duchamp's *Fountain*: Its History and Aesthetics in the Context of 1917," 64–94. I also wish to acknowledge here the very helpful reading that Jennifer L. Roberts gave an early draft of this chapter and our ensuing conversations about it.

3. Tomkins, *Duchamp*, 140.

4. "French Artists Spur on an American Art," *New York Herald Tribune* (October 24, 1915), section 4: 2–3, reprinted in Kuenzli, ed., *New York Dada*, 133.

5. Kuenzli, 133–34.

6. According to the *New York World* editor Frank Irving Cobb, who claimed to have privately interviewed Woodrow Wilson in the White House only hours before he asked Congress for a declaration of war, the president expressed concern about the civil liberties he knew he would have to breach: "Once lead this people into war and they'll forget there ever was such a thing as tolerance. To fight you must be ruthless and the spirit of ruthless brutality will enter the very fibre of our national life, infecting Congress, the courts, the policeman on the beat, the man in the street." As quoted in *Cobb of "The World": A Leader in Liberalism: Compiled from His Editorial Articles and Public Addresses*, ed. John L. Heaton (New York: Dutton, 1924), 270. Historians have questioned whether the interview actually took place as reported; see Arthur S. Link, "That Cobb Interview," *Journal of American History* 72 (June 1985), 7–17, and Thomas Fleming, *The Illusion of Victory: America in World War I* (New York: Basic Books, 2003), 6–8.

7. Jane Heap, "Notes," *The Little Review* 5(2) (June 1918), 62. Duchamp, a friend of Heap's, was not among the artists and writers included in this issue, but one of his rotary pieces was later (Spring 1925) featured on the cover of the magazine.

8. Gabrielle Buffet-Picabia, "Some Memories of Pre-Dada: Picabia and Duchamp" (1949), from Robert Motherwell, ed., *The Dada Painters and Poets: An Anthology* (New York: Wittenborn, Schultz, 1951), 258–59.

9. See Nell Kimball, *Her Life as an American Madam, by Herself*, ed. with introduction Stephen Longstreet (New York: Macmillan, 1970), 278–79; the "Martha" letter is quoted without source in John Ellis, *Eye-Deep in Hell: Trench Warfare in World War I* (New York: Pantheon, 1976), 152–153.

10. Buffet-Picabia, 260.

11. Colin Jones, *Paris: Biography of a City* (New York: Viking, 2005), 398–400. I consulted the following works, and several others, to learn about the role of the public toilet in Western history and modern life: William A. Cohen and Ryan Johnson, eds., *Filth: Dirt, Disgust, and Modern Life* (Minneapolis: University of Minnesota Press, 2005), Olga Gershenson and Barbara Penner, eds., *Ladies*

and Gents: Public Toilets and Gender (Philadelphia: Temple University Press, 2011), David Inglis, *A Sociological History of Excretory Experience: Defecatory Manners and Toiletry Technologies* (Lewiston, NY: Mellen, 2001), Dominique Laporte, *History of Shit* (1978), trans. Nadia Benabid and Rodolphe el-Khoury, with introduction el-Khoury (Cambridge, MA: MIT Press, 2000), Roy Palmer, *The Water Closet: A New History* (Newton Abbot, UK: David & Charles Publishers, 1973), Barbara Penner, *Bathrooms* (London: Reaktion, 2014), and Peter Stallybrass and Allon White, *The Politics and Poetics of Transgression* (Ithaca: Cornell University Press, 1986). The most recent, and very useful, collection of essays on the politics of peeing is Harvey Molotch and Laura Norén, eds., *Toilet: Public Restrooms and the Politics of Sharing* (New York: New York University Press, 2010).

12. Baron Haussmann as quoted in wall text for "Old Paris Album" section of the National Gallery of Art's Charles Marville exhibition, fall 2013; available online at http://www.nga.gov/content/ngaweb/features/marville/the-old-paris-album.html. See Sarah Kennel et al., *Charles Marville: Photographer of Paris*, exh. cat. (Washington, DC: National Gallery of Art, 2013).

13. Paul B. Franklin, "Object Choice: Marcel Duchamp's *Fountain* and the Art of Queer Art History," *Oxford Art Journal*, 23:1 (2000), 30–31. See George Chauncey, *Gay New York: Gender, Urban Culture, and the Making of the Gay Male World, 1890–1940* (New York: Basic Books, 1994), 195–201 on public washrooms—"tearooms"—as sites for homosexual encounters in late nineteenth and early twentieth century New York.

14. Floyd Dell, *Love in the Machine Age: A Psychological Study of the Transition from Patriarchal Society* (New York: Farrar & Rinehart, 1930), 83.

15. Havelock Ellis, *Studies in the Psychology of Sex*, vol. 3, book 1, *Erotic Symbolism* (New York: Random House, 1936), 59. Quoted in Weinberg, *Speaking for Vice*, 110. See also Havelock Ellis, *My Life* (Boston: Houghton Mifflin, 1939), 84.

16. Virginia Woolf to Lytton Strachey (April 23, 1918) and to Roger Fry (April 24, 1918), in *Letters*, vol. 2, 1912–1922, ed. Nigel Nicholson with assistant editor Joanne Trautmann (New York: Harcourt Brace Jovanovich, 1976), 234, as quoted in James Heffernan, "Woolf's Reading of Joyce's *Ulysses*, 1918–1920," The Modernism Lab at Yale: http://modernism.research.yale.edu/wiki/index.php/Woolf%27s_Reading_of_Joyce%27s_Ulysses,_1918–1920.

17. Helen Bishop Dennis, letter to the editors, *The Little Review* 7(1) (May–June 1920), 73–74.

18. As recalled in Beatrice Wood, *I Shock Myself: The Autobiography of Beatrice Wood* (1985), ed. Lindsay Smith (San Francisco: Chronicle Books, 2006), 29.

19. Ernest Hemingway, *A Farewell to Arms* (1929; New York: Scribner, 1957), 184–85.

20. Gertrude Stein, *Everybody's Autobiography* (1937; New York: Random House, 1971), 97.

21. Sometimes the implied invitation to piss in the pot has been taken literally. Legendary avant-garde rock producer Brian Eno claims in *A Year with Swollen Appendices: Brian Eno's Diary* (London: Faber and Faber, 1996), 325–26, that on receiving an invitation to speak at the Museum of Modern Art in 1990, he rigged up a hidden plastic tube that enabled him to deposit urine in the replica version of *Fountain* displayed behind glass without anyone knowing (he calls it an act of "re-commode-ification"). For this and other attempts by male

artists to interact urologically with Duchamp's readymade, see Paul Ingram, "Pissing in Duchamp's *Fountain*," *3:AM Magazine* (June 23, 2014): http://www.3ammagazine.com/3am/pissing-in-duchamps-fountain/#_edn2.

22. *Manneken Pis* calls to mind Simone de Beauvoir's discussion of peeing in the chapter on childhood in *The Second Sex* (1952) that famously begins "One is not born, but rather becomes, a woman." She considers the cultural benefits and self-confidence accruing to boys because they can urinate while standing: "To boys the urinary function seems like a free game, with the charm of all games that offer liberty of action.... The stream can be directed at will and to a considerable distance, which gives the boy a feeling of omnipotence.... Every stream of water in the air seems like a miracle, a defiance of gravity: To direct, to govern it, is to win a small victory over the laws of nature; and in any case the small boy finds here a daily amusement that is denied his sisters." Simone de Beauvoir, *The Second Sex*, trans. and ed. H. M. Parshley (New York: Vintage, 1974), 301; 308–309.

23. Cecilia Tichi, *Shifting Gears: Technology, Literature, Culture in Modernist America* (Chapel Hill: University of North Carolina Press, 1987), 57.

24. Joseph H. Ford, *Elements of Field Hygiene and Sanitation* (Philadelphia: P. Blakiston's Son, 1918), 3–4; 98.

25. P. M. Ashburn, *The Elements of Military Hygiene: Especially Arranged for Officers and Men of the Line*, 3rd ed. (Boston: Houghton Mifflin, 1920), 108; Frank R. Keefer, *A Text-Book of Elementary Military Hygiene and Sanitation*, 2nd. ed. (Philadelphia: W. B. Saunders, 1918), 187.

26. Robert H. Zieger, *America's Great War: World War I and the American Experience* (Lanham, MD: Rowman & Littlefield, 2000), 107, and Private Wilder Hopkins, quoted in Ronald Schaffer, *America in the Great War: The Rise of the War Welfare State* (New York: Oxford University Press, 1991), 155.

27. Erich Maria Remarque, *All Quiet on the Western Front* (1929), trans. Brian Murdoch (New York: Vintage, 1996), 5–6.

28. Remarque, 6.

29. Frank B. Tipton, *A History of Modern Germany since 1815* (Berkeley: University of California Press, 2003), 299.

30. Richard Cork, *A Bitter Truth: Avant-Garde Art and the Great War* (New Haven, CT: Yale University Press, in association with the Barbican Art Gallery, 1994), 106–107.

31. Alexander McClintock, *Best O'Luck: How a Fighting Kentuckian Won the Thanks of Britain's King* (New York: Grosset and Dunlap, 1917), 37–38; on McClintock's novel, see Pearl James, *The New Death: American Modernism and World War I* (Charlottesville: University of Virginia Press, 2013), 2–8.

32. With thanks to the Berlin-based art historian and curator Astrid Honold for pointing this out to me in personal correspondence, October 10, 2013.

33. F. T. Marinetti, "Manifesto of Futurism" (1909), in *Marinetti: Selected Writings*, ed. and trans. R. W. Flint (New York: Farrar, Straus and Giroux, 1972), 41–42. Principle 9 of the Manifesto declares: "We will glorify war—the world's only hygiene—militarism, patriotism, the destructive gesture of freedom-bringers, beautiful ideas worth dying for, and scorn for woman" (42).

34. See Camfield, *Marcel Duchamp, "Fountain,"* 35–36, and Naumann, *New York Dada*. Notable queer readings of *Fountain* include Weinberg,

Speaking for Vice, 205–12, and Franklin, "Object Choice," 23–50. See also Weinberg, *Male Desire: The Homoerotic in American Art* (New York: Harry N. Abrams, 2004), 37–47.

35. Paul Fussell, *The Great War and Modern Memory* (1975), new ed. with intro. Jay Winter (New York: Oxford University Press, 2013), starts with a discussion of "the ironic mode" (3–4) and declares "One reason the Great War was more ironic than any other is that its beginning was more innocent" (19–20).

36. James Francisco and Elizabeth Anne McCauley, *"The Steerage" and Alfred Stieglitz* (Berkeley: University of California Press, 2012), 62. Alex Nemerov brought this delicious fact to my attention.

37. See Penelope Niven, *Steichen: A Biography* (New York: Clarkson Potter, 1997), 405, and Richard Whalen, *Alfred Stieglitz: A Biography* (Boston: Little, Brown, 1995), 342.

38. Harriet Monroe, "What War May Do," *Poetry* 10 (June 1917), 142–45, quoted in Mark W. Van Wienen, *Rendezvous with Death: American Poems of the Great War* (Urbana: University of Illinois Press, 2002), 17.

39. See Edmund Gosse, "War and Literature," *Edinburgh Review* 220 (October 1914), 313, as quoted in Samuel Hynes, *A War Imagined: The First World War and English Culture* (New York: Atheneum, 1991), 12, and, more generally, Hynes, chapters 1 and 2, on the prowar fervor of British writers and artists. See also Roland N. Stromberg, *Redemption through War: the Intellectuals and 1914* (Lawrence: Regents Press of Kansas, 1982), and Robert Wohl, *The Generation of 1914* (Cambridge, MA: Harvard University Press, 1979), for wide-ranging discussions of intellectual support for the war as a moral astringent; Daniel Pick, *War Machine: The Rationalisation of Slaughter in the Modern Age* (New Haven, CT: Yale University Press, 1993), for nineteenth and early twentieth century European justifications for killing on an industrial scale; and Richard Slotkin, *Regeneration through Violence: the Mythology of the American Frontier, 1600–1860* (Middletown, CT: Wesleyan University Press, 1973), which traces the notion of redemption through violence to earlier periods in American history.

40. Helmut Friedel et al., eds., *Marcel Duchamp in Munich 1912* (Munich: Schirmer/Mosel, in cooperation with Lenbachhaus, 2012).

41. Marsden Hartley, *Somehow a Past: The Autobiography of Marsden Hartley*, ed. Susan Elizabeth Ryan (Cambridge, MA: MIT Press, 1997), 86. See Bruce Robertson, "Marsden Hartley and Gay Berlin," in Scholz, ed., *Marsden Hartley: the German Paintings* 140–47, and, for a more detailed account of the German capital's relative tolerance of homosexuality, Robert Beachy, *Gay Berlin: Birthplace of a Modern Identity* (New York: Knopf, 2014).

42. See Charles F. Stuckey, *Toulouse-Lautrec: Paintings* (Chicago: Art Institute of Chicago, 1979), 221; also Julia Frey, *Toulouse-Lautrec: A Life* (New York: Viking, 1994), 398, and Gabriel P. Weisberg, "The Urban Mirror: Contrasts in the Vision of Existence in the Modern City," in *Paris and the Countryside: Modern Life in Late-19th-Century France*, exhibition curated by Carrie Haslett (Portland, ME: Portland Museum of Art, 2006), 23.

43. Asta Nielsen as quoted in Adam Hochschild, *To End All Wars: A Story of Protest and Patriotism in the First World War* (London: Macmillan, 2011), 216; in turn from Thomas Levenson, *Einstein in Berlin* (New York: Bantam

Books, 2003), 143–44. Hartley's encomium of von Freyburg, quoted at greater length in Chapter 1, is from a letter to Stieglitz dated October 29, 1914; see James Timothy Voorhies, ed., *My Dear Stieglitz: Letters of Marsden Hartley and Alfred Stieglitz, 1912–1915* (Columbia: University of South Carolina Press, 2002), 166.

44. Roxana Robinson, *Georgia O'Keeffe: A Life* (New York: Harper & Row, 1989), 136.

45. For details, see Camfield, *Marcel Duchamp, "Fountain"* (as in n. 2).

46. When Arturo Schwarz, then 84, spoke with me at his home in Milan on December 6, 2010, he kindly described his endeavor to reproduce the lost readymades (*Fountain* was only one of several that had vanished). Duchamp's involvement in the project resulted in a lasting friendship between them. Schwarz's memories of the artist were precise and enthralling.

47. Sarah Greenough, *Alfred Stieglitz: The Key Set: The Alfred Stieglitz Collection of Photographs*, vol. 1, 1886–1922 (Washington, DC: National Gallery of Art, in conjunction with Harry N. Abrams, 2002), xxxiii.

48. Greenough, xxxiii.

49. The photograph, now in the collection of the Philadelphia Museum of Art, is reproduced in Camfield, *Marcel Duchamp, "Fountain,"* 21. Elena Filipovic regards Duchamp's living-space arrangement as a documented quasi-exhibit; see "A Museum That is Not," *e-flux* 4 (March 2009): http://www.e-flux.com/journal/a-museum-that-is-not/.

50. See Camfield, "Marcel Duchamp's *Fountain*," 68–69 and 88, n. 20, on Duchamp's reflections (from 1966) on the various puns involved in the signature. Kirk Varnedoe and Adam Gopnik, in *High & Low: Modern Art, Popular Culture* (New York: Harry N. Abrams and the Museum of Modern Art, 1991), 274–78, suggest that Duchamp did not actually acquire the urinal from Mott Ironworks: "We can count the drain holes, visible in the photographs of the original item, and their number and pattern do not match anything in the Mott line; so we are licensed to speculate that Duchamp bought from a lesser source (the holes match perfectly with those in the flat-back Bedfordshire of the A. Y. MacDonald Company) and illegitimately ennobled the object with the classier brand-name association" (276–77). On Duchamp's propensity for puns, see George H. Bauer, "Duchamp's Ubiquitous Puns," in Kuenzli and Naumann, *Marcel Duchamp: Artist of the Century*, 127–48. On the uniquely modern comic spirit of *Fountain* and other works by Duchamp, see Michael North, *Machine-Age Comedy* (New York: Oxford University Press, 2009), 96–110. Here I wish to thank Catherine Dossin and Till Richter for helping me consider the trilingual nature of Duchamp's punning at the moment America joined France in the war against Germany.

51. General Leonard Wood to Theodore Roosevelt, March 5, 1915, as quoted in David M. Kennedy, *Over Here: The First World War and American Society*, 25th anniversary ed. (New York: Oxford University Press, 2004), 161.

52. D. H. Lawrence, *Studies in Classic American Literature* 1923; New York: Viking Press, 1964), vii–viii. Adorno never actually made the famous aphorism attributed to him, at least not in such a lapidary formulation; it originally appeared in attenuated form in his essay "Cultural Criticism and Society"

(1947), reprinted in *Prisms* (1955), trans. Samuel and Shierry Weber (Cambridge, MA: MIT Press, 1981), 34. He made similar statements in *Notes to Literature* (1958) and *Negative Dialectics* (1966).

53. Olivier Razac, *Barbed Wire: A Political History*, trans. Jonathan Kneight (New York: New Press, 2002).

54. See Leah Dickerman et al., *Dada: Zurich, Berlin, Hannover, Cologne, New York, Paris* (Washington, DC: National Gallery of Art, in association with D.A.P./Distributed Art Publishers, 2006), 363; also, the website "MoMA Learning," entry for *Fresh Widow*: http://www.moma.org/learn/moma_learning/marcel-duchamp-fresh-widow-1920. The French art historian Béatrice Joyeux-Prunel analyzes the military correlations of the *Large Glass* in chapter 14 of *Les avant-gardes artistiques. Une histoire transnationale. vol. 1, 1848–1918* (Paris: Gallimard, 2016). My thanks to Professor Joyeux-Prunel for sharing her text with me. And thanks again to Astrid Honold, as in n. 32, for our email conversations about Duchamp and matters military. On that subject, see Kieran Lyons, "Fat and Failure: Marcel Duchamp's Military Imagination," *Technoetic Arts: A Journal of Speculative Research* 7(1) (2009), 31–48.

55. Lawrence, *Studies*, 2.

56. Duchamp to Jean Crotti, July 8, 1918, Archives of American Art; quoted in Tomkins, 206.

57. *Lafayette! We Come!* (1918; aka *La Princesse voilée*), directed by Léonce Perret, has been lost. The artist played one of a group of blinded soldiers being read to by the film's female star. See Tomkins, 206, and the cast and credit information on IMDb.com.

58. The building they mutually occupied, 33 West 67th Street, entered the National Register of Historic Places in 1985.

59. Max Ernst, quoted in Fabio Gygi, "Shattered Experiences—Recycled Relics: Strategies of Representation and the Legacy of the Great War," in *Matters of Conflict: Material Culture, Memory and the First World War*, ed. Nicholas J. Saunders (New York: Routledge, 2004), 81. Hans Richter used a different metaphor to convey the essential ephemerality of the anti-art moment that he had shared with his contemporaries: "Dada was not an artistic movement in the accepted sense; it was a storm that broke over the world of art as the war did over the nations. It came without warning, out of a heavy, brooding sky." Richter, *Dada: Art and Anti-Art*, trans. David Britt (New York: Harry N. Abrams, 1965), 9.

Chapter 6 "To See or Not to See"

1. Pearl James, *The New Death: American Modernism and World War I* (Charlottesville: University of Virginia Press, 2013), 5. See also, for example, Evelyn Cobley, *Representing War* (Toronto: University of Toronto Press, 1993), James Dawes, *The Language of War: Literature and Culture in the U.S. from the Civil War through World War II* (Cambridge, MA: Harvard University Press, 2002), and Samuel Hynes, *The Soldiers' Tale: Bearing Witness to Modern War* (New York: Penguin, 1997). Paul Fussell, *The Great War and Modern Memory* (New York: Oxford University Press, 1975), is the classic text on the perceived inadequacy of language to represent modern

industrialized warfare. Allyson Booth, *Postcards from the Trenches: Negotiating the Space between Modernism and the First World War* (New York: Oxford University Press, 1996), also surveys the intersection of modern warfare and modernist literature, a topic taken up in recent years by numerous literary scholars but, in the art realm, relatively few art historians.

2. Stéphane Audoin-Rouzeau and Annette Becker, *14–18: Understanding the Great War*, trans. Catherine Temerson (New York: Hill and Wang, 2002), 26. George Bernard Shaw (March, 1917), quoted in Roland N. Stromberg, *Redemption by War: The Intellectuals and 1914* (Lawrence: The Regents Press of Kansas, 1982), 152.

3. Beatrice Wood, *I Shock Myself: The Autobiography of Beatrice Wood*, ed. Lindsay Smith (1985; San Francisco: Chronicle Books, 2006), 29–30; William A. Camfield, *Marcel Duchamp, "Fountain"*, introduction Walter Hopps (Houston: The Menil Collection and Houston Fine Arts Press, 1989), 24–26. Wood's diary, quoted in Camfield, 24, suggests that the encounter between Bellows and Arensberg took place on Saturday, April 7. James Cameron based Rose Bukater, the central female character of his 1997 blockbuster *Titanic*, on Beatrice Wood; for details, including her romantic involvement with Duchamp, see David M. Lubin, *Titanic* (London: British Film Institute, 1997).

4. Charles Brock, "George Bellows: An Unfinished Life," in Brock et al., *George Bellows*, exh. cat. (Washington: National Gallery of Art, 2012), 15.

5. The impromptu "Arch Conspirators" party is described—and Sloan's etching of it reproduced—in Heather Campbell Coyle and Joyce K. Schiller, *John Sloan's New York*, exh. cat. (Wilmington: Delaware Art Museum in association with Yale University Press, 2007), 67. See Van Wyck Brooks, *John Sloan: A Painter's Life* (New York: Dutton, 1955), 199; see also Erik Peter Axelson, "The Free and Independent Republic of Washington Square (Part II), *Daily Plant* 22 (4388) (January 24, 2007), and (although the year of the incident is incorrectly noted) Luc Sante, *Low Life: Lures and Snares of Old New York* (New York: Vintage, 1992), 336. Man Ray's recollection of Bellows is in Man Ray, *Self-Portrait* (Boston: Little, Brown, 1963), 70.

6. Mahonri Sharp Young, *The Paintings of George Bellows* (New York: Watson-Guptill, 1973), 15.

7. Bellows, as quoted in Charles Hill Morgan, *George Bellows: Painter of America* (New York: Reynal, 1965), 77. On Bellows, boxing, and early twentieth century codes of masculinity, see E. A. Carmean, Jr., John Wilmerding, Linda Ayers, and Deborah Chotner, *Bellows: The Boxing Pictures* (Washington, DC: National Gallery of Art, 1982), Marianne Doezema, *George Bellows and Urban America* (New Haven, CT: Yale University Press, 1992), 66–121, Robert Haywood, "George Bellows's *Stag at Sharkey's*: Boxing, Violence and Male Identity," *Smithsonian Studies in American Art* 2, no. 2 (Spring 1988): 2–15, and David Peters Corbett, "Life in the Ring: Boxing, 1907–1909," in Brock et al., *George Bellows*, 71–79.

8. On the excavation paintings, see Sarah Newman, "Working Life: Pennsylvania Station Excavation, 1907-1909," in Brock et al., *George Bellows*, 87–95, and Doezema, *George Bellows and Urban America*, 8–65.

9. *Report of the Committee on Alleged German Outrages* (the "Bryce Report") (New York: Macmillan, 1915); *New York Times* (May 13, 1915). For modern

assessments of the German occupation, see John Horne and Alan Kramer, *German Atrocities, 1914: A History of Denial* (New Haven, CT: Yale University Press, 2001), Jeff Lipkes, *Rehearsals: The German Army in Belgium, August 1914* (Leuven: Leuven University Press, 2007), and Larry Zuckerman, *The Rape of Belgium: The Untold Story of World War I* (New York: NYU Press, 2004).

10. Bryce Report, 10. Quotations in the following paragraphs are from 52 and 26.
11. In a memorial tribute to Bellows after his premature death, a friend recalled him having said to his critic, Joseph Pennell: "No, I was not present at the murder of Edith Cavell: neither, so far as I have been able to learn, was Leonardo present at the Last Supper." Joseph Russell Taylor, "On the Death of George Bellows," *Ohio State University Monthly* (February 1925), as quoted in Mary Sayre Haverstock, *George Bellows: An Artist in Action* (New York: Merrell in association with the Columbus Museum of Art, 2007), 152. An earlier description of the encounter, "When Lithographers Differ," appearing on page one of *American Art News* 18, no. 20 (March 6, 1920), offers a different version of Bellows's witticism: "I didn't have a ticket to that affair—neither did Rembrandt to the Crucifixion." Thanks to Charlie Brock, National Gallery of Art, Washington, DC, for helping me trace the origins of the quip.
12. Susan Sontag, *Regarding the Pain of Others* (New York: Farrar, Straus and Giroux, 2003), 42–43; 44; 47. Ernest Hemingway, introduction to *Men at War: The Best War Stories of All Time*, ed. Hemingway (New York: Crown, 1942), xiv.
13. Sontag, *Regarding the Pain*, 104–13, reconsiders the claims she put forward in *On Photography* (New York: Farrar, Straus and Giroux, 1977) that atrocity images serve to desensitize and pacify a public already gorged on them.
14. Susan Sontag, acceptance speech for Jerusalem Prize for Literature, May 9, 2001, as reprinted in Sontag, *At the Same Time: Essays and Speeches*, ed. Paolo Dilonardo and Anne Jump (New York: Farrar, Straus and Giroux, 2007), 151.
15. Thanks to Paul Manoguerra, who was then the curator of American art at the Georgia Museum of Art, for spending a Sunday afternoon with me in August 2006 at his exhibition, "Let Loose Upon Innocence: George Bellows and World War," where we discussed at length the Bellows war lithographs and paintings he had assembled. For more on Bellows and the First World War, see Charlene Engel, "The Man in the Middle: George Bellows, War, and 'Sergeant' Delaney," *American Art* 18(1) (Spring 2004), 78–87; Lauris Mason and Joan Ludman, *The Lithographs of George Bellows: A Catalogue Raisonné* (rev. ed., San Francisco: Alan Wofsy Fine Arts, 1992); Glenn C. Peck, *With My Profound Reverence for the Victims: George Bellows*, exh. cat. (New Paltz: Samuel Dorsky Museum of Art at the State University of New York, 2001); Peck and Gordon K. Allison, *George Bellows and the War Series of 1918* (New York and Springfield, Mass.: Hirschl & Adler Galleries and the Museum of Fine Arts, Springfield, 1983); Carol Troyen "War, 1918," in Brock et al., *George Bellows*, 255–273; and Krystyna Wasserman, "George Wesley Bellows' War Lithographs and Paintings of 1918" (unpublished MA thesis, University of Maryland, 1981).
16. Arthur Ponsonby, *Falsehood in War-Time: Containing an Assortment of Lies Circulated throughout the Nations during the Great War* (New York: E. P.

Dutton, 1928), 11; 19; Pablo Picasso, *Picasso on Art: A Selection of Views*, ed. Dore Ashton (New York: Viking, 1972), 21 (original from Marius De Zayas, "Picasso Speaks," *The Arts* 3 (May 1923), 315–26, as quoted in Alfred Barr, *Picasso: Fifty Years of His Art* (New York: Museum of Modern Art, 1974). Ponsonby's "first casualty" aphorism is often attributed to United States Senator Hiram Johnson, an isolationist who declared in 1917, "The first casualty when war comes is truth"; similar phrasing has been attributed to a lost fragment by the ancient Greek playwright Aeschylus, who allegedly wrote: "In war, truth is the first casualty."

17. Evan Edward Charteris, *John Sargent* (1927; New York: Benjamin Blom, 1972), 215; with Sargent's letter to him of September 11, 1918, quoted on 214.

18. Martin Jay, *Downcast Eyes: The Denigration of Vision in Twentieth-Century French Thought* (Berkeley: University of California Press, 1993), 212–13.

19. See Peter Sloterdijk, "Gas Warfare—or: The Atmoterrorist Model," in *Terror from the Air*, trans. Amy Patton and Steve Corcoran (New York: Semiotext(e), 2009), 9–46; quotations from 14; 18.

20. Wilfred Owen, "*Dulce et Decorum Est*" (1917–18), in *Collected Poems*, ed. C. Day Lewis with memoir by Edmund Blunden (New York: New Directions, 1964), 55.

21. On Sargent's religious murals for the Boston Public Library as well as his World War I murals for Harvard's Widener Memorial Library and their relation to *Gassed*, see Sally M. Promey, *Painting Religion in Public: John Singer Sargent's "Triumph of Religion" at the Boston Public Library* (Princeton, NJ: Princeton University Press, 1999).

22. Vera Brittain, *Testament of Youth: An Autobiographical Study of the Years 1900–1925* (New York: Macmillan, 1933), 395.

23. After the Second World War, the painting was rechristened *General Officers of World War I*.

24. The jibe was made by David Piper, Director of London's National Portrait Gallery from 1964–1967. Paul Cox, Associate Curator at the Gallery, tracked down this irreverent comment for me via John Cooper, the Gallery's former Education Officer, who heard it directly from Piper.

25. For a thorough breakdown of the film, see Alexander Walker, *Stanley Kubrick, Director*, with Visual Analysis by Sybil Taylor and Ulrich Rucherti (New York: Norton, 2000), 66–113.

26. With thanks to my seminar student Meagan Rosenberg for helping me hone this comparison.

27. John Thomas, "*Gassed* and Its Detractors: Interpreting Sargent's Major War Painting," *Imperial War Museum Review* 9 (November 1994), 42–50, quotation on 47.

28. The decentralized nature of *Gassed* calls to mind Gertrude Stein's remark, quoted in Chapter 1, that the Great War "was not a composition in which there was one man in the centre surrounded by a lot of other men but a composition that had neither a beginning nor an end" (see page 14). Gertrude Stein, *Picasso* (1938), in *Gertrude Stein on Picasso* (New York: Liveright, 1970), 18–19.

29. Many thanks to my colleague John J. Curley, a specialist in late twentieth and early twenty-first century painting and sculpture, for helping me to see how *Gassed* anticipates a modernist aesthetic.

30. Virginia Woolf, "The Royal Academy," in *Essays of Virginia Woolf, Volume 3: 1919–1924*, ed. Andrew McNeillie (San Diego: Harcourt Brace Jovanovich, 1986), 92–93.

31. Santanu Das, *Touch and Intimacy in First World War Literature* (New York: Cambridge University Press, 2005), 1.

32. Richard Schickel, *D. W. Griffith: An American Life* (New York: Simon and Schuster, 1984), 345.

33. Lillian Gish, in *The Movies, Mr. Griffith, and Me* (Englewood Cliffs, NJ: Prentice-Hall, 1969), 191, recalls Griffith exclaiming, "That fellow Churchill! Just as the talk becomes interesting, he gets me in a corner and starts telling me a story that he wants to sell me.... They're all right but no better than mine."

34. Kevin Brownlow, *The War, the West, and the Wilderness* (New York: Knopf, 1979), 144.

35. Gish, 200.

36. On the surreptitiously purchased footage, see Russell Merritt, "D. W. Griffith Directs the Great War: The Making of *Hearts of the World*," *Quarterly Review of Film Studies* 6(1) (1981), 45–65, and Schickel, 349–53.

37. Brownlow, 148–49.

38. Fernand Léger quoted in Fabio Gygi, "Shattered Experiences—Recycled Relics: Strategies of Representation and the Legacy of the Great War," in Nicholas Saunders, ed., *Matters of Conflict: Material Culture, Memory, and the First World War* (New York: Routledge, 2004), 75.

39. Vidor in *Esquire*, May 1935, quoted in Brownlow, 186.

40. Guy Westwell, *War Cinema: Hollywood on the Front Line* (London: Wallflower, 2006), 23. Westwell is quoting in turn from Bernd Hüppauf, "Modernism and the Photographic Representation of War and Destruction," in Leslie Devereaux and Roger Hillman, eds., *Fields of Vision: Essays in Film Studies, Visual Anthropology, and Photography* (Berkeley: University of California Press, 1995), 94–124 (quotations on 101). See also Hüppauf, "Experience of Modern Warfare and the Crisis of Representation," *New German Critique* 59, special issue on Ernst Jünger (Spring–Summer 1993), 51. For more recent studies of war as photographic spectacle, see Wendy Kozol, *Distant Wars Visible: The Ambivalence of Witnessing* (Minneapolis: University of Minnesota Press, 2014), Jan Mieszkowski, *Watching War* (Stanford, CA: Stanford University Press, 2012), and Barbie Zelizer, *About to Die: How News Images Move the Public* (New York: Oxford University Press, 2010). The gnomic French information theorist Paul Virilio has made many provocative forays into this topic; see, for example, *War and Cinema: The Logistics of Perception* (New York: Verso, 1989) and *The Information Bomb* (New York: Verso, 2000).

41. Edward Steichen, *A Life in Photography*, chapter 5, "World War and Voulangis," n.p.; first page after plate 62.

42. Steichen, second page after plate 62.

43. Steichen, fourth page after plate 62. On Steichen's WWI military career, see Von Hardesty, "The 'Lost Years' of Edward Steichen, 1914–1919," *Historically Speaking* 14(4) (September 2013), 20–23. For a compendium of WWI aerial reconnaissance photographs from numerous archives, see Birger Stichelbaut and Piet Chielens, *The Great War Seen from the Air: In Flanders Fields, 1914–1918* (New Haven, CT: Yale University Press in cooperation with Mercatorfonds; In Flanders Fields Museum, Ypres; Imperial War Museums, United Kingdom; and Royal Museum of the Armed Forces and of Military History, Brussels, 2013). For Steichen's career as a commercial photographer, see Patricia Johnston, *Real Fantasies: Edward Steichen's Advertising Photography* (Berkeley: University of California Press, 1997).

44. Hannah Arendt, *The Human Condition* (Garden City, NY: Doubleday Anchor, 1959), 228. Allan Sekula regards Steichen's aerial photography along these lines in "Transforming Images: Steichen at War," *Artforum* 14 (December 1975), 26–35, reprinted as "The Instrumental Image: Steichen at War," in Sekula, *Photography Against the Grain* (Halifax: Nova Scotia Press, 1989), 32–51.

45. Although Steichen did not make his aerial reconnaissance photographs for art-gallery display, and they were not seen in that context until long after the war had ended, they constitute early waypoints on a politicized aesthetic of "machine-vision" military photography that eventuated in the 1960s cinema of Stanley Kubrick (*Dr. Strangelove* [1964] and *2001: A Space Odyssey* [1968]), the materialist filmmaking of Michael Snow (*Wavelength* [1967]), and the art videos of German filmmaker and installation artist Harun Farocki, as in, for example, *Eye/Machine* (2001), a video series that combines "smart bomb" footage from the 1991 Gulf War, taken from cameras mounted in the warheads of missiles approaching enemy targets, with repetitive and human-presence-devoid footage of high-tech industrial machinery at work.

46. Penelope Niven, *Steichen: A Biography* (New York: Clarkson Potter, 1997), 461. On camouflage and war, see Hanna Rose Shell, *Hide and Seek: Camouflage, Photography, and the Media of Reconnaissance* (New York: Zone Books, 2012). The literature on camouflage is extensive, but a good place to start, with regard to the themes of this chapter, is Alexander Nemerov, "Vanishing Americans: Abbott Thayer, Theodore Roosevelt and the Attraction of Camouflage," *American Art* 11(2) (Summer 1997), 50–81. See also Elizabeth Louise Kahn, *The Neglected Majority*: "*Les Camoufleurs,*" *Art History, and World War I* (Lanham, MD: University Press of America, 1984).

47. Niven, 461.

48. Steichen, fourth page after plate 62.

49. Edward Steichen, *The Family of Man* (New York: Museum of Modern Art, 1955). Classic criticisms of *The Family of Man* include Roland Barthes, "The Great Family of Man," in *Mythologies* (1957), trans. Annette Lavers (New York: Hill and Wang, 1972), 100–102, John Berger, *About Looking* (New York: Pantheon Books, 1980), and Allan Sekula, "The Traffic in Photographs," *Art Journal* 41(1) (1981), 15–21. Gerd Hurm deconstructs Barthes's politicized reading of the exhibition in "Why Barthes Was Wrong: Reassessing the Early Reception of *The Family of Man,*" in *"The Family of Man" Revisited: Photography in a Global Age*, Gerd Hurm, Anke Reitz, and Shamoon Zamir, eds. (London: I. B. Tauris, forthcoming 2017). See also Monique Berlier, "*The Family of Man*: Readings of an Exhibition," in *Picturing the Past: Media, History, and Photography*, ed. Bonnie Brennan and Hanno Hardt (Urbana: University of Illinois Press, 1999), 206–41, and Jean Back and Viktoria Schmidt-Linsenhoff, eds., *"The Family of Man," 1955–2001: Humanism and Postmodernism; A Reappraisal of the Photo Exhibition by Edward Steichen*, bilingual ed. (Marburg: Jonas Verlag, 2004). For a nuanced discussion of the political and cultural context in which the show appeared, see Eric J. Sandeen, *Picturing an Exhibition: "The Family of Man" and 1950s America* (Albuquerque: University of New Mexico Press, 1995). More recent interpretations of the exhibition include Blake Stimson, *The Pivot of the World: Photography and Its Nation* (Cambridge, MA: MIT Press, 2006), and Fred

Turner, *The Democratic Surround: Multimedia and American Liberalism from World War II to the Psychedelic Sixties* (Chicago: University of Chicago Press, 2013), 181–212.

50. Judith Butler, "Precarious Life," in *Precarious Life: The Powers of Mourning and Violence* (London: Verso, 2004), 128–51 (quotation from 145).

Chapter 7 "Being There"

1. Willa Cather, *One of Ours* (New York: Knopf, 1922); *New York Times*, "Topics of the Times" (May 15, 1923), 18; see John Hohenberg, *The Pulitzer Prizes: A History of the Awards in Books, Drama, Music, and Journalism, Based on the Private Files over Six Decades* (New York: Columbia University Press, 1974), 61.

2. Ernest Hemingway to Edmund Wilson, November 25, 1923, *Ernest Hemingway: Selected Letters, 1917–1961*, ed. Carlos Baker (New York: Scribner, 1981), 105; see Steven Trout, "Antithetical Icons? Willa Cather, Ernest Hemingway, and the First World War," *Cather Studies 7: Willa Cather as Cultural Icon*, ed. Guy Reynolds (Lincoln: University of Nebraska Press, 2007), 269–87, and Trout, *Memorial Fictions: Willa Cather and the First World War* (Lincoln: University of Nebraska Press, 2002).

3. H. L. Mencken, "Portrait of an American Citizen," *The Smart Set* 69(2) (October 1922), 140–41, a review of Willa Cather's *One of Ours* (1922), as reprinted in *H. L. Mencken on American Literature*, ed. S. T. Joshi (Athens: Ohio University Press, 2002), 79.

4. Henry James, "The Art of Fiction" (1888), in *Selected Fiction*, ed. Leon Edel (New York: Dutton, 1953), 595; 594. Even though Hemingway seems counter to Henry James in practically every way, he considered adding as an epigraph to *A Farewell to Arms* James's remark that language becomes "used up" and depreciated during wartime—a core theme of Hemingway's novel. James made the remark to the *New York Times* (March 21, 1915, 5:3–4) in an interview in which he urged young Americans to volunteer for ambulance service, which Hemingway did in fact do as soon as he came of age. See Peter Buitenhuis, *The Great War of Words: British, American, and Canadian Propaganda and Fiction, 1914–1933* (Vancouver: University of British Columbia Press, 1987), 61, and Michael S. Reynolds, *Hemingway's First War: the Making of "A Farewell to Arms"* (Princeton, NJ: Princeton University Press, 1976), 60–61.

5. Reynolds, *Hemingway's First War*, 15.

6. On the privileging of the combat veteran's view of warfare, see Jay Winter, "Introduction: Henri Barbusse and the Birth of the Moral Witness," in Barbusse, *Under Fire*, trans. Robin Buss (1916; New York: Penguin, 2003), vii–xxii, and the essay he cites, Joan Scott, "The Evidence of Experience," *Critical Inquiry* 17 (Summer 1991), 780ff. On the gender implications of this privileging, see Trudi Tate, *Modernism, History and the First World War* (New York: Manchester University Press, 1998), and Margaret R. Higonnet, "Authenticity and Art in Trauma Narratives of World War I," *Modernism/Modernity* 9 (2002), 91–107, as well as Higonnet's *Lines of Fire: Women Writers of World War I* (New Haven, CT: Yale University Press, 1987) and Higonnet, Jane Jenson, Sonya Michel, and Margaret Collins Weitz, eds., *Behind the Lines: Gender and the Two World Wars* (New Haven, CT: Yale University Press, 1987).

7. Pershing quoted in H. Avery Chenoweth, *Art of War: Eyewitness U. S. Combat Art from the Revolution through the Twentieth Century* (New York: Friedman/Fairfax, distributed by Sterling Publishing, 2002), 103. The other AEF artists, besides Harvey Thomas Dunn, were William James Aylward, Walter Jack Duncan, George Matthews Harding, Wallace Morgan, Ernest Clifford Peixotto, J. Andre Smith, and Harry Everett Townsend.

8. Harvey Dunn as quoted in Robert Karolevitz, *Where Your Heart Is: The Story of Harvey Dunn, Artist* (Aberdeen, SD: North Plains Press, 1975), 53. My other chief sources of information about Dunn are Chenoweth, *Art of War*, Alfred Emile Cornebise, *Art from the Trenches: America's Uniformed Artists in World War I* (College Station, TX: Texas A & M University Press, 1991), Peter Krass, *Portrait of War: The U.S. Army's First Combat Artists and the Doughboys' Experience in WWI* (Hoboken, NJ: John Wiley, 2007), Kevin Louis Nibbe, "The Greatest Opportunity: American Artists and the Great War, 1917–1920," PhD dissertation, University of Texas at Austin, 2000, and Steven Trout, *On the Battlefield of Memory: the First World War and American Remembrance, 1919–1941* (Tuscaloosa: University of Alabama Press, 2010), 157–75.

9. Chenoweth, *Art of War*, 102.

10. Nibbe, "The Greatest Opportunity," 235; Townsend quotation on 237, as drawn from Harry Everett Townsend, *War Diary of a Combat Artist*, ed. Alfred Emile Cornebise (Niwot, CO: University Press of Colorado, 1991), 137.

11. Trout, *On the Battlefield of Memory*, 167; 164.

12. Elaine Scarry, *The Body in Pain: The Making and Unmaking of the World* (New York: Oxford University Press, 1985), 122; see also 118–19.

13. Richard Seelye Jones, *A History of the American Legion* (Indianapolis, IN: Bobbs-Merrill, 1946), 344, supplies the number of dues-paying American Legion members for each year throughout the 1920s and 1930s. The following sampling (rounded off to the nearest thousand) shows the waxing and waning of membership during these decades: 1920 (843,000); 1925 (609,000); 1929 (794,000); 1931 (1,054,000); 1933 (770,000), 1938 (975,000), 1939 (1,033,000).

14. On the use of stag films for male bonding at members-only clubs such as the American Legion, see Dave Thompson, *Black and White and Blue: Adult Cinema from the Victorian Age to the VCR* (Toronto: ECW Press, 2007), 55. On the movies they might have screened, see Al Di Lauro and Gerald Rabkin, *Dirty Movies: An Illustrated History of the Stag Film, 1915–1970*, with introductory essay by Kenneth Tynan (New York: Chelsea House, 1976), and on stag films and film theory, Linda Williams, *Hard Core: Power, Pleasure, and the "Frenzy of the Visible"* (Berkeley: University of California Press, 1989). Stag films from the post-WWI period are viewable on request at the Kinsey Institute for Research in Sex, Gender, and Reproduction at Indiana University, Bloomington.

15. I am indebted to Trout, *On the Battlefield of Memory*, 170, for this comparison.

16. Tom Lea, "Battle Fatigue," *Life* 18(34) (June 11, 1945), 65. A generation later, the British photojournalist Don McCullin provided a similar portrait of inner desolation with his now-iconic photograph *A Shell-Shocked U.S. Marine after the Battle in Hue* (1968), or, as it is more commonly known, *Shell-Shocked Soldier*.

17. See Ann Murray, "A War of Images: Otto Dix and the Myth of the War Experience," *Aigne* 5(6) (2014); also Paul Fox, "Confronting Postwar Shame in Weimar Germany: Trauma, Heroism and the War Art of Otto Dix," *Oxford Art Journal* 29(2) (2006), and Annette Becker, with Philippe Dagen, *Otto Dix: The War/Der Krieg* (Milan: 5 Continents, 2004).

18. From *Otto Dix Speaks about Art, Religion, War*, posthumously released 1976 sound recording by the Erker Gallery in St. Gallen, Switzerland, as presented in the Getty Research Institution's 2014 exhibition *World War I: War of Images, Images of War*. Trans. by co-curator Anja Foerschner. Audiofile at http://www.getty.edu/research/exhibitions_events/exhibitions/ww1/index .html. See also Philipp Gutbrod, *Otto Dix: The Art of Life* (Ostfildern, Germany: Hatje Cantz, 2010), 33–34.

19. The best source of information on Claggett Wilson and display of his works is the website maintained by his relative Claggett Wilson Read: www.claggettwilson.com. See also Michael Barton, "WAR ART: Claggett Wilson," from *Stand To! The Journal of the Western Front Association* 85 (April/May 2009), 16–20, and Kevin Nibbe's excellent insights in "The Greatest Opportunity," 308–30. Nicole D. Eaton, a graduate student at the University of Missouri–Columbia, is currently conducting dissertation research on Wilson, and I thank her for her insights as well. The disappearance of the original war portfolio during Wilson's transit home from Germany is noted in Helen C. Candee, "Claggett Wilson as a War Painter," *The Spur* 25 (3) (February 1, 1920), 37, and Harriet Hungerford, "The War Scenes of Claggett Wilson," *Art and Archaeology* 9(5) (May 1920), 240.

20. Claggett Wilson to Arthur Wesley Dow, from "Somewhere in France, March 15, 1918," as printed in "Alumni Activities: Teachers College in War Service," *Teachers College Record* 19 (1918), 408–9.

21. Ernest Hemingway, *In Our Time* (1925; New York: Scribner, 2003), 29.

22. Ernest Hemingway, *A Farewell to Arms* (1929; New York: Scribner, 1957), 185.

23. Henry McBride in *The War Paintings of Claggett Wilson, with Appreciations by Alexander Woollcott and Henry McBride* (New York: J. H. Sears, 1928), n.p.

24. King Vidor, *A Tree is a Tree: An Autobiography* (New York: Harcourt, Brace, 1953), 116.

25. Laurence Stallings, *Plumes* (1924), new introduction George Garrett, new afterward Steven Trout (Columbia: University of South Carolina Press, 2006), 348.

26. Maxwell Anderson and Laurence Stallings, Note to *What Price Glory* in *Three American Plays* (New York: Harcourt, Brace, 1926), 3. In this original publication of the play, as well as the 1926 film version, no question mark is appended to the title.

27. Review of *What Price Glory* in *The Woman Citizen*, n.d., 11, quoted in Leslie Midkiff DeBauche, *Reel Patriotism: The Movies and World War I* (Madison: University of Wisconsin Press, 1997), 173.

28. Anderson and Stallings, *What Price Glory*, 63–64.

29. Thomas Boyd, *Through the Wheat* (1923), new introduction Edwin Howard Simons (Lincoln: University of Nebraska Press, 2000), 131; 132.

30. Boyd, 132 and 252; Alexander Woollcott in *War Paintings of Claggett Wilson*, n.p.

31. Boyd, 265–66.

32. McBride's appreciation, n.p.

33. Gilbert Seldes was one of the first cultural critics to take comic strips seriously; see *The Seven Lively Arts* (1924; rpt. New York: A. S. Barnes, 1957), "The 'Vulgar' Comic Strip," 193–205, and "The Krazy Kat That Walks By Himself," 207–19. For a good, art-focused introduction to early American comic strips, see John Carlin, Paul Karaski, and Brian Walker, eds., *Masters of American Comics* (Los Angeles: Hammer Museum and the Museum of Contemporary Art, in association with Yale University Press, 2005). See also Randy Duncan and Matthew J. Smith, *The Power of Comics: History, Form, and Culture* (New York: Continuum, 2009), Gerard Jones, *Men of Tomorrow: Geeks, Gangsters, and the Birth of the Comic Book* (New York: Basic Books, 2004), and Scott McCloud, *Understanding Comics: The Invisible Art* (New York: HarperCollins, 1993).

34. Douglas MacArthur, *Reminiscences* (New York: McGraw-Hill, 1964), 58. On the cultural, political, and military history of barbed wire, see Alan Krell, *The Devil's Rope: A Cultural History of Barbed Wire* (London: Reaktion Press, 2002), Reviel Netz, *Barbed Wire: An Ecology of Modernity* (Middletown, CT: Wesleyan University Press, 2004), and Olivier Razac, *Barbed Wire: A Political History*, trans. Jonathan Kneight (New York: New Press, 2002).

35. James Dickey, keepsake for the Joseph M. Bruccoli Great War Collection, Aiderman Library, University of Virginia, 11 November 1993–28 February 1994 (1993), as quoted in Mary Habeck and H. B. McCartney, "Trench Warfare: Did Trench Warfare Lead to Pointless Slaughter?" *History in Dispute*, ed. Dennis Showalter, vol. 9: *World War I: Second Series* (Detroit: St. James Press, 2002), 230–36. *World History in Context*. Web. June 30, 2014.

36. Nicole D. Eaton, the PhD candidate mentioned in n. 19, has generously shared with me some of her dissertation-related findings on Wilson's sexual orientation and his interest in homoerotic imagery and literature.

37. On Brangwyn's poster, see Ruth Walton, "Four in Focus," in *The Power of the Poster*, ed. Margaret Timmers (London: V & A Publications, 1998), 146–53.

38. "Dollar and Scents," *Time* 12(17) (October 22, 1928), 35–36.

39. "Shell-Hole Stuff," *Survey Graphic* 24(3) (March 1935), 36. Quoted in Nibbe, "Greatest Opportunity," 330.

40. On Whitney's life and art, see B. H. Friedman, with the research collaboration of Flora Miller Irving, *Gertrude Vanderbilt Whitney* (Garden City, NY: Doubleday, 1978), and Janis Conner and Joel Rosenkranz, *Rediscoveries in American Sculpture: Studio Works, 1893–1939* (Austin: University of Texas Press, 1989), 169–76. For a detailed account of Whitney's role in the formation of the art museum named for her, as well in the New York art world of the early twentieth century, see Avis Berman, *Rebels on Eighth Street: Juliana Force and the Whitney Museum of American Art* (New York: Atheneum, 1990).

41. Whitney's statue for the *Titanic* memorial, a tall male figure with arms stretched wide to embrace the wind, may have been the inspiration for Leonardo DiCaprio's "King of the World" moment in James Cameron's 1997 blockbuster film *Titanic*.

42. Guy Pène du Bois, "Mrs. Whitney's Journey in Art," *International Studio* 76 (January 1923), 352, as quoted in Conner and Rosenkranz, *Rediscoveries in American Sculpture*, 169.

43. Rodin quoted in Friedman, 465.

44. Gertrude Vanderbilt Whitney papers, box 16, folder 24, Juilly files, in the Archives of American Art, Smithsonian Institution, Washington, D.C. Quoted in part in Friedman, 349.

45. On Quentin Roosevelt as "America's boy-knight," see Linda Robertson, *The Dream of Civilized Warfare: World War I Flying Aces and the American Imagination* (Minneapolis: University of Minnesota Press, 2003), 350–56. His romantic relationship with Flora Payne Whitney is described in Thomas Fleming, *The Illusion of Victory: America in World War I* (New York: Basic Books, 2003), and Edward Renehan, *The Lion's Pride: Theodore Roosevelt and His Family in Peace and War* (New York: Oxford University Press, 1998). See also Quentin Roosevelt, *Quentin Roosevelt: A Sketch with Letters*, ed. Kermit Roosevelt (New York: Scribner, 1921).

46. Flora Miller Biddle, *The Whitney Women and the Museum They Made: A Family Memoir* (New York: Arcade, 2012), 43.

47. See *A Farewell to Arms* (1932), directed by Frank Borzage, starring Gary Cooper and Helen Hayes, and photographed by the great Charles Lang. The famously outlandish final sequence, a romantic apotheosis that has nothing to do with Hemingway, shares elements with Whitney's *Found* (Fig. 104), a two-figure piece imagining transmutation from life to death.

48. De W. C. Ward, "Poor Little Rich Girl and Her Art," *New York Times Magazine* (November 9, 1919), SM4.

49. Michele H. Bogart, *Public Sculpture and the Civic Ideal in New York City, 1890–1930* (Chicago: University of Chicago Press, 1989), 276.

50. Friedman, 450.

51. See Jennifer Wingate on Whitney's determination to challenge "the prevailing triumphant ideal" in *Sculpting Doughboys: Memory, Gender, and Taste in America's World War I Memorials* (Burlington, VT: Ashgate, 2013), chapter 3.

52. Friedman, 483. Saint-Nazaire had been the chief port of disembarkation for AEF troops on their way to the battlefields of France. It was also the site of a hushed controversy, for US officials, concerned about the spread of venereal disease, had insisted that American soldiers and sailors stay away from the town's flourishing brothels, which constituted a major source of its municipal revenue. Local authorities objected to the military edict, and the dispute went all the way up to French Prime Minister Georges Clemenceau, who implored the AEF commander, General Pershing, to permit American forces to use bordellos that would be reserved exclusively for them and supervised by AEF medical authorities. Word of the proposition reached Secretary of State Newton B. Baker, who shot back a response to the high-level official who conveyed the message, "For God's sake, Raymond, don't show this to the president or he'll stop the war." See Fred D. Baldwin, "The Invisible Armor," *American Quarterly* 16(3) (Autumn 1964), 435–36.

53. Friedman, 654.

Chapter 8 "Behind the Mask"

1. Edward Steichen, *A Life in Photography* (Garden City, NY: Doubleday, 1963), n.p., chapter 8 (page following plate 112); Penelope Niven, *Steichen: A Biography* (New York: Clarkson Potter, 1997), 515. Steichen misremembers the title of the film as *The Green Hat*, which was the name of the bestselling novel on which the movie, *A Woman of Affairs* (1928), was based; the scene in question begins approx. 30 minutes into the film (chapter 7 on the MGM home

video laser disc). In their excellent study of studio glamour photography in the 1920s, Robert Dance and Bruce Robertson claim that Steichen did more than misremember the title of the film Garbo was filming. He also distorted or reported incorrectly a number of other details, including the scene on which she was working, the amount of time allocated to the shoot, the hairstyle she was wearing, and the originality of the hands-to-head gesture, which had already become a familiar Garbo motif. See Dance and Robertson, *Ruth Harriet Louise and Hollywood Glamour Photography* (Berkeley: University of California Press, 2002), 177–79.

2. Klaus-Jürgen Sembach, "Greta Garbo," trans. Sonja Hauser, ed. Dee Pattee, in *Greta Garbo: Portraits 1920–1951* (New York: Rizzoli, 1986), 7.

3. On glamour as a culturally specific phenomenon, see Judith Brown, *Glamour in Six Dimensions: Modernism and Radiance of Form* (Ithaca, NY: Cornell University Press, 2009), Carol Dyhouse, *Glamour: Women, History, Feminism* (New York: Zed Books, 2010), and the aforementioned Dance and Robertson *Ruth Harriet Louise and Hollywood Glamour Photography*; see esp. their chapter on Garbo and her photographers, 157–84. According to Brown, 101–102, "Garbo's power rested, at least partially, in the lunar quality of her skin, the glow that erased the human detail and staged the tremendous and ethereal vitality of her eyes. No one better understood this than the generation of glamour photographers who worked in the studio system of Hollywood. Glamour photography, emerging in the 1920s and reaching its apex in the 1930s, was explicitly designed to produce the celebrity as beyond human, as intangible as light."

4. Niven, 466; Steichen *A Life in Photography*, chapter 5 (fourth page following plate 62); the quotation in the following paragraph ("I could not deny to myself . . .") is also from this page.

5. Ezra Pound, *Hugh Selwyn Mauberley* (1920), Part I, poem IV. The fact that men stood in trenches was crucial to the massive proliferation of facial injuries. During WWII, which was not an extended trench war, the injuries addressed by plastic surgeons were primarily burns. The massive firebombs and the use of flamethrowers as well as large deposits of gasoline everywhere vastly increased the number of these casualties. In addition, there was a better understanding of fluid rehydration and intravenous therapy. The use of sulfonamides and antibiotics towards the end of the war also were important technological advances available during the Second World War that had not been available during the First. I thank Dr. Enrique Silverblatt, a practicing plastic surgeon, for clarifying this point for me in correspondence, April 24, 2015. I also wish to thank Dr. Silverblatt for sharing with me his Princeton University senior thesis in the History and Philosophy of Science, "World War I and the Emergence of Plastic Surgery as a Specialty" (May 1974).

6. Vera Brittain, *Testament of Youth* an Autobiographical Study of the Years 1900–1925 (New York: Macmillan, 1933), 339; *an Autobiographical Study of the Years 1900–1925* (New York: Macmillan, 1933), 339; Helen Zenna Smith (Evadne Price), *Not So Quiet . . . Stepdaughters of the War* (1930), with afterword by Jane Marcus (New York: Feminist Press, 1989), 95.

7. "Miracles of Surgery on Men Mutilated in War," *New York Times Magazine* (January 16 1916), SM6.

8. Ellen N. La Motte, *The Backwash of War: The Human Wreckage of the Battlefield as Witnessed by an American Hospital Nurse* (1916), in Margaret R. Higonnet, ed., *Nurses at the Front: Writing the Wounds of the Great War* (Boston: Northeastern University Press, 2001), 63.

9. On changing standards of female beauty in America, see Lois W. Banner, *American Beauty* (New York: Knopf, 1983). On artistic representations of beauty in the 1920s, see Teresa A. Carbone et al., *Youth and Beauty: Art of the American Twenties* (New York: Brooklyn Museum, 2011). See also Chapter 2 above.

10. Stettheimer diary entry quoted by Parker Tyler, *Florine Stettheimer: A Life in Art* (New York: Farrar, Straus, 1963), 71. For differing readings of the painting, see Barbara J. Bloemink, *The Life and Art of Florine Stettheimer* (New Haven, CT: Yale University Press, 1995), 151–53, Ann Sutherland Harris and Linda Nochlin, *Women Artists: 1550–1950* (New York: Alfred A. Knopf, in association with Los Angeles County Museum of Art, 1979), 267, and Matthias Mühling, Karin Althaus, and Susanne Böller, eds., *Florine Stettheimer* (Munich: Lenbachhaus, 2014), 134 and 138. My thanks to Klaus Benesch for walking through the Florine Stettheimer exhibition with me in Munich in December 2014.

11. On bodybuilding as a post-WWI international phenomenon, see Ana Carden-Coyne, "From Pieces to Whole: The Sexualization of Muscles in Postwar Bodybuilding," in *Body Parts: Critical Explorations in Corporeality*, ed. Christopher E. Forth and Ivan Crozier (Lanham, MD: Lexington Books, 2005), 207–28, and, more generally, Carden-Coyne, *Reconstructing the Body: Classicism, Modernism, and the First World War* (New York: Oxford University Press, 2009). See also Gabriel Koureas, "'Desiring Skin': Eugenics, Trauma and Acting Out of Masculinities in British Inter-war Visual Culture," in *Art, Sex and Eugenics: Corpus Delecti*, ed. Fae Brauer and Anthea Callen (Burlington, VT: Ashgate, 2008), 163–87. On the new attitude toward suntans (but without connecting it as I have done to World War I), see Kevin White, *The First Sexual Revolution: The Emergence of Male Heterosexuality in Modern America* (New York: New York University Press, 1993), 22. For a cross-cultural study, see George L. Mosse's pioneering *Nationalism and Sexuality: Middle-Class Morality and Sexual Norms in Modern Europe* (Madison: University of Wisconsin Press, 1985), esp. chapter 6, "War, Youth, and Beauty," 113–132.

12. Umberto Eco, ed., *On Ugliness*, trans. Alastair McEwen (New York: Rizzoli, 2007), compiles a wide array of images and texts representing ugliness and grotesquerie through the ages and provides a multi-lingual bibliography on the topic. See also Susan M. Schweik, *The Ugly Laws: Disability in Public* (New York: New York University Press, 2009). For an eloquent and moving meditation on ugliness, see Lucy Grealy's *Autobiography of a Face* (New York: Houghton Mifflin, 1994), the author's firsthand account of losing her jaw to childhood cancer and spending the rest of her life coping with the reactions of strangers—and, more importantly, those of her own estranged self—to the extreme abnormality of her face.

13. Béla Belázs, *Theory of the Film: Character and Growth of a New Art*, trans. Edith Bone (London, 1952; New York: Dover, 1970), 286–87. The German feminist scholar Michaela Krützen takes exception to this claim, stating, "Garbo as an expression of protest against the existing social order seems absurd, especially in view of the feminist discussion about woman's suffering in the melodrama . . . a suffering which is to improve the woman morally." She also critiques Garbo idolatry by other prominent intellectuals Rudolph Arnheim, Siegfried Kracauer, and Roland Barthes; see Krützen, *The Most Beautiful Woman on the Screen: The Fabrication of the Star Greta Garbo* (New York: Peter Lang, 1992), 114–18; quotation on 115.

14. As quoted in Reginald Pound, *Gillies: Surgeon Extraordinary* (London: Michael Joseph, 1964), 34–35. To this heartbreaking vignette might be appended Nina Berman's now-famous 2006 photograph *Marine Wedding, Ohio*, exhibited at the 2010 Whitney Biennial. It shows the wedding of a hesitant-looking 21-year-old woman, Renée Kline, to her longtime sweetheart, Marine sergeant Ty Ziegel, 24, who had been injured by a suicide bomber in Iraq and undergone more than fifty operations at a medical center in Texas. The groom wears full dress uniform with insignia and medals, including a Purple Heart, pinned to his chest, but his "dead white face," in the words of a reviewer, "is all-but featureless, with no nose and no chin, as blank as a pullover mask." Holland Cotter, "Words Unspoken Are Rendered on War's Faces," *New York Times* (August 27, 2007); see also Anne Wilkes Tucker and Will Michaels with Natalie Zelt, *War Photography: Images of Armed Conflict and Its Aftermath* (New Haven, CT: Yale University Press, in association with the Museum of Fine Arts, Houston, 2012), 346 and 437. Kline and Ziegel divorced a year later, and Ziegel died of a drug and alcohol overdose on the day after Christmas, 2012.

15. Harold D. Gillies, *The Development and Scope of Plastic Surgery*, the Charles H. Mayo lectures for 1934 (Chicago: Northwestern University Press, 1935), 2, quoted in Sander L. Gilman, *Making the Body Beautiful: A Cultural History of Aesthetic Surgery* (Princeton: Princeton University Press, 1999), 161; Ernest Hemingway, *A Moveable Feast* (New York: Scribner, 1964), 82. On *J'Accuse*, see Steven Philip Kramer and James Michael Welsh, *Abel Gance* (Boston: Twayne, 1978), 61–77, and Jay Winter, *Sites of Memory, Sites of Mourning: The Great War in European Cultural History* (Cambridge: Cambridge University Press, 1995), 15–18. For a social and literary study of these men and their like, see Marjorie Gehrhardt, *The Men with Broken Faces: Gueules Cassées of the First World War* (New York: Peter Lang, 2015).

16. "Miracles of Surgery on Men Mutilated in War," *New York Times Magazine* (January 16, 1916), 6:1, quoted in Elizabeth Haiken, *Venus Envy: A History of Cosmetic Surgery* (Baltimore: Johns Hopkins University Press, 1997), 32. André Breton defined surrealism in his first *Surrealist Manifesto*, published in Paris in 1924; see Breton, *Manifestoes of Surrealism*, trans. Richard Seaver and Helen Weaver (Ann Arbor: University of Michigan Press, 1972), although the term was introduced earlier by the poet Guillaume Apollinaire in the preface to his play *Breasts of Tiresias* (1903, first performed in 1917). On surrealism and the *mutilés de guerre*, see Amy Lyford, *Surrealist Masculinities: Gender Anxiety and the Aesthetics of Post-World War I Reconstruction in France* (Berkeley: University of California Press, 2007), and Sidra Stich, ed., *Anxious Visions: Surrealist Art* (Berkeley: University of California Art Museum, 1990). Plastic surgery figures into a number of motion picture melodramas made over the years, perhaps most memorably so in the French horror film *Eyes without a Face* (*Les yeux sans visage*), a cult classic directed in 1960 by the latter-day surrealist Georges Franju. Disfigured in a car accident, a sad and ethereal young woman glides through much of the film with her face eerily covered by a supernaturally smooth white mask.

17. Harold D. Gillies, *Plastic Surgery of the Face: Based on Selected Cases of War Injuries of the Face Including Burns* (London: Frowde; Hodder and Stoughton, 1920).

18. Sir Harold Gillies and D. Ralph Millard, Jr., *The Principles and Art of Plastic Surgery*, 2 vols. (Boston: Little, Brown, 1957), vol. 1, 40. (On Gillies's surgical

methods of "sex conversion," see vol. 2, 383–88.) On Spreckley in later life, see BBC News: Quick Guide, Faces of Battle (2007) http://news.bbc.co.uk/nol/shared/spl/hi/picture_gallery/07/magazine_faces_of_battle.

19. On Henry Tonks, see Emma Chambers, *Henry Tonks: Art and Surgery* (London: The College Art Collections of University College London, 2002). Tonks and to a lesser extent Gillies are fictionalized in Pat Barker's historical novel *Toby's Room* (New York: Doubleday, 2012).

20. Tonks quoted in Evan Edward Charteris, *John Sargent* (1927; New York: Benjamin Blom, 1972), 212; R. I. L. to Thomas Fox, July 12, 1918, in the John Singer Sargent-Thomas A. Fox Papers in the Boston Atheneum, as quoted in Sally M. Promey, *Painting Religion in Public: John Singer Sargent's "Triumph of Religion" at the Boston Public Library* (Princeton, NJ: Princeton University Press, 1999), 238.

21. Ernst Friedrich, *War Against War!* (1924), introduction Douglas Kellner (Seattle: Real Comet Press, 1987).

22. Friedrich, *War against War!*, 218.

23. While there is no direct evidence that Bacon owned *War against War!*, the Estate of Francis Bacon informs me that "A copy of the book was owned by the artist Denis Wirth-Miller, whose studio in Wivenhoe, Essex, Francis Bacon shared at various times, and it is very likely that he did see the book there." Correspondence, January 18, 2016. On the cultural reverberations of the book, see Douglas Kellner, "Introduction: Ernst Friedrich's Pacifistic Anarchism," in Friedrich, *War against War!* Kellner's introduction is available online at http://www.uta.edu/huma/illuminations/kell20.htm. See also Dora Apel, "Cultural Battlegrounds: Weimar Photographic Narratives of War," *New German Critique* 76, special issue on Weimar Visual Culture (Winter 1999), 49–84.

24. Susan Sontag, *Regarding the Pain of Others* (New York: Farrar, Straus and Giroux, 2003), 40; Andy Warhol interviewed by Gene R. Swenson, "What is Pop Art? Interviews with Eight Painters (Part 1)," *ARTnews* 62(7) (November 1963), 62.

25. On the "return to order" in various artistic formats, see, for example, Kenneth Silver, *Esprit de Corps: the Art of the Parisian Avant-Garde and the First World War, 1914–1925* (Princeton, NJ: Princeton University Press, 1989), Silver et al., *Chaos & Classicism: Art in France, Italy, and Germany, 1918–1936* (New York: Guggenheim Museum, 2010), Romy Golan, *Modernity and Nostalgia: Art and Politics in France between the Wars* (New Haven, CT: Yale University Press, 1995), and Winter, *Sites of Memory*.

26. Courtney Graham Donnell, Susan S. Weininger, and Robert Cozzolino, *Ivan Albright*, ed. Susan F. Rossen (Chicago: Art Institute of Chicago, 1997); see plates 1–2, pages from Albright's medical sketchbook in 1918–19, and plate 17, with accompanying text about *Into the World There Came a Soul Called Ida*. See also photograph, on 180, of Albright standing before the painting in his studio.

27. See Katherine Ott, David Serlin, and Stephen Mihm, eds., *Artificial Parts, Practical Lives: Modern Histories of Prosthetics* (New York: New York University Press, 2002), for cultural analyses of various modern prosthetic technologies.

28. F. Derwent Wood, "Masks for Facial Wounds," *The Lancet* (June 1917): 949. See also Ward Muir, "The Men with the New Faces," *The Nineteenth Century and After* 82 (October 1917), 746–53.

29. Anna Coleman Ladd, *The Candid Adventurer* (Boston: Houghton Mifflin, 1913), 296–97, as discussed in David M. Lubin, "Masks, Mutilation, and Modernity: Anna Coleman Ladd and the First World War," *Archives of*

American Art Journal 47, 3–4 (Fall 2008), 7–8. The only period source I have found for images of Ladd's non-mask sculpture is the 24-page pamphlet *The Work of Anna Coleman Ladd* (Boston: Seaver-Howland Press, 1920).

30. Sharon Romm and Judith Zacher, "Anna Coleman Ladd: Maker of Masks for the Facially Mutilated," *Plastic and Reconstructive Surgery* 70:1 (1982): 108.

31. La Motte, *Backwash of War*, in Higonnet, ed., *Nurses at the Front*, 16. On the design "lag" between facial destruction and prosthetic reconstruction, see Katherine Feo, "Invisibility: Memory, Masks, and Masculinities in the Great War," *Journal of Design History* 20(1) (Spring 2007): 17–27.

32. Anna Coleman Ladd in Padraic King, "How Wounded Soldiers Have Faced the World Again with 'Portrait Masks,'" *Saint Louis Post-Dispatch* (March 26 1933), unpaged clipping in Ladd papers, Archives of American Art (box 2, folder 4). See also Grace S. Harper, "New Faces for Mutilated Soldiers," *Red Cross Magazine* 13 (November 1918), 44–45. T. S. Eliot, *The Waste Land* (1922), Section I, "The Burial of the Dead," lines 38–40.

33. See YouTube video "Anna Coleman Ladd's Studio for Portrait Masks in Paris," at http://www.youtube.com/watch?v=bCSzrUnie2E. The back story of this film, shot and edited by the Red Cross Bureau of Pictures, can be found in Alison Marcotte and Alex Villanueva, "Anna Coleman Ladd's Paris Studio for Facial Prosthetics, 1918," *SourceLab* I(2) (2015), located at http://scalar.usc.edu/works/red-cross-work-1918/index. See also Gerry K. Veeder, "The Red Cross Bureau of Pictures, 1917–1921: World War I, the Russian Revolution and the Sultan of Turkey's harem," *Historical Journal of Film, Radio and Television* 10(1) (1990): 47–70.

34. On Ladd, see Claudine Mitchell, "Facing Horror: Women's Work, Sculpting Practice, and the Great War," in *Work and the Image*, vol. 2, *Work in Modern Times: Visual Mediations and Social Processes*, ed. Valerie Mainz and Griselda Pollock (Burlington, VT: Ashgate, 2000), 33–53, quotation on 44; Caroline Alexander, "Faces of War," *Smithsonian Magazine* (February 2007), 72–80; Feo, "Invisibility"; Lubin, "Masks, Mutilation, and Modernity," 4–15; and Romm and Zacher, 104–11. See also Lettie Gavin, *American Women in World War I: They Also Served* (Niwot, CO: University Press of Colorado, 1997), 194–97, and Mercedes Graf, *On the Field of Mercy: Women Medical Volunteers from the Civil War to the First World War* (New York: Humanity Books, 2006), 293–310. For additional bibliography, see Lubin, "Masks," 15, n. 1. The Anna Coleman Ladd papers, collected by her friend Robert Edwards of Beverly, Massachusetts, after her death in 1939, entered the Archives of American Art, Smithsonian Institution, in 1991; these were put online in 2014. The Library of Congress holds the corresponding American Red Cross records, 1917–1934. On Ladd's concern as a sculptor of war memorials to "represent the truth of war in its most terrible and ghastly aspect" and to help "induce the public to rebel against war," see Jennifer Wingate, *Sculpting Doughboys: Memory, Gender, and Taste in America's World War I Memorials* (Burlington, VT: Ashgate, 2013), 162–67. Aaron Shaheen, a literary scholar, devotes a chapter to Ladd in his book-in-progress, *The Prosthetic Spirit: Great War Rehabilitation in American Literature and Culture.*

Jody Shields, *The Crimson Portrait: A Novel* (Boston: Little, Brown, 2006), draws loosely (very loosely) on the historical figures Anna Coleman Ladd and the American maxillofacial plastic surgeon Varaztad Kazanjiian in its psychological tale of a philanthropic upper-class English widow who seeks a recon-

structed face for a disfigured soldier with whom she falls in love. Ladd is also fictionalized in *The Mask Maker,* an as-yet unproduced feature-length project by the independent filmmaker Amy Waddell, who has shared her screenplay with me. HBO's historical crime series *Boardwalk Empire* (2010–2014), set in the 1920s, features a melancholy but violent secondary character named Richard Harrow, who lost half his face in the First World War and wears a tin mask. Series creator and head writer Terence Winter has said in interviews that his inspiration for Harrow came from reading about Anna Coleman Ladd.

35. Haiken, *Venus Envy,* 34–35.

36. Percy Marks, *The Plastic Age* (New York: Grosset & Dunlap, 1924). On Clara Bow, see David Stenn, *Clara Bow: Runnin' Wild* (New York: Doubleday, 1988).

37. John Gloag, *Plastics and Industrial Design* (London: George Allen & Unwin, 1945), 32, quoted in Brown, *Glamour in Six Dimensions,* 153. See Jeffrey L. Meikle, *American Plastic: A Cultural History* (New Brunswick: Rutgers University Press, 1995), and Robert Sklar, ed., *The Plastic Age (1917–1930)* (New York: George Braziller, 1970). Georgia O'Keeffe quoted in Charles C. Eldredge, *Georgia O'Keeffe* (New York: Harry N. Abrams, 1991), 64. Thanks to Joyce Tsai for talking with me about the early history of plastics.

38. Charles Baudelaire, "The Painter of Modern Life," section XI, "In Praise of Cosmetics," in *"The Painter of Modern Life" and Other Essays,* trans. and ed. Jonathan Mayne (London: Phaidon, 1964), 31–34, quotation on 33.

39. Kathy Peiss, *Hope in a Jar: The Making of America's Beauty Culture* (New York: Metropolitan Books, 1988), and, for a view closer to the era in question, Gilbert Miller Vail, *A History of Cosmetics in America* (New York: The Toilet Goods Association, 1947). See also Geoffrey Jones, *Beauty Imagined: A History of the Global Beauty Industry* (New York: Oxford University Press, 2010), and, on art and makeup, Melissa Hyde, "The 'Makeup' of the Marquise: Boucher's Portrait of Pompadour at Her Toilette," *Art Bulletin* 82(3) (September 2000), 453–75; Marni Reva Kessler, *Sheer Presence: the Veil in Manet's Paris* (Minneapolis: University of Minnesota Press, 2006), chapter 2, "Making Up the Surface," 34–61; and Susan Sidlauskas, "Painting Skin: John Singer Sargent's *Madame X,*" *American Art* 15(3) (Autumn 2001), 8–33.

40. Helena Rubinstein, *My Life for Beauty* (New York: Simon and Schuster, 1966), 57–58; see also Lindy Woodhead, *War Paint: Madame Helena Rubinstein and Miss Elizabeth Arden: Their Lives, Their Times, Their Rivalry* (Hoboken, NJ: John Wiley, 2003), and Michèle Fitoussi, *Helena Rubinstein: The Woman Who Invented Beauty,* trans. Kate Bignold and Lakshmi Ramakrishnan Iyer (London: Gallic Books, 2013). Rubinstein has recently been the subject of an art exhibition at the Jewish Museum in New York; see Mason Klein, *Helena Rubinstein: Beauty is Power* (New York: Jewish Museum, 2014).

41. On Rubinstein's collection of African masks, see Klein, *Helena Rubinstein,* 90–96, Rubinstein, *My Life,* 50–51, and Woodhead, *War Paint,* 15–7, 165–66, and 425; on Arden and her world, see Alfred Allan Lewis and Constance Woodworth, *Miss Elizabeth Arden* (New York: Coward, McCann & Geoghegan, 1972). On Elsie de Wolfe, see her autobiography, *As Is* (1935; New York: Arno, 1974), Jane S. Smith, *Elsie de Wolfe: A Life in the High Style* (New York: Athenaeum, 1982), Alfred Allan Lewis, *Ladies and Not-So-Gentle Women* (New York: Viking, 2000), and Penny Sparke's excellent analytical study *Elsie de Wolfe: The Birth of Modern Interior Decoration* (New York: Acanthus Press, 2005).

42. See A'Lelia Bundles, *On Her Own Ground: The Life and Times of Madam C. J. Walker* (New York: Scribner, 2001), and Davarian L. Baldwin, "From the Washtub to the World: Madam C. J. Walker and the 'Re-creation' of Race Womanhood, 1900–1935", in *The Modern Girl Around the World: Consumption, Modernity, and Globalization*, ed. Alys Eve Weinbaum, Lynn M. Thomas, Priti Ramamurthy, Uta G. Poiger, Madeleine Yue Dong, and Tani E. Barlow (Durham, NC: Duke University Press, 2008), 55–76. Also Beverly Lowry, *Her Dream of Dreams: The Rise and Triumph of Madam C. J. Walker* (New York: Vintage, 2003), and Peiss, *Hope in a Jar*.

43. See Oscar Wilde, "The Truth of Masks" (1891), "Pen, Pencil, and Poison: A Study in Green" (1891), and "Phrases and Philosophies for Uses of the Young" (1894), all in *The Artist as Critic: Critical Writings of Oscar Wilde*, ed. Richard Ellman (New York: Random House, 1968), quotations from 323, 389, and 433; Friedrich Nietzsche, *Beyond Good and Evil* (1886, section 40), trans. R. J. Hollingdale (New York: Penguin, 1973), 51. On women and masking or masquerade, see Martha Banta, "Masking, Camouflage, Inversions, and Play," chapter 5 in her *Imaging American Women: Idea and Ideals in Cultural History* (New York: Columbia University Press, 1987), and Terry Castle, *Masquerade and Civilization: The Carnivalesque in Eighteenth Century English Culture and Fiction* (Stanford, CA: Stanford University Press, 1986).

44. Edward Gordon Craig, "A Note on Masks" (1910), in *Craig on Theatre*, ed. J. Michael Walton (London: Methuen, 1983), 21. On the avant-garde fascination with primitivism and violence in the years leading up to the First World War, see Modris Eksteins, *Rites of Spring: the Great War and the Birth of the Modern Age* (New York: Houghton Mifflin, 1989).

45. Walter Sorell, *The Other Face: The Mask in the Arts* (London: Thames and Hudson, 1973), 15; Eugene O'Neill, "Memoranda on Masks," *American Spectator* (November 1932), 3. Some of O'Neill's experimental dramas, such as the Pulitizer Prize-winning *Strange Interlude* (1928), were staged with characters holding masks while delivering revelatory soliloquies, in order to signify these as "strange interludes" of authenticity. The playwright's friend Marsden Hartley depicted masks in some of his paintings of the early 1930s, possibly in reference to his closeted homosexuality. See Amy Ellis, " 'The Great Provincetown Summer': The Impact of Eugene O'Neill on Marsden Hartley," in *Marsden Hartley*, ed. Elizabeth Mankin Kornhauser (New Haven, CT: Wadsworth Atheneum Museum of Art, in association with Yale University Press, 2002), 99–102. I'm grateful to Charlie Eldredge for pushing me to think about art and masks in post-WWI visual culture.

46. See Alys Eve Weinbaum, "Racial Masquerade: Consumption and Contestation of American Modernity," in Weinbaum et al., eds., *The Modern Girl Around the World*, 120–46; quotation on 120; "The Beginning of the 'Age of Masks,' " *Vanity Fair* (January 1922), 54. "Don't Wear a Tired Thirsty Face," Coca Cola ad in *McCall's* 60(7) (April 1933), 37.

47. Ernest Hemingway in Kiki (Alice Prin), *Kiki's Memoirs*, trans. Samuel Putnam with introduction Ernest Hemingway (New York: Black Manikin Press, 1930). See Woodhead, *War Paint*, 133 and 165, and Billy Klüver, *Kiki's Paris: Artists and Lovers, 1900–1930* (New York: Harry N. Abrams, 1989). See also Whitney Chadwick, "Fetishizing Fashion/Fetishizing Culture: Man Ray's *Noire et blanche*," *Oxford Art Journal* 18(2) (1995), 3–17, and Wendy A. Grossman and

Steven Manford, "Unmasking Man Ray's *Noire et blanche*," *American Art* 20(2) (2006), 134–47.

48. Paul Sternberger, "Reflections on Edward Weston's *Civilian Defense*," *American Art* 17(1) (Spring 2003), 48–67, provides historical and artistic contexts for Weston's photo.

49. Joan Riviere, "Womanliness as a Masquerade," *International Journal of Psychoanalysis* 10 (1929), 303–13. Reprinted in various collections, including Hendrik Marinus Ruttenbeek, ed., *Psychoanalysis and Female Sexuality* (New Haven, CT: College and University Press, 1966), 209–20. One might propose that these days self-masking pertains to men no less than it does to women, at least in the metaphoric sense that social media, such as the aptly named Facebook, encourage users to create screen names and acceptably upbeat social identities for themselves for public consumption, that is, for being "liked."

50. Paul Laurence Dunbar, "We Wear the Mask," in *Lyrics of Lowly Life* (New York: Dodd, Mead, 1896). Franz Fanon's classic anticolonial text from 1952, *Peau noire, masques blancs* (*Black Skin, White Masks*), explores the concept of internalized servility as a form of defensive racial masking. On Jolson and blackface, see Michael Rogin, *Blackface, White Noise: Jewish Immigrants in the Hollywood Melting Pot* (Berkeley: University of California Press, 1996).

51. See Jones, *Beauty Imagined*, 136, Linda M. Scott, *Fresh Lipstick: Redressing Fashion and Feminism* (New York: Palgrave Macmillan, 2005), 222, and Meg Cohen Ragas, *Read My Lips: A Cultural History of Lipstick* (San Francisco: Chronicle Books, 1998). The "Beauty as a Duty" ad is reproduced in Klein, *Helena Rubinstein*, 78.

52. Roland Barthes, "The Face of Garbo," in *Mythologies* (1957), trans. Annette Lavers (New York: Hill and Wang, 1972), 56–57; Rudolph Arnheim, *Film Essays and Criticism*, trans. Brenda Benthien (Madison: University of Wisconsin Press, 1997), 216.

53. Krützen, *Most Beautiful Woman on the Screen*, 69.

54. Lucy Fischer, "Greta Garbo and Silent Cinema: The Actress as Art Deco Icon," in *A Feminist Reader in Early Cinema*, ed. Jennifer M. Bean and Diane Negra (Durham, NC: Duke University Press, 2002), 476–98.

Chapter 9 "Monsters in Our Midst"

1. Figures from David M. Gosoroski, " 'Brotherhood of the Damned': Doughboys Return from the World War," *VFW, Veterans of Foreign Wars Magazine* 85(1) (September 1997), 33. On disabled American veterans, see John M. Kinder, *Paying with Their Bodies: American War and the Problem of the Disabled Veteran* (Chicago: University of Chicago Press, 2015), and Beth Linker, *War's Waste: Rehabilitation in World War I America* (Chicago: University of Chicago Press, 2011). See Deborah Cohen, *The War Come Home: Disabled Veterans in Britain and Germany, 1914–1939* (Berkeley: University of California Press, 2001), on their British and German counterparts, and Roxanne Panchesi, "Reconstructions: Prosthetics and the Male Body in Post WWI France," in *Differences* 7(3) (1995), 109–40, on equivalent matters in France. Specifically on German war wounded, see Jason Crouthamel, *The Great War and German Memory: Society, Politics, and Psychological Trauma, 1914–1945* (Exeter, UK: University of Exeter Press, 2009), and Robert Weldon Whalen, *Bitter Wounds: German Victims of the Great War, 1914–1939* (Ithaca, NY: Cornell University

Press, 1984). A provocatively illustrated cross-national study of wartime wounding, published in conjunction with a double exhibition at the In Flanders Field Museum in Ypres and the Dr. Guislain Museum in Ghent, is *War and Trauma: Soldiers and Ambulances, 1914–1918; and Soldiers and Psychiatrists, 1914–2014* (Veurne, Belgium: Hannibal Publishing, 2013).

2. *"Stars and Stripes": the Official Newspaper of the A.E.F.*, vols. 1–2 (rpt. New York: Arno, 1971). See also Alfred E. Cornebise, *"The Stars and Stripes": Doughboy Journalism in World War I* (Westport, CT: Greenwood Press, 1984).

3. See David M. Kennedy, *Over Here: The First World War and American Society*, 25th anniversary ed. (New York: Oxford University Press, 2004), 205–209.

4. John Dos Passos, letter of August 23, 1917, to Rumsey Marvin, from near Verdun; in *The Fourteenth Chronicle: Letters and Diaries of John Dos Passos*, ed. Townsend Ludington (Boston: Gambit, 1973), 91–92; quoted in Ludington's introduction to Dos Passos, *Three Soldiers* (1921; New York: Penguin, 1997), vii. For a biographical account, see Ludington, *John Dos Passos: A Twentieth Century Odyssey* (New York: Dutton, 1980).

5. Enid Bagnold, *A Diary without Dates* (London: William Heinemann, 1918), 90. Bagnold, later the author of *National Velvet* (1935), was writing during the Third Battle of Ypres in 1917.

6. Siegfried Sassoon, *Sherston's Progress* (1936; London: Faber and Faber, 1983), 51.

7. Sir Arbuthnot Lane, Head Surgeon at the Cambridge Military Hospital, quoted in "Want Public to Aid Disabled Soldiers," *New York Times* (June 14, 1918), 6.

8. Artillery First Sergeant Stephen J. Weston, as quoted in Edward A. Gutiérrez, *Doughboys on the Great War: How American Soldiers Viewed Their Military Service* (Lawrence: University of Kansas Press, 2014), 146. Another good compendium of doughboy reflections on the war is Mark Meigs, *Optimism at Armaggedon: Voices of American Participants in World War One* (New York: New York University Press, 1997).

9. As quoted in Gutiérrez, 145 (Private First Class Garnett D. Claman).

10. Edward M. Gutiérrez, *"Sherman Was Right": The Experience of AEF Soldiers in the Great War*, PhD dissertation, Ohio State University, 2008, 208 (Colonel Frederic M. Wise); taken from Frederic M. Wise, *A Marine Tells It To You* (New York: J. H. Sears, 1929), 298–99. The colonel's recurring nightmare calls to mind a passage from *The Waste Land*: "I think we are in rats' alley / Where the dead men lost their bones" (lines 115–116).

11. A "buck leatherneck," quoted in Dixon Wechter, *When Johnny Comes Marching Home* (Cambridge, MA: Riverside Press, 1944), 320, as found in Kennedy, *Over Here*, 217.

12. Ernest Hemingway, *In Our Time* (1925; New York: Scribner, 2003), 69; 76.

13. Dos Passos, *Three Soldiers* 175. In James Joyce's *Ulysses* (1922), when a schoolmaster sententiously says to Stephen Daedalus, "We are a generous people but we must also be just," Stephen replies, "I fear those big words...which make us so unhappy." *Ulysses* (New York: Modern Library, 1992), 31 (from Episode 2: "Nestor").

14. Statistics from George Creel, *How We Advertised America* (rpt. New York: Arno Press, 1972), summarized in Eugene Secunda and Terence P. Moran, *Selling War to America: From the Spanish American War to the Global War on Terror* (Westport, CT: Praeger Security International, 2007), 33.

15. George Seldes, *One Man's Newspaper Game: Freedom and the Press* (Indianapolis, IN: Bobbs-Merrill, 1935), 37, quoted in Secunda and Moran, 44. Ford said to the *Chicago Tribune* in 1916: "History is more or less bunk…the only history that is worth a tinker's damn is the history that we make today."

16. On the American Civil War, see David Blight, *Race and Reunion: The Civil War in American Memory* (Cambridge, MA: Belknap Press of Harvard University Press, 2001), and Drew Gilpin Faust, *This Republic of Suffering: Death and the American Civil War* (New York: Knopf, 2008).

17. Laurence Stallings, *Plumes* (1924), introduction George Garrett, afterword Steven Trout (Columbia: University of South Carolina Press, 2006), 91–92.

18. See Stallings, *Plumes*, 188; quoted passages from 129; 187; 80.

19. Ernest Hemingway, *A Farewell to Arms* (1929; New York: Scribner, 1957), 55.

20. William March, *Company K*, introduction Philip D. Beidler (1933; Tuscaloosa: University of Alabama Press, 1989), 123–37; quotations from 127 and 132; the passage in the following paragraph is on 136–37. For an in-depth study of March's literary career, see Roy S. Simmonds, *The Two Worlds of William March* (Tuscaloosa: University of Alabama Press, 1984).

21. Erich Maria Remarque, *All Quiet on the Western Front*, trans. Brian Murdoch (1929; London: Vintage, 1996), 186. Lt. Col. Dave Grossman, who taught psychology at West Point, examines the mental turmoil faced by soldiers who have been trained to kill in *On Killing: The Psychological Cost of Learning to Kill in War and Society* (Boston: Little, Brown, 1995).

22. Chris Hedges, *Death of the Liberal Class* (New York: Nation Books, 2010), 57. Hedges's polemical and prize-winning *War Is a Force That Give Us Meaning* (New York: Public Affairs, 2002) also draws on classical literature to explore the adverse psychological consequences of war on societies that undertake them for what they mistakenly imagine will be psychological benefits.

23. Thomas Craven, "John Steuart Curry," *Scribner's Magazine* 103 (January 1938), 39, discusses Curry's relationship with his mentor Dunn (the full essay appears on 37–41, 96, and 98). On Curry in general, see Patricia Junker et al., *John Steuart Curry: Inventing the Middle West* (New York: Hudson Hills Press, in association with the Elvehjem Museum of Art, University of Wisconsin-Madison, 1998). See also James M. Dennis, "John Curry's Reactive Women," in his *Renegade Regionalists: The Modern Independence of Grant Wood, Thomas Hart Benton, and John Steuart Curry* (Madison: University of Wisconsin Press, 1998), 143–70, esp. 169.

24. Barbara W. Tuchman, *The Guns of August* (New York: Macmillan, 1962), 440. Philip Young, *Ernest Hemingway: A Reconsideration* (New York: Harcourt, Brace and World, 1966), 94. See Gutiérrez, *Doughboys on the Great War*, esp. 43–45, and Keith Gandal, *The Gun and the Pen: Hemingway, Faulkner, and the Fiction of Mobilization* (New York: Oxford University Press, 2008), for arguments that the Lost Generation's literature of disillusionment did not accurately represent most soldiers' experiences or remembrances of the war. Gandal, 5, writes: "[T]he 'quintessential' male American

modernist novelists were motivated, in their celebrated postwar literary works, not so much, as the usual story goes, by their experiences of the horrors of World War I but rather by their inability in fact to have those experiences."

25. See David Levering Lewis, *W. E. B. Du Bois: Biography of a Race, 1868–1919* (New York: Henry Holt, 1993), 515–80.

26. For details of the jubilant parade, as drawn from the period press, see Henry Louis Gates, Jr., "Who Were the Harlem Hellfighters?" *The Root*, November 11, 2013: http://www.theroot.com/articles/culture/2013/11/who_were_the_harlem_hellfighters.html. On the homecoming parades for black troops in New York and elsewhere, including the American South, see Chad L. Williams, *Torchbearers of Democracy: African American Soldiers in the World War I Era* (Chapel Hill: University of North Carolina Press, 2010), 214–22.

27. Williams, *Torchbearers*, 216–17; Noble Sissle reminiscence quoted on 216.

28. The major biographical source on VanDerZee is Rodger C. Birt, "A Life in American Photography," in Deborah Willis-Braithwaite, with biographical essay by Rodger C. Birt, *VanDerZee: Photographer, 1886–1983* (New York: Harry N. Abrams, 1998), 26–73. The first published portfolio of VanDerZee's work is *The World of James Van DerZee* [*sic*], compiled with an introduction by Reginald McGhee (New York: Grove Press, 1969). See also Regenia Perry, *James VanDerZee* (Dobbs Ferry, NY: Morgan and Morgan, 1973).

29. The pair of VanDerZee's double portraits of Roberts and Johnson are analyzed by Jennifer D. Keene in "The Memory of the Great War in the African American Community," in *Unknown Soldiers: The American Expeditionary Forces in Memory and Remembrance*, ed. Mark A. Snell (Kent, OH: Kent State University Press), 73–74, and Mark Whalan, *The Great War and the Culture of the New Negro* (Tallahassee: University Press of Florida, 2008), 222–31; see also, on VanDerZee and the New Negro male body, 178–90.

30. Richard Slotkin, *Lost Battalions: The Great War and the Crisis of American Nationality* (New York: Henry Holt, 2004), 151. On the 369th Infantry, see Stephen L. Harris, *Harlem's Hell Fighters: The African-American 369th Infantry in World War I* (Washington, DC: Brassey's, 2003), and Jeffrey T. Sammons and John H. Morrow, Jr., *Harlem's Rattlers and the Great War: The Undaunted 369th Regiment and the African American Quest for Equality* (Lawrence: University of Kansas Press, 2014). On African American forces in the First World War, two important historical texts are Kelly Miller, *Kelly Miller's History of the World War for Human Rights, Being an Intensely Human and Brilliant Account of the World War and Why and For What Purpose America and the Allies Are Fighting and the Important Part Taken by the Negro, Including the Horrors and Wonders of Modern Warfare, The New and Strange Devices, etc.* [the "etc." is his, not mine] (Washington, DC: Austin Jenkins, 1919; rpt. New York: Negro Universities Press, 1969), and Emmett J. Scott, *Scott's Official History of The American Negro in the World War* (Washington, DC: Emmett J. Scott, 1919). Academic studies of the topic include Arthur E. Barbeau and Florette Henri, *The Unknown Soldiers: Black American Troops in World War I* (Philadelphia: Temple University Press, 1974), Adriane Lentz-Smith, *Freedom Struggles: African Americans and World War I* (Cambridge, MA: Harvard University Press, 2009), and Williams, *Torchbearers*

of Democracy (as in n. 26). See also Jennifer D. Keene, *World War I: American Soldiers' Lives* (Westport, CT: Greenwood Press, 2006), 93–105. For the viewpoint of black journalists and editors on the question of African American participation in the Great War, see William G. Jordan, *Black Newspapers and America's War for Democracy, 1914–20* (Chapel Hill: University of North Carolina Press, 2001). Black literary responses are discussed in Mark Whalan, "Not Only War: The First World War and African American Literature," in *Race, Empire and First World War Writing*, ed. Santanu Das (New York: Cambridge University Press, 2011), 283–300, and political ramifications are explored in Barbara Foley, *Spectres of 1919: Class and Nation in the Making of the New Negro* (Urbana: University of Illinois Press, 2003).

31. James Baldwin, *Go Tell It on the Mountain* (1953; New York: Dell, 1985), 142. See Vincent Mikkelsen, "Coming from Battle to Face a War: The Lynching of Black Soldiers in the World War I Era," PhD dissertation, Florida State University, 2007. On lynching as photographed for newspapers and tourist postcards, see Dora Apel and Shawn Michelle Smith, *Lynching Photographs* (Berkeley: University of California Press, 2007), which in turn responds to the disturbing images exhibited in James Allen, Hilton Als, and Leon F. Litwack, *Without Sanctuary: Lynching Photography in America*, with foreword by Congressman John Lewis (Santa Fe, NM: Twin Palms, 2000). Julia Faisst argues that while lynching served to intimidate black Americans and silence them politically until the civil rights era, it prompted the development of black literary and artistic modernism by forcing black creative artists to devise alternative forms of self-expression. See Faisst, "Shadow Archive: Lynching Photography, Afro-Modernist Literature, and Black Citizenship," in her *Cultures of Emancipation: Photography, Race, and Modern American Literature* (Heidelberg: Universitätsverlag Winter, 2014), 171–217.

32. The gruesome account of Mary Turner's lynching is from Philip Dray, *At the Hands of Persons Unknown: The Lynching of Black America* (New York: Random House, 2002), 245–46, drawn in turn from "Fury of the People," *Atlanta Constitution*, May 23, 1918.

33. Richard Wright, *12 Million Black Voices: A Folk History of the Negro in the United States*, with photographs by Edwin Rosskam (New York: Viking Press, 1941), 88; "double-cross" quotation in Barbeau and Henri, *Unknown Soldiers*, 174.

34. Dorothy Canfield [Fisher], *The Day of Glory* (New York: Henry Holt, 1919), 124–25. Similar instances of editorial cartoons promoting the lynching of Germans, including German-American editors of German-language newspapers, can be found in Erik Kirschbaum, *The Eradication of German Culture in the United States: 1917–1918* (Stuttgart: H.-D. Heinz, 1986), and in Kirschbaum's more recent *Burning Beethoven: The Eradication of German Culture in the United States during World War I* (New York: Berlinica, 2015), esp. chapter 5, "500,000 Lampposts to Hang German-Americans."

35. Slotkin, 487–88; Michael B. Shear, "Belated Recognition for Valor of 2 Soldiers in World War I," *New York Times* (June 3, 2015), A11–12.

36. Stephen Crane, *The Monster* (1898) in *Stephen Crane: Prose and Poetry* (New York: Library of America, 1984), 391–448. For readings of the tale as an allegory of race in late nineteenth century America, see Elaine Marshall, "Crane's 'The Monster' Seen in the Light of Robert Lewis's Lynching,"

Nineteenth-Century Literature 51(2) (1996), 205–24, and Lee Clark Mitchell, "Face, Race, and Disfiguration in Stephen Crane's 'The Monster,'" *Critical Inquiry* 17(1) (Autumn, 1990), 174–92.

37. Slotkin, 519–20.

38. On African American women and the First World War, see Addie W. Hunton and Kathryn M. Johnson, *Two Colored Women with the American Expeditionary Forces* (1920; rpt. New York: G. K. Hall, 1997), Darlene Clark Hine, *Black Women in the Nursing Profession: A Documentary History* (New York: Garland, 1985), and Hine, *Black Women in White: Racial Conflict and Cooperation in the Nursing Profession, 1890–1950* (Bloomington: Indiana University Press, 1989), 102–107.

39. W. E. B. Du Bois, "Returning Soldiers," *The Crisis* 18 (May 1919), 13. The passage reads as follows: "We *return*. We *return from fighting*. We *return fighting*. Make way for Democracy! We saved it in France, and by the Great Jehovah, we will save it in the United States of America, or know the reason why."

40. The quotation is from page 2 of an undated (ca. 1943) and unaddressed letter ("Dear Friends") in box 1, folder 5 of the Horace Pippin notebooks and letters, circa 1920, 1943, in the Archives of American Art, Smithsonian Institution. These papers have been digitized and are available online at http://www.aaa.si.edu/collections/horace-pippin-notebooks-and-letters-8586. Regarding the notebooks and letters, see Anne Monahan, "'I Remember the Day Varry [*sic*] Well': Horace Pippin's War," *Archives of American Art Journal* 47(3–4) (Fall 2008), 16–23. Secondary sources for Pippin include Selden Rodman, *Horace Pippin, A Negro Painter in America* (New York: Quadrangle Press, 1947), Selden Rodman and Carole Cleaver, *Horace Pippin: The Artist as a Black American* (Garden City, NY: Doubleday, 1972), and Judith E. Stein, ed., *I Tell My Heart: The Art of Horace Pippin* (New York: Universe; Philadelphia: Pennsylvania Academy of Fine Arts, 1993). Other good interpretive sources of Pippin's war paintings include Steven Trout, *On the Battlefield of Memory* (Tuscaloosa: University of Alabama Press, 2010), and Williams, *Torchbearers of Democracy*. The art historian and literary scholar Celeste-Marie Bernier examines Pippin's war art at length in *Suffering and Sunset: World War I in the Art and Life of Horace Pippin* (Philadelphia: Temple University Press, 2015). The first major Pippin exhibition in two decades was held at the Brandywine River Museum in Chadds Ford, Pennsylvania, in 2015; see Audrey Lewis, ed., *Horace Pippin: The Way I See It* (New York: Scala Art Publishers, 2015).

41. Rodman and Cleaver, 54–55.

42. Rodman, 11; see also Kevin Louis Nibbe, "The Greatest Opportunity: American Artists and the Great War, 1917–1920," PhD dissertation, University of Texas at Austin, 2000, 305.

43. Nibbe, 308; Richard Cork, *A Bitter Truth: Avant-Garde Art and the Great War* (New Haven, CT: Yale University Press, in association with Barbican Art Gallery, 1994), 300.

44. Recounted in "My Life's Story," online in the Pippin Papers, and printed in Rodman, 80.

45. For histories of the KKK in post-WWI America, see Nancy K. MacLean, *Behind the Mask of Chivalry: The Making of the Second Ku Klux Klan* (New York: Oxford University Press, 1994), and Thomas R. Pegram, *One Hundred*

Percent American: The Rebirth and Decline of the Ku Klux Klan in the 1920s (Lanham, MD: Rowan & Littlefield, 2010).

46. Lewis Jacobs, *Rise of the American Film: A Critical History* (New York: Harcourt, Brace, 1939), 303; quotation from Willard Huntington Wright in *Photoplay* (September 1921). On the history and international reception of *Caligari*, see Mike Budd, ed., *"The Cabinet of Dr. Caligari": Texts, Contexts, Histories* (New Brunswick, NJ: Rutgers University Press, 1990). On *Caligari*'s metaphoric relationship to the war and political insanity, see Anton Kaes, *Shell Shock Cinema: Weimar Culture and the Wounds of the War* (Princeton, NJ: Princeton University Press, 2009), 45–86, parts of which also appear in *"The Cabinet of Dr. Caligari*: Expressionism and Cinema," in *Masterpieces of Modernist Cinema*, ed. Ted Perry (Bloomington: Indiana University Press, 2006), 41–59.

47. The first detailed account of the film's vexed production history is in Siegfried Kracauer, *From Caligari to Hitler: A Psychological History of the German Film* (Princeton, NJ: Princeton University Press, 1947), 61–76.

48. Unsigned review (March 1921) in Stanley Hochman, ed., *From Quasimodo to Scarlet O'Hara: A National Board of Review Anthology, 1920–1940* (New York: Frederick Ungar, 1982), 13.

49. The *Caligari* incident is described in David K. Skal, *Monster Show: A Cultural History of Horror* (rev. ed., New York: Faber and Faber, 2001), 37–40. Upton Sinclair recreated it fictionally in the opening chapters of his 1922 novel *They Call Me Carpenter: Tales of the Second Coming* (Chicago: Paine Book Co., 1922). See "No German Film Here; Legion Wins Fight After Riots," *Los Angeles Daily Mirror*, May 8, 1921. According to Hollywood historian Mary Mallory in her *Los Angeles Daily Mirror* blog, posted December 29, 2014: 'The Cabinet of Dr. Caligari' was praised virtually everywhere it played in the United States that year. *Exhibitors Trade Review*'s January 21, 1922 issue recognized it as one of the Exceptional Photoplays of 1921. Major cities like New York, San Francisco, Seattle, and Philadelphia loved it. In fact, 'The Cabinet of Dr. Caligari' played for months in Philadelphia. Newspapers in such diverse cities as Bisbee, Arizona, Topeka, Kansas, Cleveland, Pittsburgh, and Newberry, South Carolina, praised the film in reviews, calling it sensational, spectacular, or fantastic. Many Americans were flocking to theaters curious to see new artistic foreign films, and came away impressed by the many excellent movies filling cinemas after the long drought during and after World War I." http://ladailymirror.com/2014/12/29/mary-mallory-hollywood-heights-los-angeles-bans-the-cabinet-of-dr-caligari/.

50. Slotkin, *Lost Battalions*, 138–51.

51. Figure for disability benefit claims taken from K. Walter Hickel, "Medicine, Bureaucracy, and Social Welfare: The Politics of Disability for American Veterans of World War I," in *The New Disability History: American Perspectives*, ed. Paul K. Longmore and Lauri Umansky (New York: New York University Press, 2001), 238. See Wechter, *When Johnny Comes*, 385, for a lower estimate of permanent disabilities caused by the war.

52. Martin F. Norden, *Cinema of Isolation: A History of Physical Disability in the Movies* (New Brunswick, NJ: Rutgers University Press, 1994).

53. Siegfried Sassoon, as in n. 6.

54. See James Curtis, *James Whale: A New World of Gods and Monsters* (Minneapolis: University of Minnesota Press, 2003), and, for entertaining and insightful histories of Whale's two *Frankenstein* movies, Robert Horton, *Frankenstein* (New York: Wallflower Press, 2014), and Alberto Manguel, *Bride of Frankenstein* (London: British Film Institute, 1997). Manguel, 59–62, draws apposite comparisons between Whale's *Bride* and Duchamp's *The Bride Stripped Bare by Her Bachelors, Even*.

55. Andre Sennwald, "Gory, Gory, Hallelujah: Being an Inquiry into the Cinema's Recent Trend to Horror," *New York Times* (January 12, 1936), X5.

56. David J. Morris, *The Evil Hours: A Biography of Post-Traumatic Stress Disorder* (Boston: Houghton Mifflin, 2015), 2–3. Grossman, *On Killing*, 309, points out that in the "old horror stories and movies, very real but subconscious fears were symbolized by mythic but unreal monsters, such as Dracula [and Frankenstein and the Wolf Man], and then exorcised exotically, such as by a stake through the heart. In contemporary horror, terror is personified by characters who resemble our next-door neighbor, even our doctor. Importantly, Hannibal the Cannibal, Jason, and Freddy are not killed, much less exorcised; they return over and over again."

57. Victor Turner, *Betwixt and Between: The Liminal Period in Rites of Passage* (La Salle, IL: Open Court, 1987), 5, as quoted in Morris, 7. T. S. Eliot, *The Waste Land* (1922), Section I, "The Burial of the Dead," lines 38–40. (Quoted previously in Chapter 8.)

58. Lyrics to "Remember My Forgotten Man" by Al Dubin and music by Harry Warren.

59. The source novel for *The Last Flight* is John Monk Saunders, *Single Lady* (1931; rpt. Carbondale and Edwardsville: Southern Illinois University Press, 1976).

Chapter 10 "Epilogue"

1. See Frederick Lewis Allen, *Only Yesterday: An Informal History of the 1920s* (1931; rpt. New York: HarperCollins, 2000), 194, Kathleen Drowne and Patrick Huber, *The 1920s* (Westport, CT: Greenwood Press, 2004), 65 and 149, and Paul Sann, *Fads, Follies and Delusions of the American People* (New York: Crown, 1967), 39–46. According to Cynthia Overbeck Bix, *Fad Mania: A History of American Crazes* (New York: 21st Century Books, 2014), 13–14, Kelly logged over 20,613 hours aloft during his flagpole-sitting career but died penniless and forgotten. "His body was found on the streets of New York City. His pockets were empty—except for a bundle of tattered newspaper clippings about his once-famous stunts."

2. F. Scott Fitzgerald, "The Diamond as Big as the Ritz" (1922), in *Babylon Revisited and Other Stories* (New York: Scribner, 1960), 113.

3. Lewis Hine, "Social Photography: How the Camera May Help in the Social Uplift" (1909), reprinted in Alan Trachtenberg, ed., with notes by Amy Weinstein Meyers, *Classic Essays on Photography* (New Haven, CT: Leete's Island Books, 1980), 111. For an introduction to Hine, see Alan Trachtenberg, *America & Lewis Hine: Photographs 1904–1940* (New York: Aperture, in association with the Brooklyn Museum, 1977).

4. Daile Kaplan, *Lewis Hine in Europe: The Lost Photographs* (New York: Abbeville, 1988), and, on Hine between the wars, Kate Sampsell-Williamson, with foreword by Alan Trachtenberg, *Lewis Hine as Social Critic* (Jackson: University Press of Mississippi, 2009), 129–74.

5. Lewis W. Hine, *The Empire State Building*, introduction Freddy Langer (Munich: Prestel, 1988).

6. On DuPont's financial fortunes, see Alfred D. Chandler and Stephen Salsbury, *Pierre S. du Pont and the Making of the Modern Corporation* (New York: Harper & Row, 1971), Gerard Colby, *Du Pont Dynasty: Behind the Nylon Curtain* (Secaucus, NJ: Lyle Stuart, 1984), Max Dorian, *The du Ponts: From Gunpowder to Nylon* (Boston: Little, Brown, 1962), and Graham D. Taylor and Patricia E. Sudnik, *DuPont and the International Chemical Industry* (Boston: Twayne, 1984). See also Roland Marchand, *Creating the Corporate Soul: The Rise of Public Relations and Corporate Imagery in American Business* (Berkeley: University of California Press, 1998), 131–32. In a June 1918 speech, a Du Pont executive bragged about the company's wartime profits: "I am proud to admit that we have made millions of dollars. If we had lost millions, our critics today who condemn us would laugh and call us idiots and fools and the Kaiser would have the laugh on this government because it was not prepared with powder"; quoted in Dorian, *The du Ponts*, 192.

7. Ric Burns, James Sanders, and Lisa Ades, *New York: An Illustrated History* (New York: Knopf, 2003), 378–82, with quotation from Colonel William A. Starett on 378–79. In "The Mohawks in High Steel" (1949), *The New Yorker* reporter at large Joseph Mitchell profiled high-altitude riveters from the Mohawk nation who had no fear of extreme heights; see Mitchell, *Up in the Old Hotel* (New York: Pantheon, 1992), 267–90.

8. Mark Cotta Vaz, *Living Dangerously: The Adventures of Merian C. Cooper, Creator of "King Kong"* (New York: Villard Books, 2005). Cooper was a co-founder of Pan American Airlines, a strong advocate of American aeronautical might, and a frequent collaborator with conservative Hollywood director John Ford, producing some of Ford's most acclaimed films, including *The Lost Patrol, Fort Apache, She Wore a Yellow Ribbon, The Quiet Man*, and *The Searchers*. As noted in Chapter 4, Cooper also produced *Aces of Aces*, a 1933 war film with strong pacifist overtones; this was an aberration from his norm. For a postmodernist rumination on King Kong and contemporary skyscraper-scaling daredevils, see Meaghan Morris, "Great Moments in Social Climbing: King Kong and the Human Fly," in *Too Soon, Too Late: History in Popular Culture* (Bloomington: Indiana University Press, 1998), 123–57. Peter Conrad unites Hine's airborne workmen with King Kong in *The Art of the City: Views and Versions of New York* (New York: Oxford University Press, 1984), 211–14. On depictions of WWI aviation in painting, printmaking, and sculpture, see Jon Mogul and Peter Clericuzio, *Myth + Machine: Art and Aviation in the First World War* (Miami Beach, FL: The Wolfsonian and Florida International University, 2015). On the filmmakers' unauthorized use of real Navy biplanes to "jazz" the Empire State Building for the finale of *King Kong*, see Lawrence H. Suid, *Guts & Glory: The Making of the American Military Image in Film*, rev. and expanded ed. (Lexington: University Press of Kentucky, 2002), 52–53.

9. Ian Kershaw, *Hitler, 1889–1936: Hubris* (New York: Norton, 1999), 485.

10. Laurence Stallings, *The First World War: A Photographic History* (New York: Simon and Schuster, 1933). See Aaron J. Gulyas, "Pictures Worth A Thousand Words: *The First World War: A Photographic History* and Perceptions of the Great War," *Hanover Historical Review* 8 (Spring 2000), n.p.; online at http://history.hanover.edu/hhr/hhr5-2.html.

LIST OF FIGURES

David M. Lubin is the Charlotte C. Weber Professor of Art at Wake Forest University. He is the author of *Shooting Kennedy: JFK and the Culture of Images* and *Picturing a Nation: Art and Social Change in Nineteenth-Century America*, among others.

INDEX